SOLITARY PLEASURES

The Historical, Literary,

and Artistic Discourses

of Autoeroticism

Edited by

PAULA BENNETT

VERNON A. ROSARIO II

ROUTLEDGE *New York · London*

Published in 1995 by

Routledge
29 West 35th Street
New York, NY 10001

Published in Great Britain by
Routledge
11 New Fetter Lane
London EC4P 4EE

Copyright © 1995 by Routledge

Printed in the United States of America.

"I tend my flowers for thee" reprinted by permission of the publishers and the Trustees of Amherst College from *The Poems of Emily Dickinson*, Thomas H. Johnson, ed., Cambridge, MA: The Belknap Press of Harvard University Press, Copyright © 1951, 1955, 1979, 1983 by the President and Fellows of Harvard College. Also reprinted by permission of Little, Brown and Company from *The Complete Poems of Emily Dickinson*, edited by Thomas H. Johnson. Copyright 1929, 1935, by Martha Dickinson Bianchi; Copyright © renewed 1957, 1963 by Mary L. Hampson.

"Jane Austen and the Masturbating Girl" from *Tendencies* by Eve Kosofsky Sedgwick. Copyright © Duke University Press 1993. Reprinted with permission.

"The Social Evil, the Solitary Vice and Pouring Tea" by Thomas Laqueur, from Zone 5: *Fragments for a History of the Human Body*, edited by Michael Feher with Ramona Naddaff and Nadia Tazi (New York: Zone Books, 1989). Copyright © 1989 Urzone, Inc. Reprinted with permission.

Library of Congress Cataloging-in-Publication Data

Solitary Pleasures: The Historical, Literary, and Artistic Discourses of
 Autoeroticism. Edited by Paula Bennett, Vernon A. Rosario II.
 p. cm.
 Includes bibliographical references and index.
 ISBN 0-415-91173-7. — ISBN 0-415-91174-5 (alk. paper)
 1. Masturbation—History. 2. Masturbation in literature.
 3. Masturbation in art. I. Bennett, Paula. II Rosario, Vernon A.
HQ447.S73 1995
306.77'2—dc20
 95-22216
 CIP

To Kent
and to Luke,
best of Solitude's companions.

Contents

Acknowledgments

The idea for this book came from a special session on the "Muse of Masturbation" organized by Eve Kosofsky Sedgwick for the Modern Languages Association conference in December 1989. Although Eve was not able to join in editing the anthology itself, she has remained supportive throughout, and we are particularly grateful to her for bringing the two of us together in the first place. We would also like to acknowledge the assistance of Ms. Lisa Day, who struggled valiantly with a multiplicity of "imaginative" (her term) footnote forms and of William Germano at Routledge for his enthusiastic support of our project. A thank-you is also due our contributors for their enormous patience with our extended delays on the road to publication.

among today's cultural discourses relating to sexuality. On the one hand, in the popular American media (e.g., sexual self-help books, advice columns, pop music, and film), masturbation, like other sexual topics, is treated with relative openness, albeit often with a frisson of shame. Also, as the journal editor indicates, masturbation has been a topic for serious inquiry in a variety of academic disciplines. Since the 1960s, scholars in women's studies and gay and lesbian studies, in particular, have amassed a substantial body of research on the relationship between sexuality, power, and culture. In this research, increasing attention has been paid to the links between autoeroticism and desire, and to the relationship between sexual fantasy and artistic productions such as literature and film.

On the other hand, masturbation is still a taboo or, at best, an uncomfortable subject for most people in everyday conversation. In the universities, as well, there remain scholars, such as the letter-writer quoted above, for whom the mere hint of "self-pollution" threatens to unleash an endless torrent of erotic muck. The repeated associations of pornography with both the sexual abuse of children and the exploitation of women also indicate that the role of autoerotic or masturbatory fantasy in sexual behavior is an issue fraught with tension. Both as a sexual activity and as an occasion for erotic imagining, masturbation retains its capacity to inspire profound fears. That these fears can still be enlisted to justify political attempts to control sexuality was vividly demonstrated in December 1994 when Doctor Jocelyn Elders was dismissed as United States Surgeon General as a result of her comments at an AIDS conference on the utility of reassuring children of the "normality" of masturbation.

Given how accustomed we are to the presence of other sexual discourses in the press, on television, in the legislature and the academy, the continued anxiety surrounding this—the earliest, most intimate, and perhaps the most common of all sexual behaviors—is worth pondering. Why, as the editors of this anthology discovered, does the mere mention of the word "masturbation" still raise eyebrows and evoke titters at a time when most forms of sexual activity have been talked into banality? Far more seriously, despite the exponential growth of sexual knowledge over the past two centuries, why are the activities of masturbation and masturbatory fantasizing still a source of guilt and shame.

Although the existing historical record leaves much uncertain, it is clear that masturbation, or the "spilling of seed," has been characterized in a variety of ways over time, some considerably less pernicious than others. Indeed, it is arguable that masturbation was not viewed as a serious physical and psycholog-

INTRODUCTIO

THE POLITICS OF SOLITARY PLEASUR

PAULA BENNETT & VERNON A. ROSARIO II, I

When this anthology's call for papers appeared in a prestigious ac
journal, one reader was so outraged he could hardly contain himse
letter to the editor. What would things come to, he fumed, if "men [sic]
will and judgment" did not draw the line somewhere to protect "traditio
cepts of decency and decorum." If "vulgar and distasteful" topics such as
genitals, autoeroticism, and "medical attitudes towards masturbation (f
sake!)" were taken as legitimate subjects for investigation by scholars, wh
come next? The writer's mind reeled at the possibilities his imagination
up—possibilities he assumed must have occurred to the journal's edito

As it turned out, the editor did not share the letter-writer's vision
demic Armageddon. Masturbation, he mildly replied, had been a "
topic of study for a long time in medical, sociological, and literary ci
university showed no signs of falling yet.

Both the letter-writer's limitless outrage and the editor's carefull
response are symptomatic of masturbation's continuing contradi

2

ical threat to individuals or society until the publication of *Onania, or the Heinous Sin of Self-Pollution* in 1710. Even then, the quack huckster/author peddling his "Prolifick Powder" was surprised by the number of imitators he found amongst his fellow "empirics" and orthodox physicians, who unleashed a cacophony of European and American literature condemning *manustupration* ("defilement by the hand") in both sexes. Protean in their adaptability to historical and cultural settings, this literature's apocalyptic warnings about the personal and social morbidity of "self-pollution" still haunt us today.

As historical research of the past ten years suggests, until *Onania*, the *medical* concern with "gonorrhœa," or seminal discharge, (from the Greek, γόνος, seed, and ῥοια, flux) was quite distinct from the *theological* condemnation of "spilling of seed" and from "masturbation" per se. The Roman Catholic condemnation of the mortal sin of "pollution" or *"mollities"* (softness or effeminacy) was elaborated in the Middle Ages.[1] Self-pollution was considered a "sin against nature" and its biblical condemnation was traced back to God's condemnation of Onan for having spilt his seed on the ground rather than conceiving an heir by his widowed sister-in-law Tamar as Levirate law demanded (*Genesis* 38:7–10). Theologians debated whether Onan's crime was masturbation or *coitus interruptus* since *Genesis* is unclear on this point. Nevertheless, they consistently condemned such voluntary emissions along with fornication, adultery, mollities (softness/effeminacy), sodomy, and bestiality—all classified as forms of unlawful sex.[2] But as far as we can tell, these Church strictures were only addressed to *adults*. Furthermore, according to Church writings the ills of "manustupration" were confined to defilement of the soul and mind. They did not suggest that *organic ills* were the wages of "self-defilement," nor did they envision lasting psychological damage.

Medieval physicians were generally careful to acknowledge Church injunctions against "illicit" sexual acts, but, on the whole, their concern was more with the retention of semen than with its loss—whether voluntarily or involuntarily. Since Antiquity, medical texts proposed theories of seed physiology (Gerlach 1938; Sissa 1989). In the influential work of Galen (c.131–c.201), the principle of health in both men and women was the just balance between production and excretion of the precious seminal humor. Although Galen described "gonorrhoea" (useless, involuntary excretion of seed) as a pathological condition (1625, IV:41vF), he was far more concerned with accumulated seed which, for example, could putrefy in chaste women (widows, nuns, and virgins) and produce diseases such as hysteria.[3] Galen's call for humoral balance in the retention and

excretion of seed was widely adopted by medieval medical authorities. Like the theological texts, medieval medical literature makes no mention of childhood masturbation, nor did medieval physicians, as far as we know, attach morbid physical or psychological consequences to the act of masturbation (Stenghers & Van Neck 1984, 42).

Increased concern with gonorrhœa does emerge in Renaissance medical texts, particularly in conjunction with venereal disease and various forms of illicit sexual activity. For example, the highly respected and widely translated Swiss physician Felix Platter (1536–1614), described a case of "Gonorrhœa or Running of the Reyns" in which "[a] young man with pain and heat in the hypochondria [abdomen] and Loyns, and a Gonorrhœa, his seed came forth and he felt it not, like water seven years, it consumed him…" (Platter 1664, 471–72). But Platter made no mention of manustupration as a cause of gonorrhea in the chapter on "Observations on excretion of seed." Furthermore, he was unperturbed by a patient's acknowledgment of voluntary "voiding of seed" (1664, 517).

The eccentric, self-styled "Doctor of Physicke," Andrew Boorde (1500?–1549?), did evince a more moralistic attitude toward seminal loss, identifying three kinds of "Gomorrea": first, pollutions against nature; second, pollutions due to infirmity; third, pollutions due to imbecility. He was apparently the first to suggest that "gomorrea" comes from "Sodome and Gomer" which "dyd synke to hell sodenly" for practicing the "gomorrea passio" voluntarily, which is "to meddle with any brute beast or pollute hymselfe wylfully" (Boorde 1552, f. 59 v). To the modern reader, Boorde appears to blur a variety of "sinful" sexual acts which today we categorize as quite distinct behaviors. His varieties of "gomorrhea" and even their signification cannot be matched with current sexual practices or terminology. MacDonald errs (1967, 431), therefore, when he equates Boorde's term "gomorrea passio" with "masturbation." Boorde condemns "voluntary pollution," but as it was traditionally understood—one amongst many varieties of "unnatural" and illicit "venery" and in itself composed of a number of different kinds of polluting acts.

The need for such careful historical contextualization of pre-Enlightenment medical texts is also evident when one turns to the work of the influential Dutch physician and philosopher Hermann Boerhaave (1668–1738). Like most of his colleagues, Boerhaave was far more concerned with seminal discharge (of any variety) than he was with masturbation itself. The following description of the symptomatology of excessive seminal loss does bear a striking resemblance to the portrait of the terminal onanist sketched in later anti-masturbation tracts:

The *Semen* discharged too lavishly, occasions a Weariness, Weakness, Indisposition to Motion, Convulsions, Leanness, Driness, Heats and Pains in the Membranes of the Brain, with a Dulness of the Senses; more especially of the Sight, a *Tabes Dorsalis*, Foolishness, and Disorders of the like kind. ([1708], V: 456; original italics and orthography)

However, we should be wary of clumping Boerhaave with the author of *Onania*. For Boerhaave, the *causes* for such cachexia or wasting include not only voluntary and nocturnal emissions, but also, in the case of *tabes dorsalis*, the lavish discharge of seed which "most frequently happens to those who are too furious and earlier (sic) in their Combats in the Camps of Venus" (i.e., consort with prostitutes) ([1708], V: 456n). Moreover, Boerhaave sets the whole section on excessive discharge of seed in the context of the morbid effects of excessive humoral loss, be it blood, lymphatic juice, bile, urine, or perspiration. To Boerhaave, the lavish discharge of semen was no different from the loss of *any other* vital fluid in causing a non-specific "atrophy or wasting of the whole habit for want of nutrition."

In their historical survey of documents on masturbation, Stenghers and Van Neck (1984, 44) could only identify two medical texts prior to *Onania* that contain unequivocal, if fleeting, condemnations of masturbation. The German physician Ettmüller explained in 1670 that gonorrhea might be due to "nefarious *manstuprationem*." In 1706, the British doctor Edward Baynard vaunted the use of cold baths to treat impotence, which he claimed was caused by "that cursed school wickedness of masturbation."

In summary, pre-Enlightenment medical texts were concerned with generic "seminal loss" as a source of humoral imbalance. With only two known minor exceptions, humoral theory was not employed in defense of the theologico-moral condemnation of "self-pollution." Although, as the citation from Boerhaave makes clear, physiological justifications had been well established for the later anti-onanistic crusade, Western medical opinion had not yet picked out onanism as a uniquely pernicious personal and social disease.

The anonymous publication of *Onania, or the heinous sin of self-pollution, and its frightful consequences in both sexes considered, with spiritual and physical advice to those who have already injured themselves by this abominable practice* [1710?] dramatically reordered Euro-American medical and cultural perceptions of masturbation, transforming it from one of many forms of seminal and excretory loss into a sexual practice potentially fatal to individuals and society alike.[4] Initially,

Onania was a brief pamphlet and advertisement for "Strengthening Tincture" (10 shillings) and the "Prolifick Powder" (12 shillings). These quack medications and total abstinence were, the author claimed, the only salvation from the ills of onanism: stunted growth, priapism, gonorrhœa, cachexia, blindness, phthisis, insanity, countless other disorders, and, ultimately, death (*Onania*, 12–13). In the first half of the eighteenth century, *Onania* expanded into a sizable volume, made fat by "testimonial" letters from customers rescued from the deadly clutches of onanism. By 1750, *Onania* had appeared in nineteen editions and had sold thirty-eight thousand copies (Neuman 1975, 2). Physicians—notably S.A.A.D. Tissot, then countless others in Europe and America—lent professional credibility to the moralistic views *Onania* set forth.

Numerous medical monographs and journal articles, as well as case records of hospital and insane asylum patients diagnosed as "onanists," attest to the fact that, following *Onania*, masturbation was considered a serious disease by doctors and public alike until the early twentieth century. Nevertheless, recent scholarly and popular treatments of the anti-onanism phenomenon have narrowed its cultural significance, viewing it either as a mere medical delusion or else as a sinister conspiracy on the part of the medical profession. For example, René Spitz's (1953) whiggish history presents the theory of onanistic pathology as a transient aberration of medical science, while Dr. Thomas Szasz's (1970, 180–206) anti-psychiatric critique of the anti-masturbation campaign portrays it as a sadistic, Victorian medical witch-hunt.

Focusing on a selection of particularly lurid cases, G. J. Barker-Benfield (1976) and Jeffrey M. Masson (1986) have depicted these same doctors as wholesale practitioners of medical atrocities against women, putting them, as Catherine A. MacKinnon hyperbolically states in her preface to Masson's book, on a par with the torturers of the Inquisition and the concentration camp doctors of the Third Reich. That male onanists suffered horribly from the worst excesses of the anti-masturbation campaign is virtually ignored in these texts. Barker-Benfield and Masson also fail to stress sufficiently that these extremist physicians were also censured by their contemporary colleagues.

In contrast to such reductivist approaches, more balanced historical research has included broader social issues and relied on a Freudian "repressive hypothesis," proposing, for example, that the anti-onanism campaign was a product of a so-called "Victorian Age" "synonymous with prudery" (Duffy 1963). From the functionalist sociological perspective of the Parsonian "sick role," it has been suggested that masturbation represented a silent compact between doctors and

INTRODUCTION:

THE POLITICS OF SOLITARY PLEASURES

PAULA BENNETT & VERNON A. ROSARIO II, M.D.

When this anthology's call for papers appeared in a prestigious academic journal, one reader was so outraged he could hardly contain himself in his letter to the editor. What would things come to, he fumed, if "men [sic] of good will and judgment" did not draw the line somewhere to protect "traditional concepts of decency and decorum." If "vulgar and distasteful" topics such as orgasms, genitals, autoeroticism, and "medical attitudes towards masturbation (for God's sake!)" were taken as legitimate subjects for investigation by scholars, what would come next? The writer's mind reeled at the possibilities his imagination conjured up—possibilities he assumed must have occurred to the journal's editor as well.

As it turned out, the editor did not share the letter-writer's vision of an academic Armageddon. Masturbation, he mildly replied, had been a "legitimate topic of study for a long time in medical, sociological, and literary circles." The university showed no signs of falling yet.

Both the letter-writer's limitless outrage and the editor's carefully delimited response are symptomatic of masturbation's continuing contradictory status

1

among today's cultural discourses relating to sexuality. On the one hand, in the popular American media (e.g., sexual self-help books, advice columns, pop music, and film), masturbation, like other sexual topics, is treated with relative openness, albeit often with a frisson of shame. Also, as the journal editor indicates, masturbation has been a topic for serious inquiry in a variety of academic disciplines. Since the 1960s, scholars in women's studies and gay and lesbian studies, in particular, have amassed a substantial body of research on the relationship between sexuality, power, and culture. In this research, increasing attention has been paid to the links between autoeroticism and desire, and to the relationship between sexual fantasy and artistic productions such as literature and film.

On the other hand, masturbation is still a taboo or, at best, an uncomfortable subject for most people in everyday conversation. In the universities, as well, there remain scholars, such as the letter-writer quoted above, for whom the mere hint of "self-pollution" threatens to unleash an endless torrent of erotic muck. The repeated associations of pornography with both the sexual abuse of children and the exploitation of women also indicate that the role of autoerotic or masturbatory fantasy in sexual behavior is an issue fraught with tension. Both as a sexual activity and as an occasion for erotic imagining, masturbation retains its capacity to inspire profound fears. That these fears can still be enlisted to justify political attempts to control sexuality was vividly demonstrated in December 1994 when Doctor Jocelyn Elders was dismissed as United States Surgeon General as a result of her comments at an AIDS conference on the utility of reassuring children of the "normality" of masturbation.

Given how accustomed we are to the presence of other sexual discourses in the press, on television, in the legislature and the academy, the continued anxiety surrounding this—the earliest, most intimate, and perhaps the most common of all sexual behaviors—is worth pondering. Why, as the editors of this anthology discovered, does the mere mention of the word "masturbation" still raise eyebrows and evoke titters at a time when most forms of sexual activity have been talked into banality? Far more seriously, despite the exponential growth of sexual knowledge over the past two centuries, why are the activities of masturbation and masturbatory fantasizing still a source of guilt and shame.

Although the existing historical record leaves much uncertain, it is clear that masturbation, or the "spilling of seed," has been characterized in a variety of ways over time, some considerably less pernicious than others. Indeed, it is arguable that masturbation was not viewed as a serious physical and psycholog-

ical threat to individuals or society until the publication of *Onania, or the Heinous Sin of Self-Pollution* in 1710. Even then, the quack huckster/author peddling his "Prolifick Powder" was surprised by the number of imitators he found amongst his fellow "empirics" and orthodox physicians, who unleashed a cacophony of European and American literature condemning *manustupration* ("defilement by the hand") in both sexes. Protean in their adaptability to historical and cultural settings, this literature's apocalyptic warnings about the personal and social morbidity of "self-pollution" still haunt us today.

As historical research of the past ten years suggests, until *Onania*, the *medical* concern with "gonorrhœa," or seminal discharge, (from the Greek, γόηος, seed, and ῥοια, flux) was quite distinct from the *theological* condemnation of "spilling of seed" and from "masturbation" per se. The Roman Catholic condemnation of the mortal sin of "pollution" or *"mollities"* (softness or effeminacy) was elaborated in the Middle Ages.[1] Self-pollution was considered a "sin against nature" and its biblical condemnation was traced back to God's condemnation of Onan for having spilt his seed on the ground rather than conceiving an heir by his widowed sister-in-law Tamar as Levirate law demanded (*Genesis* 38:7–10). Theologians debated whether Onan's crime was masturbation or *coitus interruptus* since *Genesis* is unclear on this point. Nevertheless, they consistently condemned such voluntary emissions along with fornication, adultery, mollities (softness/effeminacy), sodomy, and bestiality—all classified as forms of unlawful sex.[2] But as far as we can tell, these Church strictures were only addressed to *adults*. Furthermore, according to Church writings the ills of "manustupration" were confined to defilement of the soul and mind. They did not suggest that *organic ills* were the wages of "self-defilement," nor did they envision lasting psychological damage.

Medieval physicians were generally careful to acknowledge Church injunctions against "illicit" sexual acts, but, on the whole, their concern was more with the retention of semen than with its loss—whether voluntarily or involuntarily. Since Antiquity, medical texts proposed theories of seed physiology (Gerlach 1938; Sissa 1989). In the influential work of Galen (c.131–c.201), the principle of health in both men and women was the just balance between production and excretion of the precious seminal humor. Although Galen described "gonorrhoea" (useless, involuntary excretion of seed) as a pathological condition (1625, IV:41vF), he was far more concerned with accumulated seed which, for example, could putrefy in chaste women (widows, nuns, and virgins) and produce diseases such as hysteria.[3] Galen's call for humoral balance in the retention and

excretion of seed was widely adopted by medieval medical authorities. Like the theological texts, medieval medical literature makes no mention of childhood masturbation, nor did medieval physicians, as far as we know, attach morbid physical or psychological consequences to the act of masturbation (Stenghers & Van Neck 1984, 42).

Increased concern with gonorrhœa does emerge in Renaissance medical texts, particularly in conjunction with venereal disease and various forms of illicit sexual activity. For example, the highly respected and widely translated Swiss physician Felix Platter (1536–1614), described a case of "Gonorrhœa or Running of the Reyns" in which "[a] young man with pain and heat in the hypochondria [abdomen] and Loyns, and a Gonorrhœa, his seed came forth and he felt it not, like water seven years, it consumed him…" (Platter 1664, 471–72). But Platter made no mention of manustupration as a cause of gonorrhea in the chapter on "Observations on excretion of seed." Furthermore, he was unperturbed by a patient's acknowledgment of voluntary "voiding of seed" (1664, 517).

The eccentric, self-styled "Doctor of Physicke," Andrew Boorde (1500?–1549?), did evince a more moralistic attitude toward seminal loss, identifying three kinds of "Gomorrea": first, pollutions against nature; second, pollutions due to infirmity; third, pollutions due to imbecility. He was apparently the first to suggest that "gomorrea" comes from "Sodome and Gomer" which "dyd synke to hell sodenly" for practicing the "gomorrea passio" voluntarily, which is "to meddle with any brute beast or pollute hymselfe wylfully" (Boorde 1552, f. 59 v). To the modern reader, Boorde appears to blur a variety of "sinful" sexual acts which today we categorize as quite distinct behaviors. His varieties of "gomorrhea" and even their signification cannot be matched with current sexual practices or terminology. MacDonald errs (1967, 431), therefore, when he equates Boorde's term "gomorrea passio" with "masturbation." Boorde condemns "voluntary pollution," but as it was traditionally understood—one amongst many varieties of "unnatural" and illicit "venery" and in itself composed of a number of different kinds of polluting acts.

The need for such careful historical contextualization of pre-Enlightenment medical texts is also evident when one turns to the work of the influential Dutch physician and philosopher Hermann Boerhaave (1668–1738). Like most of his colleagues, Boerhaave was far more concerned with seminal discharge (of any variety) than he was with masturbation itself. The following description of the symptomatology of excessive seminal loss does bear a striking resemblance to the portrait of the terminal onanist sketched in later anti-masturbation tracts:

> The *Semen* discharged too lavishly, occasions a Weariness, Weakness, Indisposition to Motion, Convulsions, Leanness, Driness, Heats and Pains in the Membranes of the Brain, with a Dulness of the Senses; more especially of the Sight, a *Tabes Dorsalis*, Foolishness, and Disorders of the like kind. ([1708], V: 456; original italics and orthography)

However, we should be wary of clumping Boerhaave with the author of *Onania*. For Boerhaave, the *causes* for such cachexia or wasting include not only voluntary and nocturnal emissions, but also, in the case of *tabes dorsalis*, the lavish discharge of seed which "most frequently happens to those who are too furious and earlier (sic) in their Combats in the Camps of Venus" (i.e., consort with prostitutes) ([1708], V: 456n). Moreover, Boerhaave sets the whole section on excessive discharge of seed in the context of the morbid effects of excessive humoral loss, be it blood, lymphatic juice, bile, urine, or perspiration. To Boerhaave, the lavish discharge of semen was no different from the loss of *any other* vital fluid in causing a non-specific "atrophy or wasting of the whole habit for want of nutrition."

In their historical survey of documents on masturbation, Stenghers and Van Neck (1984, 44) could only identify two medical texts prior to *Onania* that contain unequivocal, if fleeting, condemnations of masturbation. The German physician Ettmüller explained in 1670 that gonorrhea might be due to "nefarious *manstuprationem*." In 1706, the British doctor Edward Baynard vaunted the use of cold baths to treat impotence, which he claimed was caused by "that cursed school wickedness of masturbation."

In summary, pre-Enlightenment medical texts were concerned with generic "seminal loss" as a source of humoral imbalance. With only two known minor exceptions, humoral theory was not employed in defense of the theologico-moral condemnation of "self-pollution." Although, as the citation from Boerhaave makes clear, physiological justifications had been well established for the later anti-onanistic crusade, Western medical opinion had not yet picked out onanism as a uniquely pernicious personal and social disease.

The anonymous publication of *Onania, or the heinous sin of self-pollution, and its frightful consequences in both sexes considered, with spiritual and physical advice to those who have already injured themselves by this abominable practice* [1710?] dramatically reordered Euro-American medical and cultural perceptions of masturbation, transforming it from one of many forms of seminal and excretory loss into a sexual practice potentially fatal to individuals and society alike.[4] Initially,

Onania was a brief pamphlet and advertisement for "Strengthening Tincture" (10 shillings) and the "Prolifick Powder" (12 shillings). These quack medications and total abstinence were, the author claimed, the only salvation from the ills of onanism: stunted growth, priapism, gonorrhœa, cachexia, blindness, phthisis, insanity, countless other disorders, and, ultimately, death (*Onania*, 12–13). In the first half of the eighteenth century, *Onania* expanded into a sizable volume, made fat by "testimonial" letters from customers rescued from the deadly clutches of onanism. By 1750, *Onania* had appeared in nineteen editions and had sold thirty-eight thousand copies (Neuman 1975, 2). Physicians—notably S.A.A.D. Tissot, then countless others in Europe and America—lent professional credibility to the moralistic views *Onania* set forth.

Numerous medical monographs and journal articles, as well as case records of hospital and insane asylum patients diagnosed as "onanists," attest to the fact that, following *Onania*, masturbation was considered a serious disease by doctors and public alike until the early twentieth century. Nevertheless, recent scholarly and popular treatments of the anti-onanism phenomenon have narrowed its cultural significance, viewing it either as a mere medical delusion or else as a sinister conspiracy on the part of the medical profession. For example, René Spitz's (1953) whiggish history presents the theory of onanistic pathology as a transient aberration of medical science, while Dr. Thomas Szasz's (1970, 180–206) anti-psychiatric critique of the anti-masturbation campaign portrays it as a sadistic, Victorian medical witch-hunt.

Focusing on a selection of particularly lurid cases, G. J. Barker-Benfield (1976) and Jeffrey M. Masson (1986) have depicted these same doctors as wholesale practitioners of medical atrocities against women, putting them, as Catherine A. MacKinnon hyperbolically states in her preface to Masson's book, on a par with the torturers of the Inquisition and the concentration camp doctors of the Third Reich. That male onanists suffered horribly from the worst excesses of the anti-masturbation campaign is virtually ignored in these texts. Barker-Benfield and Masson also fail to stress sufficiently that these extremist physicians were also censured by their contemporary colleagues.

In contrast to such reductivist approaches, more balanced historical research has included broader social issues and relied on a Freudian "repressive hypothesis," proposing, for example, that the anti-onanism campaign was a product of a so-called "Victorian Age" "synonymous with prudery" (Duffy 1963). From the functionalist sociological perspective of the Parsonian "sick role," it has been suggested that masturbation represented a silent compact between doctors and

patients: a positive diagnosis of "onanism" allowed doctors to overcome their therapeutic inefficacy, while patients' acceptance of the "onanist" sick role represented a secular, medicalized form of penance (Hare 1962; Gilbert 1975). Adopting a sociological approach, Neuman (1975) naturalizes the masturbatory phenomenon by suggesting that the earlier onset of puberty, and the bourgeois delay of marriage, led to an actual increase in the practice of masturbation precisely at a time when bourgeois values prescribed economic and sexual thrift. Similarly, Hare (1962) posits an actual increase in masturbatory behavior which he attributes to heightened fears of venereal diseases.

In his extensive review of Enlightenment anti-masturbatory literature in *Sexe et liberté au siècle des Lumières* (1983), Théodore Tarczylo rejects these Freudo-Marxist and sociological explanations, suggesting instead that the anti-onanism campaign arose paradoxically as an intrinsic part of progressive Enlightenment ideology and a growing fear of declining French fertility. Thomas Laqueur ([1989] 1995) echoes Tarczylo's critique of the existing historical literature and suggests a different ideological explanation: the "solitary vice" was accused of leading to antisociality. Laqueur rightly points out that the organic rationalizations of the dangers of masturbation are rather flimsy, even by the physiological theories of the time. He further suggests that the social interdiction of onanism served to control the perceived danger of a rampant erotic imagination and not simply to curtail the physical practice itself (1992).

Although the cultural reasons for masturbation phobia are likely to remain a matter of debate, it is nevertheless clear that after the eighteenth century, medical and popular health literature represented "onanism" as a fatal practice of epidemic proportions. The medical acumen and rhetoric deployed towards its prevention and treatment is exceptional in its diversity and in some cases in its cruelty: diets, drugs, cold showers, corsets, electrical alarms, urethral and clitoral cauterization, clitoridectomy, and labial sewing, were all recommended and utilized. Most important of all, however, was surveillance. In *Emile* (1762), Rousseau urged: "Do not leave [your pupil] alone during the day or night; at least sleep in his bed.... If he once knows that dangerous supplement [onanism], he is lost indeed" (663). But even physical restraint and constant surveillance proved disconcertingly ineffective against the most powerful stimulant at the onanist's disposal: rêverie. As Dr. J. D. T. de Bienville, in *Nymphomania, or a Dissertation Concerning the Furor Uterinus* (1775), forthrightly claimed: "This fatal rage of *Masturbation* of which the *imagination is the artisan*, leads to excesses over which the wretched criminal [i.e., nymphomani-

ac] imperceptibly ceases to have any power..." (174–75; emphasis added). Precisely because the workings of the imagination were in their own way also "imperceptible," control over the masturbator's mind became one of the physician's greatest challenges.

The multifarious technologies of bodily control, constant observation, and imaginary self-policing that were recommended and employed by eighteenth- and nineteenth-century medical practitioners and educators make the campaign to eradicate masturbation an exemplary product of what Michel Foucault described as the "carceral society": "The carceral fabric of society assures at once the real harnessing of the body and its perpetual surveillance; by its intrinsic properties, it is the punitive apparatus most appropriate to the new economy of power, and the instrument for the development of the knowledge upon which this very economy depends" (1975, 311). For over a century, the "onanist" (much like the pathologized "homosexual" evoked by certain conservative religious and political groups today) was identified as a sexually deviant, socially pathogenic type whose imagination and bodily acts inspired condemnation, fear, and an array of techniques for erotic manipulation and control.

It is only in digging deeper through the scientific and religious justifications for the condemnation of masturbation that we begin to identify the ideological grounds for the anti-onanism campaign in terms of the class, gender, racial, national, and political ideals they endorsed, as well as the new forms of physical and psychic "self-control" they induced. While nocturnal erection alarms, clitoral cautery, and terrifying warnings may no longer be part of the anti-onanism arsenal, their chilling effect still lingers around popular perceptions of masturbation. Perhaps even more importantly, by studying how the anti-onanism crusade accomplished its ideological work through the regulation of the erotic, we gain insight into the strategies employed in current battles over sexuality (whether it be homosexuality, pornography, transsexualism, sado-masochism, etc.), and the socio-political issues at stake.

Yet, even as contemporary sexual politics are not simply a tale of oppression but also a site for resistance and self-definition, so the careful analysis of the discourses of onanism over the centuries demonstrates much more than just the repression of masturbation. Unquestionably, the ontologization and "treatment" of the "onanist" led to substantial mental and physical suffering. But as Foucault suggests concerning other discourses designed to regulate sexuality (1976), there is also evidence that in constructing "solitary vice," the anti-masturbation literature stimulated the very behavior it sought to abolish. Indeed, nineteenth-cen-

tury critics themselves warned that anti-onanism literature—even the most censorious—might prematurely ignite the erotic imagination of innocent children. They were also aware that, thanks to its graphic descriptions of orgasmic self-abandon, this literature might be avidly sought for adult pornographic pleasure.

It was precisely these fears of erotic incitement that nineteenth-century anti-onanist doctors identified as the social barrier to their message. In their own eyes, they were the *promoters*, not the *repressors*, of sexual knowledge, and they universally bemoaned society's failure to properly inform children of the evils awaiting the unwary. For example, Dr. Samuel Woodward, director of the Worcester Asylum for the Insane, complained bitterly in 1835 that children continued to fall victims to "self-pollution":

> It can hardly be said that the attention of parents, teachers or even the members of the medical profession, is duly awakened to the dangers which arise from the habit of Masturbation. Even at this time many doubt the expediency of bringing the subject before the public in any form, believing that diffusing information may be the cause of greater evil to the young than the benefits which may arise from a knowledge of those dangers to all. (1835, 94)

Ironic though it may seem to us, these Jeremiahs of onanism saw themselves as the embattled and controversial advocates of sexual education. Like us, they appreciated the dangers of silence and the power of the word. Whatever the physical and psychological suffering involved, moreover, their practices were—by the collective beliefs of the time—devoted to healing. That their methods backfired on them, making them appear as social oppressors and at the same time dispersing knowledge in exactly the way their critics feared, are only two of the many paradoxical aspects of their campaign.

The anti-onanism crusade begun in the eighteenth century cannot be simply described as a reactionary campaign of gratuitous physical torture. Nor was it merely an ironic stimulant to perverse behavior—a set of discursive regulations gone awry. Rather it was a complex, powerful, and contradictory cultural phenomenon, whose traces are still with us today, and about which numerous questions remain. For example, given the relative indifference of medieval and Renaissance medical authorities to "manustupration," why did the physical acts and imaginative activities associated with masturbation become so dramatically stigmatized during the "Age of Reason"? Why was the eradication of "self-pollution" such an important goal of nineteenth-century public hygiene? Finally,

even after the "sexual revolution" and sexologists' attempts to normalize masturbation as a healthy waystation to adult sexuality and erotic self-affirmation, why are there still so many who find the topic threatening?

The essays in this collection—spanning European and American culture from the sixteenth century to the present—take seriously the "vicious pleasures of solitude": both the cruelty they inspired and the pleasures they yield. Since, as Laqueur has argued (1992), a major underlying concern of anti-onanism literature is the morbid effect of masturbation on the imagination, these essays focus on masturbation and autoeroticism as broadly construed: both the physical acts of individual "manufriction" (as opposed to "conjugal onanism" or coitus interruptus), and the solitary self-pleasurings of fantasy, especially as these self-pleasurings are reflected in or productive of literature and the arts.

Although, as we shall see, masturbatory themes are plentiful in imaginative works available for public spectatorship, a recurrent theme in these studies is the connection between autoerotic fantasies inspired by "solitary vice" and those associated with two other major solitary activities—reading and writing. Because of the degree to which they draw on fantasy life, both of these latter activities were considered dangerous by anti-onanist authors, especially when engaged in to excess or by those whose imaginations were deemed weak and susceptible (namely, women and children). Thus, the writing and reading of novels were criticized from their origins as potentially noxious. Equally troubling was solitary play with words, especially in phantastical or introspective writing such as diaries, autobiographies, and poems. In an ironic twist of language, playing with oneself came to be conceptualized not as the healthy engagement of an autonomous and creative imagination but as anti-social "self-abuse," the "sin" of self-pollution.

In probing beneath centuries of anxieties concerning masturbation and autoeroticism, these essays reveal a rich network of connections between solitary, non-procreative eroticism and autonomous, imaginative production. If the masturbation phobia of the eighteenth and nineteenth centuries came to crystallize a variety of fears about social disaggregation, physical degeneration, and psychic non-conformity, it also surfaced individuals' needs for erotic self-expression and release. For many creative artists, masturbation became a trope for the trauma and delights of imaginative rêverie, self-cultivation, and autorepresentation. Nineteenth-century bourgeois women in particular—whose opportunities for exercising and publicizing the erotic imagination were socially bounded by strict rules of decorum—found in autoerotic fantasy a means to sexual and

authorial autonomy denied them by the conventions of their society at large. However coded the forms through which they were expressed, autoeroticism and its associated dreams and fantasies were for these women energizing psychological forces, enabling their art.

Given the close connection between masturbation and the self-pleasuring imagination it would be disingenuous to claim that this volume is free of a certain counter-academic pleasure or that it does not employ academic analysis to discover (autoerotic) pleasures in the text. Not only does such pleasure characterize our encounters with the visual arts, music, and literature, but also our engagement with much academic writing as well, to which the term "mental masturbation" is tellingly—if usually jokingly—applied. Thinking itself can provide autoerotic pleasure where the thinker eroticizes the acts of the mind. As Eve Kosofsky Sedgwick suggests concerning the dichotomy between art and masturbation, such divisions are in fact unstable, and this instability works to undermine the opposition between the critical-aesthetic and the autoerotic reified by guardians of artistic "purity" and academic "seriousness."

The positive and generative relations between masturbation and other forms of creativity comprise a story still largely untold. The essays contained in this volume attempt both to recognize the damage that masturbation phobia has done and acknowledge masturbation's and autoeroticism's continuing power to enrich a wide variety of cultural forms. In bringing such a collection together, we hope to situate the continuing social anxiety regarding masturbation in its appropriate historical context even as we examine the multiple ways in which masturbation and its accompanying autoerotic fantasizing have contributed to human life.

Beginning with Laura Weigert's analysis of the use of masturbatory themes in sixteenth-century German depictions of witches and prostitutes, *Solitary Pleasures* traces masturbation's presence in Euro-American culture as an historical phenomenon, as a theoretical node, and as a point of reference for the interpretation of diverse works of art and literature. In "Autonomy as Deviance: Sixteenth-Century Images of Witches and Prostitutes," Weigert proposes that autonomous female eroticism and social independence were both viewed as threats to male potency by sixteenth-century German artists. Men such as Albrecht Dürer and Hans Baldung Grien expressed their anxieties through the iconographic fusion of two groups of socially deviant women, witches and prostitutes, who were depicted engaging in a variety of genital acts suggesting mutual and solo masturbation. By asking why this particular kind of sexual activity is visually related to

both groups of women, Weigert is able to establish an interpretative framework for these images that addresses both the sexual discourses of the period and the formation of social categories that marginalized the women themselves.

Mark Twain's encounter with Titian's Venus of Urbino, "the foulest, the vilest, the obscenest picture the world possesses," provides the occasion for Kelly Dennis's extended meditation on the ambiguities of mimesis and representation in "Playing with Herself: Feminine Sexuality and Aesthetic Indifference." Now viewed in publicly controlled and supervised spaces, Renaissance depictions of the reclining female nude were originally intended for private delectation. However, historians of art have traditionally denied to such works their power to arouse male spectators autoerotically by claiming for them an aesthetic distance pornographic images presumably lack. "Aesthetic indifference demands the sublimation of pleasure," Dennis argues, but in so far as women are identified with fleshly materiality, representations of their autoeroticism undermine the philosophic and aesthetic hierarchies upon which the Platonic doctrine of art as mimesis depends.

In "Forbidden Pleasures: Enlightenment Literature of Sexual Advice," Roy Porter surveys changing methods and ideologies in the historiography of sexuality. Noting the dearth of studies on the early modern period in Europe, he discusses seventeenth-century sexual advice manuals and their connection to the eighteenth-century emergence of anti-masturbatory pamphlets, particularly *Onania*. In this popularization and commercialization of medical knowledge about sexuality, Porter observes that there was a fine line between pedagogy and pornography, and between the repression and the incitement of masturbation.

Eighteenth- and nineteenth-century French literature on masturbation is the focus of Vernon A. Rosario's essay, "Phantastical Pollutions: The Public Threat of Private Vice in France." He examines the shared medical and social concerns of S.A.A.D. Tissot and Jean-Jacques Rousseau: respectively, the physician most responsible for the condemnation of masturbation, and the philosopher dedicated to connecting an exploration of sexuality to a theory of the subject—particularly of the emerging autonomous subject in a new democratic era. Rosario explores the representation of onanism as a threat to the individual body and imagination in the eighteenth century, and how it was increasingly perceived as a threat to social health in the nineteenth century.

In "Jane Austen and the Masturbating Girl," Eve Kosofsky Sedgwick elaborates a notion of masturbation as a trope for the diseased woman and, more subtlely, the creative woman writer. Taking *Sense and Sensibility* as a novel of the

relatively early phase of anti-onanist discourse, Sedgwick argues that Marianne Dashwood is constructed in the novel as an embodiment of the "masturbatrix," who is afflicted simultaneously by hyperaesthesia and by the emboldening, addiction-producing absent-mindedness contemporary physicians saw as one of the sequelae of the disease. Sedgwick interprets the tremendous anxiety the masturbatrix figure evoked in the nineteenth century, and still provokes today, as one manifestation of the social need to control female creativity.

In the brief but germinal essay, "The Social Evil, the Solitary Vice and Pouring Tea," Thomas W. Laqueur draws an analogy between nineteenth-century assumptions regarding masturbation and those concerning prostitution, arguing that both were construed as social rather than sexual forms of disease. Laqueur argues that economic anxieties and a concern for "unproductive" behavior were the twin motors driving the transformation of this solitarily performed sexual activity into a loathed and feared form of "social vice".

The issue of sublimation is brought up by Christopher Looby in "'The Roots of the Orchis, the Iuli of Chestnuts': The Odor of Male Solitude." Looby draws our attention to an ephemeral yet mnemonically powerful metonym of male masturbation, the odor of semen. Drawing upon the literary works of Walt Whitman and Herman Melville, the popular scientific texts of Homer Bostwick and Francis Parkman, Looby shows how masturbation was a collective, homosocial concern of nineteenth-century American men. Aromatic arousal, he argues, was part of a rhetorical and therapeutic ploy to evoke and to regulate not only the olfactory *imaginaire* but also erotic fantasy and male sexuality itself.

Paula Bennett returns to issues of female creativity in "'Pomegranate-Flowers': The Phantasmic Productions of Late-Nineteenth-Century Anglo-American Women Poets," by highlighting the metaphoric appearance of masturbation and autoerotic fantasizing in late-nineteenth-century women's writing (in particular, the work of Harriet Prescott Spofford, Emily Dickinson, and Christina Rossetti). Bennett argues that both autoeroticism and its coded incarnations in poetry, especially the excessive use of flower and fruit imagery, were powerful means for autonomous explorations of women's sexuality and imagination. Nineteenth-century Anglo-American women writers used this imagery in the service of a conception of female sexuality that was neither phallus-centered nor dedicated to an erotics of refusal.

In "Fragments of a Poetics: Bonnetain and Roth," Lawrence R. Schehr searches for a "poetics of masturbation" through the works of two novelists, one French, one American, who made masturbation the focus of their works.

Noting that masturbation cannot speak autonomously in its own voice, Schehr traces the transition of masturbatory poetics from a rhetoric of illness in the naturalist novel to one of emancipation in contemporary texts. Bound as it is by literary ideologies, social surveillance, and psychoanalytic hermeneutics, masturbation has employed "the borrowed tongues of repression" in myriad ways to make itself known.

Roger Celestin, in "Can Robinson Crusoe Find True Happiness (Alone)? Beyond the Genitals and History on the Island of Hope," explores issues of erotism, economy, and sociality in the classical figure of isolation: Robinson Crusoe. Using Defoe's original creation and Tournier's modernist reinvention of Crusoe, Celestin examines the links between solitude, sexuality, memory, and writing in a world without an other, concluding that the goal of Tournier's project—the achievement of a state of bliss that transcends the dichotomy of self and other—may, in the last analysis, be impossible to write.

In the final essay, "Coming in Handy: The J/O Spectacle and the Gay Male Subject in Almodóvar," Earl Jackson, Jr. employs psychoanalytic theory to demonstrate the importance of autoeroticism in constituting sexual subjectivity. Jackson criticizes the violence against women implicit in traditional Freudian and Lacanian narratives of "healthy" heterosexual male development. While this violence is most spectacularly reenacted in popular cinema, Jackson argues that gay male pornography, on the other hand, encourages "narcissisitic intersubjectivity" between real and fantasized masturbatory companions. Jackson goes on to demonstrate how Pedro Almodóvar cites gay jerk-off (J/O) video forms in his films *Law of Desire* and *Matador* to invoke a gay male spectator who is simultaneously pleasured and politicized. By insisting that masturbation offers an "intersubjective opportunity" for gay men, Jackson brings our anthology into the present, providing "closure" by suggesting alternative constructions to "solitary pleasure" that will engage the powerful social role it plays.

Taken together, the essays presented in this volume will establish masturbation and related issues of sexual imagination and erotic autonomy as subjects of import for cultural history, psychology, women's studies, gay and lesbian studies, and the history of literature and the arts. No anthology can be comprehensive. But *Solitary Pleasures* is a first step. To date, the analysis of masturbation, especially in the humanities, has been fragmented into disciplines and individual papers. In particular, the crucial links between autoerotic fantasy life and creativity have only been sporadically explored because of the lingering discomfort with the open discussion of this topic, and, as Dennis observes, the need

to insist on aesthetic distance in art.

We believe that such continuing unease is an index of deeper cultural anxieties, especially those related to the conflict between personal autonomy and sexual, social, and even academic order. In situating masturbation anxiety historically, and in demonstrating the myriad ways in which masturbation has nevertheless served as a locus for creative effort as well as for political resistance, we may gain a new appreciation of masturbation. Beyond the constraints of orthodox reproductive practices, solitary pleasure is a fundamentally generative form of sexual behavior, deeply implicated in the creative process and therefore basic to much that is good and enriching in human life.

NOTES

1. In classical texts, the *molles* or *malthakoi* in Greek, were "soft" or effeminate men who took the receptive role in coitus (Halperin 1990, 22). In medieval confessional texts, *mollities* was a common term for effeminacy, sodomy, and voluntary pollutions (Stengers & Van Neck 1984, 29-32). This led to an easy association between what today appear as clearly distinct "sins." This association between sodomy and masturbation nevertheless persisted into the nineteenth century (Bullough & Voght 1976).

2. St. Paul's first epistle to the Corinthians (6:9–10) was a frequently cited text: "Do not be fooled: neither the bawdy, nor the idolatrous, nor the *molles*, nor the sodomites, nor thieves…will inherit the heavenly Kingdom."

3. Thomasset and Jacquart (1985, 236) discuss the "disease of continence" in the works of Galen, Constantine the African, and Avicenna.

4. There is no extant first edition of *Onania*. The British Library catalogue dates a now destroyed first edition as "1710?" Stengers and Van Neck (207 n.1) date it 1715. MacDonald (424 n.4) dates it around 1708.

REFERENCES

Barker-Benfield, G. J. 1976. *The Horrors of the Half-Known Life. Male Attitudes Towards Women and Sexuality in America.* New York: Harper and Row.

Bienville, J. D. T. de. [1771] 1775. *Nymphomania, or a Dissertation Concerning the Furor Uterinus.* Trans. Edward Wismot. London: J. Bew. Photo facsimile: 1985. New York: Garland Publishing.

Boerhaave, Hermann. [1708] 1746. *Academic Lectures on the Theory of Physic*, 5 vols., in-8. London: W. Innys.

Boorde, Andrew. 1552. *The Breviary of Health, for all manners of sickness and diseases which may be in man or woman.* 2 vols. in 1, in-4. London: W. Powell.

Bullough, Vern L. & Martha Voght. 1976. Homosexuality and its Confusion with the "Secret Sin" in pre-Freudian America. In *Sex, Society and History*, ed. V. L. Bullough, 112–124. New York: Science History Publications.

Duffy, John. 1963. Masturbation and Clitoridectomy. A Nineteenth-Century View. *Journal of the American Medical Association* 186(3): 166–168.

Foucault, Michel. 1975. *Surveiller et punir: Naissance de la prison*. Paris: Gallimard.

_____. 1976. *Histoire de la sexualité. Vol. 1: La volonté de savoir*. Paris: Gallimard.

Galen, Claude. 1625. *De Locis affectis*. In *Opera*, vol. IV, book six. Venice: Iuntas.

Gerlach, Wolfgang. 1938. Das Problem des "weiblichen Samens" in der antiken und mittelaltlichen Medizin. *Sudhoffs Archiv* 30(4–5): 177–193.

Gilbert, Arthur N. 1975. Doctor, Patient and Onanist Diseases in the Nineteenth Century. *Journal of the History of Medicine* 30: 217–234.

Hare, E. H. 1962. Masturbatory Insanity: the History of an Idea. *Journal of the Mental Sciences* 108: 1–25.

Laqueur, Thomas W. [1989] 1995. The Social Evil, the Solitary Vice and Pouring Tea. In *Solitary Pleasures: The Historical, Literary, and Artistic Discourses of Autoeroticism*. Eds. Paula Bennet and Vernon A. Rosario II, 155-161. New York: Routledge.

_____. 1992. Credit, Novels, Masturbation. Unpublished manuscript presented at "Choreographic History" conference, 16 Feb. University of California Riverside.

MacDonald, Robert. 1967. The Frightful Consequences of Onanism: Notes on the History of a Delusion. *Journal of the History of Ideas* 28: 423–431.

Masson, Jeffrey M. 1986. *A Dark Science: Women, Sexuality, and Psychiatry in the Nineteenth Century*. New York: Farrar, Straus, and Giroux.

Neuman, Robert P. 1975. Masturbation, Madness, and the Modern Concepts of Childhood and Adolescence. *Journal of Social History* 8: 1–22.

Onania. [1710?]1776. *Onania, or the heinous sin of self-pollution and all its frightful consequences (in both sexes) considered, with physical and spiritual advice to those who have already injured themselves by this abominable practice*. 8th ed. Anonymous. London: n.p.

Platter, Felix. 1664. *Histories and observations of all the afflictions of the functions of the body and soul*. English trans. of *Observationum in hominis affectibus plerisos corpori et animo functionum laesio dolore, aliave molestia et vitio infensis*. London: Peter Cole.

Rousseau, Jean-Jacques. [1762] 1969. *Emile, ou De l'Education. Oeuvres complètes*, 4:239–868. Paris: Pléiade.

Sissa, Giulia. 1989. Subtle Bodies. In *Zone 5: Fragments for a History of the Human Body*, Part 3, ed. Michel Feher, 133–156. New York: Zone Books.

Spitz, René. 1953. Authority and Masturbation, Some Remarks on a Bibliographical Investigation. *Yearbook of Psychoanalysis* 9: 113-145.

Stengers, Jean & Anne Van Neck. 1984. *Histoire d'une grande peur: La masturbation.* Brussels: Editions de l'Université de Bruxelles.

Szasz, Thomas. 1970. *The Manufacture of Madness.* New York: Harper & Row.

Tarczylo, Théodore. 1983. *Sexe et liberté au siècle des Lumières.* Paris: Presses de la Renaissance.

Thomasset, Claude & Danielle Jacquart. 1985. *Sexualité et savoir médicale au Moyen Age.* Paris: Presses Univérsitaires de France.

W. [Woodward, Samuel B.] 1835. Remarks on masturbation; Insanity produced by masturbation; Effects of masturbation with cases. *Boston Medical and Surgical Journal* 12: 94–97, 109–111, 138–141.

1

AUTONOMY AS DEVIANCE:

SIXTEENTH-CENTURY IMAGES OF WITCHES

AND PROSTITUTES

LAURA WEIGERT

I n 1514, Baldung Grien dedicated a drawing with the satirical greeting, "to the Clergyman Happy New Year" (fig. 1). The drawing depicts the entwined bodies of three women: one peers from between her legs at the viewer, while a second straddles her, her arm wrapped around the third, who holds a cauldron in one hand and touches her own genitals with the other. This drawing is one of a group of prints, drawings, and paintings of similar subject matter produced by Albrecht Dürer and the circle of artists around him. Representing either witches or prostitutes, the compositional focus is, in all cases, genital stimulation. How were these striking images with unusual and blatant sexual content received both visually and conceptually by their contemporary audience? To address this question I isolate the sexual iconography shared by this group of images. I then discuss the corresponding discourses in which the sexual behavior of witches and prostitutes converges.

This group of images serves as a particularly rich source with which to explore the sexual beliefs of the early sixteenth century. All of the examples

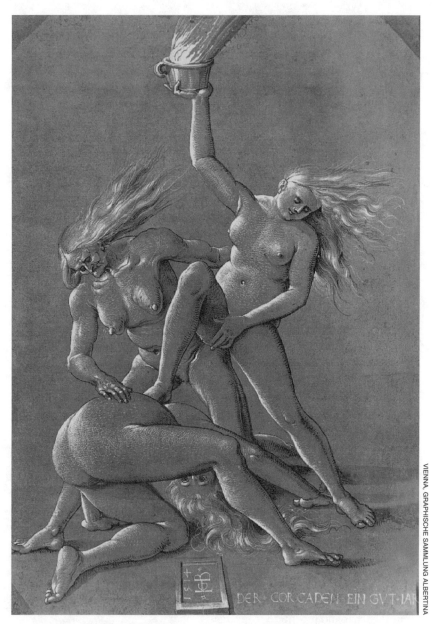

Figure 1. Hans Baldung Grien, Three Witches, 1514, pen on red-brown tinted paper, heightened with white.

employ a similar iconography and emphasize sexual activity among women, an element which is not characteristic of contemporary textual sources. These images were produced during a period in which definitions of sexual practice were particularly contested. Furthermore, the images depict two categories of women then at the forefront of these discussions on sexual matters: prostitutes and women accused of practicing witchcraft. A coincidence therefore exists between the production of the images and the increased marginalization of these two groups; in both cases their sexual activity was the focus.

Art historical literature has not related these images to sexual discourses or to the formation of social categories. The studies of Baldung Grien's depictions of witches link his work to polemics on witchcraft that would have been available to him in Strasbourg at the time. Linda Hult (1984, 261–62; 1987, 266–71) argues that Baldung's images serve a polemical function similar to that of the anti-witch treatises. Sigrid Schade (1983) explores the depiction of the bodies of women in Baldung's witches, placing them in the broader context of the denigration of the female body in southern German visual imagery as well as relating them to the contemporary anti-witch tracts.[1]

However essential this project has been for deciphering aspects of Baldung Grien's images of witches, it does not provide an adequate interpretive framework to analyze their sexual content. The issue which I address is not how witches are represented in visual imagery, but rather why particular kinds of sexual activity were related visually to witches. That this sexual iconography was not limited to witches, but included prostitutes as well, suggests that similar attitudes existed concerning these groups of women. Thus my paper expands the visual field established in other studies to include both images of witches and of prostitutes. And, rather than concentrating exclusively on beliefs about the practices of witches, I situate the images in terms of discourses on sexual matters contemporary to their production.

THE IMAGES

I base my discussion on prints, drawings, and paintings produced by artists in southern Germany in the first half of the sixteenth century. Among the images of witches are a print and three drawings signed by Baldung Grien, an engraving by Dürer, a drawing by the Master H. F., a copy of a Baldung drawing by Urs Graf, and a print by Sebald Beham.[2] The sample of depictions of bathing

women/prostitutes includes a print by Sebald Beham, a drawing intended for a print by Dürer, and an anonymous painting identified as a copy of a painting by Baldung Grien.[3]

The sample of sabbath images diverges significantly from contemporary illustrations included in anti-witch sermons.[4] These didactic prints specified the results of the evils of sorcery. One example, a print produced in Baldung's workshop, illustrated Johann Geiler von Kaysersberg's sermon against witches (fig. 2). The effect of the witches' spell is directly narrated by the inclusion of a man who has lost his pants. He peers from a tree on the left-hand side of the print at the group of women gathered around a collection of animal bones. One of the witches, who is clothed, holds a stick on which hangs the man's pants. The loss of his pants refers to the witches' usurpation of male authority and power, and by extension their reported ability to cause impotence.[5]

The images of bathing women also deviate from contemporary bath scenes which relate narratives of sexual exchange. Although the public baths served the whole community's hygenic needs, they frequently served as brothels as well. Civic records from southern German urban communities document this alternate use of the bathhouses, and popular broadsheets associate women who worked in the bathhouses with prostitutes (Brundage 1987, 527; Wiesner 1986, 96).[6] Fifteenth-century representations of bathhouses underscore their dual function, as is seen in the Master of the Banderoles' late-fifteenth-century print, *The Fencing Room* (fig. 3). The right-hand side of the print is split into two levels: below, three women attempt to pull a man in a fool's costume into the bath with them; above, a man and a woman embrace behind a disheveled bed. The two scenes are united within the same architectural structure, which is covered by a sheet enclosing both the bed and the bath. In all related examples, the bathhouse is constructed as a site of sexual exchange.

The transition from a narrative of sexual exchange to an isolated view of women at the bath can be traced in two drawings by Dürer. A drawing dated 1516 depicts two clothed men approaching a group of four women (fig. 4). The setting is clearly a bathhouse: a bathmaid's cap identifies the older woman as a procuress, buckets of water are set on the floor, and the women are naked. The exchange between the men and women is sexual: one man holds a skewer with sausages on it; the other holds out a bowl and a spoon, as if he is requesting to be served.[7] In another Dürer drawing, from 1496, the actions of the women do not involve men, although they are observed by a man, barely visible in the doorway in the background (fig. 5). A group of six women sit or stand in a bathhouse, identi-

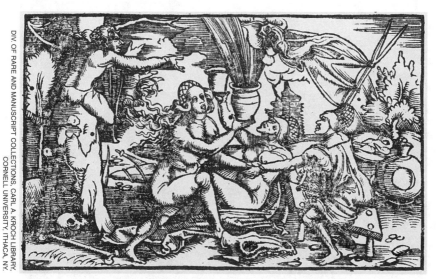

Figure 2. Workshop of Hans Baldung Grien, "Three Witches Preparing for flight," from Johann Geiler von Kayserberg's *Die Emeis,* fol. 37v. woodblock print, 1516, 8.8 × 14.2 cm.

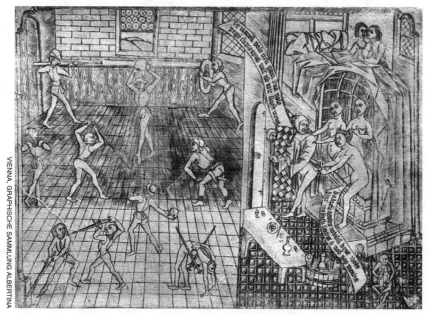

Figure 3. Master of the Banderolles, *The Fencing Room*, engraving.

23

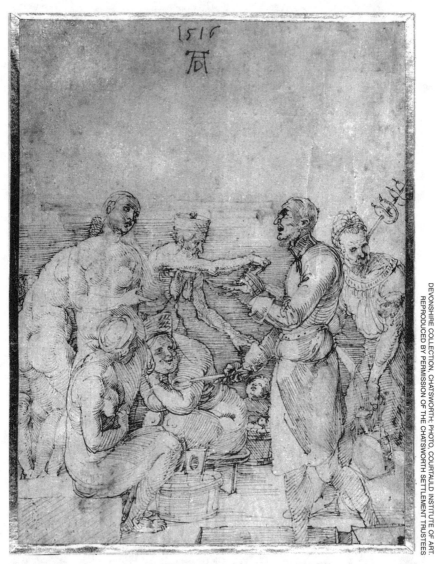

Figure 4. Albrecht Dürer, *The Women's Bath*, drawing, 1516, 283 × 217 mm.

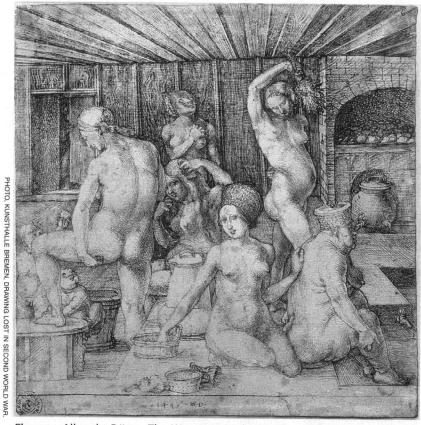

Figure 5. Albrecht Dürer, *The Women's Bath*, drawing, 1496, 231 × 226 mm.

fied by the water spigot, furnace, and the pots and basins of water. The women are in the process of washing and touching themselves and each other. A younger woman washes the back of an older woman, who wears the procuress's hat; the thigh and arm of the washer press against the older woman's buttocks and back, respectively. Another woman stands with one leg raised on a bench, facing into the room. She appears to wash the front of her body, but her back obscures the exact location of her gesture. Genital stimulation is not overtly included; yet the drawing conveys the pleasure of physical contact between women.

In my sample of images, as compared with other contemporary or previous depictions of the same groups of women, the male presence is extracted and the images are stripped of the narrative content which hinges on the inclusion of men as active participants or covert observers. The lack of a male presence is essential to the specific sexual iconography coincident in these images of witches and prostitutes. All of the prints, drawings, and paintings depict groups of women only, one of whom is always older, all of whom are naked, united in their bathing or sabbath rituals. These activities employ the same instruments: brushes, scissors, mirrors, and buckets. Small children are frequently included as well. Furthermore, what is only hinted at in Dürer's *Bathwomen* is made explicit: the images focus on women caressing their own or another's genitals.

An anonymous copy of a lost painting by Baldung Grien, *The Woman's Bath* demonstrates the correspondence between depictions of witches and bath women (fig. 6). Three women of varying ages gather around a concave mirror: the youngest strokes her genitals with a brush; the middle-aged woman, combing her hair back from her face, observes her reflection in the mirror, a reference to vanity; and the eldest, who is seated, looks at the pair of scissors in her hands. The gathering takes place in a darkened room devoid of any furnishings except for a classical column, ornamented by two bronze reliefs to the left of the women. The scene is dimly lit by an open door in the background, through which a fourth participant, naked but wearing a white headdress, joins or observes the event. The interior space, the mirror, and the fact that all three of the women are engaged in some form of hygienic activity identify the setting as a bathhouse. Yet the unkempt hair of the eldest woman, the dark room, and the concave mirror around which the three are intently grouped visually link the painting to depictions of witches' sabbaths. This example is particularly indicative of the way these images link the two groups visually by deemphasizing the defining characteristics of witches and prostitutes and the specifics of the bathhouse or sabbath settings.[8]

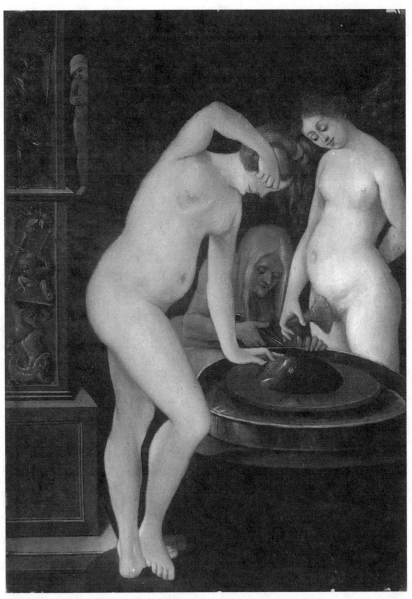

Figure 6. Late sixteenth- or early seventeenth-century copy after lost painting by Hans Baldung Grien of ca. 1515, *Women's Bath*, painting, 46.2 × 32.4 cm., Staatliche Kunsthalle Karlsruhe.

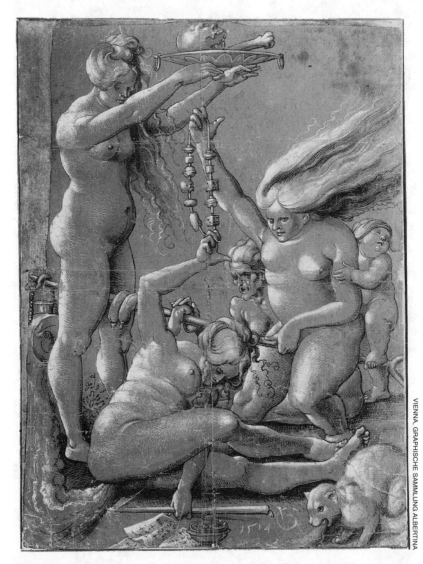

Figure 7. Urs Graf, *Female Witches Preparing for Flight,* 1514 copy after Hans Baldung Grein, pen on red-brown tinted paper heightened with white, 29.4 × 21.6 cm.

Similarly, the drawing addressed to the clergyman contains only the bare minimum of information with which to identify its subject (fig. 1). The cauldron held upwards by the youngest of the three women spews a torrent of liquid beyond the upper frame of the drawing. The undefined magical force which causes the flames to emit from the sabbath cauldron sweeps the long hair of the women upwards and away from their bodies. The cauldron and the witches' flowing hair serve to identify the women as witches and the setting as a sabbath gathering.

The coordinated dance of the three women unites their entangled limbs. Each woman, positioned precariously, is held in balance by her physical contact with the others. The woman holding the cauldron, with one foot on the ground and the other raised in the air, lunges diagonally. She is supported by the two other women: her raised thigh rests on the side of the older woman, who additionally steadies her with her hand on her back, and her foot on the back of the third. The older woman leans forward, her right hand on the back of one woman, her left resting on the back of the other. She straddles the back of the bent woman, her genitals covered (or touched) by the leg of the woman holding the cauldron. The tensed muscles and erect nipples of the three women convey a sense of energy which is arrested and contained into a frozen frame of graceful, controlled poses.

The left hand of the woman holding the cauldron occupies the direct center of the drawing. Her hand is linked visually to the cauldron propped on the open palm of her hand and steadied by one bent finger with which it shares a vertical axis. This left hand is placed over her genitals, slightly towards her right thigh. Her thumb and first two fingers are straight, outlined in white against her upper thigh. Between the two straightened fingers and the bent last digit, her third finger is hidden. Turned inward, this finger disappears at the location of her genitals. The visual parallel with the cauldron above reads as simultaneous actions which are causally linked: clitoral stimulation and orgasm. The organization of the figures positions this gesture of digital clitoral manipulation at the focus of the composition.

In relation to the subject depicted, the address to the clergyman adds a sense of irony to the drawing.[9] The text reads, "Der Cor Capen ein gut jar" (To the Clergyman, Happy New Year). The gestures and unabashed nudity of the witches mock the sexual ethics which the recipient of the drawing represented; their demonic practices are a sacrilege to his Christian faith. The inscription also functions as an attack on the putative immorality of the clergy. Anti-cleri-

cal propaganda in the early sixteenth century accused the clergy of frequenting prostitutes and secretly housing concubines. Drawing from this common tactic to slander the virtue of clerical celibacy, the dedication to a cleric renders the identity of the women depicted ambiguous: are they witches or prostitutes?

The drawing by Urs Graf of 1514, more explicit in its references to a sabbath gathering, also focuses on the sexual activity of witches (fig. 7). The group of women has become a coordinated sexual machine: one holds tightly between her legs a broomstick which extends forward, stimulating simultaneously the second; a third, older woman, is hidden behind her, only her head and the hand which she rests on one of the limp sausages hanging from the broomstick are visible. The devil's rosary further links the women. Held upward by one, it is grasped by another who sprawls on the ground. The women are synchronized in their actions, yet each concentrates on what she alone is doing.

As the masturbatory gesture in Baldung's *Three Witches* (fig. 1) is at the precise center of the drawing, genital stimulation is the compositional focus of the Urs Graf drawing (fig. 7). The seated woman occupies the center of the print: she clutches the rosary, and with determined effort she reaches between her legs to grasp a thin, long candle; this is lit at the end closest to her body, the wick protruding from the opposite end.[10] A torrent of steam and flames exudes from her vagina and billows upwards, stopping at the metal pot which hangs from the broomstick between the legs of the other two women. The hand which grasps the candle which heats and stimulates her genitals is at the center of the composition. It forms the base of a horizontal axis which extends from her hand to the wilted sausage, to the rosary, and ends at the skull, which marks the upper point of the drawing.

The two prints by Sebald Beham mimic the poses of Dürer's depictions of witches and bath women. The gestures of Beham's figures in these two cases parody and expose the potential sexual content in Dürer's versions of the subjects. As in his *Bathwomen* (fig. 5), Dürer's *Four Witches* (fig. 8) conceal their actions. Grouped closely, their bodies touch. The woman on the far right faces the viewer, her left hand resting on the cloth which descends from her shoulder and wraps around her hip to cloak her genitals. Her right arm is visible, but her hand is concealed by the body of the woman facing into the room. This hidden hand disappears, then, at the location of the woman's genitals. The hands of all the women are concealed by their bodies; their actions are left to the viewer's imagination.[11]

In contrast, Sebald Beham emphasizes the gestures of his bathwomen and witches. The bathhouse scene depicts three women in a small room (fig. 9). The

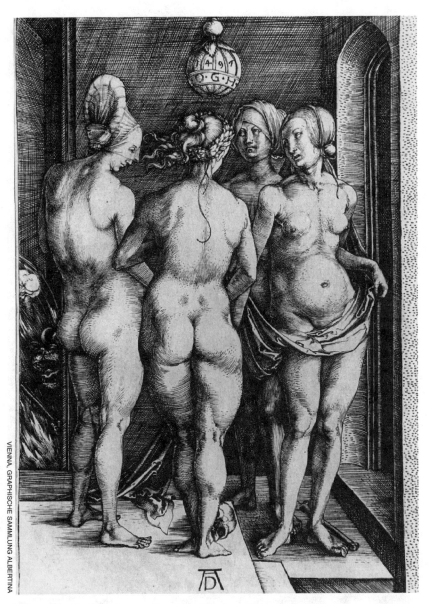

Figure 8. Albrecht Dürer, The Four Witches, 1497, engraving, 190 × 131 mm.

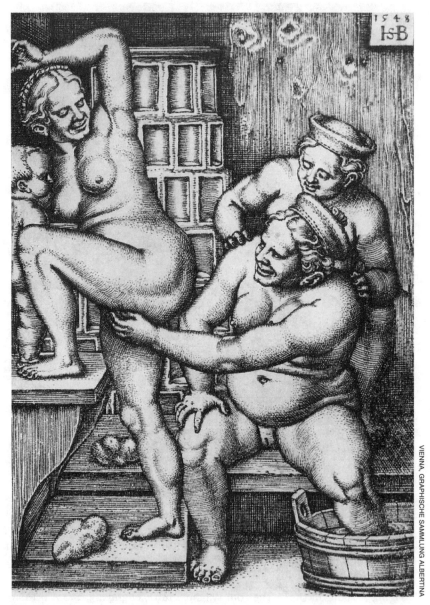

Figure 9. Sebald Beham, *Three Women in the Bath*, engraving, 1548, 81 × 56 mm.

VIENNA, GRAPHISCHE SAMMLUNG ALBERTINA

furnace, basin, sponges, and bathmaid hats identify the setting as a bathhouse. One of the older women reaches forward to touch the genitals of the youngest, who, raising her arm as if to affirm her consent to the action, looks back with a grin. The third woman crouches behind and lays both her hands on the back of the older woman.

Digital clitoral manipulation is also at the center of Beham's print of witches (fig. 10). Three women and a skeleton stand in a circle. The woman who is seen from the back places her hand on the genitals of another, her thumb positioned on the clitoris, her index finger hidden in the shadow between the woman's legs. Her other arm is slung around the shoulders of the third woman, whose body is joined to hers from the knee up, their breasts touching firmly, their arms linked. Although Beham's bathwomen relate to Dürer only in terms of their shared subject matter, the print is a clear parody of Dürer's *The Four Witches*. The postures of the three figures and the presence of the skull are similar. The addition of the skeleton (a *momento mori* motif), the fourth figure in the print, and the blatant sexual action distinguish Beham's print most significantly from Dürer's.[12] While in Dürer's *Four Witches* the gestures of the women are concealed, as is the gesture of the standing woman in his *Bathhouse*, Beham structures his composition around clitoral stimulation in his versions of the two subjects.

All of these images focus on sexual activity among and between women. Clitoral manipulation, either digital or by means of an instrument (broomstick or brush), is not only depicted in each image, but is situated at the center of each composition. This sexual stimulation includes women caressing their own genitals or those of another woman. In the cases in which a woman stimulates herself, she simultaneously touches and is touched by other women. In this respect the sexual gesture is never a solo act but one which involves all the women in the group. The depictions of witches and prostitutes thereby deny the contingency of sexual stimulation on a man's participation. These images were produced in a context in which discussions of sexual behavior and ethics circulated, all of which deemed any sexual activity outside of the married state sinful if not criminal.

SEXUAL ACTIVITY AS DEVIANCE

The sexual discourses which proliferated in early-sixteenth-century Germany, influenced by the Protestant Reformation, were related by a common focus on the establishment of categories of normality and deviance. Catholic manuals

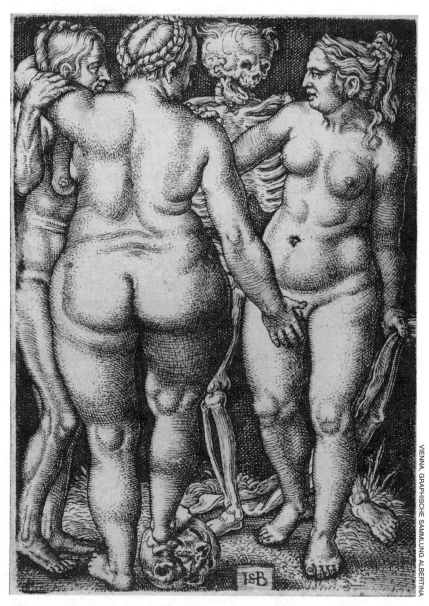

Figure 10. Sebald Beham, *Three Nude Women and Death,* engraving, 1546-50 (reworked plate of Barthel Beham, ca. 1535-7), 799 × 54 mm.

for confessors and theological writings identified all marital intercourse not leading to procreation as mortally sinful; they specified the variety of unnatural acts which were practiced by married couples (Tentler 1977, 186–87).[13] As marriage superseded celibacy as the most desirable state, a change occurred in the sexual ethics concerning married couples (compare Tentler 1977, 220 with Brundage 1987, 557). Sexual activity within the context of marriage was, according to Luther, blessed by God. Both Calvin and Luther agreed that God pardoned any sin which might be committed in sexual relations between marriage based on the value of the marriage institution (Brundage 1987, 555–56). Correspondingly, the reformers judged extramarital sex bad for the soul, family, fortune, and honor (Brundage 1987, 557). They condemned masturbation, except, presumably, in the case of mutual masturbation within marriage (Roper 1989, 67).[14] Thus in the early sixteenth century sexual sin was associated with individuals involved in sexual acts outside of marriage; it was not defined by the nature of the act itself, but depended on the status of the person involved.

Secular legislation of this period defined same-sex sexual activity as criminal. The *Bambergische Halsgerichtsordnung* of 1510 and the *Constitutio Criminalis Carolina*, (Bomberg's Rulings on Crimes Punishable by Death), its 1532 supplement, instigated by Charles V, instituted capital punishment by burning for "unchastity contrary to nature" between men, between women, or with an animal (Greenberg 1988, 302–3).[15] Evidence for the actual enactment of the punishments in Northern Europe against women is scarce, although the numbers increase significantly in the sixteenth century, as they did for male sodomites as well: compared to one execution of a woman in Speier in the fifteenth century, there were at least four executions in the sixteenth century (Crompton 1981, 17). Their crime, in these cases, was not their sexual activity per se but the fact that they posed as men (Greenberg 1988, 315). Whereas the ecclesiastical courts had dealt, for the most part, with these misdemeanors, and punishments remained within the scope of church penance, persecution of these crimes was relegated in the sixteenth century to the secular tribunals.

When reviewed in light of contemporary attitudes towards sexual activity which might occur between/among women, this group of images relates what was considered either sinful or criminal sexual activity to women accused of witchcraft and to women who worked in bathhouses. The association of these types of women with sexual activities which were defined as prohibited emphasized the illicit nature of sorcery and prostitution and identified the women who engaged in them as deviant. The representation of genital stimulation among

women also functioned to make the images themselves visualizations of that which was forbidden. They embody the danger of sexual pleasure experienced by women alone, without a male presence.

The threat to men's sexual potency which witches were thought to pose is literalized in the images of their sabbath rituals. According to contemporary treatises and popular sermons on witchcraft, witches were a primary source of impotence, which they perpetrated on men from a distance during their nocturnal meetings.[16] All of the sabbath images feature sausages hanging on the witches' forked sticks. In the Urs Graf drawing (fig. 7) and Baldung's 1508 print (fig. 11), the sausages resemble penises; in all cases they hang limply. In the Urs Graf drawing the older witch places her hand on one of the sausages, and as she does so, it withers in her grasp—a visualization of her direct intervention into man's sexual potency. At a time when procreation was declared necessary for the maintenance of the social order, this motif, suggesting man's failure to perform, was particularly significant.

An extension of the threat posed by witches to man's sexual potency was the possibility that they might make use of phallic substitutes for their own purposes. In the Urs Graf drawing, the woman on the left is seated on the stick which emerges from between her legs, and which is held firmly in place by her hand.[17] The stick is supported on the opposite end by the legs of the standing woman. The witches have captured the sausages, which they hang on the sticks emerging from between the legs of two of the witches.

Trial records that discuss the sexual activity of women accused of sodomy indicate that sexual relations between women could not be conceived of without the use of some kind of penis substitute. A woman from Fontaines, who married another woman, was executed in 1535 for "wickedness which she used to counterfeit the office of a husband" (Crompton 1988, 17). In 1580, Montaigne describes an incident in France in which a woman who had dressed up as a weaver and married a woman is hanged for "using illicit devices to supply her defect in sex" (as quoted by Greenblatt 1988, 66). In these cases the women's crime was based on their use of prohibited sexual devices, with which they imitated men. In this context, the forked sticks and sausages supply a reference to the penis substitutes which were assumed to be a necessary component in all sexual activity between women.

The frenzy of the witches, their sexual activity, and the bursts of billowing liquid all contribute to the orgasmic nature of the images. In all of the sabbath images as the witches prepare for flight, a flow of liquid ending in a thick cloud

Figure 11. Hans Baldung Grien, *The Witches' Sabbath,* 1510, Chiaroscuro woodcut with grey tone block, 37.9 × 26.0 cm.

of smoke spews from between their legs. In the Baldung print, this orgasmic burst is the focal point of the composition (fig. 11). The witch at the center of the print holds a cauldron between her legs. A torrent of liquid gushes from the cauldron and bursts upwards into a foaming cloud. In Baldung's drawing for the clergyman, the cauldron in the upraised hand of the witch is juxtaposed with the gesture of her other hand (fig. 1). The cauldron spews forth liquid as she stimulates herself. The heat from the candle at the center of the Urs Graf drawing causes a similar response in the witch: a torrent of liquid emits from her genitals (fig. 7). These torrential bursts can be identified as hot air internalized in the witches or as the pollution with which they supposedly infected the world. But within the context of the sexual orgies of the sabbath, they function as visual allusions to ejaculation.

These visual references to ejaculation in the sabbath images further identify the physical perversity of the witches. According to contemporary medical literature, deriving from Galen, women were thought to have testicles and to emit semen in orgasm, which was necessary for reproduction (Laqueur 1986, 5–7). Although this medical tradition stressed the homology between the sexes, the relationship remained hierarchical: women's ejaculation was less powerful and their semen was pale and watery compared with men's. The liquid which billows forth in the sabbath rituals is evidence of a sexual climax reached by women stimulating themselves and each other. The power of their ejaculation refutes the claim of the medical authorities, positioning these witches as anatomically deviant.

The images convey the threat of women's sexual gratification that does not require a male participant. Not only are these women sexually self-sufficient, but their pleasure is magnified and potentially unlimited. At the same time this threat is undercut by enforcing a definition of sexual activity between women which assumes penetration by a penis substitute. Despite the addition of penis substitutes, however, the images, in representing clitoral stimulation, affirm the possibility of pleasure between women. This possibility had particular resonance at a time in which women who possessed a degree of autonomy came under attack.

CONSTRUCTING THE THREAT OF WITCHES AND PROSTITUTES

Moralizing literature, contemporary with the production of these images, sought to standardize the institutions of marriage and the family. These dis-

courses served to isolate individuals who did not fit into the prescribed categories. Particularly vulnerable to this marginalization and subsequent persecution were prostitutes and women accused of witchcraft.

The reformers stressed the importance of family to the well-being of society and defined marriage as the only acceptable state (Moxey 1989, 123). Luther described the single state as a pestilence and a poison to the government and world (Brundage 1987, 557). At the same time, alternatives to marriage for women were widely denounced. The monastic life, up to this point an attractive option for many women, came under attack. Women in convents all over southern Germany were accused of living in luxury and of sexual promiscuity (Chrisman 1972, 163–65; Roper 1989, 231). The effectiveness of this antimonastic literature resulted in the banning of convents, which excluded women from an institution in which they had previously exercised a degree of control removed, to a certain extent, from direct male supervision.[18]

Prostitutes and women accused of witchcraft did not fit into the legitimate social categories which were being defined by the new moralizing literature. Both prostitutes and women accused of witchcraft were unmarried. Furthermore, they lived outside the confines of orthodox German society (Monter 1977, 133). Women accused of witchcraft frequently resided away from the center of cities, and prostitution was limited to foreigners, at least by law (Roper 1985, 8). Newly emerging legislation regarding prostitution ensured that these women were excluded from the mainstream of German society. The town councils shifted restrictions from the customers to the prostitutes themselves, requiring them to wear identifying clothing, and excluding them from certain areas of the city (Wiesner 1986, 103).[19] Civic governments all over Southern Germany in the 1530s closed their official brothels and public baths (Wiesner 1986, 96, 104).

These increased restrictions, and the ensuing persecution of women accused of witchcraft, relate to the threat that these women posed to orthodox German society. Because most of these women were not married, they did not fit into the family structure that was essential to the new religious, political, and social order. The family was understood to be a microcosm of the government; the patriarch occupied the position of authority equivalent to the town council (Moxey 1989, 122–23). Women who were not married, therefore, disrupted the rule of the patriarch and by extension the communal government. Prostitutes disrupted the monogamy of the burgher couple.[20] Women accused of witchcraft resided, in many cases, outside the jurisdiction of the town councils and were thereby excluded from the control of this institution. Furthermore, many of

them were widows and land owners whose economic independence challenged the male monopoly on economic resources (Monter 1976, 133–34).

Through the contemporary discourses on prostitutes and witches, political and religious leaders displaced the threat which these women posed in the social sphere onto a discussion of their sexual activity. The *Malleus Maleficarum* (Hammer of Witches), published in 1486 by two Dominican inquisitors, associated witchcraft, for the first time, with women. Already specifying the gender of witches in the title, the authors argued that the reason that women were particularly attracted to sorcery was that women's lust is insatiable, provoking them to intercourse even with the devil (Institoris & Sprenger [1486] 1971).[21] The anti-witch tracts accused witches of practicing incest and sodomy, which was defined in this case as anal intercourse with the devil (Bullough 1982, 216). The rhetoric of the widely distributed broadsheets identified prostitutes as evil temptresses, determined to corrupt the virtues of the German male (Roper 1985, 13). As was argued in the case of witches, prostitution was said to derive from women's lust, a sin to which women accused of prostitution admitted under forced confession (Roper 1985, 15–16).

In accusations against presumed witches and prostitutes, women's uncontrolled sexual desire was cited as the cause of their deviation from proscribed moral standards. Luther equated the sexual promiscuity of the two groups when he referred to witches as, "the devil's whores" (Monter 1976, 31). Unlike the images, these discussions do not consistently relate women accused of witchcraft and prostitution to either masturbation or same-sex sexual activity, although isolated instances of such behavior exist.[22] The trial records display a fascination with the sexual life of these women. The Council required prostitutes to disclose when they had lost their virginity and whether they were married or single. The witchcraft trials of 1558 in Baden Baden included questions such as, "whether the devil slept with the accused after the pact; how the devil stole her virginity; what the devil's penis and semen were like; and whether intercourse with the devil was better than with a natural man? (Spreitzer 1988, 69). In such instances details were sought with which to construct a woman's sexual history not as a series of individual acts, but as determinant of the moral category in which the woman belonged. Her sinfulness was a function of the nature of her sexual experience.

As we have seen, the visual representations of both witches and bathhouse attendants (prostitutes) foregrounded the sexual perversity of these women. Further, the images specify the nature of this perversity: stimulation between/among

women. The potential result of women meeting away from men is thereby depicted in terms of what was considered to be illicit sexual activity. Within the social context which corresponded with the images, these particular women posed a threat because they were economically autonomous and were not controlled directly by a patriarchal figure. As a result, they challenged the political structure, which enforced its jurisdiction in the domestic sphere through the control of husband or father. This threat is displaced onto what becomes defined as the "unnatural" lust of these women in the contemporary sexual discourses. The visual representations of prostitutes and witches further specify the nature of their illicit sexual behavior. Autonomy in the social sphere is represented as autonomy in the sexual sphere, which was defined as sexual deviance.

CONCLUSION

Although ownership and sale of these pictures is not specifically documented, the associations these artists had in Strasbourg and Nuremberg suggest that the audience was wealthy and educated. These artists' patrons included respected humanists and members of the noble and imperial courts.[23] The images were therefore most likely seen by individuals connected with the political and religious leadership of southern German society. Produced for the most part in just a single copy, they were made for individual consumption. The impact of these images was therefore limited: they were not widely distributed and did not circulate between diverse levels of the population. Nevertheless, they provide an important symptom of an association made between what was considered sexual perversity and the sexual behavior of prostitutes and women accused of witchcraft.

This group of images operated within the discourses on sexuality which served to organize the contemporary social structure; the images supported and expanded the discussions on witches and prostitutes, which focused on their sexual behavior and deviant nature. By isolating clitoral stimulation as a defining aspect of their activity, the images specify the full extent of the sexual perversity of these women. Since their sexual activity excludes men, the images parallel the threat to the social order through a particular representation of the sexual order. The fear of socially and economically independent women is both displaced onto and mirrored in the representation of autonomous sexual activity between/among women.

NOTES

This article derives from a paper presented at the Midwest Feminist Conference (Chicago, 1991), and the University of British Columbia Graduate Student Symposium, (Vancouver, B.C., 1991); I thank the organizers and participants in these symposia. I would also like to thank Alex Alberro, Whitney Davis, Larry Silver, and Lisa Tickner, who helped me refine my ideas at different stages of the project.

1. After this paper was submitted, Pat Simons kindly sent me an article by Charles Zika (1989–90) that focuses on the metaphor of flight and the figure of the witch as incorporating contemporary fears about female sexuality. Our arguments overlap, particularly as they concern the threat of independent sexual activity between women. I attempt to interpret more precisely the nature of this sexual activity in a broader set of images.

2. Baldung Grien: 1508, Boston Museum of Fine Arts; 1511, Cabinet des Dessins, Louvre, Paris; 1514, Albertina, Vienna; and 1514, Albertina, Vienna; Dürer: 1497; Master H. F.: 1515, Staatliche Museum, Berlin; Urs Graf: 1514, Albertina, Vienna; Sebald Beham: 1525–27.

3. Sebald Beham 1548; Dürer 1495; copy of Baldung Grien, ca.1515, Staatliche Kunsthalle, Karlsruhe.

4. The *Malleus Maleficarum* (1486) written by Henry Institoris and Jacques Sprenger, *Von den Unholden oder Hexen* (Strasbourg, 1493) by Ulrich Molitor, and Johannes Geiler of Kaysersberg's *Die Emeis* (Strasbourg 1516) were all illustrated with woodcuts. The polemical titles of the woodcuts and the texts which accompany them describe in detail the specific evils of witches.

5. The image of a woman holding a man's pants on a stick was a common motif for the "world turned upside down," when everyday categories and hierarchies were inverted. On this type of imagery see Moxey (1989, 101–26).

6. A woodcut by Wolf Drechsel from about 1576 conflates the roles of bath attendants and prostitutes. The print depicts a bathwoman, traditionally clad in a sleeveless short dress and carrying pots of water, with the caption, "I, a bathmaid, stand here alone, with naked arms and legs, I take care of people and do the same for young men." Reproduced in Wiesner (1986, 74).

7. Both sausages and spoons were common motifs referring to penises.

8 . The painting is first documented in the "Nüditäten-Kammer" (the chamber of nudes) of the castle of the Markgraf of Basel (1773). It is then listed in the Basel collection of Peter Vischer (1751–1823), and in the collection of W. Stahlberg, Berlin, before it was given to the Staatlichen Kunsthalle, Karlsruhe, in 1943. Fischer (1939, 35) dates the original to 1515, based on stylistic characteristics and an inscription on the back of the panel. The catalogue of paintings in the Karlsruhe museum notes that the mir-

ror contains obscene images but does not specify their content (Lauts 1966, 37). Lauts describes the action of the young woman on the left as "Kurzweil" (amusement). The description in the 1773 inventory of Basel castle's collection is, "ein jung Weibsbild (die) mit einer Bürste Kurzweil treibt" (a young woman who amuses herself with a brush). Both authors evade the clear connotations of her gesture.

9. In a similar vein, the witches parody the classical theme of the three graces. The graces are replaced by three witches and their restraint by the sexual abandon of Baldung's figures.

10. Candles were blessed objects which played an important role in Catholic church rituals. It is likely that the use to which the candle and the demonic rosary are put in the drawing relates to the sacrilege of the witches sabbath through the desecration of sacred Christian practices.

11. Panofsky (1955, 71) alludes to the possibility of genital stimulation within the group of women when he writes, "the gestures of the older woman (are) suggestive of objectionable practices." The letters O.G.H. appearing above the witches' heads have not been deciphered (Panofsky 1955, 71).

12. Joseph Koerner makes a related argument concerning Baldung's images of Adam and Eve. He argues that Baldung's emphasis on lust and the flesh in his adoption of Dürer's classical vocabulary functions as a critique of Dürer's glorification of the human body and use of Italian figural conventions (1985, 52–101, esp. 72–85).

13. The possible sins committed within marriage included sexual intercourse during a holy time or in a holy place. Among the unnatural acts was any activity in which the proper orifice or proper position was not used (Tentler 1977, 196-208).

14. In this respect the reformers followed the tradition of the Catholic church. The Church's position toward masturbation was articulated to a greater or lesser extreme by numerous theologians; Thomas Aquinas, in the thirteenth century, considered it a sin against nature. At the end of the sixteenth century, the Franciscan Benedicti in his *Somme des Péchez*, deemed masturbation a mortal sin. The Reformers differed in the status which they accord to masturbation within marriage. On medieval attitudes towards masturbation see Stengers and Van Neck (1984, 29–36).

15. This legislation is significant in that it refers explicitly to sexual relations between women. Spanish law in the fifteenth century imposed the death penalty on male sodomites but does not mention women, nor does Henry VIII's legislation in sixteenth-century England. Earlier regulations assume that women sodomites existed but imposed the same punishments on both groups. The first reference in secular law to women practicing sodomy appears in a French code from Orleans of 1270. The punishment for women reiterates that for men; the man on his first offence should lose his testicles; on the second offence his member. Women should lose their member for both offenses; it is not clear what "member" refers to. The punishment for a third offence for both men and women was burning (Crompton 1981, 13). None of this legislation defines female sodomy as an activity specifically different from its male counterpart.

16. The *Malleus Maleficarum*, a treaty on witchcraft by two Dominican inquisitors, includes a lengthy response to the question as to whether witches were capable of physically removing men's penises or whether they just rendered them impotent. The inquisitors argue that witches are able to create the illusion that a man has lost his penis, deceiving his imagination, but not actually detaching his member (Institoris & Sprenger [1486] 1971, Part 1, question 9).

17. Zika discusses a Dürer print of a witch riding on a goat and points out that the way in which she holds her distaff "draws the eye to the blatant appropriation of the phallus" (1989–90, 33).

18. On the situation of convents in Strasbourg see Chrisman (1972, 163–66); on Augsburg see Roper (1989, 206–51).

19. The regulations passed against prostitutes in this period had the significant effect, retained in prostitution regulation today, of shifting the effect of legal rules from the client to the prostitute. Prior to the early sixteenth century all codified rules concerning prostitution were directed at the male clients. The first restrictions on prostitutes began in Nuremberg in 1508: women were not allowed on the streets wearing prostitutes' clothing, and prostitutes were required to wear a coat or veil when in public (Wiesner 1986, 102–104).

20. The presence of children in the images emphasizes the danger to the family ideal which witches and prostitutes embodied for the German reformers. In the sabbath scenes by Urs Graf's (fig. 7) and Baldung (1514), small children participate in the rituals. In Urs Graf's image, a child attempts to climb on the forked stick, grasping the arm of one of the witches. In the Baldung, a child attempts to climb onto the back of a ram. Although witches were accused of infanticide, it is more likely that the inclusion of children, who mimic the witches, suggests that these women might spread their demonic practices to innocent children (For a discussion of children in Baldung Grien's images of witches see Hult 1987, 257). The corresponding presence of infants in the bathhouse images supports the accusation that prostitutes were a corrupting force on the children in German communities.

21. "All witchcraft comes from carnal lust, which is in women insatiable. See Proverbs XXX: There are three things that are never satisfied, yea a fourth thing which says not, it is enough; that is the mouth of the womb. Wherefore for the sake of fulfilling their lust they consort even with devils."

22. Although sexual activity between women is not a motif in discussions concerning witchcraft or prostitution, isolated references provide additional evidence that such an association was made. Henry Institoris and Jacques Sprenger in the *Malleus Maleficarum*, in reference to the sexual practices of the incubi and succubi, describe that even these demons do not engage in such dishonorable acts as sodomy, or any sexual activity aside from vaginal penetration with witches. This addition to their text might suggest that such an association was made and was thus necessary to refute (*Malleus Maleficarum* Part 1, question 4). The link between the cult of Diana and the witches' sabbath suggests that both practices involved groups of women meeting

alone; but discussions of the pagan aspects of the witches' sabbath do not mention same-sex sexual activity between women (see Ginzburg 1991, 122–40). Lyndal Roper discusses the trial records of a procuress accused of abducting a woman's daughter. Roper argues that the mother's claim that the procuress "bewitched" the girl might be understood as a reference to sexual seduction (Roper 1989, 257–58). Brigitte Spreitzer (1988, 70) cites the witchcraft trials in Baden Baden which included the question: "whether the accused had sinned against nature? In what respect . . . with women, with herself, with animals? With wood, wax, or herbs?"

23. Baldung came from a family of university-trained professors and lawyers. His brother Caspar was a professor of law at Freiburg and his uncle Hieronymous was physician to Maximilian I (Hult 1987, 263–64). The humanist thinker Sebastian Franck was the Behams' brother-in-law and Ludwig and William IV of Bavaria their patrons (Goddard 1988, 17).

REFERENCES

Brundage, J. 1987. *Law, Sex and Christian Society in Medieval Europe*. Chicago and London: University of Chicago Press.

Bullough, Vern L. 1982. Postscript: Heresy, Witchcraft, and Sexuality. In *Sexual Practices and the Medieval Church*. Edited by Vern L. Bullough and James Brundage, 206–219. Buffalo: Prometheus.

Chrisman, Miriam U. 1972. Women and the Reformation in Strasbourg 1490–1530. *Archive für Reformationsgeschichte* 63: 143–168.

Crompton, Louis. 1981. The Myth of Lesbian Impunity: Capital Laws from 1270 to 1791. *Journal of Homosexuality*, 6: 11-25.

Fischer, Otto. 1939. *Hans Baldung Grien*. Munich: Verlag F. Bruckmann.

Ginzburg, Carlo. 1991. *Ecstasies Deciphering the Witches Sabbath*. New York: Pantheon Books.

Goddard, Stephen. 1989. The Origin, Use, and Heritage of the Small Engraving in Renaissance Germany. In *The World in Miniature, Engravings by the German Little Masters 1500–1550*, Exhibition Catalogue, Spencer Museum of Art, University of Kansas.

Greenberg, David F. 1988. *The Construction of Homosexuality*. Chicago: University of Chicago Press.

Greenblatt, Stephen. 1988. *Shakespearean Negotiations: The Circulation of Social Energy in Renaissance England*. Berkeley and Los Angeles: University of California Press.

Hults, Linda. 1987. Baldung and the Witches of Freiburg: The Evidence of Images. *Journal of Interdisciplinary History* 18 (Autumn): 249–76.

———. 1984. Baldung's Bewitched Groom Revisited: Artistic Temperament, Fantasy, and the Dream of Reason. *Sixteenth Century Journal* 15 (Fall): 259–79.

Institoris, Henry & Jacques Sprenger. [1486] 1971. *Malleus Maleficarum*. Trans. Montague Summers. New York: Dover.

Koerner, Joseph Leo. 1985. The Mortification of the Image: Death as a Hermeneutic in Hans Baldung Grien. *Representations* 10 (Spring): 52–101.

Laqueur, Thomas. 1986. Orgasm, Generation, and the Politics of Reproductive Biology. *Representations* 14 (Spring): 1–41.

Lauts, Jan. 1966. *Katalog Alte Meister bis 1800*. Karlsruhe: Staatliche Kusthalle Karlsruhe.

Maclean, Ian. 1980. *The Renaissance Notion of Women: A Study in the Fortunes of Scholasticism and Medical Science in European Intellectual Life*. Cambridge: Cambridge University Press.

Monter, William. 1976. *Witchcraft in France and Switzerland: The Borderlands During the Reformation*. Ithaca and London: Cornell University Press.

———. 1977. The Pedestal and the Stake: Courtly Love and Witchcraft. In *Becoming Visible: Women in European History*. Edited by Renate Bridenthal and Claudia Koonz, 119-136. New York.: Houghton-Mifflin.

Moxey, Keith. 1989. *Peasants, Warriors, and Wives: Popular Imagery in the Reformation*. Chicago: University of Chicago Press.

Osten, Gert von der. 1983. *Hans Baldung Grien*. Berlin: Deutscher Verlag für Kunstwissenschaft.

Ozment, Stephen. 1983. *When Fathers Ruled: Family Life in Reformation Europe*. Cambridge: Harvard University Press.

Panofsky, Erwin. 1955. *The Life and Art of Albrecht Dürer*. 4th Ed. Princeton: Princeton University Press.

Roper, Lyndal. 1989. *The Holy Household: Women and Morals in Reformation Augsburg*. Oxford: Oxford University Press.

———. 1985. Discipline and Respectability: Prostitution and the Reformation in Augsburg. *History Workshop* 19 (Spring): 3-28.

Schade, Sigrid. 1983. *Schadenzauber und die Magie des Körpers*. Worms: Werner'sche Verlaggesellschaft.

Scribner, R. W. 1987. *Popular Culture and Popular Movements in Reformation Germany*. London and Roncevert: Hambledon Press.

Spreitzer, Birgitte. 1988. *Die stumme Sünde, Homosexualität im Mittelalter*. Göppingen: Kümmerle Verlag.

Stengers, Jean, and Anne Van Neck. 1984. *Histoire d'une Grande Peur: La Masturbation*. Brussels: Editions de l'Université de Bruxelles.

Tentler, Thomas. 1977. *Sin and Confession on the Eve of the Reformation*. Princeton: Princeton University Press.

Theweleit, Klaus. 1986. *Männerphantasien*. Basel and Frankfurt am Main: Stroemfeld.

Thomasset, Claude, and Danielle Jacquart. 1985. *Sexualité et Savoir Médicale au Moyen Age*. Paris: Presse Universitaine de France.

Wiesner, Merry. 1986. *Working Women in Renaissance Germany*. New Brunswick: Rutgers University Press.

Zika, Charles. 1989–90. Fears of Flying: Representations of Witchcraft and Sexuality in Early Sixteenth-Century Germany. *Australian Journal of Art* 8: 19-47.

Zschelletzschky, Herbert. 1975. *Die Drei Gottlosen Maler von Nürnberg*. Leipzig: Veb. E. A. Seeman Verlag.

2

PLAYING WITH HERSELF:

FEMININE SEXUALITY

AND AESTHETIC INDIFFERENCE

KELLY DENNIS

Representation is where feminine sexuality comes into play.

—JACQUES LACAN

Or la pudeur, c'est l'essence de l'art.

—PHILIPPE LACOUE-LABARTHE

In *A Tramp Abroad*, Mark Twain describes his encounter with the art histori-
cal canon as an encounter with a broad who is a tramp. Twain observes that
Titian's *Venus of Urbino* is "the foulest, the vilest, the obscenist picture the world
possesses," due to "the attitude of one of her arms and hand," insinuating that
the canonical, Renaissance nude does not conceal her pubis but instead stimu-
lates herself (quoted in Kaplan 1990, 2). Twain's ironic assessment of the *Venus
of Urbino* [Figure 1] as masturbating has only recently been repeated and rein-
forced by art historians, *sans* implications of obscenity, who have extended this
reading to include a number of canonical paintings of female nudes, including
Giorgione's *Sleeping Venus* [Figure 2] (Goffen 1987; Kaplan 1990).[1] This expli-
cation of Venus as masturbating rather than concealing herself represents, at
first glance, a radical transformation in the traditional visual iconography of
Venus. For the pose of the *Venus of Urbino* as *venus pudica*—the gesture with

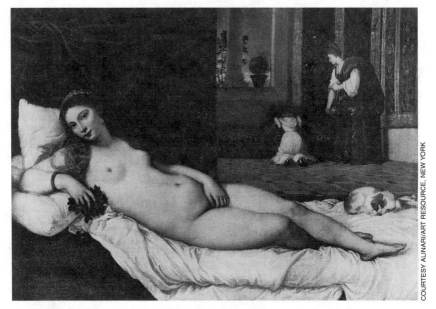

Figure 1. Titian, *Venus of Urbino*, c. 1538. Florence, Uffizi.

Figure 2. Giorgione (finished by Titian), *Sleeping Venus*, c. 1510. Germäldegalerie, Dresden.

which she has traditionally been assumed to conceal her pubis—originated with Praxiteles's fourth century BC depiction of the *Aphrodite of Knidos*, and became a primary iconographic trait in depictions of Venus or Aphrodite in both sculpture and painting (Goffen 1987; Kaplan 1990).[2] Yet the iconography of the *venus pudica* pose is far from unambiguous even at its inception, inasmuch as the gesture simultaneously "calls attention to the part of herself which she pretends to conceal" (Goffen 1987, 697).

While Plato described the imminent dangers of art due to its mimetic remove from the Idea, men were attempting to copulate with the *Knidian Aphrodite* [Figure 3], so enamored were they of her derrière, ideally depicted and displayed in sculpture-in-the-round.[3] Despite their renown today for the depiction of ideal physical beauty, up until the fourth century the Greeks in fact depicted only the male nude, while women and goddesses remained veiled—rightly so as Hegel would later note—due to their inherent licentiousness.[4] The *Knidian Aphrodite* derived her notoriety not only as the first nude depiction of a woman, but for the reaction she elicited from viewers: Pliny claimed that her derrière bore the cum stains of her male audience's lust (Pliny *Natural History* 36.5. 20–21; Pollitt 1965, 128; Pollitt 1972, 157 n.9), testimony to both the success of its mimetic remove from the Idea as well as the dangers inherent in that success.

I want to linger a moment over this sculpture of a woman said to incite male masturbation for the implications it bears on the female nude in general and on images of female masturbation in particular. While representations of sexualized women, or, rather, *sexualized* representations of women as the nude are a mainstay of the Western art historical canon, representations of feminine sexuality are debatably few if any, since images of feminine pleasure, artistic or pornographic, are generally regarded as phallicized insofar as they are by men, for men. It is not surprising, then, that even at its inception, the *venus pudica* pose signaled a rather ambiguous modesty to Classical beholders of the *Knidia*. The licentiousness with which the Aphrodite was perceived was blamed neither on her audience nor on her creator, the sculptor Praxiteles, but on the statue itself, as demonstrated by Lucian, who attributes to her prudent gesture a mere "token modesty" belied by her "dewy" and inviting glance (quoted in Pollitt 1965, 157).

The first depiction of a nude woman, the *Knidian Aphrodite* is both the object of voyeurism as well as its justification. She is depicted "surprised washing," attempting to conceal her pubis with her left hand and reaching for her wrap with the other. Classical scholar Martin Robertson explains that the "fem-

Figure 3. Roman, Statue of the Aphrodite of Knidos (Roman copy of Greek original by Praxiteles), Vatican, Marble, Imperial age, ht.: 2.05 meters, modern right forearm, hand, and head.

PHOTO. GERMAN ARCHEOLOGICAL INSTITUTE OF ROME

inine" stance of the Classical statue—knees close together in order to enhance the width of the hips—requires the structural support of the water pot from which she retrieves her robe, a sculptural innovation designed to support the *contrapposto* pose, also a Praxitelian invention. As Robertson further qualifies, however, the pot and robe do not simply support the statue but constitute an "integral part" of the representation which "motivat[es] the nudity (something Greek artists never felt necessary in a male figure)" (Robertson 1981, 140–41).

That the Aphrodite's gaze should belie her modest gesture, that she should invite the transgression that takes place, is not very remarkable in light of the sculpture's Archaic precedents—painted kraters and statues which "run away if not tied down" and address the viewer in the first person.[5] What is noteworthy about the "dewy" and inviting glance of the Aphrodite, however, is that it helps to justify what has already been determined: the nudity of the female body is always already obscene, unlike the heroism of the male nude.[6] The female nude is *the nude*. Lynda Nead remarks that, for example, in Sir Kenneth Clark's classic opus, *The Nude* (Clark 1956), at some point "the female nude loses its specificity" and, "dropping the gendered prefix," becomes "the nude" and all it represents in the high-art tradition. That "the nude" is always understood to be female is marked by the qualification "the male nude" whenever the nude in question is *not* female (Nead 1992, 13).

Male nudity in and of itself signifies the spiritual, whereas female nudity signifies the sensual, what is animal in man (Lacoue-Labarthe 1975, 73).[7] Unlike the heroic male nude tradition which continues up until the nineteenth century, female nudity in Western art can never be its own *raison d'être*. Just as the structural support narratively motivates Aphrodite's nudity, her nudity itself justifies the statue's violation: as such, the female nude in particular invites this transgression of the "normal" image-beholder space.

Yet what constitutes the "normal" image-beholder space and why should its transgression be taboo? Pliny's invocation of the image of a man touching, fondling, or masturbating before a Greek statue violates the "purity" with which we regard Classical art today, as does the alien notion that the pure, white sculptures of Antiquity occupying the Louvre were originally painted—indeed, garishly so to our eyes. More to the point, masturbation does not jibe with our notion of art because of our association of this solitary activity with pornography, by which the male viewer is said to contribute to the objectification of women, degrading women by degrading images of women.[8] Yet recent feminist rewritings of art history imply that autoeroticism is a defining attribute of male

spectatorship in the reminders that nude images from the Renaissance were commissioned for private display, and in the admonishment that certain images from the nineteenth century, also commissioned and cause for scandal even then, were kept behind curtains and revealed only to privileged *confrères*. Additionally, art history often testifies to the mimetic success of a Da Vinci or a Michelangelo with anecdotes of pygmalionesque patrons "who love too much" even the religious imagery they commission and subject to various indelicacies, thus following Pliny's rhetorical example.[9] That this male aesthetic experience tends to be implied rather than stated in general theories of spectatorship is in part because most of these images now occupy public museum space for all to enjoy aesthetically, if not carnally.

Mark Twain equated the *Venus of Urbino* with pornography, concluding ironically that, "[i]n truth, it is too strong for any place but a public Art Gallery" (quoted in Kaplan 1990, 4). As Twain alludes, the context of the modern museum transforms art from what might otherwise be considered pornography, and monitors whatever effects the image might have on its viewers. The public museum or gallery is a controlled and even surveillanced space of viewing where access to the image is delimited by the presence of other viewers, and, in the twentieth century, by cameras and electronic beepers; the space of the private collector, on the other hand, represents a closed, unobserved, and intimate arena in which the object can be approached and touched and where the viewer may touch himself.[10] The viewer's distance from the work of art contributes to its status as merely erotic, whereas his proximity to the image identifies it as obscene.

The distinctions governing the somewhat arbitrary—to take Twain's point— disparity between public and private viewing of art invoke a dialectic between touch and sight, proximity and distance, in the activity of beholding, and bear not only upon the definition of art but upon our contemporary distinction between erotica and pornography, which also concerns *distance*. That is, whereas popular claims to erotica's emphasis on foreplay rather than coitus and on figures in various states of undress rather than nude are said to leave "room" for imagination or "space" for fantasy, pornography's all-nude depiction of women is "too close," "too natural," "too real."[11]

The distinction between erotica and pornography, distance and proximity, is a crucial one: what does it mean to be "too close" to an image? Clearly the admirer of the *Knidian Aphrodite* came entirely "too close" and quite enjoyed doing so. Pleasure, however, as Plato states in the *Laws*, should never be the basis for the judgment of imitation.[12] Aesthetic indifference demands instead

the sublimation of pleasure, a "double distance from things and from the self: the individual posits the object as spectacle by positioning himself as spectator" (Lichtenstein 1993, 19). This is why for Plato and the later neoclassical tradition, the ability to *judge* imitation "correctly" is even more important than truthful imitation itself (*Laws* 2.669a-b).[13] One of the dangers of imitation, experiencing pleasure rather than remaining indifferent, would not only mean being "too close" to the object but too close to the Other, since in "losing" oneself to pleasure, one loses "possession" of oneself (Hollier 1984, 10).

In her book, *The Eloquence of Color*, Jacqueline Lichtenstein distinguishes between mimetic and representational theories of art: Mimetic theory originates with Plato's metaphysics and subsequently dominates the Western philosophical and critical discourse on art expressly, so it would seem, in order to eradicate the very possibility of the representational theory of art espoused by Aristotle. Briefly, Platonic mimetic theory assigns to the image the hierarchically inferior status of being a mere copy of the object, itself a copy of the Truth or Idea. Located at a tertiary remove from Truth, the image is consequently deficient by definition and by distance, and its "rectitude" is determined by how "correctly" it resembles the object, itself once removed from the Truth (*Laws* 2. 667–676; Cf. the *Republic* 10. 595–608).

The demand for similitude, however, undermines the very hierarchy upon which Plato's aesthetic theory relies, since, "[p]aradoxically...the more naturalistic Archaic sculpture became, the more it was acknowledged as false, as imitation (*mimesis*), as not the thing itself but only its likeness" (Hurwit 1985, 259). That is to say that the increasing *naturalism* of artistic likeness in Greek art was the result of elaborate techniques of *illusionism*—shade, shadow, etc.—which, rather than leaving unseen what was not immediately visible to the eye (as in the earlier symmetry and geometry of Archaic art), instead *alluded* to what could *not* be seen. In his *Natural History*, Pliny describes the quintessential "naturalism" so admired in the work of Parrhasios as follows:

> This in painting is the high-water mark of refinement; to paint bulk and the surface within the outlines, though no doubt a great achievement, is one in which many have won distinction, but to give the contour of the figures, and make a satisfactory boundary where the painting within finishes, is rarely attained in successful artistry. For the contour ought to round itself off and so terminate as to suggest the presence of *other parts* behind it also, and disclose even what it hides. (Pliny, *Natural History;* 35.36. 67–68; emphasis added)

The renowned naturalism of Classical and Hellenistic art is constituted by the allusion to "other parts" as well as to what Gombrich refers to as "the Beholder's Share" (Gombrich 1972), the viewer's ability to fill in the blanks of illusion's "rounded off contours." Thus the more "real" the imitation appeared, the more it relied on appearance to maintain its similitude. "Naturalism" implicated imitation as *representation*, "promising" with a curved line what could not be seen and simultaneously "revealing" what was "obscured" to sight. Mimesis therefore depends increasingly upon the ability to represent the difference between the object as we see it and the object as we know it, and so increasingly appealed to—or rather "exploited" in Plato's terms—what Plato considered the "confusion" and "weakness" in our souls which makes us susceptible to such "false" pleasures.[14]

Thus both mimetic activity and the judgment of imitation rely upon a certain *finesse* between distance and proximity: mimesis, deficient for its remove from the Truth, is required to approximate the object, while the judgment of imitation relies upon an appropriate distance or indifference both from imitation and from the self. Too close, and the viewer may lose himself in the pleasures of imitation, may confuse resemblance with identity.[15] Mimetic theory, then, describes an "ethics of representation"[16] with regard not only to imagery but to the viewing subject, prescribing for both art and its beholding a proper and hierarchical distance, articulated by a rhetoric of propriety and decorum (Lichtenstein 1990, 99). The judging subject, in his susceptibility to the pleasures of imitation, reproduces this mimetic hierarchy as well as its dangers in his relation to representation.

Perhaps, then, it is Parrhasios' trick of letting a curved line "suggest the presence of other parts" which rendered heretofore "invisible" to art history the fingers of Giorgione's *Sleeping Venus*, wedged as they are in the cleft between her thighs. The seductions of illusionism have always been suspect within an art historical tradition whose origins lay in the puritanism of Plato's iconoclasm.

Moreover, the seduction and appeal of illusion to the "weakness" in our souls has been customarily defined as "feminine," and it is the "femininity" of illusionism's curved lines—suggesting representation's *other parts* —for which Plato denounces imitation (Lichtenstein 1993, 37–54). This gendering of the "curve" of illusionism is not simply due to the "femininity" of the form of its appearance, but to the *form* appearance grants:

> Painting is the cosmetic art par excellence and by definition....Pictorial activity does
> not merely modify, embellish, or make up an already present reality whose insuffi-

ciency could be revealed if its ornaments were removed, like a woman without her makeup. Behind the layers of paint used by the painter to represent forms in a picture nothing remains, just the stark whiteness of a canvas.... It is like an adornment from which nature is absent, makeup whose coloring does not merely correct the faults of a face but invents its features and gives it a form, a garment that cannot be taken off without pulling off the skin, an originative metaphor. (Lichtenstein 1993, 43)

As Lichtenstein observes, Plato equates painting with cosmetics and other artifices of flattery and seduction which appeal to the "weakness of the soul." For Plato the threat of the art of imitation lay in the fact that painting does not "present us with an illusory appearance but with the illusion of an appearance whose very substance is cosmetic" (43). The collusion between illusion and the invisible—what we believe we *know* is there—points to the possibility that reality is constituted by its appearance rather than by a Truth which grants its coherence and unity; the possibility that the shadows on the walls of Plato's allegorical cave are not cast but indeed are all there is to the real; the possibility that mere resemblance *is* identity.

What, then, to make of the ejaculate on the *Knidia*? It is not that the artifice of the Aphrodite is so skillful that she was mistaken for a "real" woman. Stimulation may derive from the very incontrovertability of the fact that she is not "real" which is itself pleasurable. Despite the prominence of the *trompe l'oeil* parable of Zeuxis and Parrhasios to mimetic theory,[17] neither artist nor beholder share the belief that the painter has indeed created the objects of his painting: as Lichtenstein observes, only Plato would have us believe that the artist "by exhibiting at a distance his picture of a carpenter...would deceive children and foolish men, and make them believe it to be a real carpenter" (Lichtenstein 1993, 43; Plato, *Republic* 10. 598c). Rather, *trompe l'oeil*—"to fool the eye"—articulates the tension between mimetic and representational theories of art insofar as it highlights the role of the viewer as a *willing* "dupe" of representation, as willing to collapse the distance believed to exist between what we see and what we know.[18] Gombrich describes the beholder's participation in this duplicity as a pleasurable part of the aesthetic experience, "when the art lover discover[s] the joy of stepping back from the canvas to enjoy the sensation of visible brushstrokes disappearing behind the emergent illusion.... The distance from the canvas weakens the beholder's power of discrimination and creates a blur which mobilizes his projective faculty" (Gombrich 1972, 222). This plea-

surable sensation, invoked in the viewer unable to discriminate the emerging illusion, is what Plato would repress, denying all appearance, all imagery. What is therefore at stake in the mimetic theory underlying the Western tradition of art history is the preservation of Truth by disavowing the necessity of the viewer's participation in the illusionism of imagery and the potential not only for losing the self in the identification with resemblance but the pleasure derived therefrom.[19]

> It is the difference between a woman who is seen
> and a woman who exhibits herself.
> —DIDEROT

Art historians have only recently begun to participate in "knowing" what Twain "saw" a century ago. Noting that Titian's *Venus of Urbino* [Figure 1] and Giorgione's *Sleeping Venus* [Figure 2] are images of female autoeroticism, Renaissance art historians have justified this depiction as appropriate to the period: at this point in Renaissance Venice, the orgasm of both male and female partners was believed to be necessary for conception to take place. Masturbation was thus theologically justifiable in order for the woman, longer in taking her pleasure, to achieve orgasm during intercourse for the purposes of conception.[20] Thus, by the time of the Renaissance, the "token modesty" of the Classical *venus pudica* gesture is fully transformed from an iconography of *pudeur* to one of prurience. In the case of both *Venus* paintings, however, there seems to have existed among viewers and art historians alike a tacit agreement not to see, or rather to disavow seeing.[21] I am less concerned here with the cultural imperatives behind the refusal to see masturbation in these images than in the inevitability of this disavowal within the context of the female nude.

While there are a number of images which have been identified as autoerotic,[22] the Giorgione and the Titian will be the primary focus here as there are a number of crucial differences between them—one situated in a landscape, the other in an interior—which seem to be cause for iconographic and identificatory distress to modern art historians as well as to Renaissance viewers. Like Twain, sixteenth-century viewers of the *Venus of Urbino* were aware of the lasciviousness of the image, as her original owner Guidobaldo della Rovere described the painting simply as a picture of a "naked woman" (Goffen 1987, 697). Rona Goffen notes that scholars have since more or less followed suit, finding "no hint of any mythological connotation,"[23] in their assesment that "she

is no goddess, and indeed no lady" (1987, 695). On the other hand, evidence that Giorgione's depiction is both goddess and lady includes her situation in an "idealized landscape," modern x-ray evidence that a small cupid was originally included in the iconography and then painted over, and that she is asleep—her arm over her head in unselfconscious abandon, an iconographic addition to the *venus pudica* gesture—all of which justify her otherwise extraordinary pose (695, 700).

Despite the fact that the *Sleeping Venus* is unmistakably masturbating, the landscape and the iconography of sleep determine the image as less subversive than the *Venus of Urbino*. Why is this? The association of the female nude with landscape or agriculture is a centuries-old precedent by this time, one which situates woman and her sexuality as natural and as *of* nature, diffusing the threat constituted by "Renaissance beliefs about the insatiable sexuality of women" (Goffen 1987, 700). The lush landscape is generally understood as a metaphor for the fertility and generation of the female body.[24] Associated with landscape, she is safely contained within landscape as well as within the surface of the canvas. More importantly, this association between nature and the female body is *mimetic*: she not only resembles the landscape, she is identified with it. Lacking distinction from the image, she inhabits the visual environment much as those mimetic insects which assimilate themselves to their environment to avoid detection by predators.[25] Traditionally associated with the landscape *as* background, woman is undifferentiated from background and believed to be undifferentiated from herself.[26]

Collège de Sociologie member Roger Caillois identified the distinction between resemblance and identity as the "ultimate problem" in mimetic activity (as quoted in Hollier 1984, 13–14), a feminine ambiguity in mimesis that for Plato played out historically in the representational differences between sculptural and painterly *pudeur*. Kaplan, for example, describes an essential difference governing the depiction of *pudeur* in sculpture and painting, remarking that "the true *pudica* gesture never involves overt touching of the crotch: in sculpture the hand is discreetly placed several inches out in front, while in painting either tresses or fabric shield the genital area from direct contact with fingers" (Kaplan 1990, 2). That is, while sculpture allows one to circumambulate around the figure in order to witness her modesty and establish that she does not in fact touch herself overtly [Figure 4], the two-dimensional surface of painting, undistinguished from itself, does not permit us the certitude that the woman does not touch herself, resulting in the patently fetishistic barrier of

Figure 4. Roman, Statue of the Aphrodite of Knidos (Roman copy of Greek original by Praxiteles), marble, 2nd. century A.D., ht.: 168 cm, Katherine K. Alder Fund, 1981.11; left side.

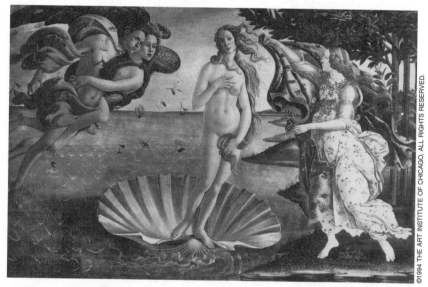

Figure 5. Botticelli, Birth of Venus, c. 1478. Florence, Uffizi.

"tresses or fabric" between hand and genitals to assure us of that fact, as in the earlier *Birth of Venus* by Botticelli [Figure 5].[27]

Yet despite the absence of "overt touching" in the original *venus pudica* gesture in the statue of the *Knidian Aphrodite*, she was nonetheless herself overtly touched by her viewers. The transformation from sculpture to painting of the *venus pudica* pose from feminine modesty to masturbation, from concealing from sight to seeing touching, invokes a centuries-old debate between sculpture and painting, manifested as touch and sight, as *proper* domains of artistic representation, for which the female body is the inevitable, allegorical site of this aesthetic conflict. Eroticism is acutely implicated in the Renaissance *paragone*, the "rivalry" between sculpture and painting, which Goffen observes motivates Titian as well as his admirers (Goffen 1987, 691–92). Renaissance imagery mastered Parrhasios' techniques of naturalism, "incorporating two or more views in one scene so as to provide a more complete image" (691). Unlike sculpture, which is three-dimensional and completely differentiated, enabling the viewer to walk around, observe and, as we noted with the *Knidia*, touch as easily as he could distinguish that she was not touching herself, Renaissance imagery is renowned for its use of color in order to invoke the flesh from the two-dimensional surface of the image.[28] Praising the earlier *Venus and Adonis* by Titian, an admirer notes particularly how "Venus's flesh responds to her weight as she sits," stating that

> there is no man so acute of vision and of judgment who, seeing her, does not believe her to be living…that he does not feel himself warmed, softened, and all the blood coursing in his veins. Nor is this a wonder; if a statue of marble can in a way with the stimuli of its beauty so penetrate into the marrow of a youth that he leaves a stain there, then what can this [picture] do, which is of flesh, which is beauty itself, which seems to breathe. (quoted in Goffen 1987, 692)

As Goffen observes, Titian's contemporary deliberately invokes the legend surrounding the sculpture of the *Knidian Aphrodite* in order to assert the supremacy of painting over sculpture, the former whose fleshly eroticism is claimed to surpass that of sculpture, as evidenced by the still more extreme physical response claimed here. This extremity of physical response to the image is compatible with the "Renaissance eroticization of the sense," expressed in the conceit that the image, "Galatea-like, harbored the possibility that stone might turn to flesh and painted surfaces might come to life" (Findlen 1993, 63–64). Above

all, the investment of eroticism in sensory perception indicates the degree to which images are conceived as having the power to "move" their audience in a distinctly pleasurable fashion.

How did we get from Plato's suppression of pleasure in the judgment of representation to pleasure's being the primary characteristic of that same judgment? The transition here from a three-dimensional sculpture said to incite male masturbation to a two-dimensional painting of a masturbating woman for which the former is held to be a model is a clue, for the transgression of the "normal" viewing distance has decidedly different connotations when enacted by the viewer than when presupposed of the image itself. The association of woman with the surface of the image is additionally reproduced by the erotics of a traditional, prescribed viewing distance, manifested by the sense that one may "enter" the picture, a presumptive supplement to the missing third dimension in painting. The convention of the nude's "availability" for the delectation of the male viewer is partially defined by her situation: positioned on a bed or palette, she is situated lower than the spectator, as defined by her position beneath or equivalent to the horizon line, as can be witnessed in both the *Venus of Urbino* and the *Sleeping Venus*. Additionally, the convention includes a space between the bed and the picture's frame, providing an easily "transgressible" distance which allows the spectator *entrée*. Moreover, the convention prescribes the nude's gaze as coy and inviting, as in the Titian, or, as in the *Sleeping Venus*, she is otherwise "abandoned" to the beholder's gaze which implicates the viewer as a voyeur.[29]

The attention to the conflicting meanings of the iconography of *pudeur* and the acceptable immodesty of sleep concerning the autoeroticism of the *Dresden Venus* directs us to a more in-depth inquiry into what sleep might figure in painting, such that it mitigates the potential here for obscenity. For while Kaplan observes that "the *pudica* pose...is inappropriate in a sleeping woman who does not seem to be aware of the viewer's presence" (1990, 2), Goffen remarks to the contrary that her state of unselfconscious repose mitigates the *Dresden Venus's* autoeroticism as merely occupying the realm of fantasy and "Renaissance Dreams," and the image subsequently lacks the same willful subversion as the *Venus of Urbino*, who coyly acknowledges the viewer as she caresses herself (1987, 698–99).

Sleep places the *Dresden Venus* within what Michael Fried refers to as an "absorptive" paradigm in painting, by which the beholder is ignored or goes unacknowledged by the painting, in order to "establish the fiction that no one is

standing before the canvas," and which Fried identifies as a formal or pictorial problematic within painting, albeit manifested differently in a given historical period (Fried 1980, 108). Sleep in particular figures for Caillois the "irreversibility" of the distinction between mimetic and non-mimetic activity. That is, as Denis Hollier explicates,

> what distinguishes being awake is that wakefulness distinguishes itself from sleep—wakefulness implies consciousness of not being asleep—while the reverse is not true—sleep is not able to distinguish itself from wakefulness, since being asleep does not imply a consciousness of not being awake. In these oppositions *only one of the two terms carries the distinction, only one is able to distinguish itself from the other.* And that is precisely *why ambiguity ends at this point.* (Hollier 1984, 6; emphasis added)

Sleep, then, like the association between woman and landscape, figures for the mimetic function of painting as that against which the viewer distinguishes himself, is distinguished from himself as a spectator. He is distinct—non-mimetic, non-resemblant—by virtue of the fact that he (alone) can distinguish himself as such. "Mimesis pretends to announce the end of differences," as Hollier explains, all the "better to reserve" what he identifies as the "vital" ontological difference between life and death, which I would qualify instead as the preservation of the "vital difference" of sexual difference (13).[30]

This fiction of subjective distinction is predicated upon the presumed autonomy of the image which in turn reassures the viewer of his own subjective autonomy. By acknowledging the viewer, the *Venus of Urbino,* on the other hand, threatens the very subject-object distinction upon which that beholder-painting relation is presupposed.[31] The sense that Titian's depiction of Venus is somehow more obscene than that of Giorgione is in part due to this conflict between acceptable "access" to the image and the sense that, unveiled, the image might be "too close," might threaten our belief that we are other to the shadows on the walls of the cave.[32]

To be anti-pornography is to be anti-masturbation.
—ANON.

What can be determined thusfar is that within art history, mimesis, as a theory which hierarchizes relations between signs, functions to obviate the more problematic relation between the image and the beholder, namely the uneasiness

with which spatial distance produces ontological difference. Pleasure in the presumed femininity of the immoderate materiality of the image is the target of Plato's puritanical castigation of images, and it is pleasure which his theory of mimesis presumably maintains at a safe *distance*, appropriately indifferent to the seductions of illusion. It is for fear of the seductions of illusion that the poet must be cast from the *polis*, that painting must be identified as inferior and for which the image of a masturbating woman is an allegory of painting *par excellence* by virtue of the simultaneous threat of autonomy and dissolution.

The depiction of female masturbation points to and "touches overtly" the illusory depths located in the curves and shadows of painting, what is known but not seen: obscene, her "other parts" are in excess of representation.[33] Insofar as woman in and of herself signifies the fleshly materiality of mere representation, her autoeroticism establishes her "lack" of distance from herself as an ever-present danger of mimesis and flaunts Plato's fears. As Lichtenstein states, "Plato lacked neither lucidity nor coherence. He knew that to grant the image anything meant that the image would sooner or later take hold of the whole in order to destroy it. He was one of the few to have truly taken images seriously, that is, to have believed in the force of their powers" (1993, 2). Femininity is identified with the surface of the image due to woman's presumed lack of mediation on account of her always-pleasurable, autoerotic relation to herself. Luce Irigaray writes that

> In order to touch himself, man needs an instrument: his hand, a woman's body, language.... As for woman, she touches herself in and of herself without any need for mediation.... Woman "touches herself" all the time, and moreover no one can forbid her to do so, for her genitals are formed of two lips in continuous contact. (1986, 24)

The fear that woman is always touching herself, that she is never differentiated from herself constitutes the invisibility of her pleasure to phenomenal speculation and its invisibility for specular representation.[34] That man is different from himself and thereby needs a tool in order to touch himself, is pertinent to this moment in Renaissance art history which represents the transformation in the social status of painters from mere craftsmen in the middle ages (Lichtenstein 1993, 230 n. 4), for whom pigment and paintbrush are tools, to the painter as artist, whose ideas are transported unmediated onto canvas—significantly, in depictions of the female nude, herself understood to be unmediated.

It would seem, then, that the image of female masturbation represents a pleasure taken in proximity which cannot be enjoyed by man, who can only touch himself as other to himself: male masturbation enforces a distance from himself while touching himself. His "power" to objectify lies in his difference from himself, largely dependent upon and creative of the notion that woman cannot be distinct from herself. Like one who is awake, however, he is awake by virtue of his ability to distinguish himself as awake: asleep, he is no more able to distinguish himself than the perpetual repose he imposes upon (the) woman. The image of female masturbation is phallicized only insofar as the spectator, presented with feminine sexuality as a representation of identity as resemblance—i.e., presented with the knowledge that shadows reign *outside* the cave as well as inside—touches himself in order to reestablish his difference from himself, hence the so-called "phallicized" representation of feminine sexuality.

As that which discriminates erotica from pornography, the notion of appropriate distance monitors the distinction between resemblance and identity, intersecting with historical and aesthetic distinctions between media and, likewise, between high art and mass culture. The attempt to copulate with the *Knidian Aphrodite* demonstrates how real the image can be, with the pygmalionesque consequence that the image become flesh exposes flesh itself as mere appearance. The fiction of the lack in feminine sexuality is equally an exposure of the fictionality of the phallic whole to which she is compared and found wanting. If, as Phillippe Lacoue-Labarthe queries, the nudity of woman *in and of itself* signifies the sensual, would not *pudeur* —*veiled* female nudity— therefore signal the *unity* of spiritual and sensual, a unification which *figures* art itself (1975, 74)? "Woman is at stake," he states, "*not* because she represents the sensual itself in its opposition to the spiritual…but the sensual in its 'Truth,' which is the 'truth' of the figure and of appearance" (85).

In drawing attention to the feminization of the metaphors of mimesis and the concomitant anxiety with the ontological "truth" of beholding, I assert that femininity itself is a primary question whose deferral or displacement is essential to the formulation of these traditional philosophical and aesthetic hierarchies and their underlying ontological concerns. The acknowledgment and denial of the viewer in the presence and the absence of the gaze of Venus has to do with what Fried has identified as a pictorial problematic concerning the acknowledgment and denial of an audience, or what we have been identifying, with Gombrich, as the Beholder's Share (1972). The necessity of the beholder, coupled with the formal disavowal of his share as a pictorial problem as well as a

philosophical issue, points to the "resituation of sexual difference *within*" the image-beholder relation itself rather than "between him and the object of his representation" (Fried 1988, 48).[35] The aesthetic, philosophic and cultural identification of the representational object with femininity and beholding with masculinity must, therefore, be reconfigured in terms other than the traditional matrix of passivity and activity.

Femininity, or the "woman question," has generally been posed as a secondary issue, one which, as Mary Ann Doane has stated, is a deferral of a larger ontological question presumed to concern only man. Lacking masculine self-distance, woman, it is assumed, cannot pose her own ontological question.[36] Rather, sexual difference is precluded by its very positioning as subordinate to philosophic issues. My argument, on the contrary, demonstrates that woman is "excluded" from ontological questioning only insofar as she is its originary condition. The canonical *Venus* paintings of Titian and Giorgione demonstrate that the Renaissance nude, like Praxiteles' *Knidia*, shifts perilously between Classical allegory and "real" woman, such that the indeterminacy of her character bears equally upon the confusion over the nature and quality of the work of art. That illusionism's curved line alludes to what we know is there and is figured—and even fingered—by Venus indicates the degree to which sexuality is at stake in representation. The continued omission of sexual difference as the precondition of ontological questioning veils the real obscenity of ontology and permits the simultaneous seeing and not seeing that evidences both pornography and the art historical gaze.

NOTES

This essay is an abbreviated version of a chapter by the same title from my Ph.D. dissertation, "The Face of God: Representation as the Pornography of Modernity" (UCLA, 1994); a shorter version was presented under the title "Hard Evidence" at the annual meeting of the College Art Association in New York City, February 1994. I would like to acknowledge my gratitude to Cecelia Galassi, Pat Morton, and Linda Williams for their comments and contributions to this essay. Additionally, I would like to thank The Getty Center for the History of Art and the Humanities, and especially Tracey Schuster, for assistance in procuring many of the prints reproduced herein. This essay is dedicated to the memory of Richard Iosty.

1. Kaplan credits Renaissance art historian David Rosand for remarking the Twain reference. I am grateful to Paul Kaplan for generously providing me with the text of his 1990 talk.

2. See also Blinkenberg (1933, 205–212) for Archaic precursors of the *venus pudica* pose.

3. Originally commissioned for the island of Kos, Praxiteles' sculpture of Aphrodite was subsequently rejected in favor of a draped figure, for which the people of Kos would be a laughing stock. The citizens of Knidos evidently had no such objections and displayed the statue in a rotunda, so as to show her charms to their full advantage. See Robertson (1981, 141). That the sculpture was viewed from all sides is testified to by both Pliny and Lucian, as noted in Pollitt (1965, 128).

4. Hegel states that "the Greeks did not commit an error in [re]presenting most of their feminine figures clothed, while most of their masculine figures are [re]presented nude" (as quoted in Lacoue-Labarthe 1975, 53–95, 71; my translation). All translations from the French are mine unless otherwise noted. Here I have modified the translation of Hegel to retain the accent of Lacoue-Labarthe's own translation.

5. Hurwit remarks that the development of naturalism affected both the artist's conception of his art and the subsequent function of art: his creations were considered "somehow 'alive,' magical substitutes" which would address the user or beholder in the first person: "I am Nestor's cup," "So-and-so made me" (Hurwit 1985, 257–58). The first-person status of the work of art recurs throughout its Western history: the Northern Renaissance paintings of Jan Van Eyck, whose inscription proclaim "Jan Van Eyck made me," are but one additional example.

6. See especially Lacoue-Labarthe (1975, 53–95). The discussion of love that takes place in Plato's *Symposium* (after having sent the flute girl from the room so that the discussion that takes place is both homosocial and homosexual) distinguishes two kinds of love, spiritual and earthly or vulgar, as male and female respectively (Plato *Symposium*, 180d–181e).

7. "There is only," as Lacoue-Labarthe qualifies, "properly a feminine *pudendum*" (1975, 73).

8. While feminist art historians have often questioned the boundary between art and pornography, depriviledging the former in order to equate it with the misogyny presupposed of the latter, this association operates only at the level of the image's content, calling into question the legitimacy of the claim of a particular image to the status of art, and bears little on the dubious distinction between art and pornography itself. See, for example, Nochlin's claim that Courbet's painting of a woman's pubic region, *L'origine du monde*, "is literally indistinguishable from standard, mass-produced pornography—indeed, it is identical with it" (Nochlin 1986, 84; see also Dennis 1991, 122–167).

9. Gombrich (1972) recounts a number of these anecdotes.

10. On the function of the museum and the place of Renaissance and Classical art in the disciplinary foundations of art history in the late nineteenth century see Crimp (1993) and Preziosi (1989).

11. The first nude photographs were pronounced "too close, too real" by Baudelaire, among others. For this specific historical relation between the development of pornography and the invention of photography see Dennis (1991); Solomon-Godeau (1986); see Williams (1989), for a related argument within film history.

12. *Laws* 2.667e. Plato thus lays the groundwork for Kant's later formulation of "indifference" in aesthetic judgment as the distinction between cognition and pleasure (see Lichtenstein 1993, 45). " Imitation" is sometimes translated as "representation" here. However, following Lichtenstein, I have retained "imitation" in order to maintain the distinction she draws between Plato's mimetic theory of art and a representational theory of art later elucidated by Aristotle. Lichtenstein posits that Plato's mimetic theory of art functions to subordinate the ambiguities of representation to the hierarchy of Forms. Hence the apparent interchangeability of the terms imitation and representation in Plato, for whom they are one and the same. *To wit*: a few lines later in the *Laws* (2.668a), the Athenian states, "Now we may say that [e.g.] all music is an art of producing *likenesses or representations*" [emphasis added].

13. See also Lichtenstein (1990, 98–116) and Lichtenstein (1993), for a discussion of the importance of judgement within neoclassical aesthetic tradition.

14. Plato identifies the ability to distinguish what we know from what we see as a characteristic of proper judgment: "And the same things appear bent and straight to those who view them in water and out, or concave and convex, owing to similar errors of vision about colors, and *there is obviously every confusion of this sort in our souls. And so scene painting in its exploitation of this weakness of our nature falls nothing short of witchcraft*, and so do jugglery and many other such contrivances" (*Republic* 10: 602d, emphasis added).

15. The difference between resemblance and identity which is at once "essential" and yet "blurred" by mimesis is the subject of Hollier (1984, 3–16, esp. 13); the "femininity" presumed within this difference will be discussed further below.

16. Lichtenstein notes that the neoclassical French tradition relies heavily upon visual and, more specifically, painterly models in the much attended distinction between courtly wit or *finesse d'esprit* and pedantry, the latter a primary subject for critique. In particular, "the pedant is above all the one who adopts an improper distance towards both knowledge and the other. He is doubly ridiculous: first for claiming an exaggerated proximity to knowledge and also for affecting an excessive distance with regard to the other." The wit, on the other hand, possesses this *"finesse d'esprit*, which allows one to consider an object at the proper distance, neither too near, nor too far away" (Lichtenstein 1990, 99). This notion of proper distance likewise characterizes Gombrich's descriptions of the Philistine (1972, 195), as well as those primary debates between media— painting and rhetoric, sculpture and painting, etc.—elaborated in Lichtenstein (1993).

17. The tale of the competition between Zeuxis and Parrhasios has been cited as an illustration of mimesis. frequently, from Gombrich (1972) to Lacan (1981, 103 and 112–113). As recounted by Pliny, Zeuxis produced a picture of grapes so naturalistic that birds flew up to the image attempting to eat, whereupon Parrhasios painted such a realistic picture of a curtain that Zeuxis asked that it be pulled aside to display

Parrhasios' entry. Zeuxis admitted his defeat, stating, "whereas he had deceived birds Parrhasios had deceived him, an artist" (Pliny, *Natural History* 35. 36. 64–67).

18. This distinction between seeing and knowing is explicitly manifest in lifestudy classes which offer object lessons in the very illusionism despised by Plato. For example, according to the instructions in *How to Draw and Paint the Nude*, "It is important to learn to measure by eye, or with the aid of a pencil held at arm's length, and to *discard preconceived knowledge in favour of the evidence of your own eyes*" (quoted in Nead 1992, Plate 18; emphasis added). See also Lichtenstein (1993, 46).

19. Important work on the repudiation of the viewer as inherent within the work of art has been performed by Fried (1980; 1988, 43–53) and will be addressed in further detail below.

20. Cited in both Goffen (1987) and Kaplan (1990). For a more thorough discussion of the ideological transition from the necessity of female orgasm for conception to the repression of female orgasm due to its superfluity to reproduction in the eighteenth and nineteenth centuries, see Laqueur (1990 and 1987).

21. On the connection between disavowal, seeing, and fetishism see Dennis (1991, esp. 126–130).

22. E.g., Titian's *Danae*, whose hand, as Kaplan observes, "disappears somewhat mistily" into her crotch (Goffen 1987, 694; Kaplan 1990, 5).

23. Hans Tietze, as quoted in Goffen (1990, 682–706, 695 n. 17).

24. For an important rereading of agricultural metaphors of the female body, for which Plato's metaphysics stands as the "transition" from a metaphoric to a metonymic economy of sexual difference, see Du Bois (1988, 35).

25. See especially Hollier (1984, 3–16) on Roger Caillois's *Legendary Psychasthenia*.

26. One of the most important contributions to feminist theory has been the psychoanalytically-informed observation by feminist film theorists (including Laura Mulvey, Mary Ann Doane, and Tania Modleski) of the association of woman with the image as surface, with which she is said to identify and by which various "women's genres"—soap operas, "weepies"—are identified and consequently denigrated as mass culture; in opposition to the male spectator who is identified with the "gaze" in his ability to distance himself from film representation.

27. In his essay "Fetishism," Freud identifies "fur or velvet" as the most common fetishistic displacements for the female genitalia (1953–1974, 9:149–157). For a full discussion see Dennis (1991, 126–130).

28. Neither the *paragone* nor the emphasis on *colore* are isolated to the Renaissance. The rivalry between media, dating from the time of Plato and later Cicero, informs neoclassical debates such as exemplified in the writings of de Piles and Diderot, as well as the modern era. Tracing the terms and manifestations of this rivalry over the centuries is the primary concern of Lichtenstein's superb book, *The Eloquence of Color* (1993).

29. For a reassessment of the implications of voyeurism see Dennis (1991, 153–158).

30. Hollier notes that the desire for distinction is itself predicated on sexual difference (1984, 7), and in particular he identifies the point at which Caillois's argument about mimesis breaks down as his infamous example of the male praying mantis who is "assimilated" (devoured) by the female during intercourse. And while both male and female insects survive mimetic assimilation to their environment, the "vital difference" here is that the male does not survive this castratory assimilation. As Hollier notes, "Caillois's discarding of sexual difference should not itself be discarded as insignificant. But one might wonder if *the very disappearance of sexual difference in the shift from castration to mimicry might not itself be counted as one of the many tricks of mimicry*: just another sham" (1984, 13–14, n. 31; emphasis added).

31. The covert eroticism of the image leads to its being interpreted as a phallicized image of feminine sexuality unlike, for example, the uncompromising *Olympia* by Manet in the nineteenth century. The tenuousness of such "phallicizing," however, will be addressed further below.

32. This uneasiness with being "too close" is often–inadequately–identified as the implication of the viewer as voyeur. The notion of voyeurism, however, maintains the very subject-object relation presupposed between beholder and image, by which the former is held to be in a position of power and autonomy at the expense of the latter, *subject to* the former. See Dennis (1991, 153–158).

33. The questionable etymology of "obscene" as off-scene, the action that is represented off-stage (usually sexual or violent in nature) is pertinent to the discussion here. In a related argument, Lynda Nead (1992) identifies the tradition of the female nude as a representational problem of containment, the need to regulate and limit the female body. Similarly, from a sociological viewpoint, Davis (1983) identifies through literary and religious representation the fear of sex as itself a fear of the dissolution of subjective autonomy which occurs during orgasm or "erotic reality," what we have identified here as a dissolution represented within the subject-object relation figured by visual representation.

34. I have addressed the problems posed by the purported "invisibility" of feminine pleasure for the modern emphasis on vision within epistemological paradigms elsewhere. See Dennis (1991) and Williams (1989).

35. The import of Fried's work for feminist art historians has been much maligned and misunderstood, as a recent exchange between Linda Nochlin (1988, 17–42) and Michael Fried (1988, 43–53) in the exhibition catalog for a show of the work of Gustave Courbet demonstrates.

36. Doane purports the ridiculousness of this assertion as proved by the simple "reversal" of terms, in which woman does "pose" her own ontological question (1982, 75–76). Simply reversing terms, however, does little to account for the underlying ambiguities which the question itself serves to mask.

REFERENCES

Blinkenberg, Christian. 1933. *Knidia: Beiträge zur Kenntnis der Praxitelischen Aphrodite.* Copenhagen, Levin & Munksgaard.

Clark, Kenneth. 1956. *The Nude.* New York: Doubleday.

Clark, T. J. 1980. Preliminaries to a Possible Treatment of "Olympia" in 1865. *Screen* 21 (Spring): 18–41.

Crimp, Douglas. 1993. *On the Museum's Ruins.* Cambridge: MIT Press.

Davis, Murray S. 1983. *Smut: Erotic Reality/Obscene Ideology.* Chicago: University of Chicago Press.

Dennis, Kelly. 1991. Leave it to Beaver: The Object of Pornography. *Strategies: A Journal of Theory, Culture and Politics* 6: 122–167.

Doane, Mary Ann. 1982. Film and the Masquerade: Theorising the Female Spectator. *Screen* 23 (Sept/Oct): 74–87.

DuBois, Page. 1988. *Sowing the Body.* Chicago: University of Chicago Press.

Findlen, Paula. 1993. Humanism, Politics and Pornography in Renaissance Italy. In *The Invention of Pornography*, ed. Lynn Hunt, 49–108. New York: Zone.

Fried, Michael. 1980. *Absorption and Theatricality: Painting and Beholder in the Age of Diderot.* Chicago: University of Chicago Press.

———. 1988. Courbet's Femininity. *Courbet Reconsidered.* Exhibition catalog edited by Sarah Faunce and Linda Nochlin, 43–53. New York: The Brooklyn Museum.

Friedrich, Paul. 1978. *The Meaning of Aphrodite.* Chicago: University of Chicago Press.

Freud, Sigmund. 1953-1974. *The Standard Edition of the Complete Psychological Works of Sigmund Freud.* Trans. and ed. James Strachey in collaboration with Anna Freud. 24 vols. London: Hogarth Press.

Goffen, Rona. 1987. Renaissance Dreams. *Renaissance Quarterly* 40 (Winter): 682–706.

Gombrich, E. H. 1972. *Art and Illusion: A Study in the Psychology of Pictorial Representation.* Princeton: Bollingen.

Hollier, Denis. 1984. Mimesis and Castration 1937. *October* 31 (Winter): 3–16.

Hurwit, Jeffrey M. 1985. *The Art and Culture of Early Greece, 1100–480 B.C.* Ithaca: Cornell University Press.

Irigaray, Luce. 1986. *This Sex Which is Not One.* Trans. Catherine Porter with Carolyn Burke. Ithaca: Cornell University Press.

Kaplan, Paul H. D. 1990. The *Dresden Venus* and Other Renaissance Images of Female Autoeroticism. Presented at the College Art Association Annual Conference in New York.

Lacan, Jacques. 1981. *The Four Fundamental Concepts of Psycho-Analysis.* Trans. Alan Sheridan. New York: W. W. Norton and Co.

Lacoue-Labarthe, Philippe. 1975. L'imprésentable. *Poétique* 21: 53–95.

Laqueur, Thomas. 1990. *Making Sex: Body and Gender from the Greeks to Freud.* Cambridge: Harvard University Press.

———. 1987. Orgasm, Generation, and the Politics of Reproduction Biology. In *The Making of the Modern Body*, ed. Catherine Gallagher and Thomas Laqueur, 1–41. Berkeley and Los Angeles: The University of California Press.

Lichtenstein, Jacqueline. 1993. *The Eloquence of Color: Rhetoric and Painting in the French Classical Age.* Trans. Emily McVarish. Berkeley and Los Angeles: The University of California Press. (Originally *La Couleur éloquente: rhétorique et peinture à l'âge classique.* Paris, Flammarion, 1989).

———. 1990. Up Close, From Afar: The Subject's Distance from Representation. *Qui Parle* 4 (Fall): 98–116.

Nead, Lynda. 1992. *The Female Nude: Art, Obscenity and Sexuality.* London: Routledge.

Nochlin, Linda. 1986. Courbet's *L'origine du monde*: The Origin without an Original. *October* 39 (Summer): 77–86.

———. 1988. Courbet's Real Allegory: Rereading *The Painter's Studio. Courbet Reconsidered.* Exhibition catalog edited by Sarah Faunce and Linda Nochlin, 17–42. New York: The Brooklyn Museum.

Pasquier, Alain. 1985. *La Vénus de Milo et les Aphrodites du Louvre.* Paris: Editions de la Réunion des Musées Nationaux.

Pollitt, J. J. 1965. *The Art of Greece 1400–31 B.C.* New Jersey: Prentice-Hall.

———. 1972. *Art and Experience in Classical Greece.* New York: Cambridge University Press.

Preziosi, Donald. 1989. *Rethinking Art History.* New Haven: Yale University Press.

Robertson, Martin. 1981. *A Shorter History of Greek Art.* New York: Cambridge University Press.

Solomon-Godeau, Abigail. 1986. The Legs of the Countess. *October* 39 (Winter): 65–108.

Williams, Linda. 1989. *Hard Core: Power, Pleasure, and the "Frenzy of the Visible".* Berkeley and Los Angeles: University of California Press.

3

FORBIDDEN PLEASURES:
ENLIGHTENMENT LITERATURE
OF SEXUAL ADVICE

ROY PORTER

The last decades have seen a transformation in our understanding of past sexualities, stimulated largely by modern sexual liberationist campaigns, particularly those mounted by feminists and gays.[1] If once it seemed "progressive" to argue that sex was a positive power that had been subjected to ignorance and oppression, and hence that the history of sexuality ought to be told as a story of official repression, counter-action, and sexual emancipation,[2] things now seem far more complicated. The traditional tale now sounds far too biologistic; most scholars would today stress the cultural conditioning and determination of sexual orientation, attitudes, and activities. It also sounds too monolithic: we now talk not of one but of varieties of sexualities. And, finally, it sounds too crude, too Whiggish, a saga of heroes and villains. Questions of how to evaluate and make sense of the sexual orientations and experiences of earlier centuries are now much more occluded. Not least, we now have a much more realistic grasp of the limits of our knowledge. Once it was widely thought that the Victorians were sexually buttoned-up. Peter Gay and others have argued that they were

more open than that: but the evidence adduced is limited, and judgment must be suspended on the swinging Victorians.[3] Trends in demographic and family history over the last generation have led us to highlight the social pressures making for "respectable" sexual restraint both before and within marriage in the early modern era. Lawrence Stone's *Uncertain Unions* (1992) has offered extensive evidence, from church courts and similar sources, of apparently more free-and-easy sexual ways, or at least of different conventions—suitors in genteel middle-class homes in London around 1700 being invited by their sweetheart's mother to stay the night, and so forth. Were these just the exception? Is that why these were the cases that ended up in the courts? It is very hard to decide and perhaps we will never know.

The early modern period also presents a kind of conceptual void. There have been extensive attempts to conceptualize ancient and early Christian sexualities, and a welter of writings about the modern centuries (Brown 1988; Rousselle 1988). The early modern era has seen fewer bold readings. It is a gap accentuated by a lacuna in the most ambitious attempt to trace sexualities, Michel Foucault's *histoire de la sexualité*. Foucault sympathetically interpreted Ancient structures of feeling, showing the dialogue between eroticism and shifting concepts of the self, and he dazzlingly challenged conventional understanding of modern sexology. But, left tragically unfinished, Foucault's published volumes reveal a gigantic gulf between St. Augustine and the making of modern sexology in the nineteenth century, notably the hysterization of women's bodies, the pedagogization of children's sex, the socialization of procreative behavior, and the psychiatrization of perverse pleasure. The assumptions and methods used by Foucault in recovering former sexualities may be disputed: in my view he neglected, indeed cavalierly dismissed, questions of class and gender, coercive power, and conflict. But his goal—that of demonstrating the sequence of discourses within which sexuality has successively been inscribed—is surely fundamental to the enterprise shared by all contributors to this volume.[4]

Foucault taught that sexuality was discursive, that *savoir* and *pouvoir* were inseparable, and that power was not primarily negative. The intersection of all these themes lies in writing.[5] Writing about sex has taken many forms, from bawdy jests to judicial records, from libertine verse to anatomical treatises.[6] One genre assuming special significance in the early modern period, notably in the last decades of the seventeenth century, was printed sexual advice literature, a subset of the vast dissemination of know-how on such matters as medicine, manners, horsemanship, and housekeeping pouring from the presses in the post-

Gutenberg era.[7] Popularization of expertise—itself a profoundly problematic concept[8]—was a major product of print culture, and sexual knowledge formed no exception. Underlying this popularization was, of course, a learned tradition. Writing on *The "Viaticum" and Its Commentaries*, Mary Wack (1990) has recently explored medieval concern with lovesickness; early in the seventeenth century, Jacques Ferrand ([1610] 1990) produced *De la maladie d'amour;* his contemporary, Robert Burton, discussed erotic madness in the *Anatomy of Melancholy*; twenty years later, Joannes Sinibaldus (1642) published his *Geantropeiae, sive de Hominis Generatione Decateuchon*, a mammoth tractatus on sex. Such works were learned, even latinate; but from the late seventeenth century, popular vernacular manuals of sexual advice became widely available. First and foremost was the *Tableau de l'amour conjugal*, the pseudonymous work of the La Rochelle physician, Dr. Nicolas Venette, first published in 1696.[9] Venette's book is a landmark in the annals of medically grounded sexual advice tomes. It was translated into English, German, Dutch, and even Spanish—the first English version appeared in 1703 under the title of *The Mysteries of Conjugal Love Revealed*, priced at six shillings—and it became for over two centuries Europe's most popular sex guide, going through at least thirty-one French editions by 1800, and scores more in the nineteenth century and beyond (Flaubert felt sore about its sales). Venette's text is the tantalizing hodgepodge to be expected in a work essaying a new form of writing. It is learned, it is popular; it is scientific, it is ribald; it is earnest, it is playful. Quotations from the recently rediscovered Petronius jostle with autopsy reports; pieties from St. John Chrysostom mingle with prurient accounts of African erotic practices, purple passages about the power of Venus, and pharmacological tips for restoration of second-hand maidenheads.

Paralleling Venette, the best-seller in the English-speaking world was *Aristotle's Master-Piece*, first published in 1684, and often issued together with other works also spuriously attributed to the Stagyrite: *Aristotle's Complete Midwife, Aristotle's Last Legacy*, and *Aristotle's Book of Problems*.[10] Aimed at the common reader, *Aristotle's Master-Piece* had gone through at least forty-three editions by 1800, and quite probably many more now unrecorded or lost. Blatantly trading on the magic of a great name, the work had no pretensions to being the last word in medical research. It was rather a codification of sexual folklore, with sections on palmistry, physiognomy, and astrology, written for the class of reader who bought ballads and almanacs. And alongside such evergreens, dozens of other texts purveyed sexual knowledge with various emphases,

some explaining the bedroom arts, others thundering prohibitions, some claiming to cure venereal disease, others centering on gynecological matters. Our first really solid evidence of what literate Europe took as its "all you need to know about sex but never dared to ask," these texts are of deep historical interest. All the more surprising, then, that they have remained so neglected. There is only one work in the English language devoted exclusively to their study, Alan Rusbridger's *Concise History of the Sex Manual* (1986), and that is a jokey, prurient potboiler, with virtually no references before the 1880s—a sign of how readily it is assumed that the history of sexuality is overwhelmingly a modern one.

Foucault believed there had been a growing sexual garrulity; "this is the essential thing," he wrote, "that Western man has been drawn for three centuries to the task of telling everything concerning his sex; that since the classical age [that is, the seventeenth century] there has been a constant optimization and an increasing valorization of the discourse on sex" ([1976] 1978, 23). Hence the "repressive hypothesis"—the idea that sex was rendered taboo, unspeakable—was false. In many ways Foucault was right. The mere existence of such works as the *Tableau de l'amour conjugal* and *Aristotle's Master-Piece* refutes without further ado the repressive hypothesis in its crass form: authors did not find such texts too abominable to write, magistrates did not outlaw them, or at least not always, and customers bought them. Yet naturally things were not so simple; censorship and repression work in subtle ways. Purchasers may not have handled their sex books in the same way as they handled others. "Away to the Strand to my bookseller's," Samuel Pepys notoriously wrote in his diary on February 9, 1668:

> and bought that idle, roguish book, *L'escholle des Filles;* which I have bought in plain binding (avoiding the buying of it better bound) because I resolve, as soon as I have read it, to burn it, that it may not stand in the list of books, not among them, to disgrace them if it should be found. (1970–83)

If magistrates did not burn erotica, it appears that buyers' superegos may have done their work for them, or at least felt the need to mouth such upright sentiments to the conscience of their journal. Carnal knowledge was evidently a complex thing, desired, dangerous, denied all at once. And readers enjoyed playing with fire.

In the post-Gutenberg centuries, writers ceaselessly agonized over the act of creation: authorship.[11] And their anxieties applied with particular force to

questions of sexual discourse, its legitimacy, and especially its diffusion. Since the Fall, carnal knowledge had been original sin; could its propagation then be proper, or should it be kept under wraps? The shame of sexual knowledge within the Christian creed meant, at the very least, that such dissemination could not be as unproblematic as the publishing of agricultural advice. Above all, the potential role of the medical profession in spreading carnal knowledge could readily come under suspicion. Doctors after all had a direct financial stake in sickness and thus in encouraging activities, like sex, that could create business for themselves. Not least, especially in the guise of the man-midwife, the physician or surgeon was often seen as a kind of voyeur, pornographer, or adulterer, gaining erotic kicks out of medico-sexual practice.[12] Yet, as Foucault implies, the game of testing the taboo, speaking the unspeakable, evidently spurred sly and devious pleasures. Defining, denying, and defiling the conventions of writing sex perhaps gave frissons equivalent to delineating and desecrating the conventions of sex itself. And money must have talked as well. As popular culture grew commercialized in the Grub Street era, sex books became a fad, breeding profits through establishing erotic consumerism. Sex was prostituted in printed pornography; as with phone sex today, sex talk developed delights of its own.[13]

Hence an essential ingredient, even pleasure, of early sex manuals is controversy about the legitimacy of sex literature. There were plenty of objecting voices—real and fantasized—claiming that writing sex was indecent and pernicious. These protests had to be rebutted. In the counter-arguments that developed, professions of the public interest loomed large. Authors appealed to social need and popular demand. The nation was manifestly suffering sexual miseries and afflictions: impotence, infertility, venereal diseases. Such troubles were the outcome of ignorance, or, worse still, misinformation from false friends, overconfident *confidantes* or rapacious quack doctors. "How many married Men and Women have complain'd to me of Seminal and other Weaknesses, Gleets, &c. to their depriving them of having Children?," thundered John Marten in his *Gonosologium Novum: Or, A New System of all the Secret Infirmities and Diseases, Natural, Accidental, and Venereal in Men and Women* (1709), "How many totally defective or incapable of performing the Conjugal Duty, being wholly abrid'g of that pleasing Sensation, and that from Venereal as well as Natural and Accidental occasions, is almost incredible to consider?" (Marten 1709, A3). Such victims solicited advice, *deserved* advice, retorted the obliging authors: people should not die, or suffer, from ignorance. Hence so long as vulgar errors were current and quacks were puffing erroneous opinions, responsible authors

were duty-bound to counter lies with truth. He had been driven to write on delicate matters, apologized Marten in his *Treatise of all the Symptoms of the Venereal Disease, in both Sexes*, "that no Persons therefore for the future may be drove to the Necessity of Ship-wrecking their Bodies, Purses and Reputations upon those Rocks of Destruction, (I mean those wretched Ignoramus's QUACKS, MOUNTEBANKS, and ASTROLOGERS that swarm in every Corner, imposing on the too credulous World their peddling insignificant *Remedies*" (1708, xxxiii). Many judged this a classic case of the pot calling the kettle black, since Marten himself was widely regarded as an empiric.

False views were apparently ubiquitous. Thus, a couple of generations later, the Scottish medical popularizer William Buchan exposed the widespread belief that a man could be cured of venereal disease by deflowering a virgin. The only way to scotch such "absurd opinions," he argued, was through popular education. It was for this reason that he had penned his *Observations Concerning the Prevention and Cure of the Venereal Disease* (1796), maintaining that "these hints [would] conduce to put the young and unwary on their guard against the direful consequences of this insidious malady." Public-spirited doctors had to be bold, because the venereally infected found it essential to "conceal" their conditions (1796, i–ii, xvi).

There was thus the argument from necessity. There was also an assertion of right. After all, this was the age of Enlightenment. If by no means all *philosophes* trumpeted the rights of man, in a democratic fashion, there was unanimity among the party of humanity about the rights to knowledge. Hence, in intrepid *sapere aude* fashion, many authors proclaimed the sovereignty of knowledge and the universal right to knowledge about one's own body and its functions. Holding people in a state of ignorance was, it was argued, a ploy of princes and priests; knowledge was democratic and liberating. "While men are kept in the dark," proclaimed Buchan, "and told that they are not to use their own understanding in matters that concern their health, they will be the dupes of designing knaves." The thirst for knowledge could thus be portrayed not as idle curiosity, some dubious *libido sciendi*, but as integral to the human, humane and humanist quest for self-knowledge (1796).[14] Venette's English translator contended that

> There is nothing human nature is more desirous of knowing than the origin of their being; which is explained in this little treatise; the admirable order of nature in the production of man, is exactly set forth for the satisfaction of every Reader. A

young man may know, by this book, what constitution he is of, and whether he is disposed for continency or matrimony. He may learn at what age he ought to marry, that he may not be enervated in his younger years, and pass a considerable time of his life without pleasure. (Venette 1750, iii)

The mysteries of generation were thus the key to the secrets of one's very being.

Necessity? Yes. Entitlement? Maybe. But surely hazards too. For might not trumpeting the ins-and-outs of sexual techniques imperil the innocent? Would not cures for VD spare the guilty? Indeed, might not the corruption of virtue be the diabolical motive of authors inflamed by the *libido scribendi*? Innocents no more needed to read sex handbooks to comport themselves properly than, in Papal eyes, it was necessary to scan the Bible to be suffused with grace.

Authors had their rejoinders at the ready. True innocence, they protested, would never be corrupted;[15] and it was a wicked world anyway, that would in any case itself profane and deprave. "It is impossible to prevent every thing that is capable of sullying the imagination," argued the author of *Onania*, "*Dogs* in the Streets, and *Bulls* in the Fields may do mischief to Debauch's Fancy's, and it is possible that either Sex may be put in mind of Lascivious Thoughts, by their own *Poultry*." Under such circumstances, it was surely preferable to reinforce modesty with knowledge, than wait until other "Causes of Uncleanness in general, such as *Ill-Books, Bad-Companions, Love-Stories, Lascivious Discourses, and other Provocatives* to *Lust* and *Wantonness*" undermined unwary vulnerability (*Onania*, 130–32, 12).

In works like Venette's, claiming to instruct in the arts of marital love, the risk of corrupting innocence was not perceived as paramount. For heterosexual coitus was an act which, it was assumed, everyone would wish to perform, indeed, by Nature's promptings and civic responsibility, *ought* to perform. The job of instruction manuals was thus principally to specify the right parties, times, circumstances and postures:

Constitution, age, climate, season, and our way of living, influence all our caresses. A man at twenty-five, of a hot complexion, full of blood and spirits, who lives in the fertile plains of Barbary, and in easy circumstances, is better able to kiss a woman five times a night in the month of April, than another aged forty of a cold constitution, who lives on the barren mountains of Sweden, and gets his bread with pain and difficulty, can once or twice a night in the month of January. (Venette 1750, 111)

Once a work like the *Tableau de l'amour conjugal* had stipulated that it was intended solely for the eyes of the married, there was little that could be indecent to mention. Indeed, scanning them today, we may find them notably anatomically explicit, graphic in their descriptions of male and female sexual equipment, the mechanics of foreplay, and the optimal postures.

Considerations of innocence, however, weighed infinitely more heavily in the case of masturbation. Rising from the anonymous *Onania* (1710) through Tissot's *Onanism* (1761)[16] and beyond, the masturbation panic has been explored by many historians, most thoroughly by J. Stengers and A. Van Neck in *histoire d'une grande peur: La Masturbation* (1984), and most challengingly by Thomas Laqueur.[17] There is no room here to explore the contested meanings of this *grande peur*,[18] though I shall briefly return to the question later in the essay. The special feature of masturbation is that it was portrayed as entirely pernicious—a vice doubly dangerous because it could be savoured in secret with the aid of just a lurid imagination. Since it was assumed to be a sin principally of unmarried men and women, books against onanism were outwardly targeted at the young and single. Such individuals had no business having a sex life at all: was it not, therefore, needlessly provocative to impart to them cognizance of forbidden practices? Was not the danger, critics thundered, that writings against self-abuse like *Onania, Or the Heinous Sin of Self-Pollution, And all its frightful Consequences, in both Sexes, Consider'd with Spiritual and Physical Advice to those, who have already injur'd themselves by this abominable practice. And seasonable Admonition to the Youth of the Nation, (of both Sexes) and those whose Tuition they are under, whether Parents, Guardians, Masters, or Mistresses* would instruct youngsters in a crime they had never even conceived, and would serve, in other words, as a school of vice?

It was an objection all authors condemning the secret vice felt obliged to rebut. To speak or hold one's tongue? The author of *Onania* had his riposte. Precisely because masturbation was a "heinous sin," he claimed, it was crucial that the warning be broadcast not just to *habitués* but also to adolescents "who never contracted this guilt" (3). For innocence was unlikely to prove an impregnable citadel against temptation. Hence "forewarned is forearmed" was the best philosophy. *Onania* thus enunciated a robust policy to refute:

> Those who are of Opinion, that notwithstanding the Frequency of this Sin, it never ought to be spoke of, or hinted at, because the bare mentioning of it may be dangerous to some, who without it, would never have thought of it. (A/A)

Reading about sex would not prove a dangerous thing, the Preface argued, so long as what was read was proper—that is, not fiction or similar titillating *belles lettres* but *Onania* itself and other pious, improving works. Of course, the line between the uplifting and the arousing was a fine one, but it was one that *Onania*'s author felt confident could be drawn. He was, he declared, "fully persuaded, that there are very few Sentences throughout the Book, which do not more or less tend to the Mortification of Lust, and not one that can give Offence to the chastest Ear," even a female one (A/A).

Not all were so readily convinced, the author admitted. In the preface to the seventh edition he disclosed that, although in earlier versions he had "taken all imaginable Precaution against every Danger of raising impure Thoughts, even in the most Lascivious," he had, nevertheless, found to his "sorrow, that some People, not only are Deaf to all wholesome Advice, but likewise will misconstrue and pervert the most candid Meaning"; indeed, "some have accused me of writing obscenely and forwarding the Corruption of Manners" (A/A). Hence, he had been led to ponder whether it might not be better to omit "several Words and Passages, against which I know that Exceptions have been made" (A/A). In other words, *Onania*'s advocacy of candor was shaky from the start: might not plain-speaking be obscene, if not in intention at least in effect? And the matter would not rest there. At the opening of the first chapter, the author returned to the problem that was fretting him:

> It is almost impossible to treat of this Subject so as to be understood by the meanest Capacities, without trespassing at the same time against the Rules of Decency, and making Use of Words and Expressions which Modesty forbids us to utter. (3)

At this point, the author seems to be changing tack somewhat, emphasizing that his goal was less total truth than morality:

> As my great Aim is to promote Virtue and Christian Purity, and to discourage Vice and Uncleanness, without giving Offence to any, I shall chuse rather to be less intelligible to some, and leave several things to the Consideration of my Readers. (3)

For the risk was that "by being too plain," he would "run the Hazard of raising in some corrupt Minds, what I would most endeavour to stifle and destroy." He would thus, he confided, say rather little on the subject of how women masturbated with dildos because "it would be impossible to rake in so much Filthiness,

as I should be oblig'd to do, without offending Chastity" (4). Indeed, even this much had to be said under cover of Latin: "*cum Digitis & aliis Instrumentis*" (A/A). But, as will by now be clear, the author, by a curious strategy, had been informing readers precisely what it was that was too inflammatory for them to be told. This is not, *ipso facto*, to adjudge him guilty of hypocrisy or bad faith; it is merely to point out the predicaments of talking the taboo.

The ultimate tactic lay in disavowal and offloading responsibility. "It was reasonable to think," the author excused himself, "that in the beginning of the Second Chapter, I had taken all imaginable Precaution against every Danger of raising impure Thought's, even in the most Lascivious." Not so:

> But as I found to my sorrow, that some People, not only are Deaf to all wholesome Advice, but likewise will misconstrue and pervert the most candid Meaning, I would in the 4th 5th and 6th Editions, and likewise in this *Seventh*, to shew the integrity of my Intention, have omitted several Words and Passages, against which I know that Exceptions have been made. (A/A)

He would, in other words, have happily gone in for self-censorship. But he didn't—"this, I say I would have done, had not some Gentlemen of great Piety as well as Penetration, diswaded me from it by this Argument," that an author "ought never to be blamed for relating Facts as they are stated" (A/A).

Hence he had been persuaded by higher authority—these upright gentlemen—that the author was not answerable for his opinions. Indeed, in such professions of highmindedness, whole batteries of higher authorities, especially the dead, were frequently invoked. Venette justified his frank talk about matters sexual by contending that the Bible and the Church Fathers had set a wholesome precedent. And, in his turn, playing the martyred innocent, John Marten cited *The Tableau* on this very matter. "*Venette* tells us," he noted, with a double denial of responsibility,

> if modestly speaking of affairs of the *Secret Parts* be blamable, either St. Austin, St. *Gregory* of *Nice*, nor *Tertullian* should be perus'd, who all speak of Conjugal Affairs in such terms, as he durst not Translate. And by the same rule, one would suppress the Book of *Secrets of Women*, wherein he sets forth a great many things to provoke to Love. And in fine, the Books of Physicians and Anatomists ought not to be seen, if the Complaints above recited were just and reasonable. (1709, A4v)

Friends and other, preferably dead, authors were thus ultimately accountable for any alleged lewdness. As also were the readers. For the bottom line, claimed the author of *Onania*, was that purity or prurience lay in the reader's head. "Therefore, as I shall be forc'd to make use of some expressions in this Chapter," he explained in his second chapter, "which tho' spoke with a Design the most remote from Obscenity, may, working by the reverse, perhaps furnish the Fancies of silly People with Matter for Impurity; therefore I say, I beg of the Reader to stop here, and not to proceed any further, unless he has a Desire to be chast, or at least be apt to consider whether he ought to have it or no" (16–17). *Caveat lector*: but, one might respond, what surer come-on could there be than to beg the reader to "stop here"? A parallel might be seen in the disclaimer-*cum*-prompt offered by Venette, whose Preface insisted that his work was intended only for the "small number of learned and judicious persons" who could be expected to share the pure love of "naked truth" which he was imparting: which reader, at that point, would exclude himself? (1750, preface).

Thus the heart of the matter: if the heinous sin of self-abuse arose from mischievous knowledge, was not any or all information liable to be misused? *Onania* erected a pious warning notice: "every Body, who would write profitably against any sort of Uncleanness whatever, and not do more Harm than Good by his Endeavours, ought to be very careful and circumspect as to this particular" (3). But the writer's final ploy was to insist that his own stance was at least franker and more effective than that adopted by others. In particular he castigated "the Learned *Ostervald*," author of the *Traité contre l'impureté*, published in Amsterdam in 1707 and translated into English in the next year as *The Nature of Uncleanness Consider'd ... to which is added A Discourse Concerning the Nature of Chastity and the Means of Obtaining it*. Ostervald, accused *Onania*, had, "through an Excess of Modesty," completely omitted all discussion of masturbation whatsoever. By passing "over this abominable Sort of Impurity in Silence," or by muttering about "it in such general Terms, blending it with lesser Trespasses of the Uncleanness," Osterwald had "failed of Representing the Heinousness that is in it" (4).

Interestingly, Osterwald had admitted as much. In his preface, he had granted that, "being too scrupulously modest," he had remained silent upon "many particulars," whereon he had been "forc'd to be defective." Osterwald conceded that certain points

should have been more enlarg'd upon; and some Objections more particularly con-
sider'd; but this would have necessitated me to touch upon some Things, which
Decency forbids. There are also divers Things, which I am oblig'd to express only in
general Terms; others which I dare but just hint; and others again that I am forc'd
totally to suppress. (qtd. in *Onania* 5).

Ostervald here put his finger on the problem. It was all very well for handbook
authors to protest their writings could do no hurt. Venette, for example, dis-
avowed any danger by insisting that he was merely enunciating what comes nat-
urally. "We need no instructions ... to learn love," Venette somewhat disingenu-
ously insisted. His teachings were harmless, because they were Nature's teach-
ings. "Nature has taught," he claimed, "both Sexes such Postures as are allow-
able; and that contribute to Generation; and Experience has shown those that
are forbidden and contrary to health." Hence, his treatise "was not made to
bring the work of generation or action of the genital parts, into a method... That
has been done before by the strength of Nature alone." Yet such blather obvi-
ously begged all the questions. For if it were natural, why the need to teach it in
the first place? If disseminating carnal knowledge had no power to corrupt, how
could it have power to purify or fortify? Venette and others seemed to have
trapped themselves in self-contradictory denials of the medium through which
they had chosen to express themselves. If not precisely duplicitous, the apologia
could hardly be convincing (1750, 114).

These were problems—when to speak, when to be silent—that did not go
away. They loomed large in the work of the most significant writer on self-abuse
in the second half of the eighteenth century, the Swiss physician Tissot, author
of *Onanism or a Treatise upon the Disorders Produced by Masturbation* (Jordanova
1978; Emch-Deriaz 1984, 1992). Unlike the author of *Onania*, whose prime
idiom was moral, personal and religious, Tissot, as befitted a physician, focussed
his attention largely on the physiological and pathological evils (barrenness,
wasting away) supposedly following self-abuse. Tissot explicitly distanced his
text from *Onania*, condemning the English work as "a real chaos ... one of the
most unconnected productions that has appeared for a long time."[19]
Nevertheless, he adopted many of the same positions regarding speech and cen-
sorship as in *Onania*. What was the proper langage for sexual discourse?

I have not neglected any precaution that was necessary to give this work all the
decency, in point of terms, that it was susceptible of.... Should such important

subjects be passed over in silence? No, certainly. The sacred writers, the fathers of the church, who almost all wrote in living languages, the ecclesiastical writers, did not think it proper to be silent upon crimes of obscenity, because they could not be described without words. (1761, 4)

Like Venette, Tissot thereby grounded his claim to speak on "indecent" matters upon the Fathers—in the process, as Ludmilla Jordanova has remarked, enhancing his own prerogative to pontificate in a quasi-religious tone, and contributing to a fascinating dialogue between the medical and the religious modes of authority (Jordanova 1987).

Emphasizing how "desirous" he was, in the public interest, of "rendering this work of a more general utility" (1761, xi), Tissot made a point of noting that he had written in French rather than Latin; the consequence was, he lamented, that he had thereby landed himself in the "difficulty of conveying ideas, the terms and expressions of which are indecent" (1761, vi). He stressed, however, that in such cases of potential indelicacy, he "must be allowed the expression; the subject authorizes such licences" (1761, 2).

Rather more reticent about what was licensed was the late-eighteenth-century British physician Thomas Beddoes, a prolific medical writer of politically radical views, ferocious in his condemnation of political interference with free speech by reactionary British ministries during the French Revolution.[20] Beddoes was firmly convinced of the dangers of masturbation.[21] Yet, despite his championship of free speech, he found it impossible to mention those dangers except through windy periphrasis.

Self-pollution, commonly begun at boarding school, was subsequently, Beddoes argued, encouraged by the sedentary habits of high-society teenagers, who were allowed to loll on sofas reading lubricious romances: "novels render the sensibility still more diseased," he accused, "they increase indolence, the imaginary world indisposing those, who inhabit it in thought, to go abroad into the real" (1802, 1 iii 77). Their imaginations being thus inflamed, the results were dire, for self-abuse led to debility and disease. Onanism was thus disorder caused, or exacerbated, by the suggestive, seductive power of language. Not least, Beddoes believed, masturbation had been the cause of the poet, author, and churchman Jonathan Swift's premature senility, leading to "loss of associative power" and attendant "nervous complaints," culminating in the "madness of misanthropy" (1802, 3 ix 184–90).[22]

How many readers of Beddoes's *Hygëia: or Essays Moral and Medical, on the*

Causes Affecting the Personal State of our Middling and Affluent Classes (1802), the book that levelled these charges, actually picked all this up, however, from the text?—how many gathered the force of this crucial warning? For the fact is that nowhere, throughout the numerous pages devoted to the subject, did Beddoes use any term whatsoever—be it "onanism," "self-abuse," or "masturbation"that directly and explicitly denoted the practice. His entire discussion was cloaked in circumlocutions and emotive generalities. Indeed, throughout his popular works of medical advice, on many occasions when he felt obliged to address sexual matters, Beddoes took refuge in the decent obscurity of a foreign or a learned tongue. At one point, discussing female libido, he printed entirely in French a passage about "*fureur érotique*" (79); and elsewhere he broke into Latin to broach the topic of seminal emissions, stating that a particular person had had a "debilitating" night, and adding, in a footnote, "*hoc nomine designatur pollutio nocturna*" (1802, 3 ix 41).[23] Elsewhere he discussed dizziness as a symptom of sexual irregularity in a page of Latin "to avoid giving offence" (1802, 3 ix 157). He further stated that he would desist from mentioning one of the causes of hypochondria by name, wishing to "avoid scandalizing the overdelicate among my readers" (1802, 2 viii 89).

Regarding Swift's complaint—Beddoes clearly believed that Swift had induced dementia and prematre aging by his own hand—he beat about the bush by saying that Swift's mental condition "scarcely admits of any but a physical solution," and contending that literary critics, "not being professional men, [had] failed to develope the mystery fully" (1802, 3 ix 194).[24] In other words, even in a work explicitly committed to breaking the magical, and pathological, power of misleading pseudo-medical terms, Beddoes found the pressures too powerful to permit straight talk.

Beddoes "resolved" his problem in a most unsatisfactory, and (if one wishes) prurient, manner, by pretending transparency while creating tantalizing smoke-screens. The author of *Onania* had tried a slightly different tactic, warning the reader not to proceed with reading his work *unless* —"he has a Desire to be chast." He was allowing the reader to close the book, and thereby divest himself of responsibility for the consequences of discovering the naked truth about masturbation; but only at the price of condemning himself as smutty and dirty-minded. All self-regarding readers were thus morally obliged to read on. It thus became the moral duty of the man or woman in the street to opt for knowledge over ignorance, even while the author was warning that he was running grave risks of "intrenching upon Modesty." As in so many contemporary texts—

Tristram Shandy would be the perfect fictional parallel—the author cunningly secured the reader's collusion in the games of sexual knowledge he was playing.[25] From *Onania* to *Hygëia*, the author thereby embroiled himself and the reader in complex strategies.

CONCLUSION

I have examined the dilemma of speaking of forbidden pleasure in the sex-advice literature of three centuries ago. I wish to suggest in conclusion some issues of general relevance for understanding the rise of a literature of masturbation. First, the problem of text and context in time. The sex manuals I have been surveying crystallized around 1700. One can see reasons for that. Print culture had been growing; in the early Enlightenment the Church was ripe for challenge; medicine was growing in authority, while some of the characteristic anxieties of bourgeois society were beginning to emerge. The works discussed—works like the *Tableau de l'amour conjugal* and *Aristotle's Master-Piece*—literally remained in print for well over two centuries. During that period, sundry alterations were made to their texts, long, of course, after the death of the author—though, medico-scientifically speaking, they were certainly not kept up to date. Hence something paradoxical seems to have been afoot. For some reason, the sexual knowledge people were acquiring through print was old-fashioned. Why? Was that the way people wanted it? Did the name of Aristotle give legitimacy or respectability? Did it create a frisson? Did the fossilized air of such books help validate them with censors? These questions have hardly begun to be addressed. To progress further, we need to bring to bear all the best insights of the *"livre et société"* school, the techniques of the history of reading pioneered by Roger Chartier and Robert Darnton (1982, 1985, 1989), and to learn from existing studies of chapbooks and fairy tales: how far were the uses of sex literature mythic and ceremonial? (Rivers 1982).

Second, and an obviously related question, that of reading itself. A great merit of the critical literary theory of the last twenty years has been to teach us the need for subtler techniques with texts. This is patent in the case of the handbooks here under consideration. They were often anonymous or pseudonymous, and they were revised, obviously by some publisher's hack, through successive scissors-and-paste editions. We generally know nothing of the author's intentions. Equally, because of the somewhat shameful nature of their subject-matter,

we know next to nothing about how they were actually read or used, beyond the crude fact that some of those I have mentioned sold and sold and sold, and so must have answered *some* want in the public.[26]

In particular, we need to be sensitive to profound ambiguities, to conspiratorial and collusive double-meanings and double-readings, to ways the texts may not be saying what they mean, or meaning what they say. These works uniformly protested their highmindedness. But were they written as smut? Were they sold as smut? Were they read as smut? Did they trade on the taboo? Such is the interpretation forcefully advanced by Peter Wagner. In "The Veil of Science and Morality: Some Pornographic Aspects of the ONANIA," he has contended that this genre of work had a hidden agenda and should be construed as concealed pornography: "the hidden aim in every case," he argues, "was the sexual stimulation of the reader." In other words, anti-masturbation literature, as with *L'escholle des Filles* for Pepys, was literature to masturbate with.[27]

In a parallel manner, it may be argued that the advice literature was meant to be read, or at least *was* read, via an exercise in reversal. They were instruction manuals in the forbidden. Angus McLaren has particularly observed the helpful interdictions that fill the manuals. *Aristotle's Master-Piece* cautioned husbands not to withdraw too rapidly; women were advised to lie still after coition and in particular to avoid sneezing. Why? Because all such acts would hinder conception. Venette listed the coital postures to be avoided because they were unlikely to lead to conception. Was not all this a veiled form of contraceptive guidance? Were these works then the devil's manuals? The questions are crucial, but the answers elude us, for we are confronted with a profound problem (McLaren 1984).

Alongside the immemorial folk history of sex, print culture brought sex books into prominence. Thereafter people had sex, and people had sex books. Some had one, some had the other, some had both. The relations between writing sex books, reading sex books, and having sex, thought and action, use and abuse, are profoundly enigmatic, and subject to *Tristram Shandy*-like regressions (Porter 1989).

For the fact of the matter is that Foucault was only half right in his demolition of the "repressive hypothesis." The crude hypothesis is false; there were, as he stressed, ever more writings about sex, writings that were rarely wholly banned. Nevertheless, Foucault was misleading on another issue. For, in a certain regard, sex was indeed comprehensively silenced. Despite all the coitus going on, despite all the copies of erotica in circulation, our hard evidence about the sexual lives, thoughts, and feelings of Europeans in 1650, 1750, or 1850 remains pathetical-

ly meagre, because it was a domain of life that was furtive and shameful, as was the body itself, whose fragmented past is only now being pieced together. Hundreds of British working-class autobiographies survive from this period, but hardly any mention sex, let alone masturbation (Vincent 1980). On the positive side, we do have the texts I have been discussing. We must never mistake texts for people, but texts, properly read, can illuminate. And on the potentially positive side, we have modern scholarship, with its program of recovering sexualities long hidden from history. Over the last generation, social historians have been rediscovering the history of the silenced, the micro-realities of the dynamics of gender, of parents and children, family and household, masters and servants. They have been probing the interpersonal complexities of struggle and collusion, duplicity and complicity, control and resistance, individuation and stereotyping, socialization and difference. Richer histories of private life, of popular culture, of life-style, of representations, are being constructed, histories from below that avoid the trivialities of traditional social history—history with the politics left out—and assume significance by being alert to culture and gender conflict, the construction of the self, the production and reproduction of power relations, and, not least, the capacity of language and symbols to define reality (Burke 1991). One dimension this new social history can reclaim is sexuality.

NOTES

1. Good evidence is offered by the new *Journal of the History of Sexuality*, and, to name just a few books, Mort (1987); Bray (1982); Weeks (1981; 1985); Birken (1989). Excellent recent feminist studies include Jordanova (1989); Nead, (1988); Russett (1989); Schiebinger (1989); and Showalter (1987).

2. In this category we might place popular works such as Taylor (1954); Tannahill (1980); and Young (1964). Such works depend heavily upon the researches of early– twentieth–century sexologists such as Bloch, for whom see, for instance (1909; 1934; 1958; 1938).

3. Gay (1984; 1986; 1980); Marcus (1964); Degler (1974); Johnson (1979); Smith (1977).

4. Foucault ([1976] 1978; [1984] 1985; [1984] 1987; and Vol. 4 unfinished). For some discussion, see Porter (1991a).

5. For studies of a reflective, critical and philosophical nature that deal with the interface of writing and sexuality, see Barker (1984); Worton and Still (1993).

6. For a popular introduction, see Loth ([1961] 1962); Bold (1983).

7. For some discussion of the ambiguities of the genre of popularized knowledge, see the introduction to Porter (1992); Eisenstein (1979).

8. For such complexities see Mechling (1975–76).

9. See discussion in Porter (1990; 1984, 4).

10. See Porter (1985); Beall (1963); Blackman (1977); Power, (1931); Johnson (1932).

11. For the roots of worries about authorship, see Chaytor (1945); see also the contribution to this volume by Laqueur.

12. For discussion of the history of the idea of forbidden knowledge, see Delumeau (1990). For the lubricious see Porter (1988).

13. For Grub Street, see Rogers (1972) and Pinkus (1980).

14. For the Enlightenment commitment to free knowledge see Gay (1967–69, 1971, 1966–69).

15. This was a line still convenient in Freud's day. Justifying his sexually explicit interrogation of "Dora," Freud riposted, "there is never any danger of corrupting an inexperienced girl. For where there is no knowledge of sexual processes even in the unconscious, no hysterical symptom will arise; and where hysteria is found, there can be no longer any question of 'innocence of mind' in the sense in which parents and educators use the phrase" (Freud 1953–74, vii, 1–122, 49).

16. See on Tissot: Jordanova (1987).

17. See MacDonald (1967); Stengers & Van Neck (1984); Engelhardt (1974); Hare (1962). See also Laqueur's contribution to this volume.

18. Consult Laqueur in this volume.

19. Tissot (1761, vi): "This work has nothing in common with the English *Onania* but the subject, except a quotation of two pages and a half, which I have taken from thence: such a rhapsody could afford me no assistance. Those who read the two works will I hope be sensible of the total difference there is between them: those who read this alone may be misled by the affinity of the titles, and inclined to think there is a great similitude between the two books: but happily there is none."

20. See Porter (1991), especially chapter three for Beddoes's political views.

21. One wonders whether this had anything to do with personal factors. From around his fortieth year, Beddoes clearly felt himself in decline. We know little about his sexual life and habits, beyond that he married in his mid-thirties and that within a few years his marriage was clearly failing (his wife temporarily left him, flinging herself upon his best friend, Davies Giddy). Whether Beddoes looked to some sexual vice in himself to explain his own decline cannot be ascertained. But there may be one clue. In a last letter to Davy just before his death, Beddoes described himself in failure as "like one who has scattered abroad the Avena fatua of knowledge from which neither brand, nor blossom nor fruit has resulted." The image strikingly echoes the sin of Onan, scattering his seed fruitlessly upon the ground. See Stansfield (1984, 249).

22. The most illuminating discussion of Swift and masturbation is Ormsby-Lennon (1988).

23. One wonders whom it is that Beddoes is trying to protect: is it women? or children?

24. This seems a splendid instance of the pot calling the kettle black.

25. For Sterne's elusively smutty strategies, see New (1984).

26. See Fissell (1992) and the items referred to in her footnotes.

27. See Wagner (1982, 1983a, 1983b, 1986, 1987, 1988).

REFERENCES

Aristotle's Masterpiece or, the Secrets of Generation Displayed. 1690. Version 1. London: J. How.

Barker, F. 1984. *The Tremulous Private Body.* London: Methuen.

Beall, Otho T., Jr. 1963. *Aristotle's Masterpiece* in America: A Landmark in the Folklore of Medicine. *William and Mary Quarterly* 20: 207–22.

Beddoes, Thomas. 1802. *Hygëia: Or Essays Moral and Medical, on the Causes Affecting the Personal State of Our Middling and Affluent Classes.* 3 vols. Bristol: J. Mills.

Birken, Lawrence. 1989. *Consuming Desire: Sexual Science and the Emergence of a Culture of Abundance, 1871–1914.* Ithaca and London: Cornell University Press.

Blackman, Janet. 1977. Popular Theories of Generation: The Evolution of *Aristotle's Works*: The Study of an Anachronism. In *Health Care and Popular Medicine in Nineteenth-Century England: Essays in the Social History of Medicine,* ed. John Woodward and David Richards, 56–88. London: Crown-Helm.

Bloch, Iwan. 1938. *A History of English Sexual Morals.* Trans. William H. Forstern. London: Francis Aldon.

———. 1934. *Sex Life in England Illustrated: As Revealed in Its Obscene Literature and Art.* Trans. Richard Deniston. New York: Falstaff.

———. 1958. *Sexual Life in England Past and Present.* Trans. William H. Forstern. London: Arco.

———. 1909. *The Sexual Life of Our Time.* Trans. M. Eden Paul. London: Rebman.

Bold, Alan, ed. 1983. *The Sexual Dimension in Literature.* Totowa, N.J.: Barnes and Noble.

Bray, Alan. 1982. *Homosexuality in Renaissance England.* London: Gay Men's Press.

Brown, Peter. 1988. *The Body and Society: Men, Women, and Sexual Renunciation in Early Christianity.* New York: Columbia University Press.

Buchan, W. 1796. *Observations Concerning the Prevention and Cure of the Venereal Disease.* London: T. Chapman, Fleet Street; Edinburgh: Mudie and Sons.

Burke, Peter, ed. 1991. *New Perspectives on Historical Writing.* Cambridge: Polity Press.

Burton, Robert. [1621] 1948. *Anatomy of Melancholy*. Ed. Floyd Dell and Paul Jordan-smith. New York: Tudor.

Chaytor, H. J. 1945. *From Script to Print*. Cambridge: Cambridge University Press.

Darnton, R. 1985. *The Great Cat Massacre and Other Episodes in French Cultural History*. Harmondsworth: Penguin.

———. 1982. The High Enlightenment and the Low-Life of Literature in Pre-revolutionary France. In *The Literary Underground of the Old Regime*, 1–40. Cambridge: Harvard University Press.

Darnton, R., and Daniel Roche, eds. 1989. *Revolution in Print: The Press in France 1775–1800*. Berkeley and Los Angeles: University of California Press.

Degler, Carl N. 1974. What Ought to Be and What Was: Women's Sexuality in the Nineteenth Century. *American Historical Review* 79: 1467–90.

Delumeau, Jean. 1990. *Sin and Fear: The Emergence of a Western Guilt Culture, 13th–18th Centuries*. New York: St. Martin's Press.

Eisenstein, Elizabeth. 1979. *The Printing Press as an Agent of Change: Communications and Cultural Transformations in Early-Modern Europe*. 2 vols. Cambridge: Cambridge University Press.

Emch-Deriaz, Antoinette. 1992. The None-Naturals Made Easy. In *The Popularization of Medicine, 1650–1850*, ed. Roy Porter, 134–59. London: Routledge.

———. 1984. *Towards a Social Conception of Health in the Second Half of the Eighteenth Century: Tissot (1728–1797) and the New Preoccupation with Health and Well-Being*. Ann Arbor: University Microfilms International.

Engelhardt, Tristram. 1974. The Disease of Masturbation: Values and Concept of Disease. *Bulletin of the History of Medicine* 48: 234–48.

Ferrand, Jacques. [1610] 1990. *A Treatise on Lovesickness*. Trans. and ed. Donald A. Beecher and Massimo Ciavolella. Syracuse: Syracuse University Press.

Fissell, Mary. 1992. Readers, Texts and Contexts: Vernacular Medical Works in Early Modern England. In *The Popularization of Medicine*, ed. Roy Porter, 72–96. London: Routledge.

Foucault, Michel. [1976] 1978. *The History of Sexuality, Vol. 1*. Trans. Robert Hurley. London: Allen Lane.

———. [1984] 1985. *The History of Sexuality, Vol. 2: The Use of Pleasure*. Trans. Robert Hurley. New York: Random House.

———. [1984] 1987. *The History of Sexuality, Vol. 3: The Care of the Self*. Trans. Robert Hurley. New York: Random House.

Freud, Sigmund. 1953–74. Fragment of the Analysis of a Case of Hysteria. In *The Standard Edition of the Complete Psychological Works of Sigmund Freud*. Translated and edited by James Strachey. London: Hogarth Press.

Gay, Peter. 1984. *The Bourgeois Experience: Victoria to Freud, Education of the Senses*. Vol. 1. New York: Oxford University Press.

———. 1986. *The Bourgeois Experience: Victoria to Freud, The Tender Passion.* Vol. 2. New York: Oxford University Press.

———. 1967–69; 1966–69. *The Enlightenment: An Interpretation.* 2 vols. New York: Knopf; New York: Vintage.

———. 1971. *The Party of Humanity: Essays in the French Enlightenment.* New York: Norton.

———. Victorian Sexuality: Old Texts and New Insights. *American Scholar* 49 (1980): 372–77.

Grosvenor-Myer, V., ed. 1984. *Lawrence Sterne: Riddles and Mysteries.* London: Vision.

Hare, E. H. 1962. Masturbatory Insanity: The History of an Idea. *Journal of Mental Science* 108: 1–25.

Johnson, Thomas H. 1932. Jonathan Edwards and the "Young Folks' Bible." *The New England Quarterly* 5:37–54.

Johnson, Wendell Stacy. 1979. *Living in Sin: The Victorian Sexual Revolution.* Chicago: Nelson-Hall.

Jordanova, Ludmilla. 1987. The Popularisation of Medicine: Tissot on Onanism. *Textual Practice* 1: 68–80.

———. 1989. *Sexual Visions: Images of Gender in Science and Medicine Between the Eighteenth and Twentieth Centuries.* London: Harvester Wheatsheaf.

Laqueur, Thomas. 1989. The Social Evil, the Solitary Vice, and Pouring Tea. In *Fragments for a History of the Human Body, Zone 5,* Part 3, ed. Michel Feher, 334–342. New York: Zone.

Loth, David. [1961] 1962. *The Erotic in Literature: A Historical Survey of Pornography as Delightful as It is Indiscreet.* London: Secker and Warburg.

McLaren, Angus. 1984. *Reproductive Rituals: The Perception of Fertility in England from the Sixteenth to the Nineteenth Century.* London and New York: Methuen.

MacDonald, Robert H. 1967. The Frightful Consequences of Onanism: Notes on the History of a Delusion. *Journal of the History of Ideas* 28: 423–31.

Marcus, Steven. 1964. *The Other Victorians: A Study of Sexuality and Pornography in Mid-Nineteenth Century England.* New York: Basic Books.

Marten, John. 1708. *A Treatise of All the Symptoms of the Venereal Disease, in both Sexes....* 6th ed. London: Crouch.

———. 1709. *Gonosologium Novum: Or, a New System of All the Secret Infirmities and Diseases, Natural, Accidental, and Venereal in Men and Women.* 6th ed. London: Crouch.

Mechling, Jay. 1975–1976. Advice to Historians on Advice to Mothers. *Journal of Social History* 10: 44–63.

Mort, Frank. 1987. *Dangerous Sexualities: Medical-Moral Politics in England.* London: Routledge and Kegan Paul.

Nead, Lynne. 1988. *Myths of Sexuality: Representations of Women in Victorian Britain.* Oxford: Basil Blackwell.

New, M. 1984. At the Backside of the Door of Purgatory. In *Lawrence Sterne: Riddles and Mysteries*, ed. V. Grosvenor-Myer, 15–23. London: Vision.

Onania, Or the Heinous Sin of Self-Pollution, And All Its Frightful Consequences, in both Sexes, Consider'd with Spiritual and Physical Advice to Those, who have already injur'd themselves by this abominable practice. And seasonable Admonition to the Youth of the Nation, (of both Sexes) and those whose Tuition they are under, whether Parents, Guardians, Masters, or Mistresses. 8th ed. London.

Ormsby-Lennon, Hugh. 1988. Swift's Spirit Reconjured: Das Dong-An-Sich. *Swift Studies* 3: 9–78.

Osterwald, Jean Frederic. [1707] 1708. *Traité contre l'impureté.* Translated as *The Nature of Uncleanness Consider'd...to which is added A Discourse Concerning the Nature of Chastity and the Means of Obtaining It.* London: R. Bonwicke.

Pepys, Samuel. [1668] 1970–83. *The Diary of Samuel Pepys.* 11 vols. Ed. R. Latham and W. Matthews. London: Bell and Hyman.

Pinkus, Philip. 1980. *Grub Street Stripped Bare.* London: Constable.

Porter, Roy. 1991a. *Doctor of Society: Thomas Beddoes and the Sick Trade in Late Enlightenment England.* London: Routledge.

———. 1991b. Is Foucault Useful for Understanding Eighteenth and Nineteenth Century Sexuality? *Contention* 1: 61–82.

———. 1990. Love, Sex, and Medicine: Nicolas Venette and his *Tableau de l'amour conjugal.* In *Erotica and the Enlightenment*, ed. Peter Wagner, 90–122. Frankfurt: Lang.

———. 1992. *The Popularization of Medicine, 1650–1850.* London: Routledge.

———. 1985. "The Secrets of Generation Display'd": *Aristotle's Masterpiece in Eighteenth-Century England.* In *Unauthorized Sexual Behaviour During the Enlightenment.* Special issue of *Eighteenth Century Life* vol. 3 (May): 1–21.

———.1984. Spreading Carnal Knowledge or Selling Dirt Cheap? Nicolas Venette's *Tableau de l'Amour Conjugal* in Eighteenth Century England. *Journal of European Studies* 14: 233–55.

———. 1988. A Touch of Danger: The Man-Midwife as Sexual Predator. In *Sexual Underworlds of the Enlightenment*, ed. G. S. Rousseau and R. Porter, 206–32. Manchester: Manchester University Press.

———. 1989. 'The Whole Secret of Health': Mind, Body and Medicine in *Tristram Shandy.* In *Nature Transfigured*, ed. John Christie and Sally Shuttleworth, 61–84. Manchester: Manchester University Press.

Power, D'Arcy. 1931. Aristotle's Masterpiece. In *The Foundation of Medical History*, Lecture 6. Baltimore: William and Wilkins.

Rivers, Isabel, ed. 1982. *Books and Their Readers in Eighteenth Century England.* Leicester: Leicester University Press.

Rogers, Pat. 1972. *Grub Street: Studies in a Subculture.* London: Methuen.

Rouselle, Aline. 1988. *Porneia: On Desire and the Body in Antiquity.* Trans. Felicia Pheasant. New York: Basil Blackwell.

Rusbridger, Alan. 1986. *A Concise History of the Sex Manual, 1886–1986*. London and Boston: Faber and Faber.

Russett, Cynthia Eagle. 1989. *Sexual Science: The Victorian Construction of Womanhood*. Cambridge: Harvard University Press.

Schiebinger, Londa. 1989. *The Mind Has No Sex? Women in the Origins of Modern Science*. Cambridge: Harvard University Press.

Showalter, Elaine. 1987. *The Female Malady: Women, Madness, and English Culture, 1830–1980*. London: Virago.

Sinabaldus, Joannes. 1642. *Geantropeiae, sive de Hominis Generatione Decateuchon*. Rome: F. Caballus.

Smith, F. Barry. 1977. Sexuality in Britain, 1800–1900: Some Suggested Revisions. In *A Widening Sphere*, ed. Martha Vicinus, 182–98. Bloomington: Indiana University Press.

Stansfield, Dorothy A. 1984. *Thomas Beddoes M.D. 1760–1808, Chemist, Physician, Democrat*. Dordrecht: Reidel.

Stengers, J., and A. Van Neck. 1984. *histoire d'une grand peur: La Masturbation*. Brussels: University of Brussels Press.

Stone, Lawrence. 1992. *Uncertain Unions: Marriage in England, 1660–1753*. Oxford: Clarendon.

Tannahill, Reay. 1980. *Sex in History*. New York: Stein and Day.

Taylor, Gordon Rattray. 1954. *Sex in History*. New York: Vanguard.

Tissot, S. A. A. D. 1761. *Onanism: Or, a Treatise Upon the Disorders produced by Masturbation: Or, the Dangerous Effects of Secret and Excessive Venery*. Trans. A. Hume. London: J. Pridden.

Venette, Nicolas. 1750. *Conjugal Love; Or, the Pleasures of the Marriage Bed Considered. In Several Lectures on Human Generation*. In *The French of Venette*. 20th ed. London: The Booksellers.

Vincent, David. 1980. Love and Death and the Nineteenth Century Working Class. *Social History* 5: 223–47.

Wack, Mary F. 1990. *Lovesickness in the Middle Ages: The Viaticum and Its Commentaries*. Philadelphia: University of Pennsylvania Press.

Wagner, Peter. 1987. The Discourse on Sex—or Sex as Discourse: Eighteenth Century Medical and Paramedical Erotica. In *Sexual Underworlds of the Enlightenment*, ed. George S. Rousseau and Roy Porter, 46–68. Manchester: University of Manchester Press.

———. 1986. *Eros Revived: Erotica in the Age of Enlightenment*. London: Secker and Warburg.

———. 1988. *Eros Revived: Erotica of the Enlightenment in England and America*. London: Secker and Warburg.

———. 1982. The Pornographer in the Courtroom: Trial Reports About Cases of Sexual Crimes and Delinquencies as a Genre of Eighteenth Century Erotica. In

Sexuality in Eighteenth Century Britain, ed. P. G. Boucé, 120–40. Manchester: Manchester University Press.

———. 1983a. Researching the Taboo: Sexuality and Eighteenth–Century Erotica. *Eighteenth-Century Life* 3: 108–15.

———. 1983b. The Veil of Science and Mortality: Some Pornographic Aspects of the ONANIA. *British Journal for Eighteenth–Century Studies* 4: 179–84.

Weeks, Jeffrey. 1981. *Sex, Politics, and Society: The Regulation of Sexuality Since 1800.* London: Longman.

———. 1985. *Sexuality and Its Discontents: Meanings, Myths, and Modern Sexualities.* London: Routledge and Kegan Paul.

Worton, Michael, and Judith Still, ed. 1993. *Textuality and Sexuality: Reading Theories and Practices.* Manchester: Manchester University Press.

Young, Wayland. 1964. *Eros Denied: Sex in Western Society.* New York: Grove.

4

PHANTASTICAL POLLUTIONS:

THE PUBLIC THREAT OF PRIVATE VICE

IN FRANCE

VERNON A. ROSARIO II, M.D.

I returned from Italy, not quite as I had left for it, but perhaps as no one of my age had returned. I had brought back my virginity, but not my innocence [*puce-lage*]. I had felt the progress of the years; my restless temperament had finally declared itself, and its first quite involuntary eruption had occasioned a fear for my health that attests to the innocence with which I had lived till then. Soon reassured, I learned that *dangerous supplement that deceives nature*, and saves youth of my humour of many disorders at the expense of their health, their vigor, and sometimes their life. *That vice which shame and timidity find so convenient, has an even greater attraction for lively imaginations*: it allows them to dispose, so to speak, of the whole [female] sex at their will, and to make a tempting beauty serve their pleasure without the need for obtaining her consent. Seduced by this fatal advantage, I worked at destroying the good constitution that nature had established in me, and which I had allowed sufficient time to mature. Add to this disposition my situation at the time, rooming with a beautiful woman whose image I caressed in the depths of my heart, seeing her constantly throughout the day; in the evenings surrounded by objects that reminded me of her, sleeping in a bed where I knew she had slept. How many stimuli! The reader who imagines all this must already think me half-dead.

—JEAN-JACQUES ROUSSEAU,
Les Confession (108–109; emphasis added)[1]

"That dangerous supplement that deceives nature"? Any of the anxious readers of Rousseau's *Confessions* in 1782 would have immediately deciphered his peculiar euphemism for the "solitary vice" of "self-pollution." Rather than

simply identify this eighteenth-century concept with our current notion of "masturbation," let us begin by examining "pollution" in context. While today the word "pollution" evokes images of smog and toxic waste, this denotation of "environmental contamination" only arose in twentieth-century French.[2] Diderot and d'Alembert's *Encyclopédie* (1751–1772) provides three denotations for "*pollution*": (1) Moral: "the effusion of seed outside the function of marriage"; (2) Medical: a disease of *involuntary* ejaculation of seed; (3) Jurisprudential: defilement of sacred places (1778, 26(2), 568–71). The reader is referred to a separate article on "*manustupration*" for a discussion of the medical ailments of "those abandoning themselves without restraint to that infamous passion and sacrificing themselves to that false Venus" (570), i.e., *voluntary*, manually stimulated ejaculation.

The *Encyclopédie*'s "pollution" article reflects quite traditional distinctions. As pointed out in the introduction to this anthology, *theologico-moral* preoccupations (with church defilement and sinful effusions) and *medical* concern (with *involuntary* seminal loss or "gonorrhea") had remained quite unconnected until the publication of *Onania; or, the Heinous Sin of Self-Pollution* (1710?) in London. The medico-moral condemnation quickly made its way to Germany via a 1736 translation of *Onania* and then to France in 1746-1748 with the translation of another British work, Robert James's *Medicinal Dictionary* (first printed in London in 1743–1745).[3] By the mid-eighteenth century then, medical and quack literature condemning the disease of self-pollution had reached the French-speaking public, but the notion had probably already penetrated the popular imagination—as evinced by Rousseau's guilty confession of his adolescent discovery of solitary vice in 1728.

In this essay, I will examine the medical and cultural evolution of "onanophobia" in Francophone Europe. I will especially be relating the discourses of onanism to changing constructions of subjectivity, using Rousseau as my principal informant and paradigmatic "subject." We can begin by asking why Rousseau believed the "convenient vice" was a threat to health, vigor, and life. We must also wonder, as did Rousseau's contemporaries, why he *publicized* his lifetime addiction to the "dangerous supplement." Jacques Derrida's *Of Grammatology* (1967, 216) examines how Rousseau problematized several overlapping "dangerous supplements" (things that *add* as well as *make complete*): masturbation as a supplement to reproductive coitus, writing as a supplement to speaking, the imagination as a supplement to reality.[4] I will further argue that, for Rousseau, sexuality itself was a socially stimulated supplement to "natural"

living, and, for later nineteenth-century critics, sexuality was a supplement that threatened to undermine the very civilization it was "naturally" intended to perpetuate.

The confrontation between the "natural" *individual* and "artificial" *society* preoccupied Rousseau and many of his contemporaries. I will be teasing out several themes of this Enlightenment conflict. The first section examines the polluting effects of "civilization"—a concern shared by Rousseau and Samuel-Auguste Tissot, the prominent Swiss physician who legitimized the medical treatment of onanism. The second section focuses on critiques of civilization and masturbation as corruptors of the "soft," impressionable nerves of children. Intimately tied to these discussions of the nervous system was an emerging discourse concerning the impressionable imagination and the impact of "literature of the imagination," which I will study in the third section. The fourth section examines the new role of published confessions or autobiography in mediating the tense relationship between the personal and the public. We will see how the revelation of private vice paradoxically served to gain public absolution and reification of "perverse" sexual identities. The final section turns to the ways in which such emerging sexual beings—like the "onaniac"—were portrayed in nineteenth-century France: no longer as unfortunate, innocent victims of a corrupt civilization, but as dangerous, even criminal, social pollutants of a country threatened by industrialization, urbanization, foreign conflicts, and stagnating fertility.

TISSOT AND ROUSSEAU:
HYGIENISTS OF "CIVILIZATION" AND ITS POLLUTIONS

"Onanophobia" did not gain full medical legitimacy until the Swiss physician Samuel-Auguste-André-David Tissot (1728–1797) published *L'Onanisme, ou Dissertation physique sur les maladies produites par la masturbation* (1760) (translated from the Latin original of 1758), and translated into English as, *Onanism, or A Treatise upon the disorders produced by masturbation: or the dangerous effects of secret and excessive venery* (1766). The exceptional cultural impact of *Onania* and *L'Onanisme* has been discussed in the introduction to this volume (see also Hare 1962; Neuman 1975; MacDonald 1967; Engelhardt 1985; and Laqueur [1989] 1995). It is important however to emphasize that both works were nevertheless part of a common trend in the Enlightenment: the secularization and medical-

ization of morality. As Ludmilla Jordanova has noted on the eighteenth-century popularization of medicine, "Notions of sin, evil, crime and punishment are all incorporated into a larger vision, which sets improper sexual activity in the context of class relations, family dynamics, responsibility and dependency" (1987, 77). (As we will see in the following section, they also reflect a new interest in pedagogy since they placed children under the medical spotlight for the first time.)

The naturalization of morality was such a pervasive phenomenon in the late eighteenth century that Tissot was unable to see that his condemnation of *Onania* as merely "theological and moral trivialities" ([1781] 1991, 41) could just as well be said of his own *Onanisme*. While *Onania* listed the diseases of masturbation and hinted at humoral pathology to condemn the "sin" of onanism, Tissot deployed the full arsenal of medical rhetoric to the same moral aims: making reproductive sex normative and promoting the regulation of sexuality. In other words, the spiritual and the material aspects of pollution were telescoped: not only was onanism the defilement of the temple of the soul, but also of the temple of Nature—the body. The salubrity of Nature and the "natural" body was frequently seen as threatened by the tainting effects of "civilization" in the eighteenth century. Tissot's medical writings reflect this conception of the social causes of health and illness.

Tissot has been portrayed as a politically conservative "representative of the Ancien Régime" and opponent of the French Revolution who was faithful to the sovereign of Bern and his patrician caste (Portmann 1980). Antoinette Emch-Dériaz (1984), however, has demonstrated Tissot's close connections with the *philosophes* and has highlighted the radical politics of Tissot's three popular self-help books: *Avis au peuple sur sa santé* (Advice to common people on their health) (1761), *De la santé des gens de lettres* (On the health of men of letters) (1766), *Essai sur les maladies des gens du monde* (Essay on the diseases of the valetudinary) (1770).

In the *Avis*, Tissot complained that the fundamentally sturdier health of peasants was deteriorating due to contact with "civilized" city life whenever they spent time as soldiers or domestic servants ([1761], 7). He also worried that European populations were declining, in part due to military conscription and emigration to the colonies (1–4), but mainly because of bourgeois, urban lifestyles. This critique was even sharper in *On the health of men of letters* (1766) and *Essay on the diseases of the valetudinary* (1770) where Tissot suggested a close correlation between class and health: the healthiest were the peasants, followed by artisans, the bourgeois,

and finally the "*gens du monde*": people from different classes who had no vocation and shared a lifestyle of leisure and indolence. To fight boredom, they searched for pleasures, not in the natural satisfaction of labor, but in those "factitious pleasures" which were "opposed to the usage of nature and whose bizarreness is their only merit" (1770, 11). Tissot particularly warned of the ills brought on by the valetudinary and luxurious lifestyles of "men of letters" who had no occupation but that of their minds (Tissot [1766], 20–21; 1770, 11).

Relying on the physiological principles of his friend and medical colleague Baron Albrecht von Haller (1708–1777), Tissot explained that sedentary lives slowed down humoral circulation producing nervous weakening and visceral congestion ([1766], 70–77). He also claimed that the seminal fluid—which some compared to "nervous sap"—was weakened, which accounted for the finding that sons of geniuses were seldom as gifted as their fathers ([1766], 85–86). Since Tissot had relied on identical physiological principles in *L'Onanisme*, it is not surprising that he claimed the nervous exhaustion of the valetudinary was the same as that produced by diseases of "excessive humoral expenditure" ([1766], 45–46). This association between the exhaustion of "men of letters" and that of onanists would be echoed by nineteenth-century physicians who warned that overexertion of the literary or the erotic imaginations caused "softening" (*mollesse*) and effeminacy.

To support his contention that mental work was enfeebling, Tissot turned to Rousseau's preface to his comedy *Narcisse, or the Lover of Himself*. The play depicts the amorous intrigues of an effeminate, conceited, young aristocrat who falls madly in love with a portrait of himself dressed as a woman. Its critique of the effeminizing effects of contemporary elite culture are made even more explicitly in a paragraph from Rousseau's preface cited by Tissot:

> Study [*le travail de cabinet*] makes men delicate, weakens their temperament; and it is difficult for the soul to maintain its vigor when the body has lost its strength. Study wears out the machine, exhausts the spirits, destroys force, enervates courage; thus, one becomes cowardly and pusillanimous, incapable of resisting either sorrows or passions. (Tissot 1826, 41–42, citing *Narcisse* [1752], 966)

Appropriately enough, the preface was Rousseau's vehicle for defending his *Discourse on the Sciences and Arts* (1750), the prize-winning response to the question proposed by the Academy of Sciences and Belles Lettres of Dijon: "Has the re-establishment of the sciences and arts contributed to the refinement of

manners?" Rousseau's reply in the *negative*—suggested and approved by his friend Diderot in 1749—brought him fame and censure (Rousseau 1750, introduction). One could say, in turn, that both of Tissot's essays on the health of valetudinary "men of letters" were Tissot's reply to the hypothetical question: "Has the progress of civilization contributed to the refinement of the *body*?" Echoing Rousseau's negative response on the *moral* state of "civilized" man, Tissot replied in the negative on the *physical* state of "civilized" man.

Given their common skepticism concerning "civilization," it is not surprising that great philosophical, political, and personal sympathy existed between the two men. Tissot was quite familiar with his countryman's writings and he exclaimed in reference to Rousseau: "That Genevois is my hero."[5] They first met at Rousseau's home in Yverdun, Republic of Bern, in June 1762, and corresponded frequently thereafter.[6] Even after enormous controversy broke out over Rousseau's *Emile*, Tissot remained Rousseau's staunch defender.[7] Rousseau, in turn, admired Tissot, sought his medical advice, and recommended the doctor's services to many notable friends.[8] This is remarkable since Rousseau was an infamous doctor-hater (Elosu 1929, 349) who had described medicine as "an art more pernicious to men than all the ills it pretends to cure" (*Emile*, 269).

Rousseau, however, had no knowledge of Tissot's *L'Onanisme* when he wrote in *Emile* (1762): "If [your student] once knows that dangerous supplement, he is lost. Thenceforth his body and heart will be enervated, he will carry to the grave the sad effects of that habit, the most mortal one to which a young man can be subjected" (*Emile*, 663). This passage so delighted Tissot that he sent Rousseau copies of *L'Onanisme*, the *Avis au peuple*, and *Inoculation Justified* (1754), and begged Rousseau for a visit. Tissot exclaimed:

> You will see, Sir, in the *Avis au Peuple* p. 520, that we are almost of one mind regarding this Science [medicine] ... [He discusses several points in *Emile* on which they are in agreement.] *L'Onanisme* will prove to you that finally there is a physician who recognizes all the danger of that odious practice which you have so vigorously attacked, and has the courage to make that danger public knowledge. This book has been banned in Paris. Could there be governments in which it was important for the ministries to prohibit all assistance that can prevent the enfeeblement of the soul or the body. (Leigh 1970, letter no. 1966)

Tissot felt his social mission was comparable to that of the literatist-philosopher Rousseau. Not only did they share the same epistemological task of

observing and describing humanity, they were in similar political trouble for their candor in this mission. Tissot portrayed Rousseau and himself as solitary, courageous figures sounding the alarm on the deterioration of health and morality in their time. After all, had not *Emile* and *L'Onanisme* both been condemned as immoral, dangerous works when in fact they were important pedagogical texts?

On July 22, 1762, Rousseau thanked Tissot for the books, and wrote that, although he no longer read—especially not medical books—he had immediately read *L'Onanisme* and regretted he had not known of it earlier. He also commiserated on the banning of their books (Leigh 1970, letter no. 2022). They had indeed launched into controversial pedagogy as we see in the following section comparing Rousseau's recommendations on child-rearing with contemporaneous medical concerns about children.

CIVILIZED CORRUPTIONS OF SOFT NERVES

In drawing attention to children, the anti-onanism literature was part of a broader trend in the reification of childhood.[9] Since the flow of semen (male or female) coincided with the changes of puberty, semen was praised as the precious fluid essential to this process of maturation. It was believed that during childhood and adolescence the body needed to invest all its energy into its self-construction. Masturbation, more than any other act, threatened this "somatic economy."[10] As suggested in the previous section, the somatic economy was vulnerable to "physical" and "moral" (i.e., behavioral) effects, particularly the corruptions of "civilization." Therefore, adolescence demanded careful management of malleable nerves and imaginations.

The dangers of puberty were vividly portrayed in Rousseau's *Emile, or On Education* (1762)—one of the most influential pedagogical texts of the eighteenth century (Bloch 1974). In this peculiar hybrid of pedagogy, philosophy, moralism, and fantasy, Rousseau recommended that instructors constantly watch over their charge: "Do not leave him alone during the day or the night; at least sleep in his bed. Beware of the [sexual] instinct as soon as you are not watching; it is good as long as it acts alone, it is suspect as soon as it mixes with the institutions of mankind" (*Emile*, 663). He emphatically claimed that one of the "most frequent abuses of philosophy of our time" was the belief that the onset of puberty was due to physical and not "moral" causes (i.e., environmental

and behavioral effects) (495). His evidence for this was the variation in the age of onset of puberty with the degree of civilization: "Puberty and sexual potency are always earlier in instructed and policed peoples than amongst ignorant and barbaric peoples" (495).

As we have seen, both Rousseau and Tissot blamed "civilization" for polluting the state of "nature" and stimulating the rise of masturbation. Later medical sources echoed Rousseau's pronouncements on the etiological role of "civilization" in precociously stimulating puberty and inciting children's self-pollution. The "masturbation" entry in the *Dictionary of Medical Sciences* (1819) noted: "The diseases that are the product of the excesses of onanism become more frequent in proportion to the higher degree of civilization achieved by modern societies. This opinion, which is generally adopted by medical observers, seems to rest on numerous and well established facts...." (Fournier & Béguin 1819, 101).

In Rousseau's personal case, it was after leaving his *rural* Swiss town and during his stay in Italy—*the cradle of the Renaissance*—that Rousseau lost his *"pucelage,"* his mental virginity. While a catechumen in a monastery there, he was sexually molested before the altar, and when the molester masturbated, Rousseau reported that for the first time, "I saw shooting towards the chimney and falling upon the ground I don't know what sticky, white stuff that turned my stomach" (*Confessions*, 67). Later, back in Switzerland, it was the constant company of a beautiful woman that inflamed his desires. Rousseau's conclusion was that sexuality in general was a supplement of civilization and that, in the ideal state of nature, chastity would remain undefiled: "For myself, the more I reflect on this important crisis [of puberty] and its proximate or distant causes, the more I am persuaded that a solitary [man] raised in the desert, without books, without instruction and without women, would die virginal at whatever age he reached" (*Emile*, 663). Rousseau thus evoked the three most frequently mentioned culprits of "civilization's" epidemic of onanism: women, education, and literature.

Throughout his work, Rousseau was especially harsh in blaming women for the ills of modernity and the "unnatural" state of civilization. It was the combined strategy of female coquetry and sexual reserve that maintained civilized men in a state of desire and dependency (*Emile*, 456; see also Schwartz 1984, 36–37). It was only feminine sexual modesty that prevented the naturally more voracious female from sexually exhausting the male (*Emile*, 447). Rousseau especially criticized the "artificious and wicked women" of society (i.e., the elite) for enslaving men and denaturing the natural, maternal instincts (*Emile*, 713). Rousseau rec-

ommended that at the critical time of puberty, tutors should "distance [young men] from big cities, where women's ornamentation and immodesty rushes and frustrates the lessons of Nature.... Return them to their first quarters where country simplicity lets their passions develop less quickly" (*Emile*, 517). In Rousseau's eyes, women were fundamentally responsible for bringing on civilization and its discontents. More commonly, medical sources warned of "abominable women" and of nannies who used masturbation to pacify infants, or "more infamous yet, engage in simulacra of coitus with little boys" (Fournier & Béguin 1819, 105).

Schools were perhaps even more nefarious than women. Rousseau repeatedly complained of the corrupting effects of current education: "It is from the very first years that a senseless education decorates our mind and corrupts our judgment. All around me I see immense institutions where, at great cost, youth are raised to learn all things, except their duty" (*Discours* 24). Even more to the point, Tissot reported that, "a whole college, by this maneuver [onanism], sometimes diverted the tediousness of metaphysical scholastic lessons which were delivered by a drowsy old professor" ([1781], 97–98). The problem only became more acute with the advent of public schools, and doctors bemoaned the ironic fact that "it is principally in public establishments, where large numbers of young people of one or the other sex are united that the habit of masturbation develops with ease. Public education is without a doubt one of the best results of perfected civilization.... But by how many grave side effects are those advances compromised?" (Fournier & Béguin 1819, 104–105).

Finally, in order to understand how books were blamed for inciting masturbation, we must examine the concerns with the nervous system and the imagination elaborated in the anti-onanism texts.[11] Rousseau's oft-repeated message was that the "genital instinct" or sense was excited by a precociously aroused imagination: "As I have said a thousand times, it is by the imagination alone that the senses are awakened" (*Emile*, 662). This observation was given a solid physiological explanation by Dr. Ménuret de Chambaud in the "*manstupration* or *manustupration*" entry of the *Encyclopédie*: "The mind continually absorbed in voluptuous thoughts, constantly directs the animal spirits to the generative organs, which by repeated handling, become more mobile, more obedient to the unruliness of the imagination: the result is almost continual erections, frequent pollutions, & the excessive evacuation of seed" (1778, 20(2): 991).

The nervous system was viewed as the exchange network linking all other systems in sympathy; as such, it was the principal player in the somatic economy and was portrayed as the most refined product of the progress of civilization. The gen-

ital system, usually portrayed as the most primitive or animalistic, was nevertheless supremely important for maturation and reproduction. Together these two systems dominated the developing body: "We can consider, in youth, these two important parts of the organism, the brain and the sexual organs, as two *foyers* that mutually convey the impressions they receive, and that they excite one another in the most direct and energetic manner" (Fournier & Béguin 1819, 109). This cerebro-genital axis embodied and materialized the civilized-primitive and intellectual-sensual axes of tension that were of concern in the anti-masturbatory literature.

As in the case of education, the nervous system was caught in the dilemma of civilization: the more refined and "civilized" nerves became, the more weak and vulnerable they left children to onanism. Therefore, it was a fine line between the production of high genius and of base decadence:

> The excessive development of nervous sensibility, which is the source of so many laudable actions and so many vices—this cause, which, depending on the direction it receives, *gives birth to the most admirable productions of genius, or to those shapeless works that attest to the force and deviations of the imagination*—may be the result of a natural disposition of the organs, or the product of early education. [Infancy is remarkable for the predominance of the fully developed nervous system over the entire bodily economy, particularly the immature locomotor system.] It is immediately after birth, that period when the faculties of the newborn are beginning to develop energetically, that he runs the greatest risk. If then an unhappy accident, or, too often, foreign contact, reveal to him a new sense, so to speak, the genital organs become a site for concentrating more or less the forces of life, and the subject, carried away by a deceitful pleasure, abandons himself with furor to a vice which will soon be his perdition, or draw upon him ills more terrible than even death. (Fournier & Béguin 1819, 103; emphasis added)

The more sensitive and excitable the nerves and imagination, the more vulnerable the infantile body to onanistic addiction. Lascivious talk, romantic novels, and sensual images could excite the imagination and by sympathy incite the genitals (Fournier & Béguin 1819, 106). The *Encyclopédie*, for example, warned that "the truly morbid *nocturnal pollution* is always the effect of immoderate debaucheries of the body and the mind when,"

> not content to indulge without excess in venereal pleasures, one continually feasts the imagination with lascivious, voluptuous images, filthy conversations, libertine

and unrespectable readings; then dreams, which are often just a representation of the objects that most occupied the mind during the day, replay the same matters; the frequently exercised generative organs, heated up by the imagination, are in a continuous tension and much more susceptible to lascivious impressions, they obey the slightest misdirection and the movements destined to the ejaculation of semen, becoming almost habitual, are executed without effort. (1778, 26(2): 570)

We have seen that the medical anti-masturbatory literature was preoccupied with moral and pedagogical issues, especially in countering the pathological effects of "civilization": cities, urbanization, schools, "artificious women," and "unrespectable readings." This last item, the nervous impact of licentious texts and the somatic effect of their mental representation, haunts the anti-masturbatory discourse. In the following section I examine its relation to two important historical developments of the Enlightenment, the proliferation of "pornographic" literature and the birth of the novel.

IMAGINATION:
THE CRISIS OF REPRESENTATION AND *LES LIAISONS DANGEREUSES*

The French Enlightenment, which saw the rise of the middle class and of literacy rates, witnessed an associated explosion in the publication of "licentious literature" often colored with political and anti-clerical overtones.[12] The rise of novels in general, and "pornographic" novels in particular, was criticized by eighteenth-century cultural observers as a major pollutant of the imagination. At the time, licentious and imaginative literature was also associated with masturbation, as Rousseau made quite clear in referring to "those dangerous books...whose inconvenience is that one can only read them with one hand" (*Confessions*, 40).

Medical critics also worried that novels and pornography encouraged readers, particularly those with "impressionable brains" (i.e., children and women), to mistake the imaginary for the truth, resulting in an unhealthy, unsatisfiable over-excitation (see Goulemot 1991, 10). Rousseau perfectly described this pubescent escape into a solitary, imaginary world:

I nourished myself on situations that had interested me in my readings, I recalled them, varied, combined and appropriated them to such a point that I became one of the characters I imagined and I always saw myself in the most agreeable posi-

tions according to my taste.... This love of imaginary objects and this facility for
entertaining myself with them ended up making me disgusted with all my sur-
roundings and determining that taste for solitude which has persisted since that
time. (*Confessions*, 41)

One of the most influential Enlightenment critiques of the "vices and advan-
tages of the imagination" was by Rousseau's friend, the sensualist *philosophe*
Etienne Bonnot de Condillac (1714–1780), in his *Essai sur l'origine des connois-
sances humaines* (1746) (Essay on the origin of human understanding). Relying
on Lockean associationist psychology, Condillac suggested that the imagina-
tion allows the free linkage (*liaison*) of perceptions, thus producing new ideas
that are *not derived from nature*. These liaisons could either be made voluntarily
or accidentally through external impressions. The latter were especially tena-
cious and dangerous because, unlike consciously made liaisons, they were erro-
neously considered to be natural ([1746], 111). This was how permanent preju-
dices were formed, e.g., associating particular character traits with certain facial
physiognomies. In this same connection, Condillac criticized novels which, nor-
mally harmless, in the hands of sad people or women (who, he believed, had
more tender, impressionable brains than men) could become substitutes for real-
ity (120–21).

 As Jan Goldstein has pointed out (1987, 78–79), Condillac's theories of the
imagination were enormously important to the alienist (or mad-doctor) Phillipe
Pinel (1745–1826) and his conception of the pathology and treatment of the
demi-follies [half-follies]: mental conditions between sanity and raving lunacy.
Condillac had warned that the imagination could easily lead one to dangerous
liaisons and tenacious errors. Pinel realized that this very property of the imag-
ination could be exploited to therapeutic benefit if deployed by professionals
schooled in the techniques of "moral therapy." Thus, by the second half of the
eighteenth century, the imagination had become conceptualized as both a dan-
gerous site for implanting irrational, "unnatural" associations of ideas, as well
as a site for the willful manipulation of associations (particularly by those so
empowered). Given this construction of the imagination, we can refocus specif-
ically on the issue of the *erotic* imagination.

 As suggested in the previous section, physicians believed that an artificially
excited and corrupted imagination could produce organic changes in the geni-
tals themselves that would lead to involuntary pollutions. Conversely, genital
excitement was believed to make perverse demands on the imagination:

Thus the adult man, led by the stimulation of the generative apparatus, performs acts that his conscious will [*volonté réfléchie*] disapproves, and whose extravagance he will disapprove of once his calm is reestablished. This demonstrates how great is the influence of the former on the deliberations of the ego [*moi*]. We are familiar with the effects of this excessive irritation of the genitals which gives rise to satyriasis and nymphomania. (Fournier & Béguin 1819, 109).

Fournier and Béguin warned about imaginary excess provoking hypersexualism in both men (satyriasis) and women (nymphomania); however, it was felt that women were at greater risk. Tissot had claimed that, although the female seed was less precious and refined than the male, women were more vulnerable since "the nervous system being weaker in them and naturally more predisposed to spasms, the fits are violent" (*Onanisme*, 91). Tissot therefore devoted a separate chapter to the specific effects of onanism in females. These included hysteria, vapours, incurable jaundice, clitoral scabbing, and a uterine fury that, "depriving them of their modesty and their reason, reduces them to the level of the most lascivious brutes" (62). By this late stage of masturbational addiction and uterine fury, a patient's mind was totally subjugated to her genitals: "The habit of being occupied by a sole idea, makes it impossible to have others: it becomes imperious and reigns despotically" (99). The naturally weaker nerves and receptive imaginations of women would be a recurrent theme in the anti-masturbation literature and in other texts on erotic disorders.

These connections between masturbation, nymphomania or *furor uterinus* and the imagination were carefully elucidated by Dr. J. D. T. de Bienville in his *Nymphomania, or Treatise on Uterine Fury* (1771). Bienville was a medical popularizer and, like Tissot, wrote on the inoculation controversy as well as popular health misconceptions. In *Nymphomania*, Bienville claimed that the onanist eventually lost all shame and self-control (1775, 31): "This fatal rage of *Masturbation*, of which the imagination is the artisan, leads to excesses over which the wretched criminal imperceptibly ceases to have any power; excesses by so much the more dangerous, as they never meet with any obstacle, besides those which must succeed exhaust or extinguished strength" (1775, 174–75, *sic*). Bienville warned of the "power and dangerous effects of the imagination" and squarely blamed the imagination for both the exaggerated and repressed passions that led to onanism and nymphomania (1775, 157). Prefiguring Robert Brudenell Carter's therapeutic recommendations on hysteria (1853), Bienville insisted that the imagination was also the dominant medium for therapy:

"There are cases [of nymphomania] which will admit of a cure from a simple attention to the imagination; but there are no cases (or at least, scarcely any) in which physical remedies can alone effect a cure" (Bienville 1775, 160).

Bienville reiterated the physiological belief that self-defilers or nymphomaniacs could become trapped within the closed loop of their genitals and imagination, thus becoming sexually deviant and erotically autonomous. Tissot had also warned that, "A symptom common to both sexes and which I place in this section [on women] because it is more frequent in women, is the indifference that this infamous practice leaves for the legitimate pleasures of hymen, even as these desires and forces are not extinguished" (*Onanisme*, 63). Or worse yet, the shameless, sensually voracious *onaniste* would be driven to ever more "unnatural" stimulation in order to excite an overtaxed genital system. One increasingly common example Tissot bemoaned was "clitoridian" pollution between "*lesbides amatae*": "women who love girls with as much ardor as the most passionate men," or those unnaturally clitorally endowed women who "feel they have to erase the arbitrary differences of nature" (65–66) presumably, by penetrating other women. These associations were used to great effect in political pornography aimed at discrediting Marie Antoinette as both dissolute and power-hungry: for example, *The Uterine Furies of Marie-Antoinette, Wife of Louis XVI* (1791), and *The Private, Libertine, and Scandalous Life of Marie-Antoinette* (1791) (the latter included an engraving of the Queen being masturbated by one of her ladies-in-waiting [see Hunt 1991, 121]).

This "indifference to the legitimate pleasures of hymen" was not limited to women, though. In one case of chronic masturbation, the medical reporter noted that the male patient "had an insurmountable aversion for women, which is not rare in masturbators" (*Bull. Gén. Thér. Méd. Chir.* 1837, 322). The examples and varieties of "unnatural" stimulations and liaisons incited by onanism would multiply throughout the nineteenth century, but once again, Rousseau provided the most publicized example of how the "convenient vice" and a "bizarre taste" could induce a youngster to avoid "normal" sexual contacts. The critical passage is the famous spanking scene of the *Confessions*.

Rousseau recounts how as a child he had feared being punished by Mlle. Lambercier, his surrogate mother, while he was a boarder in her brother's house. To Rousseau's great surprise, he found the first spanking pleasurable and it only further endeared him to Mlle. Lambercier: "because I had found in pain, in shame even, a mix of sensuality which left me with more desire than fear of receiving this treatment by that same hand" (*Confessions*, 15). Alas, the second time the

spanking was cut short when Mlle. Lambercier "noticed a certain sign that this punishment was not achieving its aim." Thereafter, they were made to sleep in separate rooms and the young Rousseau was treated as a "big boy." Reminiscing about this outwardly innocuous event, the adult Rousseau concluded:

> Who would have believed that this childhood punishment, received at age eight at the hand of a girl of thirty, would have determined my tastes, my desires, my passions, my very self for the rest of my life, and furthermore quite contrary to the sense which naturally should have ensued? At the same moment that my senses were set afire, my desires took a turn that, confined to what I had experienced, they never decided to seek anything else.... Long tormented knowing not why, I visually devoured beautiful women; my imagination continually recalling them, only to put them to use in my own fashion as so many demoiselles Lamberciers....
>
> To be at the knees of an imperious mistress, obey her orders, beg her forgiveness, were the sweetest pleasures, and the more my lively imagination inflamed my blood, the more I appeared as a transfixed lover. One can imagine that this fashion of making love does not go very far.... Therefore, I have possessed few, but nonetheless had great pleasure in my own fashion; that is, by the imagination. (*Confessions*, 15–17)

In this much criticized and analyzed passage, Rousseau attributes his lifelong sexual attraction to "punishment" (what we now would call "masochism") to a commonplace experience of childhood—spanking.[13] The importance of associationist mechanisms stands out in this "psycho-sexual genetic narrative" (see Butler 1990). Affection for a maternal figure was transferred to the associated act of spanking. Rousseau himself was amazed at the power and persistence of a mental liaison that he viewed as quite contrary to the nature of punishment, as well as "contrary to nature," i.e., depraved and insane. He hints that these spanking fantasies inflamed his imagination during his "solitary vice'" and in all his erotic experiences.

In a most candid and dramatic fashion, Rousseau illustrated what doctors repeatedly claimed—even "bizarre" and painful practices could become associated with genital *pleasure* and onanism, and then become the sole focus of one's thoughts. Indeed, in the nineteenth century, pleasure in corporal punishment would be only one of an increasing number of erotic "monomanias" in which the ontologized "mastupratiomaniac" specialized in a particular type of stimulation.[14] Also, as in Rousseau's example, this pleasure was usually viewed by

physicians as the product of chance association and *imaginary obsession*. Early nineteenth-century medical writers portrayed masturbation as dangerously *hyperpleasurable* even if for "bizarre" reasons. Largely echoing Rousseau, Dr. Léopolde Deslandes wrote in the *Dictionary of Practical Medicine and Surgery* that the masturbator had an imaginary object of pleasure with which he could endlessly play and thus delay the sexual *dénouement:* "His upheavals find here an imagination on fire, and senses prepared to feel them in all their energy. For this reason, masturbation produces on the organism *a more profound impression than coitus*" (1834, 369; emphasis added).

We can now begin to pull together the many semiotic strands of the "dangerous supplement" in Rousseau's erotic confessions and in the medical anti-onanism literature. Most evidently, masturbation was represented as a "dangerous supplement" to reproductive coitus. Although the morbid physical effects of onanism were worrisome, perhaps more distressing to Rousseau and contemporary doctors was the belief that "solitary vice" opened the Pandora's Box of the imagination, which was a dangerous supplement to reality. Furthermore, these critics depicted sexual desire—particularly the erotic incitement of puberty—as a supplement to "natural" living.

But why are these supplements *dangerous*? Rousseau and many doctors represented supplements as dangerous because they threatened to *supplant* that which they originally just *complemented*. Imaginary associations seemed frighteningly protean and tenacious. This emerges clearly in the *Encyclopédie*'s warning about "*manustupration*." It claimed that the only two healthy and "natural" ways of voiding superfluous seed were in "commerce and union with women" and "that [natural excretion] provoked during the sleep of celibates by voluptuous dreams which supplement equally, and *sometimes even surpass reality*" (20(2), 990). Given the "fatal advantage" of its "convenience," the supplement—masturbation, imaginary representation, or sensual writing—threatens to surpass Nature and Reason.

Critics who depicted Rousseau's *Confessions* and philosophy as dangerous also remarked on the ill influence of novel reading and imaginativeness on Rousseau's own life and philosophies. Elie Fréron in the *Année littéraire* highlighted Rousseau's confession of having spent whole nights reading novels; from this Fréron concluded, "One now understands the source of that chimerical mind, of that taste for falsity and lies which he conveyed to his philosophy; one is no longer astonished that, being nourished on novels in his childhood, he maintained in adulthood so many paradoxes and romanesque systems" (1782,

153). Contrary to Rousseau's claims of having embarked on a unique enterprise, Fréron failed to see anything in Rousseau's project that had not been done in St. Augustine's *Confessions*. The only distinction Fréron could identify was the utter shamefulness of Rousseau's avowals (1782, 147). But the shamefulness of these confessions, and their exploration of the erotic imagination were precisely the innovation of Rousseau's autobiography.

TELLING IT ALL, OR SPEAKING THE UNMENTIONABLE

Writing about oneself is an ancient tradition; however, the word "autobiography" and philological interest in autobiography only date to the late eighteenth century (Misch [1907] 1950, 1). The current philological consensus is that autobiography is an expression of Enlightenment bourgeois culture and of the modern conception of the subject and of individuality (Lejeune 1975, 340). Literary scholars have specifically credited Rousseau with developing the modern autobiographical form (Frye 1957, 308). Although Rousseau labeled his autobiography a "Confession," his literary production is notably different. In the Roman Catholic tradition, confessions, such as St. Augustine's (397–401 A.D.), were constructed as pious and penitent monologues with God (see St. Augustine 1982, 29; I: 1(1)). The autobiographer, on the other hand, addressed his fellow men (they were usually men addressing a presumed male reader). So, although autobiography furthered the cult of the self or the "myth of the ego" (Lejeune 1975, 340), it was not a solipsistic discourse: it fundamentally examined the relation between the modern subject and its civic setting.

Rousseau's first preamble to the *Confessions* (written in 1764) is a critical document elucidating the social function of autobiography. Our understanding of other humans is generally just a reflection of our understanding of ourselves, Rousseau observes, but usually this is quite limited since, as social creatures, an individual must compare himself with another being (*Confessions*, 1148). In order to further the "knowledge of mankind," Rousseau therefore volunteers himself as the first-ever, brutally candid metric for comparison: "I will be truthful; I will be truthful without reserve; I will tell all; the good, the bad, in sum, everything" (1153). He dismisses all previous histories, confessions and memoirs as just accounts of *external* actions designed to glorify the author rather than reveal the truth (1149). To know the *truth* of an individual, he emphatically claims, is to understand the history and processes of the person's *inner* workings (1149).

Such a project, Rousseau recognizes, demands a new language and a new style to untangle the chaos of his sometimes vile, sometimes sublime sentiments:

> What trivialities, what miseries am I not obliged to expose, into what revolting, indecent, puerile and often ridiculous details must I not enter to follow the thread of my secret dispositions, to show how every impression that left a trace on my soul entered it for the first time? While I blush at the simple thought of the things I must recount, I know that stern men will yet again treat the humiliation of these shameful avowals as impudence; but either I make these avowals or I disguise myself; because if I silence something I will not be recognized in anything, it is all so bound together, it is all one in my character, and that bizarre and singular assemblage requires all the circumstance of my life to be thoroughly unveiled. (1153)

Given this construction of the inner ego, the impact of "nurture" on "nature," and the requirement to "tell all," we can better understand Rousseau's need to confess his masturbatory habits, his erotic attachment to punishment, and his sexual entanglements. His confession of the "solitary vice" is special however. Unlike the revelations of his coital intrigues, this is the sole erotic act that could have gone unmentioned without fear of ulterior revelation by anyone else. Its confession is thus the highest proof of his unreserved candor. The same can be said for Rousseau's confessions of his autoerotic punishment fantasies to which no one would otherwise have had access. In Rousseau's construction of the "true knowledge" of humans, there is no better demonstration of naked Truth than the revelation of one's erotic imagination.

Rousseau correctly guessed the reaction of his contemporaries to such disclosures. To those inured to hagiographic memoirs, Rousseau's erotic confessions seemed utterly gratuitous and revolting.[15] Elie Fréron in his *Année littéraire* (1782) sarcastically predicted that those who had thought Rousseau an ambitious slave of fame, "ready to sacrifice truth for glory" (145), would now be convinced of his utter humility, for, "how indeed could one not regard as the most modest and humble of men, someone who would unnecessarily make the most humiliating admissions, who reveals to his contemporaries and to their nephews the shameful frailties, the misery attached to humanity which we would prefer to hide from ourselves, in a word, who exposes himself, gleefully, to eternal ridicule in the eyes of his century and of posterity" (145–146). How paradoxical that one hostile reviewer complained that no one was a lesser seek-

er of the truth than Jean-Jacques! (*Journal des Gens du Monde* 1782, 112). The critics seem unable to accept Rousseau's premise that propriety had to be sacrificed for a truthful exploration of subjectivity.

Let me reemphasize that, according to Rousseau, this candor is not simply for the sake of personal exhibitionism but for the purpose of *social judgment*. Behind Rousseau's philosophical explanation of this point, he alludes indirectly to the immediate reason for his confession. In Geneva, on December 27, 1764, appeared the anonymous, libelous "Sentiment des Citoyens" ("The citizens' sentiment"), which accused Rousseau of a litany of sexual crimes: incest, abandonment of his bastard children, and bearing the traces of venereal diseases caught from his debauchery. In fact, the author was Voltaire, who lambasted Rousseau for "abjuring all the sentiments of nature just as he strips those of honor and of religion" (Voltaire 1879, 312). Rousseau's first reaction was to deny all accusations. Upon receiving the libelous broadside, Rousseau had his editor in Paris print copies along with a point-by-point defense in the footnotes (Voltaire 1879, 312, n. 3). Nevertheless, it was true that Rousseau had abandoned his three illegitimate children at orphanages. So, by early January 1765, he decisively resolved to write his *Confessions* to admit this and other "shameful frailties" so that he be known in "all the truth of nature." "Because my name must endure amongst men," Rousseau wrote in a prophetic voice, "I do not want it to carry a false reputation; I do not want to have attributed to myself virtues or vices that I did not possess" (1153).

So it was a sex scandal that was at the root of this, supposedly, "first ever" *truthful* autobiography. All the more reason, then, that Rousseau dedicated himself to displaying the secret vices of his erotic life—to the horror of his detractors. The dismay of medical authors and social critics would only grow in the nineteenth century, as, increasingly, sexuality became the cornerstone of explorations of individual subjectivity in both medical confessions and literary texts. People took to heart Rousseau's challenge: "[M]ay mankind hear my confessions, may they moan at my indignities, may they blush at my miseries. May each in turn bare their heart with the same sincerity" (*Confessions*, 5).

POLICING THE IMAGINATION FOR CRIMES OF SOCIAL-POLLUTION

While Rousseau hoped his erotic self-exploration and self-revelation would serve to clear his name and to contribute to social psychology, as we have already noted, his critics thought otherwise. To them, Rousseau's personal and literary

activities were matters of dangerous self-indulgence. Just as the "dangerous sup-
plement" had helped the solitary Rousseau turn pain into his core erotic passion
and "abjure the sentiments of nature," it was feared that "solitary pleasure" would
turn other children into erotically self-absorbed, alienated, and anti-social
beings. Dr. Desruelles, for example, portrayed a typical life-history of a mas-
turbator:

> A vague unease, an aimless desire, an uncertain discomfort, without real cause, at
> least for him [the masturbator]; everything agitates, torments, pushes him invol-
> untarily perhaps, towards a pleasure he has yet to know, for which he searches
> instinctually but which escapes him because of his innocence. Satisfied, that deceiv-
> ing pleasure soon vanishes, only to inspire the desire to see it reborn. An uneasy
> curiosity has begun, and the fleeting but attractive delirium of the senses termi-
> nates the shameful act that will devour his life, unless he renounce immediately.
> Somber, melancholic, hiding from himself, the masturbator searches isolation and
> obscurity; he has neither rest nor real enjoyment; without fondness for those around
> him, he is entirely possessed by his disgusting passion. (Desruelles 1822, 32–33)

This characterization of the habit of onanism as a "monomania" was com-
monplace in the early nineteenth century after the concept of the monomanias
was developed by Jean Esquirol (1772–1840) in 1810 (Goldstein 1987, 153).
While the total obsession with a "bizarre taste" did not literally drive Rousseau
to "the point of depravation and insanity," as he claimed (*Confessions*, 16), physi-
cians diagnosed many young people in which it supposedly did. Take, for exam-
ple, a case reported by the preeminent hygienist A. J. B. Parent-Duchâtelet
(1790–1836) of an eight-year-old girl with "vicious and criminal penchants"
whose addiction to masturbation from the age of four was so strong that she
threatened to kill her parents when they tried to curtail her solitary vice. The
Paris Commissioner of Police concluded that, "only this mortal habit [of
onanism] could have disturbed this child's intellectual organs, and caused the
horrible monomania from which she suffers" (Parent-Duchâtelet 1832, 189).

In order to prevent the initial corruption of the innocent, a whole variety of
surveillance and *physical* restraints were recommended. But as the disease of mas-
turbation was increasingly understood in the nineteenth century as a *mental disor-
der* involving a perverted imagination, it was feared that conventional physical ther-
apies could only be palliative. Claude François Lallemand (1790–1853), in his
widely reviewed volumes on "involuntary seminal losses" (1836, 1839, 1842), fret-

ted: "The eyes may watch the book, the ears listen to the word of the school-teacher, but who can stop the imagination from working? At night it will be more difficult yet; no surveillance could stop it, nor even observe it" (1836, 432).

If the imagination was the culprit, then it made sense to target it for treatment. The director of the lunatic service of the Salpêtrière, Dr. Etienne-Jean Georget (1795–1828), therefore recommended that when signs of onanism are noted in children, the doctor "strike their imagination with lectures and prescribe rigorous surveillance in a severe tone" (1840, 79). Dr. Demeaux (a fervent admirer of Lallemand, an anatomist in the Paris Faculty of Medicine, and vice-president of the Anatomical Society) proposed to take advantage of the natural shame and timidity of the masturbator by subjecting young people, ages ten to twenty, to surprise inspections twice a year by a specially trained national corps of health inspectors (1856, 1857, 1861). Those children who were not deterred from the "abominable maneuver" by the mere fear of detection, Demeaux reasoned, would at least be caught early in their addiction when intervention was still possible (1857, 939).

Lallemand had proposed perhaps an even more radical intervention—fundamental ideological reform through a return to the "principles of the Revolution and the Convention": "It would be necessary to ground the base of a national education on the *duties of the country* towards its citizens, in order to extract from all the *physical, intellectual, and moral* dispositions the greatest possible benefit for the prosperity of society, for the happiness of each individual" (Lallemand 1836, 435, original emphasis).

Lallemand makes it clear that, by the nineteenth century, the anti-onanism campaign was not simply aimed at preserving the health of individual children, but more importantly, the health of the state. It had been the Revolution that first made "social medicine" an institutional reality (Weiner 1970), and it was during the Napoleonic period that French "public hygiene" first rose to world prominence (Ackerknecht 1948). It was the early-nineteenth-century public hygienists who proposed that the health of the individual body and that of the social body were closely linked (Coleman 1982, 21). As Dr. Julien Joseph Virey (1775–1846) stated in his *Philosophical Hygiene, or health in the physical, moral, and political regimen of modern civilization* (1828), "We inherit vigor or weakness from the social state; its constitution forms our own, inspires our customs, or deploys our passions" (cited in Reveillé-Parise 1828b, 412).

It was inevitable that the "solitary passion" would also be viewed not just as a matter of individual morbidity but, more ominously, of social pathology.

Alternating their critique between the individual and the social impacts of masturbation, Fournier and Béguin provide an early example of this new emphasis on the social burden of onanism-obsessed youth:

> Above all it is in young people of one and the other sex that masturbation causes the greatest ravages; it is all the more fatal since it strikes society in its element, so to speak, and tends to destroy it by enervating, from their first steps, the subjects who would efficaciously concur in its conservation and splendor. How often we see these weakened, colorless beings, equally feeble of body and mind, owing only to masturbation, principle object of their thoughts, the state of languor and exhaustion to which they have sunken! Thenceforth, incapable of defending the nation or of serving it by honorable or useful work, they lead, in a society that despises them, a life which they have rendered useless for others and often a burden to themselves. (Fournier & Béguin 1819, 101–102)

No longer was masturbation a devastating disease simply because children were malleable and vulnerable, but, more importantly, because children were the future wealth of the nation. Fournier and Béguin newly emphasized that self-pollution was not merely a matter of self-destruction but one of social debilitation.

In the nineteenth century, the economy between the individual and the social body was understood to run on the currency of "heredity"—the biological wealth that was increasingly perceived as a *collective* endowment.[16] France's hereditary vigor seemed particularly threatened given the nation's declining fertility rate, which hygienists had noted since 1815 (Coleman 1982, 34–35). Those who squandered and weakened their seed were therefore seen as especially noxious to society.

Public hygienist Joseph Henri Reveillé-Parise (1782–1852) bemoaned the catastrophic effects of "libertinage by the hand" on social strength:

> Masturbation…is one of those scourges that attack and soundly destroy humanity…. In my opinion, neither the plague, nor war, nor smallpox, nor innumerable other such evils produce as disastrous results for humanity as this fatal habit. It is the destroyer of civilized societies, and all the more active since it operates continually and saps the generations. (Reveillé-Parise 1828a, 93)

He further warned that pale, nervous women exhausted by manustupration "could not exercise the functions of maternity;" and likewise, weak, effeminate, corset-wearing men would transmit their masturbatory deterioration to future genera-

tions. "Thus the tree is mutilated right down to its roots," exclaimed Reveillé-Parise (1828a, 93–94). Twenty-four years later, he would still be echoed by Dr. Debourge, who decried the "deplorable solitary maneuver" as a "potent cause of depopulation, whose effects are all the more fatally disastrous since, although it may not kill, it tends to bastardize, bestialize, degrade and degenerate the species" (1852, 314).

What emerges from the anti-masturbatory literature of the nineteenth century is the medical representation of "deviant" or abnormal individuals as pathological elements of the social corps—polluting its national strength and purity. Clearly a profound reversal had occurred since the early warnings of Rousseau and Tissot on the corrupting effects of civilization on the innocent, natural bodies of children. By the time of the Restoration (1814–1830), the vector of contagion had been reversed; Reveillé-Parise and other hygienists were condemning "mastupratiomaniacs" as the "destroyers of civilized societies."

While the condemnation of masturbation had not abated, during the intervening years the dramatic political, social, and ideological conflicts of the Revolution and 1st Empire had altered the French world-view. Neither the "state of nature" nor the "noble savage" were tenable Arcadian fictions any longer. Lallemand, for example, rejected Rousseauvian pastoralism and declared that peasants most commonly engaged in onanism as well as sodomy and bestiality (1836, 440). The colonized "primitives" had also proven far from docile after the Revolution, particularly those in Haiti, where ex-slaves Toussaint-Louverture (1743–1803) and Jean-Jacques Dessaline (1748?–1806) led a revolt that eventually ousted the French in 1803. The Rousseauvian ideal of the Noble Savage—free of civilized, societal constraints—was replaced in the first decades after the Revolution by the image of the barbaric "primitive" that was slave to violent, natural drives.[17] Closer to home, the once idealized healthy, happy "productive classes," became the disgruntled industrial workers, and, in large crowds, these urban poor were perceived as volatile, rebellious, and primitive masses (Nye 1975; Pick 1989). After the Revolution, even the fantasy of innocence was spent; instead, fears of social enfeeblement were woven into the anti-masturbatory literature, which represented civil order and sexual order as interdependent in such a way that the onanist became the virus of the vulnerable social body.

POLLUTING KNOWLEDGES:
FROM PERSONAL FANTASIES TO SOCIAL NIGHTMARES

Dorinda Outram has suggested that with the convulsive contests for political order that followed the French Revolution, the individual, private body became a neces-

sary, new object for ensuring the order and productivity of the social corpus (1989, 3–4). What I have proposed here is that this novel problematization of the body and the *imagination* preceded the Revolution and is evident in the attempts by philosophes and social theorists to portray masturbation and the erotic imagination as dangerous supplements to Reason and Nature. Campaigns for the hygiene of the imagination shifted their objective from the individual to society as seminal loss was reconceptualized as not merely personally debilitating humoral squandering, but as the individual's pollution of society's phantasmatic institutions: hereditary purity, moral fiber, and national strength. Masturbation became a signifier loaded not only with references to sexual deviation but also to social degeneration. Simultaneously, the exposition of sexuality was evolving as an essential element to the truthful exploration of the modern subject and its social regulation.

Rousseau's words would resonate with ironic truth throughout the nineteenth century:

> I recount very odious things about myself, of which I would be loathe to excuse; but it is also the most secret history of my soul, these are my confessions at all cost. It is just that my reputation expiate the ill resulting from my desire to preserve it. I fully expect public denunciations, the severity of judgments pronounced out loud, and I submit myself to them. But may each reader imitate me, may he enter within himself as I have done, and in the depths of his conscience dare he say to himself: *I am better than that man.* (Sketch of the *Confessions*, 1155)

Following Rousseau, growing numbers of people—through their own volition or through medico-legal coercion—plumbed the depths of their secret sexual beings at the behest of medical professionals devoted to curing onanism and other "bizarre" sexual tastes. Throughout the nineteenth century, erotic confessions were diversified and refined in interaction with doctors and their ever changing epistemological and political interests (Rosario 1993).

The Rousseauvian challenge was to publicize the most "revolting" and "indecent" personal secrets in order not only to offer "true" knowledge of the self to society, but also to "further the knowledge of mankind" in general. While Rousseau earned little sympathy or absolution from his detractors, his principle seems to have caught on as the "convenient pleasure" of self-pollution was increasingly taken as a troublesome measure of social pollution and as the solitary erotic imagination was represented as the dangerous supplement to societal reproduction.

NOTES

An early version of this essay was presented at the Lesbian and Gay Studies Conference at Rutgers University and Princeton University (1991). I appreciate the help of Dorothy Porter, Anne Harrington, David Halperin, Paula Bennett, Kent Brintnall, Robert Nye, and Koichi Kurisu, who all generously offered editorial suggestions. This research was supported in part by a National Science Foundation Graduate Fellowship

1. All translations are mine unless a translated volume has been cited. Citations of Rousseau's works will be noted by title and page number in the Pléiade edition of the *Oeuvres complètes*. For ease of reading, I have translated the titles of most of the French works I mention; the original French titles can be found in the reference list.

2. The Littré dictionary (1873) only refers to the seminal and theological denotations which the *Trésor de la langue française* (1988) lists as "literary and archaic."

3. For a more extensive examination of early-18th-century anti-onanism literature see Stengers and Van Neck (1984) and Tarczylo (1983, part 2, ch. 2).

4. Derrida productively exploits the double, almost conflicting, connotations of "supplement" (1967, 207–209). Firstly, it can refer to a complement or extension of an existing corpus, e.g., the supplement of a dictionary. Secondly, it can refer to an exterior addition or surplus, e.g., a supplementary fee for an express train. Derrida mainly explores the supplementary nature of symbols to real things (i.e., signifiers to signifieds), and of writing to speech.

5. Leigh (1970, 8: 55), letter from Tissot to Dr. J. G. Zimmermann.

6. See letter from Tissot to Rousseau, 3 July 1762 (Leigh 1970, 11: 200).

7. *Emile* went on sale in Paris at the end of May 1762. It was condemned by the Sorbonne (7 June), the Paris Parliament (9 June), the archbishop of Paris (28 August) and burned in the streets. Tissot defended *Emile* and its author to medical friends such as Haller and Johann Casper Hirzel (Leigh 1970, letters no. 2052 and 1994).

8. See Leigh (1970, letter no. 4227, Rousseau to Tissot, 1 April 1765), and letter nos. 1980, 2006, 2525, 2566 in Dufour (1930).

9. As Philippe Ariès describes it (1960), the "discovery of childhood" began distinctly at the end of the seventeenth century and was marked by the rise of children's schools, the changing iconographic representation of children, and the evolution of children's clothes.

10. Ben Barker-Benfield (1972) describes the anti-onanism campaign as an expression of an American preoccupation with spermatic economy: the self-managed accumulation and wise investment of male energies. Similar concerns are expressed in French anti-onanism texts regarding *both* men's and women's reproductive economies.

11. Laqueur (1992) has suggested that the concerns with the imagination probably out-

weighed the inadequate and often contradictory worries about the somatic patho-physiology of onanism.

12. The history of pornography—particularly in the eighteenth century, its "golden age" (Alexandrian 1989)—has been the object of much recent scholarship. Aristocratic licentiousness inspired substantial pornographic political satire, especially during the Revolutionary period (see Hunt 1993). Growing secularism and anti-Catholic sentiment at this time also created a favorable climate for anticlerical pornography depicting libertinism in convents and seminaries (Wagner 1991, 167 & 172).

13. The diagnostic label "masochism" was first coined by Richard von Krafft-Ebing (1840–1902) in his *Psychopathia sexualis* (6th ed., 1891)—his great encyclopedia of "sexual perversions." It referred to the sexual practices illustrated by the Austro-Polish author Leopold von Sacher-Masoch (1836–1895), whose *Venus in Furs* (1870) Krafft-Ebing cited as the classic description of the male masochist.

14. "*Mastupratiomanie*" and " *mastupratiomane*" seem to be have been coined by Dr. Debourge (1852), member of the Public Hygiene and Health Council of Montdidier.

15. The scathing review in *Journal des Gens du Monde* (1782) found the *Confessions* boring, insipid, egotistical, and abusive of its readers' indulgence. For other reactions to the first part of the *Confessions* see Lejeune (1975, 49–50).

16. Foucault suggested that this preoccupation with heredity represented a bourgeois shift from the aristocratic cult of "blood" (1976, 164), but as we see here, the cult of "heredity" was also a concern with blood—a genetic blood that was malleable to environmental and behavioral manipulations unlike "blue blood."

17. As English politician and paleo-historian, Sir John Lubbock (1834–1913), put it in his *Prehistoric Times* (1865), "The true savage is neither free nor noble; he is a slave to his own wants, his own passions; . . . ignorant of agriculture, living by the chase, and improvident in success, hunger always stares him in the face and often drives him to the dreadful alternative of cannibalism or death" (cited by Stocking 1968, 41).

REFERENCES

Ackerknecht, Erwin. 1948. Hygiene in France, 1815–1848. *Bulletin of the History of Medicine* 22: 117–155.

Alexandrian, Sarane. 1989. *Histoire de la littérature érotique*. Paris: Seghers.

Ariès, Phillipe. 1960. *L'enfant et la vie familiale sous l'Ancien Régime*. Paris: Plon.

St. Augustine. [397–401] 1982. *Confessions*. Trans. Louis de Mondadon. Paris: Seuil.

Barker-Benfield, Ben. 1972. The Spermatic Economy: A Nineteenth-Century View of Sexuality. *Feminist Studies* 1: 45–74.

Bienville, J. D. T. de. [1771] 1775. *Nymphomania, or a Dissertation Concerning the Furor Uterinus*. Trans. Edward Wismot from the original *La nymphomanie, ou traité de la fureur utérine*. London: J. Bew. Photo facsimile. New York: Garland Publishing, 1985.

Bloch, Jean. 1974. Rousseau's Reputation as an Authority on Childcare and Physical Education in France Before the Revolution. *Pædagogica Historica* 14: 5–33.

Bulletin générale de thérapeutique médicale et chirurgicale. 1837. Cas extraordinare de mutilation et d'introduction d'un os dans la vessie. 13: 320–324.

Butler, Judith. 1990. *Gender Trouble: Feminism and the Subversion of Identity.* New York: Routledge.

Carter, Robert Brudenell. 1853. *On the Pathology and Treatment of Hysteria.* London: John Churchill.

Coleman, William. 1982. *Death is a Social Disease. Public Health and Political Economy in Industrial France.* Madison: University of Wisconsin Press.

Condillac, Etienne Bonnot de. [1746] 1795. *Essai sur l'origine des connoissances humaines.* Vol. 1 of *Œuvres philosophiques.* Paris: Dufart.

Debourge, Rollot. 1852. De la mastupratiomanie. *Journal de médecine, de chirurgie et de pharmacologie* (Brussels) 10(15): 314–322, 404–412.

Demeaux, J. 1856. *Mémoire sur l'Onanisme et des moyens d'en prévenir ou d'en réprimer les abus dans les établissements consacrés a l'instruction publique.* Paris: Wulder.

———. 1857. Note sur l'onanisme. *Le Moniteur des hôpitaux, Revue médico-chirurgicale de Paris* 1st ser., 5: 929–935.

———. 1861. Quelques réflexions sur l'onanisme. *Le Moniteur des sciences médicales et pharmaceutiques* 2d ser., 3: 17–19, 28–29, 36–38, 42–43.

Derrida, Jacques. 1967. *De la grammatologie.* Paris: Editions de Minuit.

Deslandes, Léopolde. 1834. Masturbation. *Dictionnaire de médecine et de chirurgie pratiques* 11:368–378. Paris: J.B. Baillière.

———. 1853. *De l'onanisme et des autres abus vénériens.* Paris: Lalarge.

Desruelles, Henri Marie Joseph. 1822. Notice et observations sur les effets de la masturbation. *Journal générale de médecine, de chirurgie et de pharmacie* 79: 31–61.

Dufour, Théophile, ed. 1930. *Correspondence de Jean-Jacques Rousseau.* Paris: Armand Colin.

Elosu, Suzanne. 1929. La maladie de Jean-Jacques Rousseau. *Bulletin de la Société Française de l'Histoire de la Médecine* 23: 349–356.

Emch-Dériaz, Antoinette S. 1984. Towards a social conception of health in the second half of the eighteenth century: Tissot (1728–1797) and the new preoccupation with health and well-being. Ph.D. diss., University of Rochester.

Encyclopédie. [1751–72] 1778. *Encyclopédie ou dictionnaire raisonné des sciences, des arts et des métiers.* Eds. Denis Diderot and J. d'Alembert. Lausanne: Société Typographique.

Engelhardt, H. Tristram. 1985. The Disease of Masturbation. In *Sickness and Health in America*, ed. J. Leavitt and R. Numbers, 13–21. Madison: University Wisconsin Press.

Foucault, Michel. 1976. *Histoire de la sexualité; Vol. 1: La volonté de savoir.* Paris: Gallimard.

Fournier, H. [pseud.]. 1872. *De l'onanisme, causes, dangers et inconvénients pour les individus, la famille, et la société, remèdes.* Paris: J.B. Baillière et fils.

Fournier & Béguin. 1819. Masturbation. *Dictionnaire des sciences médicales*. Paris: Panckoucke.

Fréron, Elie. 1782. [Review of] *Les Confessions* de Jean-Jacques Rousseau. *L'Année littéraire* vol. 4, letter 8: 145–175. Paris: Mérigot. Photo reprint. Geneva: Slatkine, 1966.

Frye, Northrop. 1957. *The Anatomy of Criticism*. Princeton: Princeton University Press.

Georget, Etienne-Jean. 1840. Onanisme. *Dictionnaire de médecine ou répertoire générale des sciences médicales*. 2nd ed. Paris: Béchet Jeune, 22: 77–80.

Goldstein, Jan. 1987. *Console and Classify: The French Psychiatric Profession in the Nineteenth Century*. New York: Cambridge University Press.

Goulemot, Jean Marie. 1991. *Ces livres qu'on ne lit que d'une main. Lecture et lecteurs de livres pornographiques au XVIIIè siècle*. Aix-en-Provence: Alinea.

Hare, E.H. 1962. Masturbatory Insanity: the History of an Idea. *Journal of the Mental Sciences* 108: 1–25.

Hunt, Lynn. 1991. The Many Bodies of Marie-Antoinette: Political Pornography and the Problem of the Feminine in the French Revolution. In *Erotism and the Body Politic*, ed. Lynn Hunt, 108–130. Baltimore: Johns Hopkins University Press.

———. 1993. Pornography and the French Revolution. In *The Invention of Pornography*, ed. Lynn Hunt, 301–339. New York: Zone Books.

Jordanova, Ludmilla. 1987. The Popularization of Medicine: Tissot on Onanism. *Textual Practice* 1:68–80.

Journal des gens du monde. 1782. Sur les *Confessions* de Jean-Jacques Rousseau. Vol. 1(2): 102–112.

Krafft-Ebing, Richard von. [1886] 1891. *Psychopathia sexualis*. 6th ed. Stuttgart: Ferdinand Enke.

Lallemand, Claude François. 1836–1842. *Des pertes séminales involontaires*. Paris: Bechet Jeune.

Laqueur, Thomas. [1989] 1995. The Social Evil, the Solitary Vice and Pouring Tea. In *Solitary Pleasures: The Historical, Literary, and Artistic Discourses of Autoeroticism*. ed. Paula Bennett and Vernon Rosario II, 155–161. New York: Routledge.

———. 1992. Credit, Novels, Masturbation. Paper presented at Choreographic History conference, 16 Feb., at the University of California Riverside.

Leigh, R. A., ed. 1970. *Correspondance complète de J. J. Rousseau*. Madison: University of Wisconsin Press.

Lejeune, Philippe. 1975. *Le pacte autobiographique*. Paris: Seuil.

MacDonald, Robert. 1967. The Frightful Consequences of Onanism: Notes on the History of a Delusion. *Journal of the History of Ideas* 28: 423–431.

Misch, George. [1907] 1950. *A History of Autobiography*. Vol. 1 Antiquity. Trans. E. W. Dickes. London: Routledge and Kegan Paul.

Neuman, Robert P. 1975. Masturbation, Madness, and the Modern Concept of Childhood and Adolescence. *Journal of Social History* 8:1–22.

Nye, Robert A. 1984. *Crime, Madness and Politics in Modern France. The Medical Concept of National Decline*. Princeton: Princeton University Press.

Onania. 1723. *Onania, or the heinous sin of self-pollution*. 8th ed. London: Thomas Crouch. Facsimile edition. New York: Garland Press, 1986.

Outram, Dorinda. 1989. *The Body and the French Revolution: Sex, Class, and Political Culture*. New Haven: Yale University Press.

Parent-Duchâtelet, Alexandre-Jean-Baptiste. 1832. Penchants vicieux et criminels observés chez une petite fille. *Annales d'hygiène publique et de médecine légale*. 7:173–194.

Pick, Daniel. 1989. *Faces of Degeneration, A European Disorder, c.1848–c.1918*. Cambridge: Cambridge University Press.

Portmann, Marie-Louise. 1980. Relations d'Auguste Tissot (1728–1797) médecin à Lausanne, avec le patriciat bernois. *Gesnerus* 37: 21–27.

Reveillé-Parise, Joseph Henri. 1828a. [Book review of Simon de Metz's] *Traité d'hygiène publique appliqué à l'éducation de la jeunesse*. *Revue médicale* 2: 87–96.

———. 1828b. [Book review of J.J. Virey's] *Hygiène philosophique, ou santé dans le régime physique, moral et politique de la civilisation moderne*. *Revue médicale* 3: 405–420.

Rosario II, Vernon A. 1993. Sexual Psychopaths: Doctors, Patients and Novelists Narrating the Erotic Imagination in Nineteenth-Century France. Ph.D. Diss. Harvard University, Cabridge, Mass.

Rousseau, Jean-Jacques. [1750] 1964. *Discours sur les sciences et les Arts. Œuvres complètes*, 3: 1–30. Paris: Pléiade.

———. [1752] 1864. *Narcisse, ou l'amant de lui même. Œuvres complètes*, 2: 957–1018. Paris: Pléiade.

———. [1762] 1969. *Emile, ou De l'Education. Œuvres complètes*. 4: 239–868. Paris: Pléiade.

———. [1782–89] 1959. *Les Confessions. Œuvres complètes*, 1: 1–656. Paris: Pléiade.

Serrurier. 1820. Pollution. *Dictionnaire des sciences médicales*. Paris: Panckouke. 44: 92–141.

Schwartz, Joel. 1984. *The Sexual Politics of Jean-Jacques Rousseau*. Chicago: University of Chicago Press.

Stengers, Jean & Anne Van Neck. 1984. *Histoire d'une grande peur: la masturbation*. Brussels: Éditions de l'Université de Bruxelles.

Stocking, George W., Jr. 1968. *Race, Culture, and Evolution*. New York: Free Press.

Tarczylo, Théodore. 1983. *Sexe et liberté au siècle des Lumières*. Paris: Presses de la Renaissance.

Thomasset, Claude & Danielle Jacquart. 1985. *Sexualité et savoir médicale au Moyen Age*. Paris: Presses Universitaires de France.

Tissot, Samuel-Auguste-André-David. 1758. *Tentamen de Morbis ex Manustruptione*. Lausanne: M. M. Bosquet.

———. [1781] 1991. *L'Onanisme, ou Dissertation physique sur les maladies produites par la masturbation*. Reprint of 7th edition with preface by Christophe Calame. Paris: Éditions de la Différence.

————. [1761] 1795. *Avis au peuple sur sa santé*. 7th ed. Blois: Masson & Durie.

————. [1766] 1826. *De la santé des gens de lettres*. Nouvelle édition. Intro. and ed. F.-G. Boisseau. Paris: J. B. Baillière.

————. 1770. *Essai sur les maladies des gens du monde*. 1st ed. Lausanne: François Grasset.

Voltaire, [François Marie Arouet]. [1764] 1879. Sentiment des citoyens. *Œuvres complètes*. Paris: Garnier.

Wagner, Peter. 1991. Anticatholic Erotica in Eighteenth-Century England. In *Erotica and the Enlightenment*, ed. Peter Wagner, 166–209. Frankfurt: Verlag Peter Lang.

Weiner, Dora. 1970. Le droit de l'homme à la santé. Une Belle idée devant l'Assemblée Constituante: 1790–1791. *Clio Medica* 5: 209–223.

————. 1974. Public Health Under Napoleon, the Conseil de Salubrité de Paris, 1802–1815. *Clio Medica* 9 (4): 271–284.

5

JANE AUSTEN AND THE MASTURBATING GIRL

EVE KOSOFSKY SEDGWICK

The phrase itself is already evidence. Roger Kimball in his treatise on educational "corruption," *Tenured Radicals*, cites the title "Jane Austen and the Masturbating Girl" from an MLA convention program quite as if he were Perry Mason, the six words a smoking gun.[1] The warm gun that, for the journalists who have adopted the phrase as an index of depravity in academe, is happiness—offering the squibby pop (fulmination? prurience? funniness?) that lets absolutely anyone, in the righteously exciting vicinity of the masturbating girl, feel a very pundit.[2]

There seems to be something self-evident—irresistibly so, to judge from its gleeful propagation—about use of the phrase, "Jane Austen and the Masturbating Girl," as the Q.E.D. of phobic narratives about the degeneracy of academic discourse in the humanities. But what? The narrative link between masturbation itself and degeneracy, though a staple of pre-1920s medical and racial science, no longer has any respectable currency. To the contrary: modern views of masturbation tend to place it firmly in the framework of optimistic,

hygienic narratives of all-too-normative individual development. When Jane E. Brody, in a recent "Personal Health" column in the *New York Times*, reassures her readers that, according to experts, it is actually entirely possible for people to be healthy *without* masturbating; "that the practice is not essential to normal development and that no one who thinks it is wrong or sinful should feel he or she must try it"; and that even "those who have not masturbated...can have perfectly normal sex lives as adults," the all but perfectly normal Victorianist may be forgiven for feeling just a little—out of breath.[3] In this altered context, the self-evidence of a polemical link between autoeroticism and narratives of wholesale degeneracy (or, in one journalist's historically redolent term, "idiocy draws on a very widely discredited body of psychiatric and eugenic expertise whose only direct historical continuity with late-twentieth-century thought has been routed straight through the rhetoric and practice of fascism."[4] But it does so under the more acceptable gloss of the modern trivializing, hygienic developmental discourse, according to which autoeroticism not only is funny—any sexuality of any power is likely to hover near the threshold of hilarity—but must be relegated to the inarticulable space of (a barely superseded) infantility.

"Jane Austen and the Masturbating Girl"—the essay, not the phrase—began as a contribution to a Modern Language Association session that the three of us who proposed it entitled "The Muse of Masturbation." In spite of the half-century-long normalizing rehabilitation of this common form of isometric exercise, the proposal to begin an exploration of literary aspects of autoeroticism seemed to leave many people gasping. That could hardly be because literary pleasure, critical self-security, and autoeroticism have nothing in common. What seems likelier, indeed, is that the literal-minded and censorious metaphor that labels any criticism one doesn't like, or doesn't understand, with the would-be-damning epithet "mental masturbation," actually refers to a much vaster, indeed foundational, open secret about how hard it is to circumscribe the vibrations of the highly relational but, in practical terms, solitary pleasure and adventure of writing itself.

As the historicization of sexuality, following the world of Foucault, becomes increasingly involved with issues of representation, different varieties of sexual experience and identity are being discovered both to possess a diachronic history—a history of significant change—and to be entangled in particularly indicative ways with aspects of epistemology and of literary creation and reception. This is no less true of autoeroticism than of other forms of sexuality. For example, the Aesthetic in Kant is both substantively indistinguishable from, and at

the same time definitionally opposed against, autoerotic pleasure. Sensibility, too—even more tellingly for the example of Austen—named the locus of a similarly dangerous overlap. As John Mullan points out in *Sentiment and Sociability: The Language of Feeling in the Eighteenth Century*, the empathetic alloidentifications that were supposed to guarantee the sociable nature of sensibility could not finally be distinguished from an epistemological solipsism, a somatics of trembling self-absorption, and ultimately—in the durable medical code for autoeroticism and its supposed sequelae—"neurasthenia."[5] Similarly unstable dichotomies between art and masturbation have persisted, culminating in those recurrent indictments of self-reflexive art and critical theory themselves as forms of mental masturbation.

Masturbation itself, as we will see, like homosexuality and heterosexuality, is being demonstrated to have a complex history. Yet there are senses in which autoeroticism seems almost uniquely—or at least, distinctively—to challenge the historicizing impulse. It is unlike heterosexuality, whose history is difficult to construct because it masquerades so readily as History itself; it is unlike homosexuality, for centuries the *crimen nefandum* or "love that dare not speak its name," the compilation of whose history requires acculturation in a rhetoric of the most pointed preterition. Because it escapes both the narrative of reproduction and (when practiced solo) even the creation of any interpersonal trace, it seems to have an affinity with amnesia, repetition or the repetition compulsion, and an historical or history-rupturing rhetorics of sublimity. Neil Hertz has pointed out how much of the disciplinary discourse around masturbation has been aimed at discovering or inventing proprietary traces to attach to a practice which, itself relatively traceless, may seem distinctively to threaten the orders of propriety and property.[6] And in the context of hierarchically oppressive relations between genders and between sexualities, masturbation can seem to offer—not least as an analogy to writing—a reservoir of potentially utopian metaphors and energies for independence, self-possession, and a rapture that may owe relatively little to political or interpersonal abjection.

The three participants in "The Muse of Masturbation," like most of the other scholars I know of who think and write about masturbation, have been active in lesbian and gay as well as in feminist studies. This makes sense because thinking about autoeroticism is beginning to seem a productive and necessary switch-point in thinking about the relations—historical as well as intrapsychic—between homo- and heteroeroticism: a project that has not seemed engaging or necessary to scholars who do not register the antiheterosexist pres-

sure of gay and lesbian interrogation. Additionally, it is through gay and lesbian studies that the skills for a project of historicizing any sexuality have developed, along with a tradition of valuing nonprocreative forms of creativity and pleasure; a history of being suspicious of the tendentious functioning of open secrets; and a politically urgent tropism toward the gaily and, if necessary, the defiantly explicit.

At the same time, part of the great interest of autoeroticism for lesbian and gay thought is that it is a long-execrated form of sexuality, intimately and invaluably entangled with the physical, emotional, and intellectual adventures of many, many people, that today completely *fails* to constitute anything remotely like a minority identity. The history of masturbation phobia—the astonishing range of legitimate institutions that so recently surveilled, punished, jawboned, imprisoned, terrorized, shackled, diagnosed, purged, and physically mutilated so many people, to prevent a behavior that those same institutions now consider innocuousness itself—has complex messages for sexual activism today. It seems to provide the most compelling possible exposure of the fraudulence of the scientistic claims of any discourse, *including medicine*, to say, in relation to human behavior, what constitutes disease. "The mass of 'self-defilement' literature," as Vernon A. Rosario II rather mildly points out, can "be read as a gross travesty of public health education"[7]—and queer people have recently needed every available tool of critical leverage, including travesty, against the crushing mass of legitimated discourses showing us to be moribund, mutant, pathetic, virulent, or impossible. Even as it demonstrates the absolutely discrediting inability of the "human sciences" to offer any effectual resistance to the most grossly, punitively inflictive moralistic hijacking, however, the same history of masturbation phobia can also seem to offer the heartening spectacle of a terrible oppression based on "fear" and "ignorance" that, ultimately, withered away from sheer transparent absurdity. The danger of this view is that the encouragement it offers—an encouragement we can hardly forgo, so much need do we have of courage—depends on an Enlightenment narrative that can only relegitimate the same institutions of knowledge by which the crime was in the first place done.

Today there is no corpus of law or of medicine about masturbation; it sways no electoral politics; institutional violence and street violence do not surround it, nor does an epistemology of accusation; people who have masturbated who may contract illnesses are treated as people who are sick with specific disease organisms, rather than as revelatory embodiments of sexual fatality. Yet when so many

confident jeremiads are spontaneously launched at her explicit invocation, it seems that the power of the masturbator to guarantee a Truth from which she is herself excluded has not lessened in two centuries. To have so powerful a form of *sexuality* run so fully athwart the precious and embattled sexual *identities* whose meaning and outlines we always insist on thinking we know, is only part of the revelatory power of the Muse of masturbation.

2

Bedroom scenes are not so commonplace in Jane Austen's novels that readers get jaded with the chiaroscuro of sleep and passion, wan light, damp linen, physical abandon, naked dependency, and the imperfectly clothed body. *Sense and Sensibility* has a particularly devastating bedroom scene, which begins:

> Before the house-maid had lit their fire the next day, or the sun gained any power over a cold, gloomy morning in January, Marianne, only half-dressed, was kneeling against one of the window-seats for the sake of all the little light she could command from it, and writing as fast as a continual flow of tears would permit her. In this situation, Elinor, roused from sleep by her agitation and sobs, first perceived her; and after observing her for a few moments with silent anxiety, said, in a tone of the most considerate gentleness,
>
> "Marianne, may I ask?—"
>
> "No, Elinor," she replied, "ask nothing; you will soon know all."
>
> The sort of desperate calmness with which this was said, lasted no longer than while she spoke, and was immediately followed by a return of the same excessive affliction. It was some minutes before she could go on with her letter, and the frequent bursts of grief which still obliged her, at intervals, to withhold her pen, were proofs enough of her feeling how more than probable it was that she was writing for the last time to Willoughby.[8]

We know well enough who is in this *bedroom*: two women. They are Elinor and Marianne Dashwood, they are sisters, and the passion and perturbation of their love for each other is, at the very least, the backbone of this powerful novel. But who is in this *bedroom scene?* And, to put it vulgarly, what's their scene? It is the naming of a man, the absent Willoughby, that both marks this as an unmistakably sexual scene, and by the same gesture seems to displace its "sexuality"

from the depicted bedroom space of same-sex tenderness, secrecy, longing, and frustration. Is this, then, a hetero- or a homoerotic novel (or moment in a novel)? No doubt it must be said to be both, if love is vectored toward an object and Elinor's here flies toward Marianne, Marianne's in turn toward Willoughby. But what, if love is defined only by its gender of object-choice, are we to make of Marianne's terrible isolation in this scene; of her unstanchable emission convulsive and intransitive; and of the writing activity with which it wrenchingly alternates?

Even before this, of course, the homo/hetero question is problematical for its anachronism: homosexual identities, and certainly female ones, are supposed not to have had a broad discursive circulation until later in the nineteenth century, so in what sense could heterosexual identities exist against them?[9] And for that matter, if we are to trust Foucault, the conceptual amalgam represented in the very term "sexual identity," the cementing of every issue of individuality, filiation, truth, and utterance *to* some representational metonymy of the genital, was a process not supposed to have been perfected for another half-century or three-quarters of a century after Austen; so that the genital implication in either "homosexual" *or* "heterosexual," to the degree that it differs from a plot of the procreative or dynastic (as each woman's desire seems at least for the moment to do), may also mark the possibility of an anachronistic gap.[10]

In trying to make sense of these discursive transitions, I have most before me the model of recent work on Emily Dickinson, and in particular Paula Bennett's discussion in *My Life a Loaded Gun* and *Emily Dickinson: Woman Poet*,[11] of the relation between Dickinson's heteroerotic and her homoerotic poetics. Briefly, Bennett's accomplishment is to have done justice, for the somewhat later, New England figure of Dickinson, to a complex range of intense female homosocial bonds, including genitally figured ones, in her life and writing—without denying the salience and power of the male-directed eros and expectation that also sound there; without palliating the tensions acted out between the two; and at the same time without imposing an anachronistically reified view of the feminist consistency of these tensions. For instance, the all-too-available rhetoric of the polymorphous, of a utopian bisexual erotic pluralism, has little place in Bennett's account. But neither does she romanticize the female-female bonds whose excitement, perturbation, and pain—including the pain of power struggle, of betrayal, of rejection—she shows to form so much of the primary level of Dickinson's emotional life. What her demanding account does enable her to do, however, is to offer a model for understanding the bedrock, quotidian, some-

times very sexually fraught female homosocial networks in relation to the more visible and specularized, more narratable, but less intimate, heterosexual plots of pre-twentieth-century Anglo-American culture.

I see this work on Dickinson as exemplary for understandings of such other, culturally, central, homosocially embedded women authors as Austen and, for example, the Brontës. (Surely there are important generalizations yet to be made about the attachments of sisters, perhaps of any siblings, who live together as adults.) But as I have suggested, the first range of questions yet to be asked properly in this context concerns the emergence and cultural entailments of "sexual identity" itself during this period of the incipience of "sexual identity" in its (still incompletely interrogated) modern senses. Indeed, one of the motives for this project is to denaturalize any presumptive understanding of the relation of "hetero" to "homo" as modern sexual identities—the presumption, for instance, of their symmetry, their mutual impermeability, or even of their both functioning as "sexual identities" in the same sense; the presumption, as well, that "hetero" and "homo," even with the possible addition of "bi," do efficiently and additively divide up the universe of sexual orientation. It seems likely to me that in Austen's time, *as in our own*, the specification of any distinct "sexual identity" magnetized and reoriented in new ways the heterogeneous erotic and epistemological energies of everyone in its social vicinity, without at the same time either adequating or descriptively exhausting those energies.

One "sexual identity" that did exist as such in Austen's time, already bringing a specific genital practice into dense compaction with issues of consciousness, truth, pedagogy, and confession, was that of the onanist. Among the sexual dimensions overridden within the past century by the world-historical homo/hetero cleavage is the one that discriminates, in the first place, the autoerotic and the alloerotic. Its history has been illuminated by recent researches of a number of scholars.[12] According to their accounts, the European phobia over masturbation came early in the "sexualizing" process described by Foucault, beginning around 1700 with publication of *Onania*, and spreading virulently after the 1750s. Although originally applied with a relative impartiality to both sexes, antionanist discourse seems to have bifurcated in the nineteenth century, and the systems of surveillance and the rhetorics of "confession" for the two genders contributed to the emergence of disparate regulatory categories and techniques, even regulatory worlds. According to Ed Cohen, for example, anxiety about boys' masturbation motivated mechanisms of school discipline and surveillance that were to contribute so much to the late-nineteenth-century emergence of a widespread, class-inflected male homo-

sexual identity and hence to the modern crisis of male homo/ heterosexual defin-
ition. On the other hand, anxiety about girls' and women's masturbation con-
tributed more to the emergence of gynecology, through an accumulated expertise
in and demand for genital surgery; of such identities as that of the hysteric; and of
such confession-inducing disciplinary discourses as psychoanalysis.

Far from there persisting a minority identity of "the masturbator" today, of
course, autoeroticism per se in the twentieth century has been conclusively sub-
sumed under that normalizing developmental model, differently but perhaps
equally demeaning, according to which it represents a relatively innocuous way
station on the road to a "full," i.e. alloerotic, adult genitality defined almost exclu-
sively by gender of object choice. As Foucault and others have noted, a lush plu-
rality of (proscribed and regulated) sexual identities had developed by the end of
the nineteenth century: even the most canonical late-Victorian art and literature
are full of sadomasochistic, pederastic and pedophilic, necrophilic, as well as auto-
erotic images and preoccupations; while Foucault mentions the hysterical woman
and the masturbating child along with "entomologized" sexological categories
such as zoophiles, zooerasts, automonosexualists, and gynecomasts, as typifying
the new sexual taxonomies, the sexual *"specification of individuals,"* that he sees as
inaugurating the twentieth-century regime of sexuality.[13] Although Foucault is
concerned to demonstrate our own continuity with nineteenth-century sexual dis-
course, however (appealing to his readers as "we 'Other Victorians'"),[14] it makes a
yet-to-be-explored difference that the Victorian multiplication of sexual species
has today all but boiled down to a single, bare—and moreover fiercely invidious—
dichotomy. Most of us now correctly understand a question about our "sexual ori-
entation" to be a demand that we classify ourselves as a heterosexual or a homo-
sexual, regardless of whether we may or may not individually be able or willing
to perform that blank, binarized act of category assignment. We also understand
that the two available categories are not symmetrically but hierarchically consti-
tuted in relation to each other. The identity of the masturbator was only one of the
sexual identities subsumed, erased, or overridden in this triumph of the hetero-
sexist homo/hetero calculus. But I want to argue here that the status of the mas-
turbator among these many identities was uniquely formative. I would suggest
that, as one of the very earliest embodiments of "sexual identity" in the period of
the progressive epistemological overloading of sexuality, the masturbator may have
been at the cynosural center of a remapping of individual identity, will, attention,
and privacy along modern lines that the reign of "sexuality," and its generic con-
comitant in the novel, and in novelistic point of view, now lead us to take for

granted. It is of more than chronological import if the (lost) identity of the masturbator was the proto-form of modern sexual identity itself.

Thus it seems likely that in our reimaginings of the history of sexuality "as" (we vainly imagine) "we know it," through readings of classic texts, the dropping out of sight of the autoerotic term is also part of what falsely naturalizes the heterosexist imposition of these books, disguising both the rich, conflictual erotic complication of a homoerotic matrix not yet crystallized in terms of "sexual identity" and the violence of heterosexist definition finally carved out of these plots. I am taking *Sense and Sensibility* as my example here because of its odd position, at once germinal and abjected, in the Austen canon and hence in "the history of the novel"; and because its erotic axis is most obviously the unwavering but difficult love of a woman, Elinor Dashwood, for a woman, Marianne Dashwood. I don't think we can bring this desire into clear focus until we also see how Marianne's erotic identity, in turn, is not in the first place exactly either a same-sex-loving one or a cross-sex-loving one (though she loves both women and men), but rather the one that today no longer exists *as* an identity: that of the masturbating girl.

Reading the bedroom scenes of *Sense and Sensibility*, I find I have lodged in my mind a bedroom scene from another document, a narrative structured as a case history of "Onanism and Nervous Disorders in Two Little Girls" and dated "1881":

> Sometimes [X … 's] face is flushed and she has a roving eye; at others she is pale and listless. Often she cannot keep still, pacing up and down the bedroom, or balancing on one foot after the other…. During these bouts X … is incapable of anything: reading, conversation, games, are equally odious. All at once her expression becomes cynical, her excitement mounts. X … is overcome by the desire to do it, she tries not to or someone tries to stop her. Her only dominating thought is to succeed. Her eyes dart in all directions, her lips never stop twitching, her nostrils flare! Later, she calms down and is herself again. "If only I had never been born," she says to her little sister, "we would not have been a disgrace to the family!" And Y … replies: "Why did you teach me all these horrors then?" Upset by the reproach, X … says: "If someone would only kill me! What joy. I could die without committing suicide."[15]

If what defines "sexual identity" is the impaction of epistemological issues around the core of a particular genital possibility, then the compulsive attention paid by antionanist discourse to disorders *of* attention makes it a suitable point of

inauguration for modern sexuality. Marianne Dashwood, though highly intelligent, exhibits the classic consciousness symptoms noted by Tissot in 1758, including "the impairment of memory and the senses," "inability to confine the attention," and "an air of distraction, embarrassment and stupidity."[16] A surprising amount of the narrative tension of *Sense and Sensibility* comes from the bent bow of the absentation of Marianne's attention from wherever she is. "Great," at one characteristic moment, "was the perturbation of her spirits and her impatience to be gone" (p. 174); once out on the urban scene, on the other hand, "her eyes were in constant inquiry; and in whatever shop the party were engaged, her mind was equally abstracted from every thing actually before them, from all that interested and occupied the others. Restless and dissatisfied every where...she received no pleasure from any thing; was only impatient to be at home again..." (p. 180). Yet when at home, her "agitation increased as the evening drew on. She could scarcely eat any dinner, and when they afterwards returned to the drawing room, seemed anxiously listening to the sound of every carriage" (p. 177).

Marianne incarnates physical as well as perceptual irritability, to both pleasurable and painful effect. Addicted to "rapidity" (p. 75) and "requiring at once solitude and continual change of place" (p. 193), she responds to anything more sedentary with the characteristic ejaculation: "I could hardly keep my seat" (p. 51). Sitting is the most painful and exciting thing for her. Her impatience keeps her "moving from one chair to another" (p. 266) or "[getting] up, and walk[ing] about the room" (p. 269). At the happiest moments, she frankly pursues the locomotor pleasures of her own body, "running with all possible speed down the steep side of the hill" (p. 74) (and spraining her ankle in a tumble), eager for "the delight of a gallop" when Willoughby offers her a horse (p. 88). To quote again from the document dated 1881,

> In addition to the practices already cited, X ... provoked the voluptuous spasm by rubbing herself on the angles of furniture, by pressing her thighs together, or rocking backwards and forwards on a chair. Out walking she would begin to limp in an odd way as if she were lop-sided, or kept lifting one of her feet. At other times she took little steps, walked quickly, or turned abruptly left ... If she saw some shrub she straddled it and rubbed herself back and forth ... She pretended to fall or stumble over something in order to rub against it. (DZ, pp. 26–27)

Exactly the overresponsive centrality of Marianne's tender "seat" as a node of delight, resistance, and surrender—and its crucial position, as well, between the

homosocial and heterosocial avidities of the plot—is harnessed when Elinor manipulates Marianne into rejecting Willoughby's gift of the horse:

> Elinor thought it wisest to touch that point no more.... Opposition on so tender a subject would only attach her the more to her own opinion. But by an appeal to her affection for her mother ... Marianne was shortly subdued. (p. 89)

The vision of a certain autoerotic closure, absentation, self-sufficiency in Marianne is radiantly attractive to almost everyone, female and male, who views her; at the same time, the same autoerotic inaccessibility is legible to them through contemporaneous discourses as a horrifying staging of autoconsumption. As was typical until the end of the nineteenth century, Marianne's autoeroticism is not defined in opposition to her alloerotic bonds, whether with men or with women. Rather, it signifies an excess of sexuality altogether, an excess dangerous to others but chiefly to herself: the chastening illness that ultimately wastes her physical substance is both the image and the punishment of the "distracted" sexuality that, continually "forgetting itself," threatens, in her person, to subvert the novel's boundaries between the public and the private.

More from the manuscript dated 1881:

> The 19th [September]. Third cauterisation of little Y ... who sobs and vociferates.
>
> In the days that followed Y ... fought successfully against temptation. She became a child again, playing with her doll, amusing herself and laughing gayly. She begs to have her hands tied each time she is not sure of herself.... Often she is seen to make an effort at control. Nonetheless she does it two or three times every twenty-four hours.... But X ... more and more drops all pretense of modesty. One night she succeeds in rubbing herself till the blood comes on the straps that bind her. Another time, caught in the act by the governess and unable to satisfy herself, she has one of her terrible fits of rage, during which she yells: "I want to, oh how I want to! You can't understand, Mademoiselle, how I want to do it!" Her memory begins to fail. She can no longer keep up with lessons. She has hallucinations all the time....
>
> The 23rd, she repeats: "I deserve to be burnt and I will be. I will be brave during the operation, I won't cry." From ten at night until six in the morning, she has a terrible attack, falling several times into a swoon that lasted about a quarter of an hour. At times she had visual hallucinations. At other times she became delirious, wild eyed, saying "Turn the page, who is hitting me, etc."

> The 25th I apply a hot point to X's clitoris. She submits to the operation without wincing, and for twenty-four hours after the operation she is perfectly good. But then she returns with renewed frenzy to her old habits. (DZ, pp. 33)

As undisciplined as Marianne Dashwood's "abstracted" attention is, the farouche, absent presence of this figure compellingly reorganizes the attention of others: Elinor's rapt attention to her, to begin with, but also, through Elinor's, the reader's. *Sense and Sensibility* is unusual among Austen novels not for the (fair but unrigorous) consistency with which its narrative point of view is routed through a single character, Elinor; but rather for the undeviating consistency with which Elinor's regard in turn is vectored in the direction of her beloved. Elinor's self-imposed obligation to offer social countenance to the restless, insulting, magnetic, and dangerous abstraction of her sister constitutes most of the plot of the novel.

It constitutes more than plot, in fact; it creates both the consciousness and the privacy of the novel. The projectile of surveillance, epistemological demand, and remediation that both desire and "responsibility" constrain Elinor to level at Marianne, immobilized or turned back on herself by the always-newly-summoned-up delicacy of her refusal to press Marianne toward her confession, make an internal space—internal, that is, to Elinor, hence to the reader hovering somewhere behind her eyes—from which there is no escape but more silent watching. About the engagement she is said to assume to exist between Marianne and Willoughby, for example her "wonder"

> was engrossed by the extraordinary silence of her sister and Willoughby on the subject.... Why they should not openly acknowledge to her mother and herself, what their constant behaviour to each other declared to have taken place, Elinor could not imagine.
>
> ... For this strange kind of secrecy maintained by them relative to their engagement, which in fact concealed nothing at all, she could not account; and it was so wholly contradictory to their general opinions and practice, that a doubt sometimes entered her mind of their being really engaged, and this doubt was enough to prevent her making any enquiry of Marianne. (p. 100)

To Marianne, on the other hand, the question of an engagement seems simply not to have arisen.

The insulation of Marianne from Elinor's own unhappiness, when Elinor is unhappy; the buffering of Marianne's impulsiveness, and the absorption or,

where that is impossible, coverture of her terrible sufferings; the constant, reparative concealment of Marianne's elopements of attention from their present company: these activities hollow out a subjectivity for Elinor and the novel that might best be described in the 1980s jargon of codependency, were not the pathologizing stigma of that term belied by the fact that, at least as far as this novel is concerned, the codependent subjectivity simply *is subjectivity*. Even Elinor's heterosexual plot with Edward Ferrars merely divides her remedial solicitude (that distinctive amalgam of "tenderness, pity, approbation, censure, and doubt" [p. 129]) between the sister who remains her first concern, and Edward as a second sufferer from *mauvaise honte*, the telltale "embarrassment," "settled" "absence of mind" (p. 123), unsocialized shyness, "want of spirits, of openness, and of consistency," "the same fettered inclination, the same inevitable necessity of temporizing with his mother" (p. 126), and a "desponding turn of mind" (p. 128), all consequent on his own servitude to an erotic habit formed in the idleness and isolation of an improperly supervised youth.

The codependency model is the less anachronistic, as Marianne's and Edward's disorders share with the pre-twentieth-century version of masturbation the property of being structured as addictions. (Here, of course, I'm inviting a meditation on the history of the term "self-abuse," which referred to masturbation from the eighteenth century until very recently—when it's come, perhaps by analogy to "child abuse," to refer to battering or mutilation of oneself. Where that older sense of "abuse" has resurfaced, on the other hand, is in the also very recent coinage, "substance abuse.") Back to 1881:

> The afternoon of the 14th of September X ... is in a terribly overexcited state. She walks about restlessly, grinding her teeth.... There is foam on her lips, she gasps, repeating, "I don't want to, I don't want to, I can't stop myself, I must do it! Stop me, hold my hands, tie my feet!" A few moments later she falls into a state of prostration, becomes sweet and gentle, begging to be given another chance. "I know I'm killing myself," she says. "Save me." (DZ, p. 30)

Although *the addict*, as a medicalized personal identity, was (as Virginia Berridge and Griffith Edwards demonstrate in *Opium and the People*) another product of the late nineteenth century, the hypostatization of the notion of "will" that would soon give rise to the "addict" identity, and that by the late twentieth century would leave no issue of voluntary untinged by the concept of addiction, is already in place in *Sense and Sensibility*.[17] A concept of addiction

involves understanding something called "the will" as a muscle that can strengthen with exercise or atrophy with disuse; the particular muscle on which "will" is modeled in this novel is a sphincter, which, when properly toned, defines an internal space of private identity by holding some kinds of material inside, even while guarding against the admission of others. Marianne's unpracticed muscle lets her privacy dribble away, giving her "neither courage to speak of, nor fortitude to conceal" (p. 333) the anguish she experiences. By contrast, in the moment of Elinor's profoundest happiness, when Marianne is restored from a grave illness, Elinor's well-exercised muscle guarantees that what expands with her joy is the private space that, constituting her self, constitutes it also as the space of narrative self-reflection (not to say hoarding):

> Elinor could not be cheerful. Her joy was of a different kind, and led to anything rather than to gaiety. Marianne restored to life, health, friends, and to her doating mother, was an idea to fill her heart with sensations of exquisite comfort, and expand it in fervent gratitude;—but it led to no outward demonstrations of joy, no words, no smiles. All within Elinor's breast was satisfaction, silent and strong. (p. 310)

Such an apparently generalizable ideal of individual integrity, the unitary self-containment of the strong, silent type, can never be stable, of course. Elinor has constructed herself in this way around an original lack: the absentation of her sister, and perhaps in the first place the withholding from herself of the love of their mother, whom she then compulsively unites with Marianne, the favorite, in the love-drenched tableaux of her imagination. In the inappropriately pathologizing but descriptively acute language of self-help, Marianne's addiction has mobilized in her sister a discipline that, posed as against addiction, nonetheless also is one. Elinor's pupils, those less tractable sphincters of the soul, won't close against the hapless hemorrhaging of her visual attention flow toward Marianne; it is this, indeed, that renders her consciousness, in turn, habitable, inviting, and formative to readers as "point of view."

But that hypostatization of "will" had always anyway contained the potential for the infinite regress enacted in the uncircumscribable twentieth-century epidemic of addiction attribution: the degenerative problem of where, if not in some further compulsion, one looks for the will *to* will. As when Marianne, comparing herself with the more continent Elinor,

felt all the force of that comparison, but not as her sister had hoped, to urge her to exertion now; she felt it with all the pain of continual self-reproach, regretted most bitterly that she had never exerted herself before; but it brought only the torture of penitence, without the hope of amendment. Her mind was so much weakened that she still fancied present exertion impossible, and therefore it only dispirited her the more. (p. 270)

In addition, the concept of addiction involves a degenerative perceptual narrative of progressively deadened receptiveness to a stimulus that therefore requires to be steadily increased—as when Marianne's and her mother's "agony of grief" over the death of the father, at first overpowering, was then "voluntarily renewed, was sought for, was created again and again" (p. 42). Paradoxically afflicted, as Marianne is, by both hyperesthesia and an emboldening and addiction-producing absent-mindedness "an heart hardened against [her friends'] merits, and a temper irritated by their very attention" (p. 337), the species of the masturbating girl was described by Augustus Kinsley Gardner in 1860 as one

> in whom the least impression is redoubled like that of a "tam-tam," [yet who seeks] for emotions still more violent and more varied. It is this necessity which nothing can appease, which took the Roman women to the spectacles where men were devoured by ferocious beasts.... It is the emptiness of an unquiet and sombre soul seeking some activity, which clings to the slightest incident of life, to elicit from it some emotion which forever escapes; in short, it is the deception and disgust of existence.[18]

The subjectivity hollowed out by *Sense and Sensibility*, then, and made available *as* subjectivity for heterosexual expropriation, is not Marianne's but Elinor's; the novel's achievement of a modern psychological interiority fit for the heterosexual romance plot is created for Elinor through her completely one-directional visual fixation on her sister's specularized, desired, envied, and punished autoeroticism. This also offers, however, a useful model for the chains of reader relations constructed by the punishing, girl-centered moral pedagogy and erotics of Austen's novels more generally. Austen criticism is notable mostly, not just for its timidity and banality, but for its unresting exaction of the spectacle of a Girl Being Taught a Lesson—for the vengefulness it vents on the heroines whom it purports to love, and whom, perhaps, it does. Thus Tony Tanner, the

ultimate normal and normalizing reader of Austen, structures sentence after sentence: "Emma…*has to be tutored*…into correct vision and responsible speech. Anne Elliot *has to move*, painfully, from an excessive prudence."[19] "Some Jane Austen heroines *have to learn* their true 'duties.' They all *have to find* their proper homes" (TT, p. 33). Catherine "quite literally is in danger of perverting reality, and one of the things she *has to learn* is to break out of quotations" (TT, pp. 44-45); she "*has to be disabused* of her naive and foolish 'Gothic' expectations" (TT, p. 48). [Elizabeth and Darcy] *have to learn to see* that their novel is more properly called…" (TT, p. 105). A lot of Austen criticism sounds hilariously like the leering school prospectuses or governess manifestoes brandished like so many birch rods in Victorian S-M pornography. Thus Jane Nardin:

> The discipline that helps create the moral adult need not necessarily be administered in early childhood. Frequently, as we have seen, it is not—for its absence is useful in helping to create the problems with which the novel deals. But if adequate discipline is lacking in childhood, it must be supplied later, and this happens only when the character learns "the lessons of affliction" (*Mansfield Park*, p. 459). Only after immaturity, selfishness, and excessive self-confidence have produced error, trouble, and real suffering, can the adult begin to teach himself or herself the habits of criticism and self-control which should have been inculcated in childhood.[20]

How can it have taken this long to see that when Colonel Brandon and Marianne finally get together, their first granddaughter will be Lesbia Brandon?

Even readings of Austen that are not so frankly repressive have tended to be structured by what Foucault calls "the repressive hypothesis"—especially so, indeed, to the degree that their project is avowedly *anti*-repressive. And these anti-repressive readings have their own way of recreating the spectacle of the girl being taught a lesson. Call her, in this case, "Jane Austen." The sight to be relished here is, as in psychoanalysis, the forcible exaction from her manifest text of what can only be the barest confession of a self-pleasuring sexuality, a disorder or subversion, seeping out at the edges of a political conservatism always presumed and therefore always available for violation. That virginal figure "Jane Austen," in these narratives, is herself the punishable girl who "has to learn," "has to be tutored"—in truths with which, though derived from a reading of Austen, the figure of "Jane Austen" can no more be credited than can, for their lessons, the figures "Marianne," "Emma," or, shall we say, "Dora" or "Anna O."

It is partly to interrupt this seemingly interminable scene of punitive/pedagogical reading, interminably structured as it is by the concept of repression, that I want to make available the sense of an alternative, passionate sexual ecology—one fully available to Austen for her exciting, productive, and deliberate use, in a way it no longer is to us.

That is to say, it is no longer available to us *as passion*; even as its cynosural figure, the masturbating girl, is no longer visible as possessing a sexual identity capable of redefining and reorganizing her surroundings. We inherit it only in the residual forms of perception itself, of subjectivity itself, of institution itself. The last time I taught *Sense and Sensibility*, I handed out to my graduate class copies of some pages from the 1981 "Polysexuality" issue of *Semiotext(e)*, pages that reproduce without historical annotation what appears to be a late-nineteenth-century medical case history in French, from which I have also been quoting here. I handed it out then for reasons no more transparent than those that have induced me to quote from it here—beyond the true but inadequate notation that even eight years after reading it, my memory of the piece wouldn't let up its pressure on the gaze I was capable of leveling at the Austen novel. I hadn't even the New Historicists' positivist alibi for perpetuating and disseminating the shock of the violent narratives in which they trade: "Deal," don't they seem tacitly but moralistically to enjoin, "deal with your own terror, your own arousal, your disavowals, in your own way, on your own time, in your own [thereby reconstituted as invisible] privacy; it's not our responsibility, because *these awful things are real.*" Surely I did want to spread around to a group of other readers, as if that would ground or diffuse it, the inadmissibly, inabsorbably complex shock of this document. But the pretext of the real was austerely withheld by the informal, perhaps only superficially sensationalistic *Semiotext(e)* format, which refused to proffer the legitimating scholarly apparatus that would give any reader the assurance of "knowing" whether the original of this document was to be looked for in an actual nineteenth-century psychiatric archive or, alternatively and every bit as credibly, in a manuscript of pornographic fiction dating from any time—any time including the present—in the intervening century. Certainly plenty of the other pieces in that issue of *Semiotext(e)* are, whatever else they are, freshly minted and joltingly potent pornography; just as certainly, nothing in the "1881" document exceeds in any detail the known practices of late-nineteenth-century medicine. And wasn't that part of the shock?—the total plausibility either way of the same masturbatory narrative, the same pruriently cool clinical gaze at it and violating hands and instruments on it, even (one might add) further along the chain, the same assimilability of it to the pseudo-distantiating

relish of sophisticated contemporary projects of critique. Toward the site of the absent, distracted, and embarrassed attention of the masturbatory subject, the directing of a less accountable flood of discursive attention has continued. What is most astonishing is its continuing entirely unabated by the dissolution of its object, the sexual identity of "the masturbator" herself.

Through the frame of 1881/1981 it becomes easier to see how most of the love story of *Sense and Sensibility*, no simple one, has been rendered all but invisible to most readers, leaving a dryly static tableau of discrete, moralized portraits, poised antitheses, and exemplary, deplorable, or regrettably necessary punishments, in an ascetic heterosexualizing context.[21] This tableau is what we now know as "Jane Austen"; fossilized residue of the now subtracted autoerotic spectacle, "Jane Austen" is the name whose uncanny fit with the phrase "masturbating girl" today makes a ne plus ultra of the incongruous.

This history of impoverished "Jane Austen" readings is not the result of a failure by readers to "contextualize historically": a New Historicizing point that you can't understand *Sense and Sensibility* without entering into the alterity of a bygone masturbation phobia is hardly the one I am making. What alterity? I am more struck by how profoundly, how destructively, twentieth-century readings are already shaped by the discourse of masturbation and its sequelae: *more* destructively than the novel is, even though onanism per se, and the phobia against it, are living issues in the novel as they no longer are today.

We can be the less surprised by the congruence as we see masturbation and the relations surrounding it as the proto-form of any modern "sexual identity"; thus as lending their structure to many vantages of subjectivity that have survived the definitional atrophy of the masturbator as an identity: pedagogic surveillance, as we have mentioned, homo/hetero divides, psychiatry, psychoanalysis, gynecology. The interpretive habits that make it so hard to register the erotics of *Sense and Sensibility* are deeply and familiarly encoded in the therapeutic or mock-therapeutic rhetoric of the "1881" document. They involve the immobilizing framing of an isolated sexual subject (a subject, that is, whose isolation is decreed by her identification with a nameable sexual identity); and her staging as a challenge or question addressed to an audience whose erotic invisibility is guaranteed by the same definitional stroke as their entitlement to intervene on the sexuality attributed to her. That it was this particular, apparently unitary and in some ways self-contained, autoerotic sexual identity that crystallized as the prototype of "sexual identity" made that isolating embodiment of "the sexual" easier, and made easier as well a radical naturalization and erotic

dematerialization of narrative point of view concerning it.

And the dropping out of sight in this century of the masturbatory identity has only, it seems, given more the authority of self-evidence to the scientific, therapeutic, institutional, and narrative relations originally organized around it. *Sense and Sensibility* resists such "progress" only insofar as we can succeed in making narratively palpable again, under the pressures of our own needs, the great and estranging force of the homoerotic longing magnetized in it by that radiant and inattentive presence—the female figure of the love that keeps forgetting its name.

NOTES

"Jane Austen and the Masturbating Girl" was written in 1990, based on a paper delivered at the Modern Language Association in 1989. What I refer to as the "1881" document from *Semiotext(e)* (see n. 15, above) was later published, under less equivocal scholarly auspices, in Jeffrey Mousaieff Masson's collection, *A Dark Science: Women, Sexuality, and Psychiatry in the Nineteenth Century* (New York: Farrar, Straus and Giroux, 1986); Démétrius Alexandre Zambaco, "Masturbation and Psychological Problems in Two Little Girls," pp. 61–89, trans. Masson and Marianne Loring from "Onanisme avec troubles nerveux chez deux petites filles," *L'Encéphale*, vol. 2 (1882), pp. 88–95, 260–74.

The project sketched out in this chapter has evoked, not only the foreclosing and disavowing responses mentioned in its first paragraph, but help, encouragement, and fellowship as well: from Michael Moon, Paula Bennett, Vernon Rosario, Ed Cohen, Barbara Hernstein Smith, and Jonathan Goldberg, among others.

1. Kimball, *Tenured Radicals*, pp. 145–46.

2. See, for a few examples of the phrase's career in journalism, Roger Rosenblatt, "The Universities: A Bitter Attack ...," *New York Times Book Review*, 22 April 1990, p. 3; letters in the *Book Review*, 20 May 1990, p. 54, including one from Catharine R. Stimpson disputing the evidential status of the phrase; Richard Bernstein, "The Rising Hegemony of the Politically Correct: America's Fashionable Orthodoxy," *New York Times*, 28 October 1990, sec. 4 (Week in Review), pp. 1, 4.

3. Jane E. Brody, "Personal Health," *New York Times*, 4 November 1987.

4. Rosenblatt, "The Universities," p. 3.

5. John Mullan, *Sentiment and Sociability: The Language of Feeling in the Eighteenth Century* (New York: Oxford University Press, 1988), esp. pp. 201–40.

6. Neil Hertz, *The End of the Line* (New York: Columbia University Press, 1985), pp. 148–49.

7. Vernon A. Rosario II, "The 19th-Century Medical Politics of Self-Defilement and Seminal Economy," presented at the Center for Literary and Cultural Studies, Harvard University, "Nationalisms and Sexualities" conference, June 1989, p. 18.

8. Jane Austen, *Sense and Sensibility* (Harmondsworth, Middlesex: Penguin Books, 1967), p. 193. Further citations from this edition are incorporated in the text.

9. This is (in relation to women) the argument of, most influentially, Lillian Faderman in *Surpassing the Love of Men: Romantic Friendship and Love between Women from the Renaissance to the Present* (New York: William Morrow, 1981), and Smith-Rosenberg in "The Female World of Love and Ritual." A recently discovered journal, published as *I Know My Own Heart: The Diaries of Anne Lister* (1791–1840), ed. Helena Whitbread (London: Virago, 1988), suggests that revisions of this narrative may, however, be necessary. It is the diary (for 1817–23) of a young, cultured, religious, socially conservative, self-aware, land-owning rural Englishwoman—an almost archetypal Jane Austen heroine—who formed her sense of self around the pursuit and enjoyment of genital contact and short- and long-term intimacies with other women of various classes.

10. Foucault, *The History of Sexuality*, p. 1.

11. Paula Bennett, *My Life A Loaded Gun: Female Creativity and Feminist Poetics* (Boston: Beacon Press, 1986), pp. 13–94; *Emily Dickinson: Woman Poet* (Iowa City: University of Iowa Press, 1990).

12. Useful historical work touching on masturbation and masturbation phobia includes G. J. Barker-Benfield, *The Horrors of the Half-Known Life: Male Attitudes Toward Women and Sexuality in Nineteenth-Century America* (New York: Harper and Row, 1976); Ed Cohen, *Talk on the Wilde Side* (New York: Routledge, 1993); John D'Emilio and Estelle B. Freedman, *Intimate Matters: A History of Sexuality in America* (New York: Harper and Row, 1988); E. H. Hare, "Masturbatory Insanity: The History of an Idea," *Journal of the Mental Sciences* 108 (1962): 1–25; Robert H. MacDonald, "The Frightful Consequences of Onanism: Notes on the History of a Delusion," *Journal of the History of Ideas* 28 (1967): 423–31; John Money, *The Destroying Angel: Sex, Fitness and Food in the Legacy of Degeneracy Theory, Graham Crackers, Kellogg's Corn Flakes and the American Health History* (Buffalo, N.Y.: Prometheus, 1985); George L. Mosse, *Nationalism and Sexuality: Respectability and Abnormal Sexuality in Modern Europe* (New York: Fertig, 1985); Robert P. Neuman, "Masturbation, Madness, and the Modern Concept of Childhood and Adolescence," *Journal of Social History* 8 (1975): 1–22; Elaine Showalter, *The Female Malady: Women, Madness, and English Culture, 1830–1980* (New York: Pantheon Books, 1985); Smith-Rosenberg, *Disorderly Conduct*; and Jean Stengers and Anne van Neck, *Histoire d'une grande peur: la masturbation* (Brussels: Editions de l'Université de Bruxelles, 1984).

13. Foucault, *History of Sexuality*, I:105, 43.

14. Ibid., I:1.

15. Démétrius Zambaco, "Onanism and Nervous Disorders in Two Little Girls," trans. Catherine Duncan, *Semiotext(e)* 4 ("Polysexuality") (1981): 30; further citations are incorporated in the text as DZ. The letters standing in place of the girls' names are followed by

ellipses in the original; other ellipses are mine. In quoting from this piece I have silently corrected some obvious typographical errors; since this issue of *Semiotext(e)* is printed entirely in capital letters, and with commas and periods of indistinguishable shape, I have also had to make some guesses about sentence division and punctuation.

16. Quoted and discussed in Cohen, *Talk on the Wilde Side*, pp. 89–90.

17. Virginia Berridge and Griffith Edwards, *Opium and the People: Opiate Use in Nineteenth-Century England*, 2d ed. (New Haven, Conn.: Yale University Press, 1987). For more on the epistemology of addiction, codependency, and addiction attribution, see my chapter "Epidemics of the Will," in *Tendencies* (Durham, NC: Duke University Press, 1993).

18. Augustus Kinsley Gardner, "Physical Decline of American Women" (1860), quoted in Barker-Benfield, *Horrors of the Half-Known Life*, pp. 273–74.

19. Tony Tanner, *Jane Austen* (Cambridge, Mass.: Harvard University Press, 1986), p. 6; page numbers of remaining quotations cited in the text with TT; emphasis, in each case, added.

20. She is remarkably unworried about any possible excess of severity: "In this group of characters [in *Mansfield Park*], lack of discipline has the expected effect, while excessive discipline, though it causes suffering and creates some problems for Fanny and Susan Price, does indeed make them into hard-working, extremely conscientious women. The timidity and self-doubt which characterize Fanny, and which are a response to continual censure, seem a reasonable price to pay for the strong conscience that even the unfair discipline she received has nurtured in her." Jane Nardin, "Children and Their Families," *Jane Austen: New Perspectives*, ed. Janet Todd, Women and Literature, New Series, vol. 3 (New York: Holmes and Meier, 1983), pp. 73–87; both passages quoted are from p. 83.

21. As Mullan's *Sentiment and Sociability* suggests —and not only through the evocation of Austen's novel in its title—the eponymous antithesis "sense" vs. "sensibility" is undone by, quite specifically, the way sensibility itself functions as a point of pivotal intersection, and potentially of mutual coverture, between alloerotic and autoerotic investments. Mullan would refer to these as "sociability" vs. "isolation," "solipsism," or "hypochondria." He ignores specifically antimasturbatory medical campaigns in his discussion of late-eighteenth-century medicine, but their relevance is clear enough in, for example, the discussion he does offer of the contemporaneous medical phenomenology of menstruation. "Menstruation is represented as an irregularity which takes the guise of a regularity; it is especially likely to signify a precarious condition in the bodies of those for whom womanhood does not mean the life of the fertile, domesticated, married female. Those particularly at risk are the unmarried, the ageing, and the sexually precocious" (p. 226). "The paradox, of course, is that to concentrate upon the palpitating, sensitized body of the woman caught in the difficult area between childhood and marriage is also to concede the dangers of this condition—those dangers which feature, in another form, in writings on hysteria" (p. 228). In *Epistemology of the Closet*, especially pp. 141–81, I discuss at some length the stage historical career of the epithets "sentimentality" and "sensibility" in terms of the inflammatory and scapegoating mechanics of vicariation: of the coverture offered by these apparently static nouns to the most volatile readerly interchanges between the allo- and the auto-.

6

THE SOCIAL EVIL, THE SOLITARY VICE,
AND POURING TEA

THOMAS W. LAQUEUR

I want to sneak up on a cultural interpretation of the purported fact, widely held among nineteenth-century observers, that prostitutes are barren. My general point is that talk about sex is about a great deal else than organs, bodies, and pleasures.

It is striking, for example, how little the Greek Church Father Gregory of Nyssa is explicitly concerned with sexual intercourse or desire in his tract *On Virginity*. Instead he returns again and again to the pain of human existence—as long as men, "these mortal creatures, exist and look upon the tombs of those from whom they came into being, they have grief inseparably joined to their lives"—and specifically to the enormous anxieties of social reproduction. "Assume that the moment of childbirth is at hand; it is not the birth of the child, but the presence of death that is thought of, and the death of the mother anticipated." He enumerates the emotional commitment of being a parent: one's efforts on behalf of a child's happiness, success, life itself. Marriage, in short, is a momentous investment in the future of the social order.[1]

And virginity is a very different sort of commitment, a commitment of the soul, and by no means of the body alone, to a new and different community in Christ. As Peter Brown has recently argued, "the debate about virginity [in the early Church] was in large part a debate about the nature of human solidarity. It was a debate about what the individual did and did not need to share with fellow creatures."[2]

I make this detour in order to turn attention away from sexuality as an innate human quality that needs to be, and is, repressed in various ways at various times, or even as a historically contingent construct, following Foucault and Nietzsche, which is woven into the sinews of power. I want instead to dwell on the constitutive connection between the sexual and the social body. "Society haunts the body's sexuality," as Maurice Godelier puts it; but the body's sexuality also haunts society.[3] It proclaims deep and conflicting cultural ambitions and anxieties.

In the nineteenth century, virginity is of course no longer the issue. But the body's sexuality, in the specters of prostitution and masturbation this time, still haunts society. Their names bespeak their threat: the social evil; the solitary vice. Both terms are new and both reveal the perceived new dangers of very old practices.

I want to consider briefly the political and sexual radical Richard Carlile's treatment of the latter—the solitary vice—to emphasize how much the concern for masturbation can be construed as a concern about "the nature of human solidarity," and how little it appears to be a worry about excess or wicked sexual desire. Sociability and not repression is at stake. Carlile's *Every Woman's Book* is a sustained attack on conventional sexual morality, a plea for freeing the passions, and a practical guide to birth control. Love is natural and only its fruits can and should be controlled; marriage laws constrain excessively a passion that should not be forced or shackled; and so on. Carlile advocates Temples of Venus for the controlled, health-preserving, though extramarital satisfaction of female desire—he thought that five-sixths of deaths from consumption among young girls resulted from want of sexual commerce and perhaps as much as nine-tenths of all other illnesses as well.

But on the subject of masturbation Carlile the sexual radical is as shrill as the most evangelically inspired moralist or alarmist physician. Born of the cloister or its modern equivalents, where a diseased religion turns love into sin, "the appeasing of lascivious excitement in females by artificial means" or the "accomplishment of seminal excretion in the male" is not only wicked but physically destructive as well. Masturbation leads to disease of mind and body. Indeed the "natural and healthy commerce between the sexes" for which he offers the technology is explicitly linked to the abolition of prostitution, masturbation, pederasty, and other unnatural practices.[4]

The contrast could not be clearer between a fundamentally asocial or socially

degenerative practice—the pathogenic, solitary sex of the cloister—and the vital, socially constructive act of heterosexual intercourse. But the supposed physical sequelae of masturbation seem almost a secondary reaction to its underlying social pathology. The emphasis in "the solitary vice" should perhaps be less on "vice," understood as the fulfillment of illegitimate desire, than on "solitary," the channeling of perfectly healthy desire back into itself. The debate over masturbation that raged from the eighteenth century onward might therefore be understood as part of the more general debate about the unleashing of desire upon which a commercial economy depended and about the possibility of human community under these circumstances—a sexual version of the classic "Adam Smith problem."

Prostitution is the other great arena in which the battle against unsocialized sex and its dangers in a potentially fragmented culture was fought. "Whoring," of course, had long been regarded as wicked and detrimental to the commonweal but so had drunkenness, blasphemy and other disturbances of the peace. Not until the nineteenth century did it rise to being "*the* social evil," a particularly disruptive, singularly threatening vice. How this happened is a long story of which I want to tell only a small part.

Prostitutes were generally regarded as an unproductive commodity. Because they were *public* women; because so much traffic passed over their reproductive organs; because in them the semen of so many men was mixed, pell-mell, together; because the ovaries of prostitutes, through overstimulation, were seldom without morbid lesions; because their fallopian tubes were closed by too frequent intercourse; or, most tellingly, because they did not feel affection for the men with whom they had sex, they were thought to be barren, or in any case very unlikely to have children. One writer went so far as to argue that when prostitutes did become pregnant it was by men they especially preferred, and that prostitutes who had been transported to Van Diemen's Land reformed themselves, set up new domestic situations and suddenly found themselves fertile.[5]

Of course not every expert would agree. Indeed Jean Baptiste Parent-Duchâtelet, one of the most genuinely gifted nineteenth-century specialists in public health, whose study of prostitution is but the most famous of a series of pioneering works, insisted that there was nothing special about prostitutes. They did not have unusually large clitorides and were, therefore, not attracted to prostitution by excessive sexual desire; insofar as they had fewer children it is because they practiced abortion or birth control. Prostitution, he argues, is not inherent in bodies; in its modern form it is instead purely a pathology of commercial urban society. But in disagreeing with the general wisdom Parent is allying himself with what I take to be the main interpretive thrust of the idea of the barren prostitute.

To get at this I want to go back to the high Middle Ages when the "observation" that prostitutes are barren first appears. Aristotle, among others, had pointed out that the womb of a woman who was too hot—and the lascivious nature of prostitutes suggested such an excess of *calor genitalis*—might well be inhospitable to a new "conception." That is, it might burn up the conjoined seeds. But Aristotle did not actually equate prostitution with excess heat. Lucretius points out that prostitutes use lascivious movements which inhibit conception by diverting "the furrow from the straight course of the plowshare and [making] the seed fall wide of the plot." But this observation is in the course of a discussion of why "obviously our wives can have no use" for such wiggles.[6]

The reasons given in late medieval and Renaissance literature for the barrenness of prostitutes are several: excess heat, as mentioned above; a womb too moist and slippery to retain the seed; and the mingling of various seeds—in short, reasons very much like those given by nineteenth-century doctors. But I want to draw attention to another, less explicitly physiological explanation, which links the problem of barrenness with a more general derangement of the body politic. A twelfth-century encyclopedist, William of Conches, explains why prostitutes who engage frequently in the sexual act rarely conceive. Two seeds are necessary for conception, he reminds his readers, and prostitutes "who only perform coition for money and who, because of this fact feel no pleasure, emit nothing and therefore engender nothing." A sixteenth-century German doctor makes a very similar argument. Among the causes of barrenness, Lorenz Phrysen notes "a lack of passion in a woman for a man as, for example, the common women who work only for their sustenance."[7]

There is nothing unexpected here, at least to those who have read any medical literature written before the eighteenth century. This is another version of the old saw that orgasm is necessary for conception. But why do prostitutes not experience pleasure; why are the "common women" chosen to illustrate the point that an absence of passion causes sterility? The friction of intercourse must be as warming in harlots as in other women, yet their bodies respond differently. Why?

In both of the examples I have cited, money—or, more precisely, a somehow illegitimate exchange of money—provides the missing middle term. Prostitution is sterile because the mode of exchange it represents is sterile. Nothing is produced by it because like usury it is pure exchange. As Howard Bloch argues, it was precisely in the twelfth century and in response to a nascent market economy that usury became of urgent concern to the Church. And the particular wickedness of taking interest, it was held, is that nothing *real* is gained by it. Indeed, Aristotle, on whom Thomas Aquinas bases his case, argues that usury is "the most hated sort" of

exchange and is to be particularly censured because it represents the antithesis of the natural, the productive, household economy. It is "unnatural and a mode by which men gain from one another." A perverted economic practice, like perverted sex, breeds abominations or nothing at all:

> Interest, which means the birth of money from money, is applied to the breeding of money because the offspring resembles the parent. That is why of all modes of getting wealth this is the most unnatural.

It is as if usury were incestuous intercourse. Or, as Catherine Gallagher puts it, "what multiplies through her [the prostitute] is not a substance but a sign: money." Prostitution, if one follows this web of connections, becomes, like usury, a metaphor for the unnatural multiplication not of things but of signs without references.[8]

A deep cultural unease about money and the market economy is couched in the metaphors of reproductive biology; this is Aristotle's formulation. But, more to the point here, fear of an asocial market takes on a new avatar in the claim that sex for money, coition with prostitutes, bears no fruit. This sort of sex is set in sharp contradistinction—one senses especially in the German example—with the household economy of sex, which is quintessentially social and productive. Phrysen elsewhere in the text that I cite develops the metaphor of the productive womb protecting the fetus just as the crust of bread protects the crumbs. The image of baking, warmth, and kitchen contrasts with the cool barrenness of those who work, have intercourse, *only* for pay, completely outside the bounds of the household and the household economy.

By the nineteenth century the trope of the barren prostitute had, as I have suggested, already a very respectable seven-century-old pedigree. But the boundaries that it guarded—between home and economy, public and private, self and society—were both more sharply drawn and more fraught with conflict in the urban class society of Europe after the industrial and commercial revolutions than ever before. Or at least so thought contemporary observers. Society seemed to be in unprecedented danger from the marketplace. And the sexual body bore the widespread anxieties about this danger. (One can, and of course in a detailed study must, be more specific and contextual in making this point. Laura Engelstein, for example, is doing research on the synergistic coupling of urban anti-Semitism and sex for money; more specifically, on the ears of the Jewish prostitute in late imperial, industrializing Russia).

While masturbation threatened to take sexual desire and pleasure inward, away from the family, prostitution took it outward. Perhaps even more than masturbation

it broke the barrier between home and market that, in much social thought, was regarded as the safeguard for human solidarities against the disintegrative forces of the market. The sterility of prostitutes and their other biological defects and dangers (as well as the illnesses resulting from self-abuse) are in this context not warnings against undue sexual pleasure or inadequate sublimation but, rather, representations of the dangers of withdrawal from family and other supposed shelters from money.

The problem with masturbation and prostitution is essentially quantitative: doing it alone and doing it with lots of people rather than doing it in pairs. It is thus in the same category as other misdeeds of number, the withdrawal of the protagonist of Florence Nightingale's *Cassandra* for example, who refuses to pour tea for the household and withdraws alone to her couch. The social context, not the act itself, determines acceptability.

The paradoxes of commercial society that had already plagued Adam Smith and his colleagues, the nagging doubts that a free market economy can in fact sustain the social body, haunt the sexual body. Or, the other way around, the perverted sexual body haunts society and reminds it of its fragility.

NOTES

1. Gregory of Nyssas, *On Virginity*, in *Ascetical Works*, trans. V.W. Callahan; see pp. 14-15, 19, 51 on marriage as a microcosm of earthly commitment.

2. Peter Brown, "The Notion of Virginity in the Early Church," in *Christian Spirituality*, eds. Bernard McGinn and John Meyendorff (New York: Crossroads, 1985), p. 436.

3. Maurice Godelier, "The Origins of Male Domination," *New Left Review* 127 (May-June 1981), p. 17.

4. Richard Carlile, *Every Woman's Book or, What is Love Containing Most Important Instructions for the Prudent Regulation of the Principle of Love and the Number of a Family* (London: Richard Carlile, 1828). I used an 1892 reprint of the 1828 edition published by the Malthusian League. The tract was originally published in Carlile's *Red Republican* in 1828. See esp. pp. 18, 22, 26–27, 37–38.

5. Edward John Tait, *On the Diseases of Menstruation and Ovarian Inflammation* (London, 1850), p. 54; Michael Ryan, *The Philosophy of Marriage...with the Physiology of Generation in the Vegetable and Animal Kingdoms*, 3rd ed. (1839), p. 168; Frederick Hollick, *The Marriage Guide or Natural History of Generation* (1850), p. 72; Henry Campbell, *Differences in the Nervous Organization of Man and Woman: Physiological and Psychological* (1891), pp. 211–12; Ryan, *Jurisprudence*, p. 225; George Naphys, *The Physical Life of Women* (Walthamstow, 1879), pp. 77–78.

6. Lucretius, *The Nature of the Universe*, trans. Ronald Latham (Harmondsworth, 1951), p. 170; as far as I can tell, no one cited any evidence for this claim between its articulation in the twelfth century and its going out of favor in the late nineteenth.

7. Regarding excessive moisture as a cause of barrenness see, for example, R.B. [R. Buttleworth?], *The Doctresse: A Plain and Easie Method of Curing those Diseases which Are Peculier to Women* (London, 1656), p. 50. A variant on the heat argument is that an ordinary woman experiences two orgasms, one from the alteration in her cold state caused by the inflow of hot sperm from the male and another from her own emission. Harlots, whose wombs are already hot from excessive intercourse, lack the first. On this claim, see Helen R. Lemay, "William of Saliceto on Human Sexuality," *Viator* 12 (1981), p. 172. She attributes it to William of Conches or some twelfth-century interpolator. William of Conches as cited in Danielle Jacquart and Claude Thomasset, *Sexualité et savoir médical au Moyen Age* (Paris: Presses Universitaires de France, 1985), p. 88; Lorenz Fries (Phrysen), *Spiegel der Artzney* (1546), p. 130: "Die unfruchbarkeyt wirt auch dardurch geursacht / so die fraw kein lust zu dem mann hat / wie dann die gemeynen frawlin / welche alleyn umb der narung willen also arabeyten." My colleague, Prof. Elaine Tennent of the German Department at Berkeley, suggests that while the use of "frawlin" (i.e., "fraulein" in modern German), instead of "fraw" as in the previous clause, supports reading "gemeynen frawlin" as prostitutes, one might construe the clause to refer to common women—peasants—who work *only* to earn their keep rather than, as Luther would have preached, for the greater glory of God. This would fit nicely with the analogies made by Calvin and others between sexual heat or passion and the warmth, the ardor, that the heart ought to feel for God, on which point see William Bouwsma, *John Calvin: A Sixteenth-Century Portrait* (New York: Oxford, 1988), pp. 136–37. Phrysen taught at Strasbourg, a strongly Protestant university. Even if one were to accept this later reading, Phrysen's argument still supports my claim that one's relationship to production and exchange is linked to the body's capacity to procreate.

8. R. Howard Bloch, *Etymologies and Genealogies: A Literary Anthropology of the Middle Ages* (Chicago, 1983), pp. 173–74; Aristotle, *Politics*, in *The Complete Works of Aristotle*, ed. Jonathan Barnes (Princeton, 1984) 1.1997 (1258b1–7); this naturalistic expression of a cultural anxiety, in the case of prostitutes and perhaps also of usury, strikes me as an aspect of the new relationship between the sacred and the profane that Peter Brown discusses in his "Society and the Supernatural: A Medieval Change," *Society and the Holy in Late Antiquity* (Berkeley and Los Angeles, 1982), pp. 302–22, esp. pp. 32ff. Indeed the production of authoritative texts like that of William of Conches might be construed as evidence for Brown's shift from "consensus to authority." Catherine Gallagher, "George Eliot and *Daniel Deronda:* The Prostitute and the Jewish Question," in *Sex, Politics, and Science in the Nineteenth-Century Novel*, ed. Ruth Yeazell (Baltimore, 1986), pp. 40–41.

7

"THE ROOTS OF THE ORCHIS, THE IULI OF CHESNUTS": THE ODOR OF MALE SOLITUDE

CHRISTOPHER LOOBY

There have been a few men who could smell me.
—CHRIS STEVENS, the disc jockey in the television show *Northern Exposure*

I want to read an American anti-masturbation treatise of the mid-nineteenth century and consider the ways in which this manifestly erotophobic text may be, paradoxically, erotogenic in the extreme. The text in question (and others like it) incites the very desires it condemns, and in this case it does so (at least in part) by stimulating what I will be calling the olfactory *imaginaire*: the realm of actual and fantasmatic smell sensations, immediate and vicarious responses to odors, and significations and associations attached to those sensory phenomena. Much of the pleasure of reading this anti-masturbation text or any other is owing to the way it brings the reader into imaginary proximity to the masturbating body of the sexual deviant. In its construction of this proximity—the spectacle of the masturbating body close at hand—the text demonstrates how the ostensibly anti-social practice of autoeroticism (notoriously the "solitary vice") is embedded, in the period in question, in a homosocial context that renders masturbation a phenomenon of collective male concern (the masturbator, in this literature, is almost always a boy or a man). Nineteenth-century American men didn't just masturbate; they

thought concertedly about each other masturbating. In this collective thought of masturbation, the odor of semen (or its textualized, fantasmatic representation) is the embodiment, as it were, of the solitary vice's inscription within a scene of male-male desire.

THE ODOR OF SEMEN

In 1895, suspicious deputy chaplain W. D. Morrison thought he detected in the cell of Oscar Wilde in Wandsworth Prison a particular (and, evidently, familiar and identifiable) odor: "the odour of his cell is now so bad that the officer in charge of him has to use carbolic acid in it every day," the chaplain wrote. "I fear from what I see and hear [and, obviously, *smell*] that perverse sexual practices are again getting the mastery over him," Morrison continued. The odor in question was that of ejaculated semen, which then, as now, was frequently likened to the smell of ammonia or chlorine.[1] The authorities denied that Wilde had degenerated under their care into a chronic masturbator, instead attributing the smell to Jeyes's disinfectant (Ellmann 1988, 495). The chaplain was transferred to another post, and the olfactory sensation that had suggested to him a scandalous failure of (and, possibly, Wilde's unashamed resistance to) the penitentiary's disciplinary regime was, presumably, forgotten—although, if odor sensation and memory are as closely linked as they are said to be (Engen 1991, Schab 1991), Chaplain Morrison may very well, when remembering the scene of his professional mishap, have been revisited fantasmatically by Wilde's spermatic scent.

The odor of semen—one's own semen, ejaculated externally where its exposure to air allows it to volatilize, and causes its distinct pungency to register upon one's olfactory receptors[2]—carries for men an inevitable mnemonic association with their first pubescent experiences of autoeroticism.[3] According to Trygg Engen, "A long-term odor memory can be established with only one exposure. An episode is tagged in memory with whatever odor happens to be present. And then, like a bad habit [!], this odor connection is difficult to unlearn and forget" (Engen 1991, 6). The "domination of the first association relates to the way in which odors are committed to memory. An odor is integrated into the mental representation of an experience; it has no identifiable attribute of its own but exists as an inherent part of a unitary, holistic perceptual event" (Engen 1991, 7). Because odor sensation is so crude in itself, but becomes more acute by virtue of its intimate associations with other sensations present at the same time (especially

including taste and touch), odor memory has the power to retrieve the allied sensations that were originally associated with it, reproducing imaginarily the whole multimodal sense-perceptual event. Odor memory cannot be summoned at will; it needs to be triggered by olfactory stimulation in the present, by the same odor or by a similar odor easily confused with it (although the presently sensed odor may only register unconsciously, leaving one to imagine that the odor memory was summoned voluntarily). Thus the odor of *another* man's semen, recognized as such by the man who (like Deputy Chaplain Morrison) smells it, inevitably carries with it a host of disorienting associations with the kinds of stigmatized sexual practices and erotic events that would have introduced one to that smell in the first place and taught one to recognize it: associations with one's own solitary masturbation, with external ejaculation during sex with a partner, or with experiences of mutual and/or collective masturbation, either homosexual or heterosexual.

Whatever the specific associations for particular persons, the odor of semen is, as it were, the aroma of non-procreative sex: *recognizing* that odor could be tantamount (for those who subscribe to the hegemonic nineteenth-century sexual-reproductive ideology) to a confession that one has personal experience of one or another contraceptive sexual practice. According to the dominant sexual ideology, semen is properly deposited inside a woman's vagina, where, unexposed to air, its odor would not make itself known to the nose. But when a man recognizes the odor of another man's semen, the recognition itself is a kind of homosexual event, a scented rupture in the surface homosociality of everyday life: a revelation of the strong, pervasive presence in normal daily homosocial experience of the volatile male-male erotic bonds that subtend it.

In the United States, half a century before Morrison's charged encounter with the odor of Oscar Wilde's semen, masturbation phobia had also prevailed rather widely, although at least one authority, the physician Homer Bostwick, an authority on "spermatorrhea" (the "disease" of nocturnal emission and involuntary spermatic discharge) and other "seminal diseases," including masturbation and masturbatory insanity, found the odor of semen not unpleasant at all. In his published work on the subject, *A Treatise on the Nature and Treatment of Seminal Diseases, Impotency, and Other Kindred Affections: with Practical Directions for the Management and Removal of the Causes Producing Them; Together with Hints for Young Men*, Bostwick observed that "[t]he smell of semen is specific, heavy, affecting the nostrils, yet not disagreeable. The same odor is observed in the roots of the orchis, the iuli of chesnuts, and the antheræ of many plants" (1847, 23). To this rather lyrical description of the smell of the sexual secretion he liked to call "the

very cream and essence of the blood" (81), Doctor Bostwick added, even more unnecessarily, and without explaining how he had come by the information, that "[t]he taste of semen is fatuous, and somewhat acrid," and that it "has a strong and peculiar odor, and a saltish taste" (23, 22). All that one can suggest to account for Bostwick's seeming acquaintance with this taste, rather surprisingly suggested in this virulently hostile anti-masturbation tract, is that he does often refer, throughout the book, to "the hand of the physician" (Bostwick 1847, 10), as well as to the need of his depraved patients for "one friendly hand outstretched to save them" (14), and he testifies as to the etiolated condition of the penis of chronic masturbators that "this organ feels like a whipcord" (135).

Actually, to be perfectly just, Bostwick doesn't exactly say that *he himself* has tasted or even smelled semen; he may have gotten his knowledge second hand. The sensory information is given impersonally: "It has a…taste…,"; "The taste … is …." And it is, of course, part of the standard protocol of chemistry research to give a preliminary gross description of the sensory qualities of a substance that will then be analyzed chemically. The actual fact of the matter seems less important, however, than the evocative intensity of the moment in the text, an intensity barely disguised by the embedding of the reported odor sensation in a cool prose announcing assorted facts from philology, chemistry, hunting lore, and so forth:

Semen is a word derived from the Latin word "*sero*" to *sow*. It has a strong and peculiar odor, and a saltish taste. It is composed of the following parts, according to the analysis of Professor Vauqelin:

WATER	900
ANIMAL MUCILAGE	60
SODA	10
SULPHATE OF LIME	30

(Bostwick 1847, 22)

… The smell of the semen of quadrupeds, when at heat, is so penetrating as to render their flesh fœtid and useless, unless castrated. Thus the flesh of the stag, *tempore coitus*, is unfit to eat. The taste of semen is fatuous and somewhat acrid. In the testes, its consistence is thin and diluted; but in the vesiculæ seminales, viscid, dense, and rather pellucid; and by venery and debility it is rendered thinner. (Bostwick 1847, 23)

Eve Kosofsky Sedgwick, writing of Nietzsche's penchant for metaphorically describing, as smelling- or sniffing-out, his ability to detect the lies of civilized morality, remarks that he "put the scent back into sentimentality" (Sedgwick 1990, 149). That is, he aggressively restored to the modern emotional psychology of goodwill, pity, love, and so forth (the sentimentality of which he deplored as vicarious and therefore mendacious) the corporeal dimension of bodily, sensual proximity it otherwise wished to repress. Homer Bostwick's rhetoric is everywhere allied with a sort of sentimental Christian moralism that disguises a deep and malicious antagonism toward bodily pleasure. Nietzsche's insistence that civilized lies stink, and that their exposure is best figured as an act of olfactory detection and discrimination, should not lead us to imagine, however, that the mere restoration and acknowledgment of olfactory experience is necessarily or intrinsically liberating. The repression of olfaction may be an essential component of bourgeois hypocrisy, but repression was not the only reaction to olfaction in nineteenth-century middle-class respectable society. It was also elaborately cultivated and socially constructed, with different smells marked as pleasant or unpleasant, disgusting or exalted, pure or filthy—or some double-binding combination of such antithetical values. It perhaps shouldn't surprise us that Homer Bostwick, whose book celebrates and enforces modern bourgeois civilized morality in its grotesque, punitive extremity, should at once appeal with undisguised delectation to taboo sensations of taste and smell *and* also condemn them. Georges Bataille has written of "the profound complicity of law and the violation of law" (Bataille [1957] 1986, 36), of the fact that—especially in the domain of the erotic—"taboos founded on terror are not only there to be obeyed," but also to be affirmed negatively by transgression (Bataille [1957] 1986, 48). The "mainspring of eroticism" is the way that transgression "suspends a taboo without suppressing it" (Bataille [1957] 1986, 36). In Homer Bostwick's taboo-enforcing text, the forbidden action (erotic self-stimulation) must be evoked powerfully, sensuously, odoriferously, and thereby invested with an aura of excitement, precisely so that its condemnation and prohibition may then have the delicious character of violence. (The scandalous aroma here is at least given a saving, manly association with the heady odor of a rutting stag.)

Bostwick's *On Seminal Diseases* is replete with the intimate details of men's bodies, even as it preaches against most of those bodies' pleasures. Much of the essential drama of the book is economically represented in the two passages quoted above in which the explosive moment of bodily sensation—of the taste and smell of a particular bodily fluid—is discursively enclosed by the dispassionate

rhetoric of etymology, the macho allusion to stag-hunting, and the scientific ritu-
al of empirical description. Such prophylactic textual surroundings probably failed
perfectly to neutralize the evoked sensations, and cannot suppress even today,
when the taste of latex may be more familiar to many of us than that of semen, a
strong whiff of a specific nostalgic charm.[4]

On Seminal Diseases may be construed as, among other things, an epistolary
novel of a deeply sentimental sort. Until page 47 it is a general treatise on the
health of the sexual organs; from there to page 223 it consists of case histories of
individual sufferers from sexual diseases, most of them presented in the form of
letters from patients appealing (in the most abject and sentimental terms) to the
physician for help and describing their symptoms in sometimes vivid detail. In
this respect the text harks back formally to the ur-text of anti-masturbation ide-
ology, the early-eighteenth-century *Onania*, which began as a modest pamphlet of
about sixty pages but grew by the sixteenth edition (London, 1737) to 194 pages
along with a supplement of 142 pages, nearly the entirety of the additions con-
sisting of letters from repentant and unrepentant masturbators (MacDonald 1967,
424–25). With a few exceptions, Bostwick's correspondents are male, and they
usually complain of one or another kind of masculine depletion: they lose semen
involuntarily, they lack semen altogether, their genital organs are small, they are
chronically sexually unaroused. Bostwick's entire regimen of "medical discipline"
(Bostwick 1847, 57) addresses this epidemic of "impaired venereal power"
(Bostwick 1847, 93) in a variety of ways, all calculated to effect "a complete
restoration of virile power" (Bostwick 1847, 94). On Bostwick's telling, which is
essentially the same as that of the medical orthodoxy of the time, there is a gener-
al "spermatic economy": semen *is* virile power, and its loss is a positive debit to
the masculine account (Barker-Benfield 1976, 175–88). It is a resource to be hus-
banded, not wasted.

The spermatic economy is an individual bodily economy, but not, however,
only that: in important ways the spermatic economy is transindividual, collective:
seminal resources are a communal property. The virile restoration effected by
Bostwick is the therapeutic gift of one man to another, male physician to male
patient. The chief stigmatized form of wasteful, debilitating venery—masturba-
tion—is markedly a solitary, antisocial practice, and it is frequently attended by a
pathological "aversion to going out"; restoration of masculine power is simulta-
neously a restoration to sexual potency and continence, *and* a return to solidarity
with the "friends and acquaintances" whom the sufferer had previously "tried to
shun" (Bostwick 1847, 95).

Masturbation is constructed in moral literature, as Thomas Laqueur has written, chiefly as a threat to human solidarity and not as a specifically sexual evil. In this literature, reaching back to the eighteenth century and to the anonymous *Onania* and the Swiss Dr. Tissot's *L'Onanisme*, masturbation is "a fundamentally asocial or socially degenerative practice," and as such is most frequently contrasted with "the vital, socially constructive act of heterosexual intercourse" (Laqueur 1990, 229). Anti-masturbation literature, however, despite its usual posing of a stark choice between horrifying degeneration (for onanists who do not reform themselves) and marriage and procreation (for those who do)—and in this regard as well Homer Bostwick is perfectly typical—nevertheless constitutes, given its countless juicy narratives of young persons discovering genital pleasures, a "vast corpus of incendiary porn whose erotogenic power is not diminished by the obligatory horrifying, cautionary end" (Laqueur 1990, 228).

Bostwick is frankly aware of this erotogenic possibility, although he disavows any complicity in providing it, ascribing only to other contemporary anti-masturbation writers the culpability that he disowns for himself: "many publications affecting to remove popular ignorance...on the abuses of the procreative organs, have been given to the world," he writes.

> With the exception of one or two respectable works, such as the excellent monograph of Lallemand, these publications have emanated from sources not entitled to regard; and have afforded, indeed, on their face, ample evidence of the unworthy motives of their authors. Many of these productions have been evidently designed to minister to depraved tastes and prurient imaginations, and by the disgust which they have excited in properly constituted minds, have, doubtless, contributed in no small degree to strengthen the prejudices against popular attempts to instruct the young with regard to these subjects which we have just deplored.
> (Bostwick 1847, 11–12)

Laqueur is right to cite this literature as corroboration for Foucault's now familiar claim that the institutions of moral and erotic discipline do not merely repress or control sexual desire, but incite it in order to shape it (Laqueur 1990, 228; Foucault [1978] 1980). The "disgust" which these texts (themselves curiously figured by Bostwick as "emanat[ions]") have "excited" in "properly constituted minds" seems to testify, ironically, to the availability of different, *im*proper sensations that the same texts can arouse in those with "depraved tastes and prurient imaginations." The erotogenic power and the erotophobic power are not com-

pletely disjunctive; they originate in the same place. And it may be that *both* responses (pleasurably excited or disgusted) are, at least in part, aroused particularly by the olfactory powers of the text. Bostwick's exploitation of these powers strikingly resembles that of certain other writers of mid-nineteenth-century America, in whose texts the olfactory *imaginaire* is also crucially related to issues of male sexual conduct and passional freedom. The literary practices of Walt Whitman, Francis Parkman, Herman Melville, and Thomas Wentworth Higginson provide a context for understanding Bostwick's charged engagement with the odor of male solitude.

THE OLFACTORY TEXT

Among Bostwick's American literary contemporaries were a number of writers whose texts aimed to be olfactory in an active sense: to produce olfactory sensations in the reader's body in seeming defiance of the nearly odorless nature of the printed book. This project of textual production of imaginary olfactory sensation is an especially striking one, contravening as it does the civilized regime of odorlessness that characterizes bourgeois modern society. It constitutes a particular instance of the "implantation of perversions" so named by Foucault (Foucault [1978] 1980, 36–49). Walt Whitman, Homer Bostwick's contemporary, wrote in the first edition of *Leaves of Grass* (1855), "The scent of these arm-pits is aroma finer than prayer" (Whitman 1982, 51). "There is something in staying close to men and women…and in the contact and odor of them that pleases the soul well" (120), he averred. Given the persistent Whitmanesque fantasy of the poet's actual bodily presence within the text or through the text ("I pass so poorly with the paper and types … I must pass with the contact of bodies and souls" [89]; "Camerado, this is no book, / Who touches this touches a man" [611]), it follows that the fantasmatic bodily contact between writer and reader that the poetry strives to effect is potentially attended by a fantasmatic smelling of, for instance, the poet's armpit odor as well.[5]

Leaves of Grass is indeed a redolent text: the very first page mentions "perfumes," "fragrance," "smoke of my own breath," "sniff of green leaves" (27). In the revised and enlarged 1860 edition of *Leaves of Grass,* the renewed and elaborated figure of the poetic text as itself the poet's body is accompanied by the incorporation of additional olfactory moments in newly-added poems: "Scented Herbage of My Breast," for instance, one of the lyrics in "Calamus" (268–70). Whitman's explanation, in a contemporary letter, of his choice of the calamus or sweet-flag as

"the token of comrades" (273) to be exchanged by youths as ritual signs of their ardent mutual devotion, emphasizes its "aromatic" quality—the "fresh, aquatic, pungent bouquet" (1356 n. 268.1)—of this variety of grass or rush that grows characteristically by the margins of ponds. What Whitman called the "recherché or ethereal sense" of this sign thus seems directly to emanate from its scent (1356 n. 268.1). The dominant conceit in "Calamus" is that the poem *Leaves of Grass* grows materially out of the ground above the poet's tomb, as if directly rooted in his buried hairy, upturned chest. (It is perhaps not irrelevant in this connection that the midline of the chest as well as the nipples and areolae are two of the major sebaceous scent-gland regions of the human body [Stoddart 1990, 58 Table 3.2].) The esoteric meaning of the poem—its celebration together of both masturbation and male-homoerotic love in defiance of "all the standards hitherto published"—is figured as a "faint odor" that may be inhaled by those who later pass by the grave (Whitman 1982, 268): according to the logic of this figure, reading equals sniffing. In "Song of Myself" the calamus is mentioned following one of Whitman's many autoerotic allusions, his enchanted declaration that "If I worship one thing more than another it shall be the spread of my own body, or any part of it,…You my rich blood! your milky stream pale strippings of my life!…Root of wash'd sweet-flag!…it shall be you!…I dote on myself, there is that lot of me and all so luscious" (211–12).[6]

The vigorous association of Whitman's textual redolence with masturbation particularly ("The pulse pounding through palms and trembling encircling fingers, the young man all color'd, red, ashamed, angry" [262]), and with unorthodox sexual practices more generally, hardly needs elaboration. Michael Moon has shown how elaborately involved *Leaves of Grass* was in contesting the proliferating discourses of male purity and anti-masturbation that were increasingly prevalent in his day. These discourses sought to proscribe many different kinds of male bodily pleasure, but especially autoerotic and homoerotic forms of gratification. What Moon describes as "the desire to locate a central place for the body in the practices of writing and reading; the desire somehow to open in the literary text a space in which the actual physical presence of the writer might come into loving contact with readers" was intimately linked to Whitman's "desire to oppose the increasingly phobic attitude to men's taking pleasure in their own and in other men's bodies which Whitman's culture began manifesting in the 1830s and after, the years of Whitman's first youth" (Moon 1991, 14). However, Whitman's attempt to project his body into or through the text ran inevitably into the problem of "the impossibility of doing so literally" (Moon 1991, 5). What Moon calls the "frustrating but ultimately incon-

trovertible conditions of writing and embodiment that actually render it impossible for him to produce in his writing more than metonymic substitutes for such contact" (6) sadly give the lie, on this account, to Whitman's famous claim that he "[w]ho touches this [book] touches a man."

But are the disembodying conditions of writing so utterly "incontrovertible," finally? Sensory hallucinations are often indistinguishable from the real thing, and phantom olfactory sensations are often remarkably vivid. If a literary text—a piece of writing—induces in its reader a hallucinated sensation (say, that of the smell of Whitman's armpits), this may need to be counted as far less than the actual sensible touch of the poet's body itself, but it is certainly something other (and more) than a mere metonymic substitute for that body. It is a sensation, for the reader, of physical proximity to the writer; a fantasmatic encounter (subjectively experienced as real) with a material exudation of the poet's body. The awakened sensation— the event in the reader's body—may be neurologically indistinguishable (or nearly so) from the "real" thing.

Among Homer Bostwick's American literary contemporaries, olfactory textuality—the incitement of such phantom smell sensations—was a matter of some persistent interest. Unlike Whitman's *Leaves of Grass*, Francis Parkman's *The Oregon Trail* (1846) sets its fantasmatic productions of olfactory sensations within a context that overtly pays heed to the reigning bourgeois value of odorlessness. Along with his cousin and traveling companion, Quincy A. Shaw, Parkman is often in search of a "bath, which the heat of the weather, joined to our prejudices, had rendered very desirable" (Parkman [1849] 1982, 79).[7] Parkman, historian and floriculturalist, betrays his attitude toward odor most clearly in his *The Book of Roses* (1866), a treatise on rose culture that presents the breeding of superior hybrid varieties as an elaborate allegory of the civilizing process, with the eradication of inferior "races" of flowers coinciding with the progressive elimination of their smell. In his career as a rose breeder—indeed, in the whole modern history of rose eugenics—strong scent has generally been sacrificed to the preferred qualities of size, color, and fullness of bloom.[8]

Parkman's demotion of scent in rose culture matches his embarrassment or self-consciousness in *The Oregon Trail* about his own body odor when he can't bathe and when he's suffering from chronic diarrhea. The rank odor of his own and his companions' bodies—the pungent odor of unbathed men in frontier camps—is one texture of scents Parkman offers for his readers' olfactory imaginations, but the most curious phantom scent in the text emanates from a scene in which Parkman is bragging to some Indians about the complete superiority of his

(white) civilization to theirs. In the midst of a scene in which Parkman addresses a gathering of Indians in an attempt to overawe them with claims about the advantages of his culture, he suddenly hears himself propound what he knows to be the specious claim that "all the [white] men were brave warriors." He is then

> assailed by sharp twinges of conscience, for I fancied I could perceive a fragrance of perfumery in the air, and a vision arose before me of white-kid gloves and silken moustaches with the mild and gentle countenances of numerous fair-haired young men. But I recovered myself and began again. (Parkman [1849] 1982, 260)

Parkman frames this momentary drama of self-distraction and self-recovery as one in which his conscience reproaches him for exaggerating the masculine bravery of his fellow Bostonians, when in fact—as he believes—many of them are foppish and weak. But I take this passage to be, first of all, a lesson on the hallucination of olfactory experience as a supplement to reading. (At the moment that this olfactory hallucination is summoned, Parkman displaces smell by sight—"a *vision* arose before me"—as if to banish the contaminating and compromising sensory mode of smell by means of the distanced and contemptuous reference to the *appearance* of the scented Bostonians. But the verb, *arose*, seems subliminally to reinvoke endophonically via its homonym—*a rose*—the odors of the scent-associated fields of floriculture and perfumery, and perhaps even the distinctive odor of attar of rose, a familiar component of colognes.[9] Thus a sound reinvokes an odor that had been displaced by Parkman's advertence to sight.) At other places in the text Parkman reports on smells he really encountered in the material sensorium, and asks the reader to imagine them; here he reports on a smell he himself imagined or "fancied"—fancied he "perceive[d]"—a "fragrance of perfumery" of some "fair-haired young men." Parkman *fantasized* this odor as he addressed the Indians (obviously it was not materially present); and as a fantasy product, the imagined scent sensation must be counted as an effect of an unacknowledged desire, a disowned longing for the smell of what he is overtly denigrating.

Parkman's aversive desire for the odor of these young men is notably not for the natural smell of their bodies, but for a concocted fragrance that they wear to replace or mask their own odors.[10] Prepared fragrances, ironically, are formulated to mimic the very same human body odors they are used to replace: what perfumers call the "top notes" of these aromatic compositions are usually made from the extracted sexual secretions of flowers (which often mimic animals' sex pheromones), while the "middle notes" are derived from resinous materials which

resemble sex steroids' odors, and the "base notes are mammalian sex attractants with a distinctly urinous or faecal odor"—i.e., musk and civet (Stoddart 1990, 162-63). When a perfume—a complex olfactory text—is sniffed, the more volatile floral notes are intensely conspicuous, while the powerfully erotogenic lower notes are often registered only unconsciously. "In offering to the perceiver a cocktail of sex attractant odours at low concentration in the base notes, [perfumes] subconsciously reveal what consciously the strident top notes seek to hide"—i.e., they simulate and accentuate the natural sexual and excretory odors of the body (Stoddart 1990, 163).[11] Parkman's fantasy fixes on the artificial scent the young men wore, as if to distance himself from the odors proper to their bodies, but the "perfumery" he is sniffing in his imagination replicates those bodies' odors anyway—or replicates their sex-attractant secretions. As Whitman's reader is invited to sniff the poet, Parkman takes a whiff of these scented young men, and invites us to participate vicariously in this olfactory hallucination. If what defines a sexual act as masturbation is the "absent object," the "phantom" provided by the "power of fancy" that "rouse[s] the organs form'd for nobler ends"—as a poem included in a 1767 *Short Treatise on Onanism* deliciously phrased it (qtd. in Haller and Haller 1974, 202)—then Parkman's daydreaming scent sensation, with its unmistakable overtones of illicit, stigmatized sexuality, is masturbatory certainly, but also seems effectively to elide the difference between the homoerotic and the autoerotic.

The fantasmatic literary production of smell is powerfully in evidence, to take one more example contemporaneous with Bostwick, Whitman, and Parkman, in Melville's *Moby-Dick*, most extravagantly in Chapter 91, "The Pequod Meets the Rose-Bud," where the reader is told "that the many noses on the Pequod's deck proved more vigilant discoverers than the three pairs of eyes aloft," thus reorienting the reader's attention away from the ocular to the nasal. "A peculiar and not very pleasant smell was smelt in the sea" (Melville [1851] 1972, 512). The sweet-smelling-sounding *Rosebud*, a French ship, has chosen to attach to its sides two whales—one, a corpse of a whale that "died unmolested on the sea" and has rotted as it floated, the other, "one of those problematical whales that seem to dry up and die with a sort of prodigious dyspepsia, or indigestion," the two whales together exhaling "an unsavory odor" that announces their approaching presence to other ships some time before they are espied (512).

The *Pequod* is soon "entrapped in the smell" of "this aromatic ship" (513); the *Rosebud*'s captain—punningly, a former "Cologne manufacturer" (515)—doesn't know that within the blasted whale's unsavory carcass is to be found the deliciously aromatic and commercially valuable ambergris,[12] and so the *Pequod*'s

unscrupulous mate Stubb cleverly contrives to persuade the unsuspecting French captain to abandon the carcasses, under the mistaken impression that his crew will catch a fever from them. Stubb, of course, is scheming to harvest the ambergris himself, and is proud to have thus "diddled" the Frenchman, as he twice puts it (Melville [1851] 1972, 517). As the *Rosebud* pulls away from the miasmic carcasses, Stubb plunges a spade into one malodorous whale's body, in search of the precious ambergris.

> Stubb was beginning to look disappointed, especially as the horrible nosegay increased, when suddenly from out of the very heart of this plague, there stole a faint stream of perfume, which flowed through the tide of bad smells without being absorbed by it, as one river will flow into and then along with another, without at all blending with it for a time. (Melville [1851] 1972, 518)

Melville's punning association of this odorous emanation with that of semen—he's talking, naturally, of *sperm* whales, and Stubb's accession to the wonderful odor is won by his "diddl[ing]" of the Frenchman—needs scarcely more comment than did Whitman's.[13] The *textual* nature of olfactory experience—the way different scents cross and mingle, "flow into and then along with [one] another," blending but distinguishable—seems (as with Parkman) to instruct us in reading. *Moby-Dick* is notoriously a multi-layered text, one whose most accessible patterns of meaning might be received as "horrible," while it always promises an eventual accession to secret deposits of a sweeter revelation. The distinction described here—a "horrible nosegay" or "plague" versus a delectable "faint stream of perfume"—asks readers to use their noses, as it were, in realizing or activating the text's esoteric meaning. To actualize the sensory/semiotic *différence* between two contrasted odors virtually requires a willful olfactory hallucination.

Inviting the reader to enter into the text's olfactory *imaginaire*, Melville is nowhere more seductive than in "A Squeeze of the Hand," three chapters after the narrative of the *Rosebud*. Ishmael's rapturous description of the collective project of sperm-squeezing on board ship is rich in double-entendre: the seamen who are squeezing the congealed lumps of sperm to render them fluid soon find each other's softened and slippery hands in ecstatic contact, while the "gentle globules" break and "discharge all their opulence" and the squeezers "snuff up that uncontaminated aroma—literally and truly, like the smell of spring violets" or the odor of a "musky meadow" (526–27). The direct appeal to the reader—"Come; let us squeeze hands all round; nay, let us all squeeze ourselves into each other; let us

squeeze ourselves universally into the very milk and sperm of kindness" (527)—beckons him into the enveloping redolence of the spermy scene. Melville, like Parkman, Whitman, and Bostwick, strives to stimulate his readers' imaginary collective experience of a powerful odor sensation, but like Whitman (and unlike Parkman and Bostwick) he is celebrating the power of the olfactory to release the homoerotic and autoerotic desires it evokes.

"If, in the simple process of writing, one could physically impart to this page the fragrance of this spray of azalea beside me, what a wonder would it seem!" wrote Thomas Wentworth Higginson in an essay called "The Procession of the Flowers" (Higginson 1862, 657). Higginson, a radical American clergyman whose abolitionist writings aimed to move his readers to take up arms against slavery and whose sentimental nature writings tried to represent the heavy, exotic scents of the flowers he rapturously loved, approaches, like Whitman, the limit of physical sensation against which his textual erotics is pressing. If, in the simple process of writing, Whitman or Parkman or Melville could have imparted to the page the "pungent bouquet" of the calamus, the "fragrance of perfumery" associated with effeminate young Bostonian men, or the "uncontaminated aroma" of the squeezed whale sperm, they no doubt would have taken advantage of such a wonder. But it may be that in inciting their readers to *imagine* such olfactory sensations they did something more wonderful: they aroused in those readers certain stigmatized desires with which those odors were inextricably associated, autoerotic and homoerotic desires secreted within the olfactory memories the text urged its readers to retrieve.

Homer Bostwick's reference to the odor of semen early in his treatise on seminal diseases may (despite his failure directly to evoke it again) have a carryover effect when, later on in the book, his many panicked male patients attest, in numbing detail, to all the ways in which they willfully induce or involuntarily suffer the emission of this aromatic bodily fluid. Bostwick's first supplicant, "C. R.," began treatment in December 1845, and, in a remarkable form of those methods of self-surveillance that Foucault described as "technologies of selfhood" (Foucault 1988), he kept a diary record of his seminal losses, sliding casually in the implied erotic scenarios between the auto- and the alloerotic:

21st. [December]—Excitement—discharge of thin, sticky, transparent, colourless stuff—a few drops.
27th.—Excitement, and drops.
29th.—Excitement and wet shirt—as large round as a half dollar.

5th. [January, 1846]—Dream about daybreak, and loss of semen; excitement during afternoon.

9th.—Met * * *. After an hour or so got erection; connexion; she showed every sign of pleasure; I did not appear to discharge, and can't say whether I failed or succeeded, or whether I had pleasure or not.

11th.—Excitement, and drops of semen.

12th.—Excitement in morning; only drops; pain in right groin; it is the left testis that is large; attempt at connexion, and penis got soft under it; a failure. This is the third decided failure, and one doubtful.

14th, Wednesday.—Feel badly; crawling sensation all over me. * * * sat on my lap; gave me erections—not firm however—soon subsided; leaked, as usual, a few drops; drank brandy.

18th.—Some excitement; felt damp, as usual, about shirt; when I got chance to examine, could see no stain; in fact these drops never leave a stain, or if so, it is very faint.

19th.—…a trace of sticky stuff discharged from penis while at stool….

25th.—Excitement, and drops.

30th.—Only so-so all day; met * * *; a semi-erection; subsided; after an hour or so, by exciting myself got erection; attempt; girl very quick; she gave over, and *then* I had discharge of semen—no jet, more like running from me; saw the semen—looked thick and rich; felt happy, because I can assure myself I have semen.

2d. [February]—…*no discharge* at all; could press out a few drops of thin looking water, semen, or some such stuff as I lose in drops….

5th.—…no erections; penis a mere pinch—wilted up; after an hour or so tried to excite myself; could not succeed—could only get it a little longer, but not hard; could not get an erection.

6th.—…I now dread I have no semen, and have lost power of erection.

8th, Sunday.—11 o'clock, A.M.; am now writing to Dr. B. I dreamed of many and various subjects last night, or rather since 4 o'clock this morning; on waking, found large and stiff stains of semen; so, thank God, I am not dry entirely, and I may yet hope; parts look small; a half erection on waking; can't call to mind any erection and jet of semen while asleep…I think both testicles are shrinking and getting smaller…may they not melt, dissolve, and run from me in drops? (Bostwick 1847, 50–55; some ellipses omitted)[14]

Semen—thick and rich, or thin and watery; jetting or dribbling, squeezed out or leaked out; transparent and colorless or otherwise—has such a viscous, sensual presence in this text that its (here) unmentioned odor is the property the reader is

left to supply. Other aromatic bodily emissions are only somewhat less obsessively dwelt upon by the masturbators who implore Bostwick for help and by the doctor in turn: pus and purulence (157, 160, 205), flatulence (147, 191, 192), "acrid" urine (155), a "mucus discharged" by "catarrh of the bladder"—"the odor of the matter discharged is very offensive"—by comparison to which the odor of semen is not offensive at all (Bostwick 1847, 231–32). Bostwick's text dwells on these odorous emanations of the male body, bringing the reader into the examination room, to within striking distance (as it were) of these exudations.

MEDICAL ODORAMA

The campaign against masturbation from the eighteenth century onward needs to be seen, as Laqueur has written, less as addressed to "a problem of excess or wicked sexual desire" than as part of a "more general debate about the unleashing of desire in a commercial economy and about the possibility of human community in these circumstances" (Laqueur 1990, 229). Masturbation is construed, on this view, as "a fundamentally asocial or socially degenerative practice," "the channeling of healthy desire back into itself" rather than into socially productive heterosexual intercourse (Laqueur 1990, 229). While it seems true to describe masturbation as in some basic way antisocial—it is a turning in upon the self, upon the self's own body, a turning away from others (leaving aside, for the moment, the possible fantasmatic presence of another/others, which would reintroduce a scenario of the social)—it is equally important to notice the ways in which even the most intimate phenomenology of masturbation relocates selfhood in the socius, as well as the ways in which masturbation and the masturbator have been discursively relocated as objects of social concern in the modern period. The masturbator may be acting antisocially, but society will not let the masturbator alone.

Even in the intimate phenomenology of autoeroticism there is an ineradicable trace of alterity. One's relation to one's hand is seemingly intimate, immediate; it is the loyal servant of one's intentions, obeying immediately the self's instructions; but at the same time the hand is, as we say, one of the body's extremities, it is at a visible remove from what we usually take to be the center of the self's location (brain, eyes, or perhaps heart); it is strange, remote, sometimes wayward (given over, at times, to automatisms). The habitual protocols of one's autoerotic life—how one rubs oneself, one's personal repertoire of strokes, rhythms, pressures—can easily become automatic and routinized, and this hiatus of intentionality, combined with the automatism of erectile and lubricatory response, can make mas-

turbation seem like something happening down there, away from the self, of its own accord. When the parent or teacher reproves the child for shamelessly touching him or herself, it is probably as much because of the unsettling spectacle of the child's seeming decenteredness, observable non-presence-to-self in the dreamy act of self-stimulation, as because of a specifically sexual taboo.

For a man, masturbation to ejaculation produces a specific reminder of this hiatus in the self's sensory circuit of pleasure. When he stimulates his genitals, his genitals stimulate him back, as it were: upon ejaculation the odor of semen comes back at him, reversing the direction of somatic stimulation and involving the sense of smell as a reflux and supplement to the primary sense of touch. I do not discount the role of other bodily odors in the experience of autoeroticism: axillary odor in particular has a prominent role in the feedback loop of erotic stimulation, and many people sniff their hands after rubbing their crotches.[15] And I do not, of course, mean to imply that the odor of vaginal secretions plays no part in female autoerotic practice. But the odor of semen, I claim, is smelled almost at no other time than during nonprocreative sex, and carries, as I have said, sense-memory associations with pubescent masturbatory experimentation, and thus it has a strongly-marked psychic association with solo sex, as well as the functional role of marking closure in the enacted drama of autoerotic stimulation-to-climax.

This reactive structure of male masturbation—you rub your body, and it rubs your nostrils back—constitutes an eruption of alterity in the midst of the intimate self-presence of autoerotic communion. One makes oneself the object of stimulation, manipulation, calculated instrumental action; and one's semen (once one has passed the threshold of what Dr. Ruth calls the "premonitory sensation"—the point of no return when one feels that orgasm is approaching inexorably, and the body's automatism takes charge) flies back in one's direction, volatilizing and invading one's nose with its specific pungency. Odors are invisible, stealthy; they are inhaled, taken into the body; they are often considered mysterious and threatening because they penetrate one's self, enter the inner confines of one's self-presence, and cannot easily be eluded. (Derrida's description of the function of hearing-oneself-speak in constructing the self's sense of integrity and being [(1967) 1973, 70–87] may need to be supplemented by a phenomenology of smelling-oneself: a friend of mine tells me that when she feels at a loss for herself she goes without bathing for a few days, until smelling her own body odor restores her sense of her own being and presence.)

In the anti-masturbation discourse that I am taking Homer Bostwick to exemplify, then, the onanist who is represented as pathologically antisocial, self-

involved, and self-enclosed is always already actually self-divided by virtue of the self-phenomenology of the body, the alterity of the hand and genitals, and the otherness of the olfactory sensation (particularly the smell of semen). The medical and moral therapy that wants to restore the masturbator to society, and especially to social reproductivity, then, needs to exploit this fundamental inner alterity of the autoeroticist's relation to his own body, needs to heighten and exaggerate the onanist's distance from his own body, and needs in addition to map that distance, as it were, over the matrices of interpersonal social differences. The masturbator's fractured relationship to his own body is, so to speak, pried apart as he is taught to identify with the physician's repelled, censorious objectification of the patient's body. In Homer Bostwick's therapeutic practice, which seeks to lead the patient from the autoerotic to the alloerotic, the first step (as we have seen) is to instruct the patient in a discipline of scrupulous self-observation (a daily objectification of the body's performances), a rendering of the pathologically spermattorheic body as *other*. But that rendering of the patient's body as an object of inspection, of specular distance, takes place within the very real and material social context of the doctor-patient relationship. This relationship—this institutionalized social relationship—is, to state the obvious, a relationship between men, and in Bostwick's narratives the "medical" quality of the relationship shades imperceptibly into a less specific quality that savors equally of the gymnasium, the gentleman's club, or any other male homosocial institution.

In Bostwick's rendering, the intimacies of the doctor's examining room are designed to reinscribe the deviant energies of autoeroticism within the social text, and they do this materially via the intensely tactile, quasi-erotic bonds between the doctor (metonymized, as we have seen, most frequently by his "hand") and the patient (present in the scenario chiefly in the form of his disordered genital-urinary and excretory systems). Bostwick published *On Seminal Diseases* at about the time that the proportion of various medical methods preferred for treating masturbation was shifting from an emphasis on non-invasive therapies (such as the water cure, dietary reform, and so forth) to surgical intervention. According to René Spitz, "It is only in the second half of the nineteenth century that sadism becomes the foremost characteristic of the campaign against masturbation" (1952, 499). Clitoridectomy; blistering of the thighs, genitals, and spinal region; cauterization of the spine and genitals; infibulation of the prepuce and labia majora; circumcision—these were among what Spitz calls the "innumerable, varied and subtle practices of a refined cruelty" (505).

Bostwick's case histories consist largely of descriptions of what he did to his patients' urethras and rectal cavities. His usual practice was to invade the patient's urethra with a "bougie" (a tapering cylindrical instrument made of a material such as rubber, metal, or waxed linen, used for purposes of dilation, exploration, and medication), and then cauterize the prostatic portion of the urethra. On Bostwick's unsurprising account, this is usually a very painful experience for the patient, who often faints dead away (Bostwick 1847, 70, 75, 89, 96, 192). This catheterization and cauterization is repeated at frequent intervals, and is the centerpiece of Bostwick's system of treatment: it is by virtue of this repetitive subjection of the masturbator to painful genital invasion that his autoerotic habits are supposed to be eradicated.

Bostwick seems to be oblivious to the erotic dynamics of this encounter between his hands and the other men's penises and anuses. (In one of his few case histories of female patients, he describes—proudly, it seems—how "[d]uring [his] examination her excitement was so great that she could with difficulty lay upon the speculum chair" [204], but he never discusses the possibility of sexual arousal that is equally present during his contact with male patients.) The possibility that at least some of his patients were actually getting off on the experience may seem remote to us. The prevalence of doctor-patient scenarios in pornography, however, should alert us to the erotic potential of the medical encounter, and Bostwick's rhetoric of discipline, pain, and suffering has an unmistakable sadomasochistic atmosphere about it.[16]

Bostwick's patients usually masturbated alone, but more than a few of them began masturbating socially, as he acknowledges—usually in school (100, 131, 133, 234). Bostwick's effort is to convert this collaborative scenario of pleasure-in-self-stimulation into the collaborative medical scenario of pain-in-genital-manipulation. In so doing, it aims to replace an implicitly homoerotic intersubjective sexual encounter with a punitive, sex-phobic, homosocial intersubjective medical encounter. The place of odor in this transformation is important, and perhaps crucial: in the case histories that comprise the largest portion of the book we no longer read of the "not disagreeable" odor of semen introduced to us earlier, but instead of "flatulency" as a side effect of "involuntary seminal emissions" (147; cf. 191, 192). We read, in addition, that "catarrh, or chronic inflammation of the bladder...is quite important to understand as connected with seminal diseases," that the "mucus discharged" in consequence is sometimes of an "enormous" quantity, and that "the odor of the matter discharged is very offensive" (231, 232). The odor of semen, so lyrically evoked earlier in the text, is displaced in the case his-

tories by evocations of other bodily products—blood, intestinal gas, stools, and pus most prominently—and by their associated odors.

One of the most powerfully olfactorily-evocative therapeutic regimens detailed in the book is also one of Bostwick's most common: he often applies up to forty leeches to the perineum and/or abdomen and inner thighs of a patient, and then has the patient stand over a steaming vat of boiling water until the leeches drop off, so that the steam keeps up the bleeding for a while longer. These post-leeching "warm fomentations" (110) are often rendered aromatic by quantities of poppy heads and hops, which are later formed into poultices and directly applied to the bleeding parts. Bostwick's therapeutic regimen thus appears to aim to interfere with the pleasurable associations of semen odor memory in several ways: by associating that odor memory with excruciating sensations in the doctor's office, and by substituting familiar odor sensations coded as disgusting (gas, pus, etc.). If we assume that the text still wants to work on its readers by cueing them to recall odors and their associations, to summon phantom odor sensations, then the therapy may work in some degree on the reader of the book as well as on the patient in the examination room.

If Bostwick's therapy succeeds, his patients will never smell semen again. Their ejaculations will only occur when their penises are inside vaginas. On Bostwick's self-aggrandizing account, his regimens are remarkably successful, achieving cures even in cases other physicians would call hopeless. And while *On Seminal Diseases* is, among other things, a promotional device designed to lure patients to his clinic, it also aims to affect its readers more generally, warning young men away from the practices that might bring them under his scary discipline, and encouraging those who are sometime masturbators to leave off their dangerous self-indulgences before it is too late.

It is to this wider category of readers that the olfactory dynamics of the reading experience may pertain particularly. Bostwick's monitory narrative interpellates his readers as actual or potential onanists, and therefore as potential subjects of his frightening but (possibly) perversely attractive therapeutic regimes. While certain strains of literary critical theory have, of late, addressed themselves to the dynamics of somatic reader response, they have chiefly considered the way sentimental literature, for instance, aims to produce tears in readers' eyes, or the way sensation fiction tries to make the heart race, the palms sweat, the hair bristle (Sánchez-Eppler 1988, 35–36; Miller 1988, 146ff.).

Pornography—there has never been any secret about this—is designed to induce the whole range of human sexual somatic responses. Bostwick's tract—

and this may be true of many, if not most, comparable texts—disavows such pornographic intentions, but plainly this disavowal is somewhat disingenuous. It *needs* to arouse its readers' bodies so as to associate that arousal effectively with punitive threats. It invites the always-potentially masturbatory reader, who may initially identify with the sexually anxious clients of Dr. Bostwick, instead to occupy the physician's scopic, stigmatizing relationship to the masturbating male body. It invites this reader to remove himself from the always-potentially-homoerotic relationship of one masturbating man to another, and instead to occupy the safely-alibied position of the caring physician in the properly homosocial relationship of doctor-patient. It invites the male reader, for whom the odor of semen has had, heretofore, aleatory associations with purposeless, perverse pleasures, to associate that odor hereafter with scandal, and to associate autoeroticism hereafter with the other intensely stigmatized odors of the lower bodily stratum. By stimulating the olfactory *imaginaire*, even by fantasmatically inducing a proscribed olfactory sensation, Bostwick's *On Seminal Diseases* addresses itself not only to the monitoring consciences of its readers, but to their self-pleasuring and self-punishing fleshly bodies.

NOTES

1. See, for instance, the anonymous untitled story that begins "Eddie was tall and sunny…," in *HOMOture*: "Then, panting, we lay still again, come-smeared hands still holding on, while the Clorox-smell of semen filled the air, until our cocks reluctantly grew limp" (1991, 27). See also James Ellroy's *White Jazz* (1992), in which a pair of "hip huggers, slashed and jizzed on" (52) are a piece of crucial evidence; when Lieutenant Dave Klein comes upon them in a closet, Ellroy uses his narrative style of telegraphic interior monologue to command the reader to imagine the smell: "Look: a small closet. Spread-legged, crotch-ripped pedal pushers tacked across the walls. Stained—smell it—semen" (32). And see also William Burroughs' *Naked Lunch*, where scent sensations of various kinds are regularly cited, among them the "[s]harp musty odor of penetrated rectum" ([1959] 1966, 77) and "[s]harp protein odor of semen" in the "Hassan's Rumpus Room" section (80).

2. According to Thaddeus Mann's authoritative modern textbook, "The oxidation of spermine [spermine phosphate, a crystalline substance found in semen; $C_{10}H_{26}N_4$] gives rise to a volatile base associated with the characteristic odour of semen" (Mann [1954] 1964, 198). Mann is moderately eloquent on the appearance, texture, and smell of semen, but displaces onto an eighteenth-century scientific predecessor, John Hunter, the responsibility for reporting on its taste: "Though at first insipid, it has so much pungency as, after some little time, to stimulate and excite a degree of heat in the mouth" (Hunter cited in Mann [1954] 1964, 2).

3. The anonymous Victorian author of the sexual autobiography *My Secret Life* records that upon first accidentally masturbating to ejaculation he "examined the viscid, gruelly fluid with the greatest curiosity, smelt it, and I think tasted it" ([c. 1890] 1966, I-VI: 50).

4. The nostalgia for the taste of semen in the post-AIDS era is poignantly reported by Douglas Crimp. In discussing the different kinds of losses experienced by younger and older gay members of ACT-UP, Crimp tells this story about a young activist of the post-Stonewall generation:

 > A group of us had seen an early '70s film at the Gay and Lesbian Experimental Film Festival and went out for drinks afterwards. The young man was very excited about what seemed to me a pretty ordinary sex scene in the film; but then he said, "I'd give anything to know what cum tastes like, somebody else's that is." That broke my heart, for two different reasons: for him because he didn't know, for me because I do. (Crimp 1989, 10-11)

5. The sexual significance of armpit odor is generally disregarded today, but it has traditionally been granted an important sex-attractant function. See Brody 1975; Gower, Nixon and Mallet 1988; Stoddart 1990, 62-70.

6. Havelock Ellis's section on smell in *Studies in the Psychology of Sex* is perhaps still the best survey of the intersection between the culture of odor and the physiology of olfaction, especially as these meet in the domain of sexuality (Ellis [1910] 1936, 2: 44-112). Ellis reports that one male correspondent "noted the resemblance of the odor of semen to that of crushed grasses" (2:106). On his part, Stoddart avers that the flowers of henna, berberry, lime, chestnut and the pollen of many grasses have semen-like odors (Stoddart 1990, 130, 159). Inasmuch as this is true, one could say that the smell of semen permeates Whitman's *Leaves of Grass*.

7. The pool in which they bathe here is punctuated by "large clumps of tall rank grass" (Parkman [1849] 1982, 77). The adjective *rank*, in addition to meaning profuse of growth, probably also means strongly odorous—which returns us to what Whitman called the "recherché and ethereal sense," the subtextual olfactory meaning of fragrant grasses.

8. Rose breeding, on Parkman's telling, is the art of "amalgamat[ing]" different "races" and "families" of roses, so that by their "intermarrying" there may be "new races" created (Parkman 1866, 7, 8, 9). The original, unmixed wild roses tend to be fragrant, but visually inferior (paler coloring, fewer petals, smaller blooms) to the modern hybrid roses. Parkman would have known as well as any rose breeder that the pursuit of visual splendor entailed a sacrifice of scent, and his text clearly privileges the visual over the olfactory pleasures of roses. For more on the relationships between the ideology of racial difference, floriculture, and odor in the work of one of Parkman's fellow floricultural enthusiasts, Thomas Wentworth Higginson, see Looby 1995a, 1995b.

9. James Creech generously suggested this possible reading. Elsewhere, Parkman cites the "sweet perfume" of the "myriads of wild roses" he comes upon in a grove ([1849] 1982, 172); and in another place mentions how, given the stimulation of the "peculiar resinous odor" diffused by pine trees, memories of the mountains of New England "*rose* like a reality before my fancy" (229; italics added). A writer in *Harper's* on "French Flower Farming" in 1856 acknowledged that "[s]ome people sneer at perfumes" because they take them to be "foppish, effeminate, a waste of money, and a foolish gratification of a sensual appetite," and hold likewise (in language that links the wearing of scent to masturbation) that a love

for the essences of flowers is "a propensity to be blushed over and indulged in secret." "Pure otto of roses," this writer goes on to say, "perfumes the most expensive soap used by rich dandies" ("Ambrosia" 1856, 58, 59).

10. In the blunt words of a contributor to *Harper's* in 1864, "Man is nasal; and the imperiousness of the Schneiderian membrane demanding scents for its gratification, and partly, also, for the suppression or mitigation of stinks, has, in all ages and among all tribes, forced the genius of man to extract perfumes from flowers" ("French Flower Farming" 1864, 50).

11. The discourse of perfumers, with its habitual musical metaphorization of the olfactory text ("top notes," etc.), performs its own displacement of smell by hearing.

12. Ambergris is a waxy, grayish substance formed in the intestines of whales, and often found floating at sea or washed ashore; it is used to slow down the rate of evaporation of a perfume. The 1856 writer in *Harper's*, promising some "queer stories" about the chemistry of perfumes, i.e., about the chemical similarities between modish scents and "the most despised and loathsome animal matters," called ambergris "a sort of *x* or unknown object in science," which in its raw state "is positively offensive to the nose; its smell, in fact, is so unpleasant, and at the same time so familiar to all who are patrons of the stable, that chemists have been led to imitate it by distilling the refuse of horse stalls" ("Ambrosia" 1856, 60).

13. The scent associations summoned by Melville are almost endlessly complex. Rosebuds and other flowers, and perfumes too, are generally identified with women; therefore, a familiar invocation of a relationship between male erotic deviancy and effeminacy is in play here. Resemblances between the shapes of flowers (their involutions out of which odors emanate) and certain erotically invested human body parts likewise highly odorous (foreskin, anus, genitalia of both sexes) have underwritten a long history of literary and artistic figurations, from scripture to Mapplethorpe—a history too extensive to pursue in detail here. I address this history and these associations in somewhat more detail in another essay; see Looby 1995b.

14. Philip C. Van Buskirk, a nineteenth-century American seaman, evidently kept a similar diary record of his seminal emissions. From January 1852 (when he resolved to discontinue masturbation) until the end of 1858, according to B. R. Burg, he kept a scrupulous record of his seminal losses, itemizing "all expenditures of semen by date and by immediate cause, recording whether they were involuntary, induced by a partner, or caused by solitary masturbation" (Burg 1994, 30).

15. A. A. Brill describes a patient who "rubbed his testicles and then smelled his hands, eventually attaining an ejaculation" (Brill 1932, 17).

16. An example of the eroticization of medical practices is offered by a community group in San Francisco called "QSM" ("Quality S/M" according to Perry [1992]). QSM offers seminars on "Medical Play" including "Catheters & Sounds," a "Catheterization Workshop," and a final class on "Surgical Suturing" (QSM [c. 1991], [4]). Also see the passage in *My Secret Life*, where the author is perplexed when he spies an erotic encounter between two men that he presumes is a medical examination ([c. 1890] 1966, I-VI:1202).

REFERENCES

Ambrosia—A Nose Offering. 1856. *Harper's New Monthly Magazine* 13: 58–62.

Barker-Benfield, G. J. 1976. *The Horrors of the Half-Known Life. Male Attitudes Toward Women and Sexuality in Nineteenth-Century America.* New York: Harper & Row.

Bataille, Georges. 1986. *Erotism: Death and Sensuality.* Trans. Mary Dalwood. San Francisco: City Lights Books.

Bostwick, Homer. 1847. *A Treatise on the Nature and Treatment of Seminal Diseases, Impotency, and Other Kindred Affections: With Practical Directions for the Management and Removal of the Cause Producing Them; Together with Hints to Young Men.* New York: Burgess, Stringer & Co.

Brill, A. A. 1932. The Sense of Smell in the Neuroses and Psychoses. *The Psychoanalytic Quarterly.* 1: 7–42.

Brody, Benjamin. 1975. The Sexual Significance of the Axillae. *Psychiatry* 38: 278–89.

Burg, B. R. 1994. *An American Seafarer in the Age of Sail: The Erotic Diaries of Philip C. Van Buskirk, 1851-1870.* New Haven: Yale University Press.

Burroughs, William S. [1959] 1966. *Naked Lunch.* New York: Evergreen/Black Cat Edition.

Crimp, Douglas. Mourning and Militancy. *October* 51 (Winter 1989): 3–18.

Derrida, Jacques. [1967] 1973. *Speech and Phenomena and Other Essays on Husserl's Theory of Signs.* Trans. David B. Allison. Evanston, Illinois: Northwestern University Press.

[Eddie was tall and sunny…]. 1991. *HOMOture* 3, SPERM (Summer): [25–27].

Ellis, Havelock. [1910] 1936. *Studies in the Psychology of Sex.* Vol. II. New York: Random House.

Ellmann, Richard. 1988. *Oscar Wilde.* New York: Knopf.

Ellroy, James. 1992. *White Jazz.* New York: Knopf.

Engen, Trygg. 1991. *Odor Sensation and Memory.* New York: Praeger.

Foucault, Michel. [1978] 1980. *The History of Sexuality, Volume 1: An Introduction.* Trans. Robert Hurley. New York: Vintage.

———. 1988. Technologies of the Self. In *Technologies of the Self: A Seminar with Michel Foucault,* eds. Luther H. Martin, Huck Gutman, and Patrick H. Hutton, 16–49. Amherst: University of Massachusetts Press.

French Flower Farming. 1864. *Harper's New Monthly Magazine* 30: 48–51.

Gower, D. B., A. Nixon, and A. I. Mallet. 1988. The Significance of Odorous Steroids in Axillary Odour. In *Perfumery: The Psychology and Biology of Fragrance,* eds. Steve Van Toller and George H. Dodd, 47–76. London: Chapman and Hall.

Haller, John S., Jr., and Robin M. Haller. 1974. *The Physician and Sexuality in Victorian America.* Urbana: University of Illinois Press.

Higginson, Thomas Wentworth. [1869] 1984. *Army Life in a Black Regiment.* New York: Norton.

———.The Procession of the Flowers. 1862. *The Atlantic Monthly,* 10 (Dec.): 649–57.

Krafft-Ebing, Richard von. [1886] 1978. *Psychopathia Sexualis, With Especial Reference to the Antipathic Sexual Instinct: A Medico-Forensic Study.* Trans. Franklin S. Klaf. New York: Stein and Day.

Laqueur, Thomas. 1990. *Making Sex.* Cambridge: Harvard University Press.

Looby, Christopher. 1995a. "As Thoroughly Black as the Most Faithful Philanthropist Could Desire": Erotics of Race in Higginson's *Army Life in a Black Regiment.* In *Race and the Subject of Masculinity,* eds. Harry Stecopoulos and Michael Uebel. Durham, NC: Duke University Press (forthcoming).

———. 1995b. Flowers of Manhood: Race, Sex, and Floriculture from Thomas Wentworth Higginson to Robert Mapplethorpe. *Criticism* 37: 109–56.

MacDonald, Robert H. 1967. The Frightful Consequences of Onanism: Notes on the History of a Delusion. *Journal of the History of Ideas* 28: 423–31.

Mann, Thaddeus. [1954] 1964. *The Biochemistry of Semen and of the Male Reproductive Tract.* London: Methuen & Co. Ltd.

Melville, Herman. [1851] 1972. *Moby-Dick; or, The Whale.* New York: Penguin.

Miller, D. A. 1988. *The Novel and the Police.* Berkeley and Los Angeles: University of California Press.

Moon, Michael. 1991. *Disseminating Whitman: Revision and Corporeality in* Leaves of Grass. Cambridge: Harvard University Press.

My Secret Life. [c. 1890] 1966. Intro. G. Legman. New York: Grove Press.

Parkman, Francis. [1849] 1982. *The Oregon Trail.* New York: Penguin.

———. 1866. *The Book of Roses.* Boston: Tilton & Co.

Perry, David. 1992. Learning from the Masters: A San Francisco University Teaches Sadomasochistic Basics and Then Some. *The Advocate.* 602 (5 May): 60–61.

Q[uality] SM. [c. 1991] Course brochure.

Sánchez-Eppler, Karen 1988. Bodily Bonds: The Intersecting Rhetorics of Feminism and Abolition. *Representations.* 24 (Fall): 28–59.

Schab, Frank R. 1991. Odor Memory: Taking Stock. *Psychological Bulletin.* 109: 242–51.

Sedgwick, Eve Kosofsky. 1990. *Epistemology of the Closet.* Berkeley and Los Angeles: University of California Press.

Spitz, René A. 1952. Authority and Masturbation: Some Remarks on a Bibliographical Investigation. *The Psychoanalytic Quarterly.* 21: 490–527.

Stoddart, D. Michael. 1990. *The Scented Ape: The Biology and Culture of Human Odour.* Cambridge: Cambridge University Press.

Whitman, Walt. 1982. *Complete Poetry and Collected Prose.* New York: The Library of America.

8

"POMEGRANATE-FLOWERS": THE PHANTASMIC

PRODUCTIONS OF LATE-NINETEENTH-CENTURY

ANGLO-AMERICAN WOMEN POETS

PAULA BENNETT

In *No Man's Land: The Place of the Woman Writer in the Twentieth-Century,*
Volume I (1988), Sandra Gilbert and Susan Gubar briefly discuss *The Voice of
Evil* (1895), a painting by art nouveau designer, Georges de Feure (1869–1929).
To these twentieth-century American critics, the painting inscribes the male
artist's anxious response to the rise of the woman writer in the last years of the
preceding century. In the painting, de Feure, a "sometime disciple of Baudelaire,"
depicts a woman engaged in masturbatory fantasizing (1988, 233). Gilbert and
Gubar do not say that masturbation is an issue. Nonetheless, the picture, which
they reproduce, makes the veiled presence of the woman's ambiguously-hidden
vice clear (figure 1).[1]

An androgynously powerful woman sits before a table on which rest her
inkwell and pen, and a few sheets of blank paper. Beside the paper lie a scatter-
ing of bracelets and rings, slipped—presumably for comfort's sake—from her
obscured right hand.[2] Leaning her head against her other hand, which is not
only fully visible but conspicuously adorned, she stares thoughtfully in the direc-

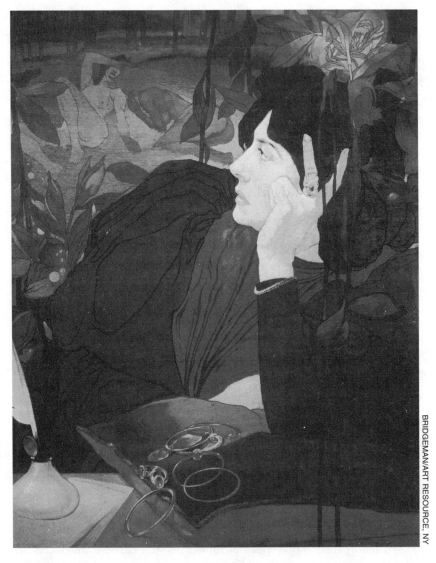

Figure 1. Feure, Georges de. *The Voice of Evil*. Private Collection.

tion of the canvas's top left corner. There two naked female forms, one white, the other a horned, Gauguinesque woman of color, recline together, making love, in a cramped visual space marked off by trees and semi-tropical foliage.

While her partner leans over her, the Caucasian woman lies back in what appears to be post-orgasmic languor, her right arm shielding her eyes, her left leg raised. Caught in this position, her breasts fall directly in the trajectory of the woman writer's gaze. As active dreamer and passive observer of this lush erotic scene, the woman writer is inextricably bound to it and to the sexually and racially transgressive behaviors it depicts. She listens, as it were, to their "voice"—intent, perhaps, on giving voice to them in turn. To her right, framing her within the scene and making her an integral part of it, rises a tall art-nou-veau flower. A sort of attenuated and perverted lily, the flower signifies the cor-ruption of female sexual purity to which the woman writer's fantasy life is also made to attest. Whether employing her hand to write—or to engage in other, even more secretive and solitary activities—in the very substance of her fan-tasies, this woman stands condemned.

To Gilbert and Gubar, however, de Feure's painting does not speak to what women writers were writing but to what *they might write* should they gain full access to their passions.

> Does de Feure fear that...the musing woman in the foreground may sweep away the mind-forged manacles of her rings and bracelets, and *begin to write* her woman's words? Possessed by passion she *may* usurp and possess language, both the voice of evil and the pen of power. Clearly, when she writes, her language will be other. Autonomous and opaque, it will be the speech of evil. So Georges de Feure has elegantly indicted and sentenced her before she can indite the sentence of her own freedom. (1988, 233–35; emphasis added)

By this account, such a woman writer has yet to arrive. First her passion must be liberated from the "mind-forged manacles" of (phallogocentric) Victorian cul-ture. Only then will her pen take the place of the penis she lacks.

However theoretically sophisticated in itself, Gilbert and Gubar's analysis of de Feure's painting does little to credit the sophistication of the women writ-ers publishing in the artist's own period. Rather, the twentieth-century critics assume—as so many others have—that, as a group, bourgeois nineteenth-cen-tury women were both linguistically and sexually repressed. This assumption no longer seems as compelling as it once did, however. Not only have social his-

torians such as Carl Degler (1974), Peter Gay (1984, 109–168 and *passim*), and Karen Lystra (1989, 88–120), supplied solid evidence for the importance of sexual pleasure in the lives of many middle-class nineteenth- century women, but literary critics, Patricia Yaeger (1988, 239–277) and I (1993) among them, have argued forcefully that, despite the interdiction on explicit language, bourgeois women did find a multitude of ways, some more coded than others, to put their pleasure into print.

Equally telling, "the repressive hypothesis" (Foucault 1978, 36–49) does little to explain the presence, let alone the impact, of the huge volume of nineteenth-century male art dealing obsessively with female sexual power. As Patrick Bade (1979, 6–39), Nina Auerbach (1982, 63–108), and Bram Dijkstra (1986, 235–271 and *passim*) have shown, far from viewing women as "passionless" (Cominos 1973, 162–168; Cott 1978, 219–36), many male artists and writers both in the United States and England and on the Continent appear to have been persuaded (even as were many of their medieval forebears) that women were the very embodiment of sexual evil. If Victorian women writers did not speak as explicitly as we do about sexuality or about the way in which they were sexually positioned within their culture, this does not mean they were ignorant on either score or that they were incapable of turning their sexuality, linguistically as well as socially, to their own ends. More particularly, given the huge body of preponderantly male literature and art devoted to such matters, it does not mean they were unaware of the autoerotic and homoerotic components within female sexuality, that is, the very components giving fin-de-siècle men such as de Feure their greatest concern.

In this essay, I discuss a representative group of poems which suggest that late-nineteenth-century women writers were evolving an erotic that in some ways provides remarkable confirmation for de Feure's fears. A shibboleth of recent critical and theoretical writing has been that women do not have access to the Symbolic and that, therefore, they cannot speak their own desire. According to this view, based on the theories of Claude Levi-Strauss and Jacques Lacan, women have no existence within (phallogocentric) culture except as objects of male discourse. Without status as cultural subjects, their principal function, linguistically speaking, is to serve as signs produced by and for another social group.[3] As a result, to express their desire—as to gain even a modicum of control over their environment—they have been forced to employ "subversive" strategies such as hysteria—the so-called "language of the body." Or they have become the "thieves" of language inherently not their own (Cixous [1976],

1981, 45–55; Cixous and Clément [1975] 1986, 63–100; see also Yaeger, 1988, 1–34).

As Catherine Clément points out, not only do such arguments glamorize silence and illness, but they attribute political efficaciousness to strategies that are dubiously "empowering" at best (Cixous and Clément [1975] 1986, 157). Moreover, these arguments ignore a vast body of women's literature—in particular, nineteenth-century women's literature—in which the authors do speak their desire, and in which they use their eroticism socially and psychologically to empower themselves. Excessive, florid, superfluous in terms of social usefulness, "perverse" in its single-minded commitment to pleasure as its only "use," this literature possesses many of the qualities theorists such as Hélène Cixous have called for when urging women to "write the body" (Cixous [1976] 1983, 284). And I believe it was this literature that men like de Feure found so threatening and that seemed so alien and opaquely "other" to them.

For its authors were not (at least, not identifiably) lesbians or masturbatrixes or any of the other pathologized sexual subtypes emerging in the last half of the nineteenth century (Foucault 1978, 36–49). They were "good" bourgeois women, well-educated, well-off, often religious, fully integrated into their society, outwardly deviant in few if any respects, even when, as in the cases of Emily Dickinson (1830–1893) and Christina Rossetti (1836–1894), they chose not to marry.[4] If such women constructed their sexuality and their sexual fantasies in ways that blurred the distinction between them and those clearly needing regulation (prostitutes, lesbians, masturbators, women of "inferior" races, and so forth), what hope did society have?[5] Where were loving and dedicated mothers—and wives—to come from? Worse yet, could bourgeois men, burdened as they were with the growing needs of capitalist society, possibly meet the sexual demands these women, so aware of their own desire for pleasure, might make? How could male narcissistic needs be fully gratified, that is, if women felt legitimately entitled to exercise their own narcissism and demand their fair share? What would happen to the sex/gender system then, based as it was—if not exactly on the "exchange of women"—then on their willed and culturally reinforced sexual and social subordination to men (Rubin 1975, 157–210)?[6]

It was, I believe, such questions that the literature I discuss raised and that help explain the innumerable paintings such as de Feure's in which women's sexual desire was associated with narcissistic corruption, masturbation, and evil. Far from being mute, the women speakers of these poems voice their desire in many different ways and in terms quintessentially their own, not the appropri-

ated or subverted language of men. Not stolen. Not somatized into the so-called hysterical language of the body. And it is, therefore, all the more significant that in speaking their desire, they—unlike their male contemporaries—rarely focus on its potential for evil even when they associate it, as they often do, with the exotic, the narcissistic, or the despised. If, as we shall see, Rossetti provides an exception to this rule, hers is an exception proving the rule. Narcissistic, auto-erotic, homoerotic, transgressive, masturbatory, socially excessive, even danger-ous, their desire may have been. But for the bourgeois women writers I discuss, as for theorists such as Luce Irigaray ([1977] 1985) and Patricia Yaeger (1988) today, female sexual desire was also a source of creative power, giving women autonomous access to the springs, pleasures, and imaginative richnesses of life. While they knew that the exercise of this power could place them outside the domestic pale—at least as that pale was ideologically defined—this knowledge does not appear to have troubled them half as much as, quite understandably, it troubled men.

Of the many nineteenth-century poems by women centering on autoeroti-cally-based female sexual desire, none is more striking than the American poet Harriet Prescott [Spofford]'s "Pomegranate-Flowers" (1861). In this poem, originally published in the May 1861 *Atlantic Monthly*, Spofford (1835–1921), a writer of extravagant, not to say reckless, stylistic effects, devotes twenty-seven stanzas to a young woman's ecstatic response to a pomegranate tree, the gift of a now absent lover.[7] A seamstress, or, possibly, a lace-maker, the young woman lives in a garret room, overlooking a "narrow, close, and dark" street, in a shady section of a "sea-board town" (by the "long wharves" [573, lines 1, 22, 17]). Whether, as her occupation and location appear to suggest, she also works as a prostitute is left moot. Certainly, such details, when taken together with the ambiguous identity of her "lover," who, Spofford says, could be either a sailor or a foreigner, raise the question. What is beyond question, however, is that alone and abandoned in her "small room" (575, line 94) this girl still possesses notable erotic resources of her own.

Seizing on the pomegranate tree as the focus for her sexual fantasizing, the sometime seamstress weaves her sensual response to its exotic (Southern) beauty into the lace she embroiders with her hands. By means of her fantasies, she not only escapes the ugliness and confinement of her immediate surroundings, she also experiences directly the bursting power of female sexuality itself, a sexuality which Spofford depicts in the conventionalized and readily decodable terms of women's identification with nature—in particular, with flowers (Bennett 1993,

237–239). Fully open to her own eroticism, the young woman converts her day-dreams directly into a source for her "daedal" art, an art which gives her, like the mythic labyrinth-maker, Daedulus, the freedom and power of (imaginative) flight:

> Bent lightly at her needle there
> In that small room stair over stair,
> All fancies blithe and debonair
> She deftly wrought on fabrics rare,
> All clustered moss, all drifting snow,
> All trailing vines, all flowers that blow,
> Her daedal fingers laid them bare.
>
> Still at the slowly spreading leaves
> She glanced up ever and anon,
> If yet the shadow of the eaves
> Had paled the dark gloss they put on.
> But while her smile like sunlight shone,
> The life danced to such blossom blown
> That all the roses ever known,
> Blanche of Provence, Noisette, or Yonne,
> Wore no such tint as this pale streak
> That damasked half the rounding cheek
> Of each bud great to bursting grown.
>
> And when the perfect flower lay free,
> Like some great moth whose gorgeous wings
> Fan o'er the husk unconsciously,
> Silken, in airy balancings,—
> She saw all gay dishevellings
> Of fairy flags, whose revellings
> Illumine night's enchanted rings.
> So royal red no blood of kings
> She thought, and Summer in the room
> Sealed her escutcheon on their bloom,
> In the glad girl's imaginings.

> *Now, said she, in the heart of the woods*
> *The sweet south-winds assert their power,*
> *And blow apart the snowy snoods*
> *Of trilliums in their thrice-green bower.*
> *Now all the swamps are flushed with dower*
> *Of viscid pink, where, hour by hour,*
> *The bees swim amorous, and a shower*
> *Reddens the stream where cardinals tower.*
> *Far lost in fern of fragrant stir*
> *Her fancies roam, for unto her*
> *All Nature came in this one flower.*
> (575, lines 93–132)

The rich, not to say, excessive, sensuosity of these stanzas hardly needs emphasizing. The passage is a flood of erotic clichés, clichés bearing no small resemblance to those heating up the pages of much soft porn—not to mention much great literature (for example, *Canticles*, the *caput nili* for much of this poetry, including the text in question [Watts, 1977, 32–33; see also Krafft-Ebing, (1886) 1968, 31]) From the ocular to the olfactory to the gustatory, every sense is appealed to and indulged as the "glad girl" contemplates and fantasizes about—gets aroused by—her flower/her imagination. With its dark, glossy outer leaves and its swelling rosy bud, the pomegranate flower stands surrogate for her genitalia.[8] And it is these with which, clearly, she is "in love," so in love that donning the white lace veil on which she works, she effectively marries herself before her mirror. In a bizarre acting out of her own Orientalist fantasies, she becomes (as it were) Solomon and Sheba to herself:

> *Out of some heaven's unfancied screen*
> *The gorgeous vision seemed to lean.*
> *The Oriental kings have seen*
> *Less beauty in their dais-queen*
> *And any limner's pencil then*
> *Had drawn the eternal love of men.*
> (577, lines 192–197)

Having thus given the girl twenty-six stanzas in which to revel in self and flower, Spofford concludes the poem by leaving her highly narcissistic and auto-erotically-engaged subject in a state of post-orgasmic quietude and bliss, all pas-

sion spent. From the beginning to the end of the poem, not a single other person, including the long-gone sailor/lover, enters the girl's awareness or, indeed, except for a few passing street urchins, is ever mentioned in the text. Like the orgy which de Feure's woman writer dreams about, the "bacchanalian" ecstasy which Spofford's protagonist experiences, she experiences alone—or, rather, alone in the company of her flower. Utterly self-generated and self-contained, her orgasm, like that of the woman writer, is as much a mental as a physical event:

> The sudden street-lights in moresque
>> Broke through her tender murmuring.
> And on her ceiling shades grotesque
>> Reeled in a bacchanalian swing.
>> Then all things swam, and like a ring
>> Of bubbles welling from a spring
>> Breaking in deepest coloring
>> Flower-spirits paid her minist'ring.
> Sleep, fusing all her senses, soon
> Fanned over her in drowsy rune
>> All night long a pomegranate wing.
> (579, lines 287–297)

Like other women writers (Sylvia Plath [1962] 1981, for example), Spofford expresses the rising sensations of her protagonist's climactic orgasm in terms of a widening circle of concentric colored rings which break upon/within her. As is typical of the racist stereotyping defining Orientalism, the narrator identifies the girl's erotic feelings with that which is dark as well as that which is Southern or Eastern ("moresque"). Seen thusly, the seamstress's eroticism appears to swell up, metaphorically, from "below"—and this dark potential rims, however briefly, Spofford's vision of light. Even to Spofford, it appears, as to the far more virulent authors of anti-onanist literature, a young woman's unleashed "imaginings" could excite the most primitive and uncontrollable of desires, desires that lead her to the edge of regression and madness (In the poem's term, she becomes, or, rather, comes in touch with, the "grotesque.") But the breaking of the orgasm itself rescues Spofford's protagonist and brings her back to the safety and security of a less dangerous, dream-laden sleep. After a brief sally into the wild unknown, the poem ends in post-climactic contentment and the girl's sexuality

is once again depicted in positive, flower-inspirited terms. The poem's conclusion suggests that, however dangerous this young woman's sexuality may seem to be, finally its darkness does not corrupt. It liberates, integrates, empowers, and restores.

Aside, possibly, from Rossetti's "Goblin Market" ([1862] 1979) which I discuss in the final section of this essay, Spofford's "Pomegranate-Flowers" is, to my knowledge, the most lavish and fully displayed poem on masturbation by an Anglo-American woman writer in the late nineteenth century. Taken all in all, it is also among the most obvious. That it appeared in a bastion to bourgeois good taste such as *The Atlantic Monthly* must therefore give pause. However hostile the cultural response would eventually become to expressions of female sexual autonomy, male editors in Spofford's day were, apparently, ready to accept such celebrations of female passion, at least as long as they were couched in appropriately coded terms. Using these terms, women writers were able, in effect, to say what they liked. Indeed, as in Dickinson's "I tend my flowers for thee" ([1861] 1955), they were even able to "sell" themselves to would-be lovers on the basis of what they had to offer—the colors, sensations, and perfumes associated with their sexual arousal:

> *I tend my flowers for thee—*
> *Bright Absentee!*
> *My Fuchsia's Coral Seams*
> *Rip—while the Sower—dreams—*
>
> *Geraniums—tint—and spot—*
> *Low Daisies—dot—*
> *My Cactus—splits her Beard*
> *To show her throat—*
>
> *Carnations—tip their spice—*
> *And Bees—pick up—*
> *A Hyacinth—I hid—*
> *Puts out a Ruffled Head—*
> *And odors fall*
> *From flasks—so small—*
> *You marvel how they held—*

Globe Roses—break their satin flake—
Upon my Garden floor—
Yet—thou—not there—
I had as lief they bore
No Crimson—more—

Thy flower—be gay—
Her Lord—away!
It ill becometh me—
I'll dwell in Calyx—Gray—
How modestly—alway—
Thy Daisy—
Draped for thee!
(1955, 270–71; #339)

While Dickinson's speaker concludes by saying she will drape her "Daisy" "modestly" in gray, "Her Lord—away!," the poem's point lies in the orgy of color, sound, taste, and touch that precedes this final, disassociating act. The "gay" flower—with its Spoffordian hint at prostitution—will only temporarily don a drab outer garment.[9] At heart, it "dreams," and its dreams—the phantastical, autoerotic imaginings of a flower-poet—are as lush and unrestrained as the draped daisy is "gray."

As the disproportionate number of lines given to her testifies, it is this dreaming, self-loving, "crimson," female persona—not her modest, nunlike antithesis—to whom the poet-speaker assumes her lover is attracted. Otherwise, if he truly wants her "gray," why the lavish investment of poetic energy in proving the opposite (twenty-two lines out of twenty-seven)? Why, that is, expose the "crimson" lady secreted inside the nun's "calyx" (the virginal and vaginal "chalice"), unless it is precisely the crimson lady—the masturbatory and orgasmic dreamer of dreams—whom the speaker knows her lover desires, albeit only as long as her sexual dreaming is at least nominally dedicated to him?

Spofford's and Dickinson's poems do more than establish that late-nineteenth-century bourgeois women were free to celebrate their sexuality in their poetry, however. These poems also indicate that their authors saw female sexuality, especially in its autoeroticism and homoeroticism—its intense pleasure in femaleness itself—as a source of personal as well as imaginative power for women. Nowhere does this enabling perspective reveal itself more clearly than, paradoxically, in the oblique allusions to prostitution both poets deploy.

To nineteenth-century ideologues of social purity, the prostitute ranked among society's premier symbols for the sexualized woman—an ultimate type for the degradation to which any good woman could sink should she abandon her spiritual nature and give way to her "baser" instincts and the incitements of the flesh. In a binary still to some extent with us today, a woman who was not "good," who failed sexually to live up to her social and domestic obligations, was, by definition, "fallen," or more colloquially, a whore. Like the lesbian, the nymphomaniac, and the masturbatrix, with whom she was typically grouped in anti-onanist literature, the whore (whether a whore in fact or a whore in imagination) gave to lust and "self"-gratification what rightfully belonged to husbands, country, and God. By the laws of nature, God, and man, she was therefore "unnatural," not just excessive but perverse (Foucault 1978, 36–49; Laqueur [1989], 1995).

In recuperating the prostitute by placing her metaphorically in a natural, flower-bedecked setting, Dickinson and Spofford were, I believe, rejecting precisely this definition of self-pleasure as (unnatural) perversion (Gallop 1988, 106).[10] Unlike the woman writer in de Feure's painting, their protagonists do not corrupt themselves with their sexual fantasies, however exotic the content. Rather, they use their atavism—the atavism of unchecked, autoerotically and homoerotically oriented libido—to give them power and to make their sexuality exciting. Otherwise, as Rose Terry [Cooke] (1827–1892) makes clear in "In the Hammock" (1866), a poem as blatant as "Pomegranate-Flowers" in its engagement with masturbation, they might as well be nuns. For without such atavism, women were also, sexually and imaginatively speaking, without freedom or joy. Then sex could only be a duty to them—and pleasure something, as Foucault puts it, "to be endured" (1978, 48):

How the stars shine out at sea!
Swing me, Tita! Faster, girl!
I'm a hang-bird in her nest,
All with scarlet blossoms drest,
Swinging where the winds blow free.

Ah! how white the moonlight falls.
Catch my slipper! there it goes,
Where that single fire-fly shines,
Tangled in the heavy vines,
Creeping by the convent walls.

Ay de mi! to be a nun!
Juana takes the veil to-day,
She hears mass behind a grate,
While for me ten lovers wait
At the door till mass is done.

Swing me, Tita! Seven are tall,
Two are crooked, rich, and old,
But the other—he's too small;
Did you hear a pebble fall?
And his blue eyes are too cold.

If I were a little nun,
When I heard that voice below,
I should scale the convent wall;
I should follow at his call,
Shuddering through the dreadful snow.

Tita! Tita! hold me still!
Now the vesper bell is ringing,
Bring me quick my beads and veil.
Yes, I know my cheek is pale
And my eyes shine—I've been swinging.
(1866, 106)

Given that the female speaker of "In the Hammock" is, presumably, a Spanish-speaking Roman Catholic from southern Europe or from South America, Cooke could easily have made her into an icon of evil—as, indeed, such vaguely racialized figures often were in nineteenth-century Anglo-American literature. But Cooke does not. Her "ten lovers" and her fantasies of elopement, notwithstanding, this speaker is not an evil woman. She is a "typical" adolescent, her head full of nonsense, the product of an overactive imagination (Blos 1962, 160–162). Her zest for physical pleasure—signified by her "hammock-swinging"—is not a crime; nor is she treated as a criminal. Neither is she pathologized. She is shown having far too much fun.

Rather, in this poem, it is the "good" Juana who will live behind bars and suffer the stigmata of a socially constructed disease. For Juana has sacrificed all her potential for taking joy in life, in flowers, in pleasure. Having thrown off even the restraint of her slippers, the unnamed speaker of "In the Hammock" is "free." Despite its narcissism and self-pleasuring, and its obvious suggestions of moral and sexual looseness, hammock-swinging has not corrupted her. It has helped her learn what she wants for herself. Submission, obedience, restraint (Dickinson's gray calyx) are not part of the equation. The selflessness they demand is, quite simply, antithetical to jouissance. Antithetical to life. As Dickinson's poem suggests, it is doubtful even men would want—at least as lovers—women so sexually and imaginatively dead.

While rarely as blatant as the three poets I have cited, the fact is that a surprising number of late-nineteenth-century women poets were supportive of the autoerotic and homoerotic in their speakers' sexual desires, whether or not these desires were ultimately to be directed toward heterosexual ends. The exceedingly gentle poem, "My Heart" (1879), published anonymously in *Frank Leslie's Popular Monthly*, is a case in point. Once again the author writes from the perspective of an adolescent girl, but one still in the bud—still, that is, at what Sigmund Freud (1856–1939) denigratingly identified as the masturbatory or clitoral stage of female psycho-sexual development, before the transition to "mature" heterosexuality sets in ([1925] 1950, 193–95; see also Blos 1962, 165–67). When compared to that of the three previous speakers, this young woman's fantasy life may seem relatively tame. But, taken in itself, the poem's eroticism is hard to dispute. Its inward-turningness—so typical of its own period and so alien to ours—may be harder to fathom:

I.

They say a woman's heart is like a harp,
　And like a rose that knows a blooming hour.
May be; but mine—not yet hath risen its song;
　May be; but mine—not yet hath blown its flower.

II.

'Tis true some little, wordless fantasie
　May have been wakened by a toying hand;
Some genial breeze have oped a little bud,
　A small, white flower like on lone woodland.

III.

The music, burdened with grand words, awaits
 Some master powerful and passionate;
And dreaming of the royal-hearted sun,
 The rich red rose sleeps in her vailed state.

IV.

But, oh! my heart is happy of this hush,
 So like the silence of that hour ere dawn—
So glad to dream, as little shrubs may dream
 All Winter 'neath the warm snow on the lawn.
(1879, 670)

For this young woman, as for Dickinson in the "Man of Noon" letter ([1852] 1958, 209–11)—another brilliant inditement of female adolescent sexuality—mature heterosexuality is not a consummation devoutly to be wished. It is a frightening prospect, viewed with highly mixed emotions. Let the "rich red rose" (the woman who desires marriage) have the "powerful and passionate" master, "the royal-hearted sun." The speaker is content with her barely opened bud, her "little wordless fantasie," and (however ambiguously) her "toying" (but hardly unnatural and never hurtful) hand. She will remain in the woods, resisting her own blooming, as long as she can. Her heart is no harp on which any man can play. Succinctly, she prefers to play with herself.

Simple and innocuous as a poem such as "My Heart" may seem (the ambiguity of the second stanza clearly allows the poem to be read in a number of different ways), it epitomizes why the forces of social regulation became increasingly obsessed with masturbation, including female masturbation, as the nineteenth century wore on. As Thomas Laqueur ([1989] 1995), Karen Lystra (1989, 100), and Vernon Rosario II (1995, this volume) have all pointed out, the privacy and autonomy of masturbatory activity were precisely the qualities that made it threatening to a society insisting on the sociality of sex, that is, to a society that constructed sex as social. Sociality, for women, meant submission to men and commitment to motherhood. (It is worth noting in the last poem that the speaker's contentment is predicated not only on her isolation but on her explicit deferment of marriage, indeed, her rejection of it.) As early anti-onanist authors such as the Swiss physician Samuel Auguste Tissot (1728–1797) worried, "this infamous practice" led to "indifference…for the legitimate pleasures of hymen," in

both sexes but more frequently and, therefore, with more socially destructive potential in women (as quoted by Rosario, 1995, 101 above). Viewed thus—as unchecked by any commitment to duty and usefulness, wayward and childlike in essence—female sexual self-stimulation had the unlooked-for capacity to undermine the very foundations of the state for it subverted one of the primary sources of the state's power: women's commitment to marriage, their readiness to subordinate themselves—as social and economic subjects and as feeling human beings—to the care and feeding of their children's and their husbands' needs.

No wonder, then, that even as hundreds of nineteenth-century women began to put their fantasies into print, the expression of these fantasies made men increasingly uneasy. Whichever came first, whether thought or deed, both, as the French doctor Demetrius Alexandre Zambaco (d. 1914) makes clear, needed to be suppressed. In his case study of two young Turkish girls, ages ten and eight, whom he treated for onanism, Zambaco comments:

> We have already said that, when X first began to masturbate, nature was not demanding anything at all; that is to say, it was not the genital organs which led to her desire to masturbate. Rather, it was an idea, a cerebral impulse, which led X to excite her sexual organs, still quiescent and insensitive in themselves. I would express my thoughts better if I said that her masturbation, at the beginning, was cerebral masturbation, and it was only later that it became sexual. The clitoris and the vagina, awakened and sensitized by these repeated touchings, gave rise, in their turn, to lascivious thoughts, and so X reached the point in her story where we now find her, continuing her lamentable habits by means of two separate excitations: cerebral and sexual. ([1882] 1986, 72)

"Cerebral masturbation" is just, if not more, dangerous than the "real thing." For the mind, especially the plastic mind, such as women and children were thought to possess, all too readily incited the individual to move from thinking to doing.

But what happens to the woman poet—the woman who needs "lascivious thoughts," the free wanderings of a sensually stimulated imagination—in order to write?[11] In "Goblin Market" ([1862] 1979) Christina Rossetti transcribes the vivid imaginings and the final terror masturbatory fantasy could evoke in a woman artist who distrusts the cerebral impulses from which her artistic power flows. Like "Pomegranate-Flowers," "Goblin Market" is a long narrative poem; but unlike Spofford, Rossetti concludes her poem with her protagonist's outright rejection of the autonomous sexual power she is so briefly allowed to enjoy.

For Rossetti, as for numerable anti-onanist writers, the masturbator's attraction to "Goblin fruit"—that is, the dark forbidden fruit of autoerotic sexuality—is dangerous precisely because it inhibits the individual's integration into the daylight world of socially constructed love and labor.[12] Tempting the fruit may be, Rossetti insists, but, once devoured, it disables the partaker for life. Indeed, it invokes in Rossetti's protagonist a symptomology suspiciously like that which doctors and hygienists claimed afflicted those obsessed with masturbation to the exclusion of everything else. "Longing for the night" ([1862] 1979, 16, line 214) yet unable to sleep, absent-minded, driven by desires she cannot name, let alone satisfy, sunken-eyed, mouth faded, and prematurely aged:

> [Laura] *no more swept the house,*
> *Tended the fowls or cows,*
> *Fetched honey, kneaded cakes of wheat,*
> *Brought water from the brook:*
> *But sat down listless in the chimney-nook*
> *And would not eat.*
> (18–19, lines 293–98)

Like her friend Jeanie, who has already died as a result of her nightime commerce with the goblin men—and like many another presumed victim of the "solitary vice"—Laura "dwindling/Seemed knocking at Death's door" (19, lines 320–21).[13]

Laura is saved, of course, by the self-sacrificial act of her sister, Lizzie. Going to the goblin men, Lizzie allows them to cover her face and neck with goblin fruit, yet, to their consternation, she does not partake herself. Rather, she returns to her fatally stricken sister, to let Laura eat—but this time, as it were, in a social (therefore, alloerotic) setting:

> *Hug me, kiss me, suck my juices*
> *Squeezed from goblin fruits for you,*
> *Goblin pulp and goblin dew.*
> *Eat me, drink me, love me;*
> *Laura, make much of me.*
> (23, lines 468–72)

The "fiery antidote" (26, line 559) works. Having realized in the flesh what was, presumably, the content of her self-isolating, autoerotic fantasizing (that

is, making love to her sister), Laura is thoroughly and completely repelled by
what she longed for. Indeed, in a scene that brilliantly conflates male anxieties
respecting witches and sorceresses with medical attitudes toward lesbians and
hysterics, possessing the fruit causes Laura to act as if she were (hysterically)
possessed:[14]

> Her lips began to scorch,
> That juice was wormwood to her tongue,
> She loathed the feast:
> Writhing as one possessed she leaped and sung,
> Rent all her robe, and wrung
> Her hands in lamentable haste.
> (24, lines 493–98)

Indulging in her sister—for whom the "fruit" apparently stands as vehicle—does
not gratify Laura. Rather, this incestuous lesbian episode homeopathically cures
her—by making her temporarily "ill." Thus released from the dread disease of her
own imagination and miraculously restored to youth, beauty, and innocence, Laura
gives up all desire for goblin "dew" (an ambiguously clitoral image [Bennett 1993,
236]) and goes on like her sister Lizzie—but quite unlike the author herself—to
marry and "have children of [her] own" (25, line 545). Her "mother-hear[t] beset
with fears," she recounts to them the cautionary tale of her own near fatal passage
through adolescence and of "The wicked, quaint fruit-merchant men,/Their fruits
like honey to the throat/But poison in the blood" (25, lines 553–55). "Men sell
not such in any town" (line 556), the narrator adds parenthetically, underscoring for
the last time the dangerous isolation of masturbatory experience. Being always
with others and never letting the mind wander off alone are the only sure ways to
protect oneself against the temptations and perverted pleasures of this strange and
exotic—but all too easily available—fruit.

The poem concludes on an uplifting moral whose very formulation in pious
platitudes stands in striking contrast to the sensuously rich, magnificently
ambiguous poetry preceding it. It is as if, in turning her back on goblin dew and
the richness of the fantasy life it signified, Rossetti turns her back on her art as
well:

> "For there is no friend like a sister
> In calm or stormy weather;

> *To cheer one on the tedious way,*
> *To fetch one if one goes astray,*
> *To lift one if one totters down,*
> *To strengthen whilst one stands."*
> (26, lines 562–67)

In these lines, Rossetti is not simply recontaining the atavism unleashed by Laura's fantasy life—as Spofford does for her protagonist at the conclusion of "Pomegranate-Flowers" or as Dickinson claims to do at the end of "I tend my flowers for thee." She is rejecting such atavism altogether and, with it, the auto-eroticism which is its source. There are no more dreams, autoerotic, homo-erotic, incestuous, or otherwise, no more "goblins," no more "grotesques." Laura's relationship to her sister—once her fantasy object—is now just that: a sisterly relationship. Her sexuality, redirected into motherhood, is the property of men. After 542 lines of some of the most gorgeous poetry in women's litera-ture, the crimson lady gives way to the gray-calyxed nun.

In light of Rossetti's religiosity and her membership in the pre-Raphaelite circle surrounding her brother, Dante—a group of artists obsessed with nothing if not with female sexual evil—it probably should not be surprising that "Goblin Market" ends as it does. But Rossetti's conclusion, unhappily, also prefigures the toll social pressure, along with the new "sciences" of sexology and psycho-analysis, would eventually take on women writers as the century drew to a close and they persisted in exploring the sexual sources of their art. Increasingly in the minds of those around them, the atavism present in these sources made the women themselves seem tainted, and large elements within the educated popu-lation, including many women writers themselves, became convinced that they were beings set apart—lesbians, freaks, women who had abandoned "normalcy" (the sociality of sex) for the dangers—and perverted pleasures—of an autoerot-ically and homoerotically charged imaginative life. They lived too close to the root of things forbidden to be seen otherwise. From de Feure's painting to Djuna Barnes's *Nightwood* (1937) and Sylvia Plath's poetry (1981), women writ-ers and their sexual fantasies became identified with "the voice of evil" instead.

But to describe the changes overtaking women writers' self-image after the turn of the century would take us well beyond the scope of this essay. Suffice it to observe that wherever we are today, and however we got here, nineteenth-century bourgeois women had their own position on female sexual-ity and its relation to women's creativity, one far more nuanced and complex

than most of our current theoretical and critical literature allows. It is also one whose richness, and whose autoerotic richness, in particular, nourished their art. These women were not silenced. Nor were they compelled to somatize their sexuality into the hysterical language of the body. For all the coding they employed, they put their desire into words. And their words speak as clearly and as resonantly as our own. If we have not heard them, it may be because, having listened to the "voice of evil" for so long, it is all but impossible for us to understand what these earlier women say.

NOTES

1. As Weigert and Dennis (this volume) make clear, there is a long history of portraits of masturbating women in Western art. In the eighteenth century (Tarczylo 1983, 223), women were sometimes portrayed, holding a book—most likely an erotic novel—in one hand, while they masturbated with the other; but de Feure's transformation of the woman reader into a woman writer is a "sign of [his] time." As successfully competing producers of the written word, significant numbers of nineteenth-century bourgeois women, as Gilbert and Gubar observe (1988, 21–43), had become threatening to male artists in ways earlier women writers were not.

2. I am indebted to my student Michael Berndt for pointing out that the woman's right hand is partially visible behind the pillow on which her left elbow rests. However, like everything else in connection with this hand, the hand with which she would masturbate as well as write, its presence is ambiguously rendered in ways quite unlike those employed in most portraits of male or female writers, where the writing hand is typically featured.

3. From Levi-Strauss on, theorists have ritually acknowledged that women also "produce signs" (i.e., speak). But this capacity is so consistently subordinated to women's supposed primary function as signs that it gets lost in most discussions. The result has been that women's complex power relationships to men, relationships that vary across national, economic, racial, and class lines, are often reduced, even in feminist theoretical literature, to a single narrative (one based, of course, on structuralist principles). (See, for example, Clément's discussion of woman as sign in Cixous and Clément, [1976] 1986, 63–71).

4. Jeffreys (1985, 116 and 165–71) observes that women who chose to remain single were not viewed as pathological until the end of the nineteenth century.

5. For example, Lipton (1987, 68 and 182) attributes much fin-de-siècle male anxiety respecting female sexuality to the breakdown of the codes of dress and behavior that had once maintained the boundaries between prostitutes and bourgeois women.

6. Even Krafft-Ebing ([1886] 1968, 2–5)—hardly an ardent advocate of feminism—

acknowledged that the system of the exchange of women had been abolished in the West. Indeed, he sees its abolition as one of the marks of the West's advanced civilization. Why this very nineteenth-century anthropological idea—whose applicability even to many pre-technological societies is moot—has acquired such caché in contemporary theory is difficult to understand; but its adoption by feminists seems self-defeating.

7. The idea that the mere sight of a flower could incite masturbation may strike some readers as improbable, but let me quote Havelock Ellis ([1945] 1964) on the matter:

> Schrenk-Notzing knows a lady who is spontaneously sexually excited on hearing music or seeing pictures without anything lascivious in them. She knows nothing of sexual relations. Another lady is sexually excited on seeing beautiful and natural scenes, like the sea. Sexual ideas are mixed up in her mind with these things and the contemplation of a specially strong and sympathetic man brings orgasm on in about a minute. Both of these ladies masturbate in streets, restaurants, railways, theatres, without anyone perceiving it. (32)

Needless to say, the fact that women could masturbate "in streets, restaurants, railways," etc., without being perceived could only add to the ways in which female masturbation was threatening to men.

8. I have discussed the bud as a clitoral symbol elsewhere (Bennett 1993, 236–48). It is used pervasively for pornographic purposes by women romance writers and even appears in Edith Wharton's posthumously discovered erotic fragment, "Beatrice Palmato" ([1919–20] in Erlich 1992, 174–76): "As his hand stole higher she felt the secret bud of her body swelling, yearning, quivering hotly to burst into bloom" (175), a sentence that could appear unchanged in any one of a thousand supermarket paperbacks. Such a sentence puts the specifically sexual nature of the floral discourse I am decoding beyond question.

9. "Gay" was a slang term for prostitute in this period. I believe that Dickinson's use of it here, together with the way the speaker hawks her wares, and her identification with "crimson," are meant, however subtlely, to suggest the sexual link that binds the good "gray" poet to her much-despised sister. If to enjoy sexual pleasure for its own sake is to be a whore, then, the poem's speaker seems to be saying, I am one, too.

10. Of Roland Barthes's definition of textual pleasure as perverse in *The Pleasure of the Text*, Jane Gallop (1988) writes, "Perversion is here defined as 'pleasure without function'..., just as perverse sexuality, according to Barthes, 'removes ecstasy (orgasm) from the finality of reproduction'.... Pleasure is perverse when it is not subjugated to any function, such as reproduction" (106). As Gallop notes, this definition of the perverse has important ramifications for women. Succinctly, insofar as it is clitorally-based (that is, located in an organ that has no "function" save the production of pleasure [Bennett 1993, 237–38; see also Laqueur 1990, 233–39]), sexual pleasure in women can be thought of as inherently or always already "perverse."

11. The tie between the creative and the sexual imaginations was well-recognized by fin-de-siècle psychological theorists. See Krafft-Ebing ([1886] 1968, 110); Freud

([1908] 1950, 173–83); and Ellis ([1940] 1965, 93–94). I think it safe to say most creative artists are aware of the connection also.

12. Obviously, the meaning of eating the goblin fruit is overdetermined and suggests a number of different sexually transgressive acts. See, for example, Leighton (1992, 135–40) and Carpenter (1991) for two excellent readings, considerably more affirmative than my own. Mine is not meant to "disprove" these critics but to add to the possibilities opened up by this extraordinary text. However, I cannot resist noting that according to Showalter (1985, 134), the "hungry neurasthenic" look of Dante Gabriel Rossetti's female models was attributed at the time to the fact that they masturbated, or that "Lizzie," the name of the protagonist's sister in "Goblin Market," is also the nickname of Dante's favorite and most beloved model: Lizzie Siddal. Did Rossetti feel that her own creativity — like that of her brother — was somehow redeemed by (or damned through) a shared, incestuous passion for this beautiful woman?

13. For comparison, see the following graphic description of the physiological consequences of chronic masturbation:

> The alimentary canal suffers like the rest of the body. The tongue is coated; constipation is almost always present, due to lack of tone in the muscular coat of the bowels and deficient secretion.... Vertigo is a common and troublesome symptom to deal with. It is often accompanied by headache. Sleeplessness, with nervous twitching of the muscles, and palpitation of the heart are common accompaniments of sexual as well as of solitary indulgence. There is general lassitude and an inability to apply the mind to continuous work." (Howe 1887, 73)

14. Clément discusses the parallel between the construction of the sorceress and that of the hysteric (Cixous and Clément [1975] 1988, 3–39). Due, no doubt, to the role the hysterical woman played in the origins of psychoanalysis, her condition and treatment have been extensively canvassed in recent critical literature. See, in particular, Showalter (1985; 1990); Bernheimer and Kahane (1990); and Sprengnether (1990). Whether such prominence justifies taking her as an archetypal symbol for the plight of women generally in Western culture, let alone for that of the woman writer, is another matter.

REFERENCES

Auerbach, Nina. 1982. *Woman and the Demon: The Life of a Victorian Myth*. Cambridge: Harvard University Press.

Bade, Patrick. 1979. *Femme Fatale: Images of Evil and Fascinating Women*. New York: Mayflower.

Bennett, Paula. 1993. Critical Clitoridectomy: Female Sexual Imagery and Feminist Psychoanalytic Theory. *Signs: Journal of Women in Culture and Society*. 18: 235–59.

Bernheimer, Charles, and Claire Kahane, eds. 1990. *In Dora's Case: Freud—Hysteria—Feminism*. 2d. ed. New York; Columbia University Press.

Blos, Peter. 1962. *Adolescence: A Psychoanalytic Interpretation*. New York: Free Press.

Carpenter, Mary Wilson. 1991. "Eat me, Drink me, Love me": The Consumable Female Body in Christina Rossetti's Goblin Market. *Victorian Poetry.* 29: 415–34.

Cixous, Hélène. 1981. Castration or Decapitation? Trans. Annette Kuhn. *Signs: Journal of Women in Culture and Society.* 7 : 41–55.

———. [1976] 1983. The Laugh of the Medusa. Trans. Keith Cohen and Paula Cohen. In *The Signs Reader: Women, Gender & Scholarship,* ed. Elizabeth Abel and Emily K. Abel, 279–97. Chicago and London: University of Chicago Press.

———. and Catherine Clément. [1975] 1986. *The Newly Born Woman.* Trans. Betsy Wing. Minneapolis: University of Minnesota Press.

Cominos, Peter T. 1972. Innocent Femina Sensualis in Unconscious Conflict. In *Suffer and Be Still: Women in the Victorian Age,* ed. Martha Vicinus, 155–72. Bloomington and London: Indiana University Press.

[Cooke] Rose Terry. 1866. In the Hammock. *Galaxy* n.v. (May): 106.

Cott, Nancy F. 1978. Passionlessness: An Interpretation of Victorian Sexual Ideology, 1790–1850. *Signs: Journal of Women in Culture and Society.* 4: 219–36.

Degler, Carl N. 1974. What Ought to be and What Was: Women's Sexuality in the Nineteenth Century. *American Historical Review.* 79 (Dec.): 1467–90.

Dickinson, Emily. (1861) 1955. I tend my flowers for thee. In *The Poems of Emily Dickinson.,* ed. Thomas H. Johnson., 270–71. Cambridge: Belknap Press of Harvard University Press.

———. (1852) 1958. Letter to Susan Gilbert Dickinson, early June. In *The Letters of Emily Dickinson,* eds. Thomas H. Johnson and Theodora Ward, 209–11. Cambridge: Belknap Press of Harvard University Press.

Dijkstra, Bram. 1986. *Idols of Perversity: Fantasies of Feminine Evil in Fin-de-Siècle Culture.* New York and Oxford: Oxford University Press.

Ellis, Havelock. [1940] 1965. *Female Auto-erotic Practices.* California: Monogram Books.

Foucault, Michel. 1978. *The History of Sexuality Volume I: An Introduction.* Trans. Robert Hurley. New York: Vintage Books.

Freud, Sigmund. [1908] 1950. The Relation of the Poet to Day-Dreaming. Trans. Joan Riviere, 173–83. In *Collected Papers,* vol 4, ed. James Strachey. London: The Hogarth Press.

———. [1925] 1950. Some Psychological Consequences of the Anatomical Distinction between the Sexes. Trans. by Joan Riviere, 186–97. In *Collected Papers,* vol. 5, ed. James Strachey. London: Hogarth Press.

Gallop, Jane. 1988. *Thinking Through the Body.* New York: Columbia University Press.

Gay, Peter. 1984. *Education of the Senses. The Bourgeois Experience: Victoria to Freud.* Vol 1. New York and Oxford: Oxford University Press.

Gilbert, Sandra M., and Susan Gubar. 1988. *The War of Words. No Man's Land: The Place of the Woman Writer in the Twentieth Century.* Vol. 1. New Haven and London: Yale University Press.

Howe, Joseph W. 1887. *Excessive Venery Masturbation and Continence: The Etiology, Pathology and Treatment of the Diseases Resulting from Venereal Excesses, Masturbation and Continence.* New York: E. B. Treat.

Irigaray, Luce. [1977] 1985. *This Sex Which Is Not One.* Trans. Catherine Porter with Carolyn Burke. Ithaca: Cornell University Press.

Jeffreys, Sheila. 1985. *The Spinster and Her Enemies: Feminism and Sexuality 1880–1930.* London and Boston: Pandora.

Krafft-Ebing, R.v. [1886] 1965. *Psychopathia Sexualis with Especial Reference to the Antipathic Sexual Instinct: a Medico-Forensic Study.* Trans. F. J. Rebman. New York: Paperback Library.

Laqueur, Thomas W. 1990. *Making Sex: Body and Gender from the Greeks to Freud.* Cambridge: Harvard University Press.

———. [1989] 1995. The Social Evil, the Solitary Vice and Pouring Tea. In *Solitary Pleasures: The Historical, Literary and Artistic Discourses of Autoeroticism,* eds. Paula Bennett and Vernon Rosario II, 155–161. New York: Routledge.

Leighton, Angela. 1992. *Victorian Women Poets: Writing Against the Heart.* Charlottesville: University Press of Virginia.

Lipton, Eunice. 1986. *Looking into Degas: Uneasy Images of Women and Modern Life.* Berkeley and Los Angeles: University of California Press.

Lystra, Karen. 1989. *Searching the Heart: Women, Men, and Romantic Love in Nineteenth-Century America.* New York and Oxford: Oxford University Press.

My Heart. 1879. *Frank Leslie's Popular Monthly* 7: 670.

Plath, Sylvia. [1962] 1981. Fever 103. In *The Collected Poems,* ed. Ted Hughes, 232. New York: Harper and Row.

Rosario, Vernon, II. 1995. Phantastical Pollutions: The Public Threat of Private Vice in France. In In *Solitary Pleasures: The Historical, Literary and Artistic Discourses of Autoeroticism,* eds. Paula Bennett and Vernon Rosario II, 101–130. New York: Routledge.

Rossetti, Christina. [1862] 1979. Goblin Market. In *The Complete Poems of Christina Rossetti,* ed. R. W. Crump, 11–26. Baton Rouge and London: Louisiana State University Press.

Rubin, Gayle. 1975. The Traffic in Women: Notes on the "Political Economy" of Sex. In *Toward an Anthropology of Women,* ed. Rayna R. Reiter, 157–210. New York: Monthly Review Press.

Showalter, Elaine. 1985. *The Female Malady: Women, Madness, and English Culture, 1830–1980.* New York: Penguin Books.

———. 1990. *Sexual Anarchy: Gender and Culture at the Fin de Siècle.* New York: Viking.

Spofford, Harriet Prescott. 1861. Pomegranate-Flowers. *The Atlantic Monthly.* 7: 573–79.

Sprengnether, Madelon. 1990. *The Spectral Mother: Freud, Feminism, and Psychoanalysis.* Ithaca: Cornell University Press.

Tarczylo, Theodore. 1983. *Sexe et liberte au siècle des lumieres*. Paris: Presses de la Renaissance.

Watts, Emily Stipes. 1977. *The Poetry of American Women from 1632 to 1945*. Austin: University of Texas Press.

Wharton, Edith. [c. 1919–1920] 1992. Beatrice Palmato. In *The Sexual Education of Edith Wharton*, Gloria C. Erlich, 174–76. Berkeley and Los Angeles: University of California Press.

Yaeger, Patricia. 1988. *Honey-Mad Women: Emancipatory Strategies in Women's Writing*. New York: Columbia University Press.

Zambaco, Démétrius Alexandre. [1882] 1986. Masturbation and Psychological Problems in Two Little Girls. In *A Dark Science: Women, Sexuality, and Psychiatry in the Nineteenth Century*, ed. and trans. Jeffrey Moussaieff Masson, 61–89. New York: Farrar, Strauss and Giroux.

9

FRAGMENTS OF A POETICS:

BONNETAIN AND ROTH

LAWRENCE R. SCHEHR

Pornography aside, fewer than a handful of novels engage the topic of mas-
turbation as a theme. Certainly there are furtive references, passing
episodes, fleeting indications, but only rarely are there direct depictions. What
references there are to masturbatory sequences, erotics, and structures are often
clad in a safe language, so as not to offend the gentle reader. In this study, I will
look at two novels in which masturbation is one of the main themes. The first of
these works is appropriately entitled *Charlot s'amuse* (Charlie has fun), an 1883
novel by Paul Bonnetain, a little-known French naturalist writer who dedicated
this whole book to the subject of self-abuse. The second book is the well-known
Portnoy's Complaint, by Philip Roth, published in 1967.

Despite the different times at which they were written, the novels are strik-
ingly similar in the associations made between masturbation and various signi-
fying systems. The depiction of masturbation is related to the purported dangers
of reading: the activity of reading may be the warning sign of self-abuse.
Secondly, the discourses about and of masturbation are repeatedly subjected to

official, meaning-controlling discourses about sexuality in general. Thirdly, there is a search for a guilt-free voice of masturbation that speaks for itself without fear of contradiction or repression. In neither case does this voice fully come into its own; in its stead, the reader discovers a rhetoric about masturbation that underlines the discursive impossibility of the act. Understanding that there is no capturable, pure voice of masturbation will also be the recognition that masturbation, even in its solitude and intimacy, always posits the other, an other that may very well turn out to be the self.

In looking at these two works, I shall focus on how masturbation is articulated through the regulatory mechanisms of discourse, the parameters of literary invention, and the insistence of the impossible fulfillment of the desire for masturbation to write itself. In short, I shall attempt to approach a fragmentary poetics of literary masturbation. To see the details of this poetics, I shall also periodically allude to the imposition of an alien rhetoric in textual formulations that redouble masturbation: the various gazes and discourses that seem to underscore the danger of the solitude of the vice. The presence of these modes of representation, no matter how lurid or violent, will seem then to take away the singularity of masturbation: its solitude and its bliss.

Masturbation is a singular activity. It is no news that the mechanics of masturbation and literary writing, at least that literary writing defined as the praxis of dead, white, European males, resemble one another.[1] A singular activity occurs with the agent in isolation, separate from any community and divorced from any absolute knowledge. He moves one hand along a somewhat cylindrical object until a liquid is released. No other is there to receive the liquid; the dried traces of that liquid may or may not be noticed at a subsequent point as tell-tale signs of the activity. However patent, generalizing, or exclusionary that analogy may appear, reviewing it helps distinguish masturbation *poetically* from other sexual praxes and *discursively* from the languages that veil it. If, medically, masturbation is considered to be one of many pathological behaviors, and if economically it is in a smaller set that includes prostitution, literarily, it stands alone. Literally alone.

I am thus separating a literary discourse that risks taking masturbation as its "subject" from a scientific discourse that pretends—though this too is a fiction—to find its distinct "object" in masturbation. If a certain number of activities are precluded by the act of writing, masturbation remains the one that is both most similar and most dangerous: writing *ex nihilo* about masturbation may turn the analogy between writing and masturbation into a dangerous

homology. Masturbation and writing are thus linked and divided by the fear that writing may metamorphose into the sin of self-abuse and by the similarity of the two activities that makes simultaneity impossible. To write is to let masturbation go, not to abandon the self, but rather to reinforce the self, as the trace and in the wake of the moving hand: writing means taking time out from ecstasy. Writing about one's masturbation, the action must stop. To continue to masturbate means to leave the action as unnarratable and unnarrated in the present tense, only to turn that action into its accomplishment, its fall, its finitude, and its death in the past tense.

In its most radical form, which is also the form most proper to it, masturbation is autoeroticism. No other hand or eye enters the game, no other subject is in the space of activity. The agent may imagine the presence of the other; he may keep the other at a distance, as voyeurism and masturbation reinforce one another. Yet when another is present as a subject, the agent is aware of the awareness of another; immediately it becomes a question of sexual interaction, exhibitionism, and touching (even mimed at a distance), in short, sexual congress. And in such cases, the language of masturbation is far less problematic. Parts of an exchange system, gifts or trade, language and masturbation as symbolic activities find a mutual interchangeability.

Though the literary appearances of masturbation have been intermittent, it has long been the subject of other discourses. In the eighteenth century, two examples stand out as "scientific" warnings against the dangers of masturbation: *Onania or the heinous sin of self-pollution*, published in 1710, and Samuel-Auguste Tissot's well-known and influential book *L'Onanisme*, published in 1760. The eighteenth century sees the danger of reading and masturbation, and Jean-Jacques Rousseau (40), for example, writes of those books one reads with one hand. Ever virtuous, he did not glance at one of those "dangerous books" until he was over thirty (Derrida 203-34). With a nod to Rousseau, Jean Marie Goulemot has studied the interrelation of masturbation and eighteenth-century pornography. For Goulemot, the pornographic work provokes, teases, and excites the reader to abandon herself or himself, to let her/himself go; in wild abandon, the free hand seeks the ecstatic subject's genitals. Through diegesis and mimesis, the writing spurs the reader to masturbate, an action seen as a metonymic *mise-en-abyme* of copulation, love-making, lewdness, and general debauchery described in the "dangerous" novel.

However, it is in the nineteenth century that the discourses about the dangers of masturbation—as well as of reading novels—become ubiquitous. The

forces of right combine in an economic and medical discourse of repression, one of whose most important targets is masturbation, seen as threatening the economic unit at the base of nineteenth-century society, as much of a threat as prostitution itself (Laqueur 340). Medical science makes masturbation pathological, a sign of the possible decline of civilization. And as Robert A. Nye notes (164-65), the second half of the nineteenth century develops a close relation between discourses of sexuality and discourses of pathology. However, a distinction is made between social and literary discourse. Whereas the discourses of economic stability and medical pathology were perceived as being capable of maintaining a safe distance from the heinous activity, in the literary model, as was already clear in the eighteenth century, there was a fear that the action might infect the writing itself.

The nineteenth century transforms the intertwined behaviors of masturbation and dangerous reading into a social interdiction of unhealthy literature and unhealthy practices. At the end of the nineteenth century, there is still an ingrained prejudice against masturbation. This "common knowledge" is seconded by discourses of social engineering, biopolitics, and eugenics that see masturbation, if not as something "dangerous," then certainly as something detrimental to well-being. Michel Foucault's entire oeuvre treats the development of discursive praxes as the fields in which any specific instance of discourse might take place. In *The History of Sexuality*, he stresses the development of the discourses of biopolitics, those official discourses that sought to regulate the individual through a series of prescriptions, admonitions, and recommendations. The discourses of biopolitics involved the identification of the individual with his (and not "his or her") political self as a citizen. The individual was to act so as best to fulfill the functions of a member of society. And yet at the end of the century the accumulated discourses of biopolitics, epitomized in the scientific stance that allows a panoptical gaze, has even found its niche in literature: the revision of realism known as naturalism.

One of the unwritten rules of naturalism was that it allowed forbidden subjects to be treated as long as the decadence, the degeneration, and the negative exemplarity of the situation could be demonstrated. And so Zola, for example, could write about alcoholism, prostitution, and lesbianism as long as those evils were eventually punished. In the wake of Zola's ground-breaking novels about those subjects, *L'Assommoir* (1880) and *Nana* (1882), Paul Bonnetain published a novel entitled *Charlot s'amuse* (Charlie has fun). As is often the case with the more scabrous objects of inquiry in naturalist writing, this exposition of mas-

turbation is primarily a visual demonstration. Not subject to a real analysis as such, masturbation is presented as an object for the panopticon and its means of explanation, the so-called scientific language of naturalism. And, as shall be seen, masturbation in the book is part of a mutable set of sexual depravities.

This novel is the singular tale of a protagonist who suffers the devastating results of being addicted to self-abuse. Poor Charlie comes from what we would now call a dysfunctional family, with lasciviousness and obscenity in its blood. With his dead father not even cold, his bereaved mother goes out and picks up someone for the night and the two are lost in their "lewd obscenity" (70).[2]

Listening in the next room, Charlie mechanically and unconsciously mimes the sex act without quite knowing what is going on. Like Emma Bovary waltzing ever and ever more rapidly at the ball, Charlie undergoes a metaphoric version of sex that is counted in his very breathing:

> Fever burned his blood; he shivered and his hands shook mechanically. Now he was dreaming that he was imitating the chauffeur. He panted from fatigue; a whistle left his dry, tight lips. Suddenly, his breath accelerated; he sighed. In his head, something was vibrating; rigid, immobile, and spent, he felt a new and mysterious feeling of infinite sweetness born in him. (71–72)

Predisposed by the social climate and the genetic traits that determine behavior and disposition, Charlie is already a soul lost to sexual pathology. In the general degeneration portrayed by naturalism, all biopolitical pathologies instantaneously mutate into others. From his mother, Charlie inherits a tendency to sexual excess; her own nymphomania or prostitution changes into his onanism and homoeroticism. Thrust into the unhealthy, male-only social situation of a Catholic school, Charlie needs only the propitious moment of actualization for his predisposition to masturbation to appear. Here, it is awakened by brother Origen, implausibly named for the early Christian and Gnostic who castrated himself to insist on his purity. Pederast, homosexual, and "ignoble berobed nymphomaniac" (102), Origen actualizes Charlie's predisposition and teaches him varieties of self-abuse, masturbation, and pollution. Calling Origen a "nymphomaniac" instead of the expected "satyr" shows to what extent the excesses of this individual and his crime go toward the monstrous and the indistinguishable and participate in the mutable biopolitical pathology already mentioned.

Yet the depths of degradation are not reached all at once and Charlie does escape from an even more heinous sin, "monstrous co-onanism" (103) because

his teacher asks for no "compensation" in return. Though Bonnetain has prepared us for the direst effects of genetic degradation (45–46), he still ensures the novel's viability by condemning the effects of such genetic degradation. Bonnetain can hardly retain his disapproval, as he cloaks his supposedly dispassionate naturalist approach in the garb of protective scientific discourse:

> And the ignoble berobed nymphomaniac instructed him, feeling in his unconscious genetic perversion an atrocious bliss [*jouissance*] in making moral defilement follow manual defilement.
>
> Half an hour later, the crime was unchangeably accomplished; the Ignorantine had a new student to whom the monstrous mysteries of unisexual practices would henceforth be familiar. (102)

One degradation follows another as the horrors of masturbation are the warning signs of total dissolution and, even worse, depravity. Brother Origen falls ill: having attempted to use his pen-holder as a dildo, he has gotten it stuck in his rectum. And, imprisoned in a discourse of depravity and repetition, Charlie has few tranquil moments, and even those bear the warning signs of danger by recalling the perils of reading: "These onanists [Charlie and his friend Lucien] recited Lamartine to each other between two kisses" (185). Generally though, Charlie's nasty habit drags him so far into the depths of degradation that he has tell-tale spots on his clothing (189). As is the case for the alcoholic Gervaise in Zola's *L'Assommoir*, there is a point in the naturalist depiction of depravity where the protective cloak of scientific discourse parts to make the depravity wholly visible to other characters. With the secret pathology out in the open, whether it is Gervaise's alcoholism or Charlie's onanism, the vice that was once invisible to others is fully illuminated for all to see. Ironically enough, as befits a world in which the discourses of biopolitics have sway, there is no longer any need for the depraved individual to protect himself or herself, for the all-powerful gaze accomplishes just that, once the action is as out in the open as the discourses decrying it.

Everything in Charlie's existence relates to this depravity. Short stays on the wagon of celibacy are succeeded by even more violent and degrading plummets into self-abuse. So even as his benefactress, with the suggestive name of Mademoiselle de Closberry, is lying unbeknownst to Charlie *in articulo mortis*, he is out humping the earth and using the planet itself as a substitute for his polluting hand: "he was at *The Pissing Pine-tree*, in the forest, bestially defiling

the thick, thatched moss, whose elasticity made his unspeakable pleasure even more delirious" (199).

In the last third of the novel, Bonnetain takes great delight in describing other such paroxysms. With the secret out in the open, literary language can blissfully reassert its own orgasmic bliss in the act of description. Only then does the totally repressed voice of masturbation itself appear: "Becoming the little pervert again, he listened to his neurosis speak" (231). But that is one brief moment, and literary excess is tamed as Bonnetain introduces the voice of reason at the level of observable, commonplace truth. Charlie's boss says, point blank, "It's the fault of Rosy Palm [*la veuve Poignet*]" (273). It is no surprise that the dénouement of the book is Charlie's suicide, poetically and impotently accompanied by one last, vain effort:

> [I]n a supreme act of self-abasement before dying, he wanted to taste the sweetness of solitary caresses once more, but he spent himself in vain stabs: the alcohol had dulled his senses.
>
> Shit! he said of this last disillusionment and this sudden impotence. (347)

That sudden impotence at the end of *Charlot s'amuse* could be the watchword for the whole novel. Bonnetain cannot escape from the scientific or biopolitical discourses that allowed him to talk about masturbation in the first place. To show it is enough; there is no need nor any possibility to let it speak at length, and Bonnetain can merely make it visible. To write about it, he must buy into the discourse of disapproval. There is no possibility of letting masturbation speak for itself, for there is no voice for the offending member. The hand can be chastened, rewritten in a safe, non-infectious discourse. But the other offending member cannot be allowed to have a voice. At least not here, and not now.

The first half of the twentieth century begins to liberate this once forbidden subject both from the discourses of biopolitics and from the perdition of literary hell. Various authors, including Proust, Joyce, Mishima, Isherwood, and Genet, "naturalize" masturbation as they make it an episode in the development of their characters. Though it results in a literary decriminalization of masturbation, this gradual naturalization still does not let masturbation speak in its own voice. Even at mid-century, the explicit depiction of anything more than an episode has to be framed by a format whose singular non-exemplarity must be obvious, as is the case in Genet's prison fantasies. Elsewhere, if freed from the

language of social engineering, masturbation still needs to be displaced into metaphor and metonymy. This is a moment of transition between the biopolitical nineteenth century and the episodic, aestheticized naturalization of literary modernism and the representation of masturbation by Roth in a work in which unadorned masturbation attempts to speak for itself. In this period between the "showing" of naturalism and the univocal, though fragmentary, voice of the post-modern, modernism uses masturbation itself as part of a metaphoric structure: a set of signifiers describe the literary work as being *like* masturbation.

A new aesthetic soon appears in which masturbation seeks its own voice, one that is neither a pale copy of intercourse nor the prey of a biopolitics that kept its power while gradually moving from prohibition to normalization. Nor will masturbation remain the eclipsed vehicle of a metaphoric discourse about textuality. Masturbation will be textually sought for its own sake in a few works that stand out in a short period of time as having engaged the subject overtly. These include, most notably, Michel Tournier's *Vendredi ou les limbes du Pacifique* and *Les Météores* and Philip Roth's *Portnoy's Complaint*. To that short list, one might add a popular example, William Peter Blatty's thriller *The Exorcist*, which involves female masturbation. Blatty's novel reduces the activity to a violation of a moral code that anyone, even a non-believer, can see; we all luridly read about Regan's masturbation with a crucifix, and it is at that point that everyone is convinced that she is truly possessed by the devil. As befits a work for mass consumption, there is no ambiguity here, no sign of pleasure, just the horrors of evil. Yet, for all that, the scene, with its reminiscences of artistic and autistic self-stimulation, is not so far removed from other versions of the same activity. In fact, *The Exorcist* could profitably be studied for the interrelations of the various acts of masturbation, the writing on Regan's body, and the whole litany of prayers, especially the exorcism itself. More recently, following in the Tournier/Roth line, there is a short text by the youthful Hervé Guibert, entitled "Le Journal de l'onaniste," included in *La Mort propagande*. And finally, in Alberto Moravia's one-joke novel, *Io e lui*, while not focusing extensively on masturbation, the author gives the penis, which is one of the two title characters, a voice much like that given to Alex's penis in *Portnoy's Complaint*.

Swept along as a part of general post-war sexual liberation, masturbation enters the realm of the discursively acceptable. On one level, its status is particularly unchallengeable. In an era that values the individual as an inviolate monad, the various languages of repression wane in favor of the code of an indi-

vidual whose language is supposed to be as unalienated as the fictional image of an inviolate ego. A good measure of the sexual liberation of the 1970s, this code makes an idiomatic use of the self both in language and in action; for this code, masturbation may be the most truthful activity imaginable. This occurs however, in and against a world in which alienation and scission are the products of an imposed, and therefore manipulative, invasive, or terrorizing discourse. And although an escape from repressive discourse is certainly welcome, we still do not know the language of masturbation. Though masturbation may no longer be implicitly or explicitly likened to other steadfast singularities like autism and psychosis, without its own discourse masturbation remains an idiot's delight, the transfixion of Saint Theresa or Saint Sebastian, though without the accompanying beatitude.

Philip Roth's *Portnoy's Complaint* (1969) is framed as a life story told by a patient lying on his psychiatrist's couch. The psychiatrist is the ostensible implied reader of this complaint; in turn, he (or she) will go on and use the information of this case study to publish an article about a psychiatric disorder named "Portnoy's Complaint" in which "Acts of exhibitionism, voyeurism, fetishism, autoeroticism, and oral coitus are plentiful" (vii). Whether we reject it or not, whether the novel itself undercuts psychoanalysis through humor and outright laughter, every textual moment, every anecdote, and every confession of an act of masturbation is immediately seconded by a discourse of the most orthodox Freudian psychoanalysis. Thus Mrs. Portnoy, little Alex's Jewish mother, is not only the archetypal Jewish mother, but also the most Freudian Jewish mother imaginable as she endlessly inquires about her son's bowel movements and as she acts as "the patron saint of self-sacrifice" (15). She is moreover the castrating mother *par excellence*, armed with a knife against her defenseless six- or seven-year-old son (16) and sure to mention his "little thing" (54, 56).

Any recounting of masturbation is thus framed both by the stereotyped language of the Oedipal crisis and by the reader's recognition that poor little Alex failed to overcome that crisis. Alex is endlessly castrated and recastrated; he is constantly overwhelmed by his father's maleness as well as the latter's inability to diminish himself in any way: the father is always constipated. Alex is repeatedly subject to a poking, prying mother and engulfed in a sea of Freudian names for his failure. Alex is subject not to one, but to two double discourses: one is the limited discourse of guilt, shame, and double binds that is stereotypical of the possessive Jewish mother; the other is a theoretical discourse of orthodox Freudianism, which despite all its verbosity, can also be seen as being limited

to stories of "mommy-daddy-me" and "peepee-doodoo." In the former case, the language of the other prevents any language of the self from occurring, existing, and assuming its rightful place. The familial language encodes the world into what is acceptable to the mother: what is kosher, i.e. clean. This realm conjures a mind-boggling alterity that has no proper name, but only a series of improper descriptions that relate to taboos, uncleanliness, or the most heinous category of "goyische," i.e., non-Jewish.

In that world of Jew and other, the world of his parents, Portnoy's favorite pastime of masturbation has no name. It passes furtively or is mistranslated into a language a mother can understand; he explains his constant trips to the bathroom: "Diarrhea! I cry. I have been stricken with diarrhea!" (20). Portnoy's digestive tract may be community property, but his penis is his, unnamed: "My wang was all I really had that I could call my own" (35). His hand, however, the other guilty partner in the bargain, is up for grabs: "[M]y father plagued me throughout high school to enroll in the shorthand course.... Earlier it was the piano we battled over" (28). Alex's penis may be his own, but he has not found a name for it outside his mother's belittling code.

The Freudian discourse names every part of Alex's body and every one of his actions in a supposedly neutral and non-judgmental discourse. But to translate is to decide and ultimately to judge, and the activity that Alex calls "whacking off" becomes necessarily, in the mind of the implied auditor or implied reader, the name that the patient (protagonist, narrator) gives to autoeroticism. Yet it is a name that sits uncomfortably "on the edge," an expression that cuts two ways: between the innocence of slang, as one expression among many for masturbation, and the reference to castration that is the literal sense of the expression. For his complaint, Alex can name freely, uninterrupted by the discourse of another, but only on the condition that this naming be subject to an act of translation. The final imprimatur of Freudian discourse is never given because, aside from the humor that more than upsets the neat model of the family novel, Alex knows the language into which his plaintive song is being translated. Good little reader that he is, Alex can challenge an interpretation from within: "I have read Freud on Leonardo, Doctor, and pardon the hubris, but my fantasies exactly" (136). So for an instant, which I believe the only one in the book, Dr. Spielvogel, perhaps named for Leonardo's fantasized bird, finds his writing already translated. And it is no accident that the passage is about playing with a bird: "this big smothering bird beating frantic wings about my face and mouth *so that I cannot even get my breath!*.... Just leave us alone, God damn it, to pull

our little dongs in peace" (136). Leonardo's fantasy of being smothered is reversed to shoo away the birds—the smothering mother and doctor. And interestingly enough, the homoerotic position eschewed for the psychiatrist/voyeur, returns here as Portnoy makes Freud's image of a homoerotic da Vinci his own.[3]

The second reversal of Freud comes late in the book, where Freud's writing is simultaneously the figure of liberation and the double of the penis itself. It is an image of Alex's internal struggle to find out whether his masturbatory activities are his death-sentence or his prelude to an act of liberation:

> [I] have been putting myself to sleep each night in the solitary confinement of my womanless bed with a volume of Freud in my hand. Sometimes Freud in hand, sometimes Alex in hand, frequently both. Yes, there in my unbuttoned pyjamas, all alone I lie, fiddling with it like a little boy-child in a dopey reverie... ever heedful of the sentence, the phrase, the word that will liberate me from what I understand are called fantasies and fixations. (208–09)

Reducing Freud to being an unwilling or unusual partner in a game of one-handed reading, Roth rewrites Portnoy's complaint for him by providing an insoluble knot in translation: how do you say "Freud" in Freudian discourse? Though clearly Dr. Spielvogel can translate both these images of Freud into what Deleuze would call "mommy-daddy-me," it is an adequation at best and more likely than not a non-sense. There is no better image to upset the Freudian apple-cart than that of using Freud's own writing as a phantom penis, as a turn-on, as one-handed reading material.

Roth's poetics of masturbation is never silent. For him, the activity at hand is always part of a group, even as it escapes from the group. Masturbation is properly or improperly part of the socialization process—and thus safely heterosexual—even when the socius is a group of one. Not for him, however, is the perversion of a circle-jerk, the recounting of which brings out in him the language of both his mother and his shrink. Though this time, they are not in a parodic form, but honestly and fully his, as if the desecration of his most sacred activity were so taboo in his own world that the only names were the proper ones of a Jewish mother ("pig") and the categories of sexual neuroses proffered by Freud and friends. Portnoy's acquaintance "is also a participant in the circle-jerks held with the shades pulled down.... I have heard the stories, but still (despite my own onanism, exhibitionism, and voyeurism—not to mention fetishism) I can't and won't believe it.... What pigs" (194). And a circle-jerk

225

includes the role of the masturbator intertwined with that of the homoerotic voyeur. For Portnoy, there is nothing more un-kosher than being cast in either role of the circle-jerk: masturbator or voyeur, the participant in this kind of circle-jerk necessarily and un-kosherly participates in a homoerotic game. And yet, contradictorily, he insists that we be there, women transfixed by a flasher and men exposed to their own homoerotic voyeurism.

Cradled and hampered by other voices in other rooms, the communicational system distinguishes sender and receiver. Roth's masturbator is performing as if he were talking to himself, but in a way that would be comprehensible were another to tune in. At times he even flirts with what Dr. Spielvogel would call a tendency toward exhibitionism. At least the exhibitionist controls what is being seen, thereby negating the homoerotic voyeur. Hence there is one scene in which Alex masturbates on a bus and another in which, to reach orgasm while being given a hand job by a woman, "instead of making believe that I am getting laid, as I ordinarily do while jerking off, I make believe that I am jerking off" (202).

What remains to be seen is how Alex finds a language for his "whacking off." Portnoy's problem is that the masturbation sequences overflow and spread out through the rest of the novel. There is a continuous threat that masturbation will overflow form and contents, discourse and *récit*. For Portnoy's tale forms the basis for the discourse of another, be it his mother or his shrink. Is this, we ask, siding momentarily with the Greek chorus of observers, the perpetual feel of adolescence: "half my waking life spent locked behind the bathroom door, firing my wad down the toilet bowl, or into the soiled clothes in the laundry hamper, or *splat* up against the medicine chest mirror" (18)? Or is it rather that the reader, too ready to agree with the chorus, though he or she is laughing and they are not, does not allow Alex to speak the pleasures of his whacking off without a translation waiting in the wings?

Separated from the discourses of Jewish motherhood and psychoanalysis, the reader does not know where to look and where to hide. Having refused the role of censor or therapist and having come upon Alex masturbating, the reader is in fact cum upon. We, he, or she, are the ones who get splashed with Alex's jism. Having escaped from a proper socius (his friends or his family) to be in his own socius of one, Alex allows the reader entry into this world, but at the price of being the *cloaca maxima* for Alex's cum: "Leaving my joint like a rocket it makes right for the light bulb overhead, where to my wonderment and horror, it hits and it hangs" (20). Occupying a middle ground in which he tries to see without being seen, a voyeur is witness to the activity that even occasionally

Alex is blind to: "eyes pressed closed but mouth wide open...not infrequently in my blindness and ecstasy, I got it all in the pompadour" (18). At least the reader will not go blind from Alex's jerking off, though the myth of going blind is ever present when Alex cums in his own eye—"I'm going blind" (203)—or worse yet, when this blindness means being unable to see women's genitals: "how I made it into the world of pussy at all, *that's* the mystery. I close my eyes, and it's not so awfully hard—I see myself sharing a house at Ocean Beach with someone in eye make-up named Sheldon" (140–41). No matter how far we have come from the biopolitics of the nineteenth century, the homoerotic still lurks about, tied up with all the other imaginable sexual perversions including self-abuse.

Always with open eyes, the reader then sees even when Portnoy himself cannot. Still without a proper name, Portnoy's act of masturbation is one of proper vision and reflection. He does not see himself as performing some parodic version of *goyische tam*, non-Jewish taste, nor does he elevate his action into an act of "autoeroticism" coupled with "voyeurism" and "fetishism." Quite simply, he gets off seeing himself whacking off: "I stood in my dropped drawers so I could see how it looked coming out" (18). That complete self-absorption and self-reflection is the only perfect view. All other positions depend on a blindness of sorts, perhaps Oedipus' own blindness, a degree of dyslexia or a myopia that overreads or misreads a simple, innocent, yet nameless act. For having accepted this role of focused observer, the reader, still distinct from the crowd, plays as Portnoy himself does: the reader is the recipient of the visual evidence. As in a porno film where the male actor withdraws before ejaculation so the viewer can see him shoot his load, the reader must see the cum as well as the violence of the orgasm.

In fulfilling such a role, the reader becomes expendable, like the water in a public urinal or the wrapper of a Mounds bar into which Alex's seed is spent (18), like a hollowed-out apple used as an adjunct for masturbation (19), like a left-over milk bottle (18), or even one of two pieces of liver, one presumably to be discarded (19) and the other to serve as dinner two hours later (150). Common to all these and to the reader as well is that they are public property, taken in or thrown out, eaten or emitted. It seems to take little talent to be a reader watching a character masturbate, even if that character is "the Raskolnikov of jerking off" (21); it is a role that is self-consuming. As the reader fulfills his obligation, he ceases to be of value until the next time. He mimes Alex himself, who is spent, no matter how briefly, after every session. And spent, the reader cannot channel his energy into the *continuity* of homoerotic

voyeurism. Finally, then, the inscription will have endured just as long and as episodically as the act.

Stripped of its translations into other discourses, masturbation becomes the event of the book and can serve as a general equivalent or a touchstone. Sex will be like masturbation, but working and living each day will also be like masturbation. Alex and the reader need to see a therapist, not because of some over-named, overread neurosis, but because life itself and the reading of life itself are painfully close to the *acte gratuit* of masturbation which is an act of dispersal, dissemination, disappearance, and death.

Still, we do not know what the proper name is for this activity, but it may be necessary only to listen. There is another voice here, aligned neither with the discourse of guilt of the mother, the discourse of comprehension of Freud, nor even the silent, all-seeing assent of the reader, the panoptical light-bulb of the novel. The voice is Alex's own, but one unsubjected to the discourse of domination. It is singlemindedly, "like some idiot microcephalic" (142), the pure desire of his libidinal excess, his penis itself: "'Jerk me off,' I am told by the silky monster" (143). But for all that, it is a singular libido at best, for though unsubjected to the constraints of an internalized voice of repression, a name/no of the father given status as a superego, it only wants what is not kosher: "'Just look at that nose.' 'What nose?' 'That's the point—it's hardly even there. Look at that hair, like off a spinning wheel. Remember "flax" that you studied in school? That's human flax! Schmuck, this is the real McCoy. A *shikse*!'" (143). The object of autoerotic longing, what the penis sees as a one-eyed jack spying on the world, has no reality as a subject. The object of this third eye is a collection of signs foisted upon the libido by some malefic anti-superego. So ultimately for Portnoy, there is always the hand of another moving his hand, always the voice of another in his ear or head, and always the space of another in which he improperly comes.

With no voice, there is no freedom. The book approaches its conclusion, which is that psychoanalysis may in fact begin. But this beginning is nothing short of parodic, just as all of Alex's activities have in some way, in the author's mind, been parodies of healthy behavior. There are parodies of two cries for freedom: "Let my peter go!" and "Jerk-off artists of the world unite! You have nothing to lose but your brains!" (283-84). There is no voice other than the one stolen; there is no language other than the borrowed tongues of repression. To them, we have just added the puritan consumer capitalism of WASP America. Alex is constantly in search of the proper name for his act; yet the more he

looks, the more his action becomes that object for the others' discourses to include, explain, and spurn. After all is said and done, he would have done better to read Wittgenstein, and been silent about that which one cannot speak, only wordlessly continuing to play with himself.

NOTES

1. My use of the word "he" reflects the creation of a text of masturbation by white male writers. White males are not alone in writing masturbatory texts, but their means of writing against the dominant forms of literature are necessarily different from those of women, black men, etc. On the relation of writing and masturbation, rather than seek some theoretical ground, which, as I hope to show in this study, must necessarily remain shaky, it might prove useful to follow a series of interrelated readings as they refer to the simultaneous joys of writing, reading, and sexuality. As I have pointed out elsewhere (*1986*, 203–23) and as other critics like De Man, Mehlman, and Doubrovsky have noted, the coexistence of the model of literature as an activity like masturbation and the model of masturbation as an activity like literature propels a good part of *Du Côté de chez Swann*. The interweaving of two sets of figures, one sexual, one auto-referentially literary, provides a motor that produces a narrative and the means by which to read it.

2. The edition I am using is a reprint of the fifth edition from 1888. It is more useful than the first edition since all the passages of the book cited at the obscenity trial have been printed in italics. Bonnetain was acquitted, undoubtedly in part because of the fact that he maintains a moralizing and implicitly condemnatory language throughout the novel despite the scabrous descriptions of sexual activity.

3. Significantly, the other bird in the story involves a recitation of Yeats's poem "Leda and the Swan," after which the auditor, Portnoy's erstwhile girlfriend, is so turned on that she insists he perform an act of cunnilingus (216–19).

REFERENCES

Bonnetain, Paul. 1979. *Charlot s'amuse*. Geneva: Slatkine Reprints.

De Man, Paul. 1979. *Allegories of Reading: Figural Language in Rousseau, Nietzsche, Rilke, and Proust*. New Haven: Yale University Press.

———. 1983. *Blindness and Insight: Essays in the Rhetoric of Contemporary Criticism*. 2d. ed. Minneapolis: University of Minnesota Press.

Deleuze, Gilles. 1964. *Proust et les signes*. 4th ed. Paris: Presses Universitaires de France.

Derrida, Jacques. 1967. *De la grammatologie*. Paris: Minuit.

Doubrovsky, Serge. 1974. *La Place de la madeleine. Ecriture et fantasme chez Proust*. Paris: Mercure de France.

Goulemot, Jean Marie. 1991. *Ces livres qu'on ne lit que d'une main.* Aix-en-Provence: Alinea.

Guibert, Hervé. 1991. *La Mort propagande.* Paris: E. B. Deforges.

Laqueur, Thomas W. 1989. The Social Evil, the Solitary Vice and Pouring Tea. *Zone 5: Fragments for a History of the Human Body.* Part 3. Ed. Michel Feher, 334–42. New York: Zone.

Mehlman, Jeffrey. 1974. *A Structural Study of Autobiography: Proust, Leiris, Sartre, Lévi-Strauss.* Ithaca: Cornell University Press.

Moravia, Alberto. 1971. *Io e lui.* Milan: Bompiani.

Nye, Robert A. 1984. *Crime, Madness, & Politics in Modern France.* Princeton: Princeton University Press.

Paglia, Camille. 1991. *Sexual Personae.* New York: Vintage.

Roth, Philip. [1967] 1990. *Portnoy's Complaint.* New York: Fawcett Crest.

Rousseau, Jean-Jacques. [1782–89] 1959. *Les Confessions.* In *Oeuvres complètes*, vol. 1. Paris: Pléiade.

Schehr, Lawrence R. 1986. *Flaubert and Sons.* New York: Peter Lang.

———. 1994. *The Shock of Men.* Stanford: Stanford University Press.

10

CAN ROBINSON CRUSOE FIND TRUE HAPPINESS (ALONE)?

BEYOND THE GENITALS AND HISTORY

ON THE ISLAND OF HOPE

ROGER CELESTIN

'NOTONANIE.' Literally, masturbation by necessity, i.e. forced on the subject by circumstances.

—SIGMUND FREUD, footnote to "General Theory of the Neuroses"

ANALOGY

The tropical island is the scene of Robinson Crusoe's "adventures." Perhaps the topos "island" itself, with its geographically marked isolation from "something else" that is the "main-land," is a particularly fitting scene of fictional solitude: the island as a perfect setting from which to examine the implications and describe the results of extended solitary existence. Perhaps the particular semantic playfulness of the following Haitian Creole expression meaning "masturbation," coming as it does from another tropical island, was influenced in its wording by its own insular origin: "Dié seul me voit," "Only God sees me." Only God can see the practioner of the "solitary vice" and only God can see Robinson Crusoe on his desert island.

The analogy may be tenuous in parts, but it does have the merit of providing at least the basis of a common frame of reference for two subjects whose affini-

ty is not immediately obvious: autoeroticism and a contemporary French reworking of Daniel Defoe's classic.

In spite of the title change, the central character of Michel Tournier's *Friday* (1967) is Robinson Crusoe, as was the case for the Defoe original (1719). However, sexuality, a topic that is completely absent from the eighteenth-century prototype, becomes the primary focus in the contemporary version, leading to a series of questions whose affinities were left unexplored by Defoe: what is the link between sexuality and solitude? Between solitude and memory? Between memory and writing? Between writing and sexuality?

It is as if the intervening years had gradually allowed for an increasingly focused exploration of these relations, in particular, for an increasingly *sexed* and linguistically *implicated* narrator. As if a span of time, an interval, had been necessary to allow for the passage from Defoe's stolid shipwrecked sailor displaced in the tropical foliage of his "Island of Despair," solely intent on returning Home, to Tournier's Robinson on Speranza, the Island of Hope (another change of name), on the threshold of his "vegetable way" described by the third-person narrator, outside the private realm of Robinson's journal:

> Robinson hesitated for some days on the threshold of what he later called his "vegetable way." He hung about the quillai with sidelong glances, discovering in the two branches thrusting out of the grass a resemblance to huge, black, parted thighs. Finally he lay naked on the tree, clasping the trunk with his arms while his erect penis thrust its way into that mossy crevice. A happy torpor engulfed him. He lay dreaming with half-closed eyes of banks of creamy-petaled flowers shedding rich and heady perfumes from their bowed corollas. With damp lips parted they seemed to await the gift to be conferred on them by a heaven filled with the lazy drone of insects. Was he the last member of the human race to be summoned to return to the vegetative sources of life? (1969, 115)

However "graphic" his text, Tournier's purpose is not to draw up a "pornographic" or "curious" catalogue raisonné of the possible combinations between Robinson's body and the fauna and flora of the island (such a book has in fact been written[1]), but to trace *his*, Robinson's, evolution from initial despair, through a series of phases that ultimately take him beyond a certain definition of autoeroticism that remains within the confines of (human) exchange, to a "non-genital," "solar," "elemental" sexuality. Retracing this metamorphosis constitutes one focus of my reading of Tournier's *Friday*.

Secondly, we will also explore some of the permutations mentioned earlier, the interplay between memory, solitude, sexuality, and writing. Out of prescribed necessity, the two Robinsons in their own enclosed space—the desert island isolated from the possibility of *exchange* with others—must rely solely on the memory of the solitary to keep the lines of communication open, to keep a more or less tenuous hold on Home. This continued contact is achieved through, among other means, the journal, through writing. Both Defoe's Robinson and Tournier's are confined to a realm in which any form of exchange, any possible reliance on the memory of others, is unavailable. The memory of others, like their bodies, is absent from the desert island. The repercussions of this isolation on the text of Robinson's journal in Tournier's *Friday* forms the second focus of my reading: the journal, like autoeroticism, as a form *turned in upon itself* (but *with another in mind*), or at least characterized more than other forms by that inward turn.

Thirdly, I will apply the label *exchange*, already mentioned with reference to both sexuality and writing, to the economic sphere, to an economy as a system of exchange. Here again, we are dealing with an absence of bodies, of the necessary and numerous others who make up the vast organization of an economy. The questions in this context are strangely similar to those raised by the absence of sexual and writing-recording bodies: to what extent is Home qua economy replicated by Tournier's Robinson on the island as a means of remaining connected? Or, another way of asking the same question: to what extent does Home represent not only the model the solitary figure attempts to rebuild through habit and memory, but the ultimate locus of exchange, a point to which any *revenue*—either as text, children, or goods—must be *brought* back (if not now, later)?

In the peculiar case of a man forced to be alone on an island for years, these questions become particularly crucial. As Gilles Deleuze—to whose article on Tournier's *Friday* [2] anyone writing about it must be indebted—summarizes them:

> True dualism thus appears with the absence of another [*autrui*]: what happens in this case to the field of perception? Is it structured according to other categories or does it instead open up on a very special matter, allowing us to enter into an informal particular? This is Robinson's adventure. [1969, 267, my translation]

Lastly, we must ask, especially since what precedes seems to elude the presence of Friday, at least at one stage, on the island, what has become of this

other presence that has given its name to Tournier's rewriting? How does it affect sexuality, text, and economy? Have the intervening years between Defoe's *Robinson Crusoe* and Tournier's *Friday* also marked the passage from subservient exotic to postcolonial subject?

Whatever the attempted answers to all the questions asked, we must keep in mind that the essential difference between the two texts, the difference that simultaneously creates, results from, and emblematizes all the other ones is that Defoe's Robinson leaves the island and returns Home, while, for Tournier's Robinson, Speranza becomes Home. One leaves, the other doesn't. One was only temporarily shipwrecked, the other goes *off-course* permanently. From this point on, I refer exclusively to Tournier's shipwrecked—and reworked—Robinson, and to the (reworked) events that leave him stranded ... but happy.

CONCOCTING AN ERSATZ "OTHER"

Even before Tournier's version begins "in earnest"—Robinson *after* the ship-wreck, at the beginning of his years on Speranza—even before we begin to see the stages of what Robinson, in his journal, will refer to as his "metamorphosis," we are offered the entire novel in the cryptic form of a tarot reading for Robinson by the captain of the ship. At the end of this reading, which precedes the shipwreck only by a few moments, Captain Von Deyssel interprets the penultimate card and gives us, the readers and Robinson, in cryptic, coded form the place and the state Robinson will attain at the end of his metamorphosis:

> In the City of the Sun, set between Time and Eternity, between Life and Death, the inhabitants are clothed with childlike innocence, having attained to solar sexuality, which is not merely androgynous but *circular*. A snake biting its tail is the symbol of that self-enclosed eroticism, in which there is no leak or flaw. It is the zenith of human perfectibility, infinitely difficult to achieve, more difficult still to sustain. (1969, 12)

What we begin with is the young heterosexual Puritan in search of fortune, bent on accumulation and the return Home that would validate his capitalistic efforts, conditioned by linear time; what the tarot points to is something vaguely pagan, beyond the androgynous, self-contained and circular, beyond striated[3] time, beyond the "time is money" of Benjamin Franklin's *Almanac*, which temporarily

becomes a model for Robinson on the island. In short a (happy) Robinson remaining on the island, with the return Home no longer even envisioned.

The difficult part, as Von Deyssel tells Robinson, is not only to reach that stage but to sustain it. Thus, even before Robinson's story proper begins, we are given both the objective and the difficulty: how to maintain, in spite of the absence of *autrui*, others who are not only Conrad's "butcher and policeman" missing in the heart of darkness,[4] but all other bodies, all other memories, all others who represent the possibility of exchange, how to reach and maintain, given this *a priori* absence, an equilibrium symbolized by the snake biting its tail.

This is the equilibrium, the "other way," Tournier's Robinson, like Defoe's, cannot at first even envision. His being alone on the island during the period immediately following the shipwreck is primarily conditioned by the desire to return to Home and its categories. The place away from Home, the *desert* island and all it represents, can only be perceived as *lack;* it can only be conceived in terms of Home and, in this particular instance, as the *negative* of Home. Home is *autrui*/another/others and all they represent. Positivity ("positive form" [113]) and re-production can only be regained at this early stage by reestablishing what has been lost by building a boat to return Home, to the shared warmth and productivity of exchange, the security of given, established, shared codes and categories. Although he is successful in building this vessel (a project that takes months? years?), Robinson is, in that very attempt at returning to the world inhabited by *autrui*, already being undermined by the absence of that other: he has built the boat so far from shore, so high up that "the task of getting it to the water was one that he could scarcely hope to complete single-handed in all that remained of his natural life" (39). The reason for this apparently absurd "lack of judgement" is precisely, as Robinson later explains to himself by means of an analogy, that *autrui* is a point of reference:

> When a painter or engraver introduces human figures into a landscape or alongside a monument, they are not there merely as an accessory. Human figures *convey the scale*, and what is still more important, they represent attitudes, possible points of view, which enrich the picture for the outside observer by providing him with other, indispensable points of reference. (54)

In his attempt at returning to the world of exchange, Robinson is thwarted by the absence of that world. The immense discouragement, the *break* that ensues ("He gave up" [39]) leads him to "the mire," a pool of stagnant water and thick slime

over which clouds of mosquitoes hovered" (39), which he, animal-like and fetus-like, inhabits with a pack of peccaries for an indeterminate time. In this libidinal bath of undifferentiated identities in which he evacuates (both waste and identity) Robinson succeeds in obliterating time and consciousness, but he does so at the cost of everything.

Emerging from the mire and the decision not to return to it marks his initial entry into the process that leads to a "solar sexuality," even if at that stage such an objective is not a conscious element in Robinson's categories. Nevertheless, the conscious decision that leads him from the mire is connected to two categories that, if not requiring the immediate presence of other bodies and memories, are at least *directed towards* them: work and writing. Robinson clearly sees the impracticality, the impossibility of an actual presence—this is what he learns from the boat-building interlude. But, in order to continue to *be* on the island *and* stay out of the mire, he must continue to function within inherited categories, he must *evoke* them, *re-pre-sent* them on the desert island. Both the journal (even if it is also a medium of the "inward turn") and work (the replicating of an economy) represent the means of a *return* that is posited, if not on the immediate, palpable presence, at least on the supposed existence and value of Home and *autrui* as ultimate points of reference.

One of these points of references is Robinson's preparing the tools of writing after the mire experience:

> He then cut himself a quill from a vulture's feather, and nearly wept with delight when he traced his first words on paper. In performing the sacred act of writing it seemed to him that he had half-retrieved himself from the abyss of animalism into which he had sunk. (46)

The other means of returning and reemerging is work, still directly following the passage in the mire: "The island lay behind him, huge and untrodden, filled with unlimited promises...he must once again take his life in hand. He must work. With no more dreaming he must consummate his marriage with solitude, his implacable bride" (4).

SEX AND WORK AND SOLITUDE

In the very wording of the decision to seek a way out of the mire through work and recording, we already see the appearance of a third category that will constantly undermine and ultimately redirect Robinson's efforts: sexuality, sexuali-

ty paradoxically formulated as "consummation of marriage with solitude," sex with/in solitude, sex alone. At this point, writing (the journal), with one's self as exclusive audience, building an economy, with one's self as sole producer and consumer, and autoeroticism seem to all be placed on a level where solitude is the common denominator, but supplemented by an in-built *autrui*, an ersatz other as a way of bypassing the dissolutive effects of this solitude. Thus, things can continue to function even if Robinson is "running on empty." But, subsequently, it is sexuality that first displays the limits of such a process, built as it is on the pretense of an existing order that has in fact disappeared with the dead others of Robinson's ship. It is through sexuality, then, that both writing and working at "civilizing" and organizing the island come to an end.

Once out of the mire, Robinson begins to work and to record; both the journal and the economy begin simultaneously. This results in the solitary simulacrum of a "civilized" island complete with a: "museum of civilized living," a "conservatory of weights and measures," and even a "CHARTER OF THE ISLAND OF SPERANZA INAUGURATED ON THE 1,000TH DAY OF THE LOCAL CALENDAR," and a "PENAL CODE OF THE ISLAND OF SPERANZA," in which article 11 clearly stipulates that "All wallowing in the mire is strictly forbidden" (71).

It is this painstakingly built structure that seeks to impose order on the "darkness," on madness, that Robinson's gradually evolving sexuality undermines; first, as an exterior and "sterile" activity that channels energy away from the economy; then, more radically, as an activity or a state that can no longer even accommodate the models built on Home as ultimate point of reference, whether writing, the production of goods, or the production of offsprings.

Robinson makes forays into the island, taking time (away) from (solitary) tilling, sowing, kneading, baking, herding, building, naming, recording, officiating, to enter the "womb of Speranza." The water-clock he has built to measure time according to economic activities ("time is money") has stopped. The entry into Speranza is described by both the third-person narrator and by Robinson in his journal. The quotation below comes from this narrator and from the journal which, as it is in Tournier's text, is in italics here:

[W]hat attracted Robinson more than anything else was a cavity or recess about five feet deep, which he found in the furthest corner of the crypt. Its walls were perfectly smooth but curiously shaped, like the inside of a mold constructed for some very complex object. The object, Robinson suspected, was his own body, after a number of attempts he succeeded in finding a posture—knees drawn up to his

> chin, shins crossed, hands resting on his feet—which enabled him to fit exactly
> into the recess.... *Yesterday I again went down into the recess. It was the last time, for*
> *now I recognize my error. During the night, while I hung suspended in a half sleep, my*
> *semen escaped me. I had only time to place my hand, for its protection over the narrow*
> *crevice, no more than two fingers broad, at the very bottom of the womb of Speranza.*
> (101–109)

After his first emergence from the womb of Speranza, Robinson's "first act in
the healing half light of the house is to start the water clock again" (106). This
return to the (reconstructed) Home is the return to time divided into segments
of production and the return to the possibility of consciousness and recording.

The sexual, autoerotic entry into Speranza constitutes a diversion of energy
from the productive economic and sexual spheres. This is in keeping with the
economy-based configurations of autoeroticism/masturbation that have oper-
ated in the West from the Greeks to the Victorians into today. In Foucault's *Le*
Souci de soi (*History of Sexuality*, Vol. III), we read that sex with prostitutes and
masturbation in Antiquity were both considered a "useless expenditure of sperm"
and also a loss of the self-control becoming to a head of household/breadwinner
(the bearded patriarchal figure that Robinson becomes): "The obligation of
maintaining one's pleasures within the framework of *monopolistic* marriage was
also, for Plato's guardian, Isocrates's chief, or Aristotle's citizen, a way of exer-
cising self-control, self-control made compulsory by his status" (1980, 31–32,
my translation).

Thus viewed, marriage, like certain types of economic organizations, is
monopolistic in that it seeks to control all the steps involved in the production
and distribution of a given type of good or service. All activity outside of the
limits of the monopoly are perceived as useless, unproductive waste.[5] This view
of the autoerotic as useless *dépense* occurring outside the realm of production
becomes increasingly more codified from the eighteenth century on. At the very
beginning of the industrial revolution (Robinson's world) the contrast could not
be clearer between:

> a fundamentally social or socially degenerative practice—the pathogenic, solitary
> sex of the cloister—and the vital, socially constructive act of heterosexual inter-
> course. But the supposed physical sequelae of masturbation seem almost a sec-
> ondary reaction to its underlying social pathology. The emphasis in "the solitary
> vice" should perhaps be less on "vice," understood as the fulfillment of illegitimate

desire, than on "solitary," the channeling of perfectly healthy desire back into itself. The debate over masturbation that raged from the 18th century onward might therefore be understood as part of the more general debate about the unleashing of desire upon which a commercial economy depended and about the possibility of human community under these circumstances—a sexual version of the classic "Adam Smith problem." (Laqueur 1989, 337)

This is the background, the ruling codes in effect as Robinson attempts to survive on his island. Reactivating the clock is Robinson's way of reconstituting himself as productive economic subject which is, besides being the subject as keeper of journal, the only way he has of being a constituted subject.

The "civilizing" of the island continues, but sexuality becomes increasingly more divergent—more "perverse" in Freud's terms[6] (indicative of a view that is not Tournier's)—from the goal of a completely civilized island that Robinson has set for himself. After the experience in the cave/womb, which is followed by Robinson's "vegetable way" mentioned above, his coupling with the combe occurs:

> He felt as never before that he was lying on Speranza as though on a living being, that the island's body was beneath him. Never before had he felt this with so much intensity, even when he walked barefoot along the shore that was teeming with so much life. The almost carnal pressure of the island against his flesh warmed and excited him. She was naked, this earth that enveloped him, and he stripped off his own clothes. Lying with arms outstretched, his loins in turmoil, he embraced that great body scorched all day by the sun, which now exuded a musky sweat in the cooler air of the evening. He buried his face in the grass roots, breathing open-mouthed a long, hot breath. And the earth responded, filling his nostrils with the heavy scent of dead grass and the ripening of seed, and the sap rising in new shoots. How closely and how wisely were life and death intermingled at this elemental level! His sex burrowed like a plowshare into this earth, and overflowed in immense compassion for all created things. (120)

In this rather Lawrentian passage, as "elemental" as this coupling is, it nevertheless remains genital. It continues to involve the made-up *autrui* (Freud's "phantasy"[7]), in this case a woman ("a woman running a little to fat but still majestic in her bearing" [121]). The mirror, the gaze of the self as other, the need of an invented other, and the continued centrality of the genitals is what

characterizes Robinson's sexuality at this stage, just as the economy of the island is posited on the ultimate existence of Home and others as comforting and economically legitimizing presences.

This is the ambivalence of Robinson's sexuality/autoeroticism at this stage: if on one hand it diverts his energy from the economically productive, it is also an activity that still conforms to a shared idea, that of an other, of a realm of (re)production (even if a "phantasy") situated outside the subject. They may seem to be radically antagonistic activities, but both the *spending* of Robinson's autoeroticism and the *hoarding* of his autarchic economy are unified in their common lack of a real outlet or market.

BEYOND CATEGORIES

As the limits of this affinity are reached, through what Robinson calls his gradual "dehumanization," it is the "something else" that lies beyond categories that remains.

The limits of Robinson as economic and writing subject and as genitally centered sexual subject are thus reached simultaneously, but, again, it is through the sexual that the necessary break with the now ghostly but still conjured-up world of others first occurs. It is through the solitariness of his sexuality that he perceives the limits of energy justified through (re)production. The absence of an "outlet" eventually leads to the crumbling of the island as a series of efficient units of production, but the realization is first made in sexual terms:

> Thus with sexual desire. It is a torrent which Nature and Society have confined within a millrace, a mill, a mechanism designed to serve an end of which it is not aware, the perpetuation of the species. I have lost this outlet.... To me, in my unique situation it is crystal clear, indeed I am forced in my entire being to live it. Lacking a woman, I am reduced to *immediate* loves. (112, 125)

What prevents Robinson from continuing, from going on to the next stage of a metamorphosis he observes and records? Why does he not, at that point, apply the lesson of the sexual to the economic? Why does he not stop all work on the island and open himself to continued change? Because, as he also observes in his journal, "In the present state of [his] return to the mire. A world is being conceived within [himself]. But a world in gestation is another name for chaos" (112).

In spite of its antagonistic relation to the economy of Speranza, the auto-erotic realm is, to a great extent, in such *adequacy* with this economy, in their common reliance on a consuming/desiring presence, that it cannot sustain him in the absence of that constructed otherness the ordered/productive island represents.

This is the point at which Friday is introduced in Tournier's version. At first he is very much Defoe's Friday: a slave, a servant, an economic subject whose presence is enlisted in a justification of the structure Robinson has imposed on the island. In Tournier's novel, however, Friday is also the catalyst that provides the passage to "something else," the passage from a subject posited on the existence of *autrui* to something that can no longer be made to fit the categories "subject" or "autoeroticism."

This passage is not effected by any sort of refocusing of Robinson's sexuality onto Friday. As he puts it in his journal, after he has become an inhabitant of the tarot's "City of the Sun": "at no time has Friday inspired me with any sodomite desire. For one thing, he came too late, when my sexuality had already become elemental and was directed towards Speranza" (211).

The exotic in this text is not the sexual object of Romantic and post-Romantic tradition[8] but, oddly enough, given Tournier's position as "20th century French author," closer to an Enlightenment tradition in which the exotic Other becomes part of "didactic fables" (Werner 1971) in which he serves a rhetoric of illustration. Friday, like the "bon sauvage" of the eighteenth century, undermines Robinson's civilizing endeavor through his mysterious affinity not only to plants and animals but to the elements themselves. He is everything Robinson stubbornly and methodically attempts to eradicate from the island. It is thus in this function of subversive opposite, rather than that of object of desire, that he plays a role in Tournier's text and in Robinson's metamorphosis.

I will not attempt here to retrace all the steps and events involved in Friday's unraveling of Robinson's civilizing venture, but I will point out the fact that he is portrayed as both cryptic and innocent, even as he *undoes* Robinson's work. He is cryptic when he says that he "will make the great dead goat Andoar fly and sing" (190). In killing him—fittingly, in a struggle in which he has no weapons—Friday has symbolically killed Robinson the patriarch: "The old male with his patriarch's head and his fleece sweating lubricity, that fawn of earth harshly rooted through his four hooves to the rocky hillside" (210). Friday makes a kite of Andoar's pelt and an aeolian harp of his horns and guts, "an elemental instrument drawing song from the winds" (210). Through actions and

words whose meanings have to be deciphered, *put into language,* Friday becomes the innocent midwife, the exotic catalyst that knows not what it does.

He is innocent when he hurriedly throws Robinson's lighted pipe (so as not to be "caught smoking") into the cave where Robinson had hoarded all of his production and all the remnants salvaged from the shipwreck (a microcosm of civilization), including (unusable since unexchangeable) gold and silver pieces and gunpowder. The ensuing explosion is reminiscent of the exploding house/Home of Antonioni's *Zabriskie Point,* with its slow motion fallout of eviscerated kitchen appliances, coffee grind, cracked television sets, etc.

This annulment, in one fell swoop, of Robinson's work on Speranza and his passing to a further stage—from the genital to the solar, from the autoerotic involving an in-built other to an autoeroticism of pure *exteriority*—had to occur simultaneously in order to avoid a return to the mire, to the locus of despair, madness, and dissolution. As Robinson again retrospectively records, the agency of this passage is Friday:

> It was not a matter of turning me back to human loves but, while leaving me still elemental, of causing me to change my element. This has now happened. My love affair with Speranza was still largely human in its nature; I fecundated her soil as though I were lying with a wife. It was Friday who brought about a deeper change. The harsh stab of desire that pierces the loins of the lover has been transformed into a soft jubilation which exalts and pervades me from head to foot, so long as the sun-god bathes me in its rays. There is no longer that loss of substance which leaves the animal, *post-coitum,* sad. My sky-love floods me with a vital energy which endows me with strength during an entire day and night. If this is to be translated into human language, I must consider myself feminine and the bride of the sky. But that kind of anthropomorphism is meaningless. The truth is that at the height to which Friday and I have soared, difference of sex is meaningless. (212)

Many things converge in this elemental, solar stage of Robinson's metamorphosis. A shift from *depth* to *surface* that an earlier solitary figure, still prey to a return to the mire had already "philosophized" about is now complete, and its sign is that shift from a sexuality of penetration—even if "autoerotic"—to a "soft jubilation which exalts and pervades." Robinson can be said to have become that Deleuzian "corps sans organes" ("body without organs") which hides no *interiority* (in the shape of an *autrui,* or example) in its recesses. In fact, there are *no more recesses;* more colloquially, but without the pejorative connotation that

the expression usually carries, Robinson's sexuality has become "skin deep." It has also become self-contained, without "loss of substance," circular like the snake of the tarot reading biting its tail, and this circularity is in turn the symbol of both the non-reproductive aspect of solar sexuality and of its connection to "elemental time," time unmarked and unjustified by production, whether sexual or economic.

BEYOND CATEGORIES?

This new state is what Robinson cannot leave for the Home the ship would take him back to, the ship that drops anchor in the "Bay of Salvation" after his "28 years, two months, and some twenty days" on Speranza:

> Beneath the rays of the sun-god, Speranza trembled in an eternal present, without past or future. He could not forsake that eternal instant, poised at the needle-point of ecstacy, to sink back into a world of usury, dust, and decay. (226)

He cannot, he will not go Home again. Instead, it is Friday who, fascinated by the brave new world announced by the ship, leaves.

Lastly, the ultimate stage of Robinson's metamorphosis is characterized by the apparent difficulty of *translation* for a Home that is still being interpellated through the *devious* medium, the *detour* the journal represents; the self-conscious recording of the ultimate stage of his metamorphosis is also among the last entries in his journal, his last attempt at making his experience, at least textually, fit into categories that will *make sense* at Home, his last attempt at translating into "human language." The end of the journal—the third-person narrator completely takes over for the last chapter of the novel—is the textual counterpart of the sexual and economic ruptures that consecrate Robinson's relinquishing of Home. The end of the journal is the end of language, although we should notice that even if the journal stops, there is *potentially* "more language" beyond the end of the text, the unstated possibility of "further adventures," of narration, opened up by the appearance of a mistreated deck-boy (christened "Thursday" by Robinson) on the island after the would-be rescue-ship has departed with Friday. The incompatibility of this appearance with the logic of Tournier's version of *Robinson Crusoe*, which points to an end of language as prerequisite to an end of categories, has been commented on elsewhere.[9]

Perhaps, as this commentator suggests, the appearance of the deck-boy implying as it does the possibility of a(n) (eternal) "replay," is the reflection of Tournier's "unambiguous commitment to the action of narration itself" (Davis 1988, 31). And this is also perhaps where the "act of narration itself," the continued flow of language, is a sign of Tournier-the-author's inescapable involvement with History, as Robinson's decision to remain on the island is, on the contrary, his own awakening from this nightmare. Perhaps, however, more than "difference of sex" is left behind by Robinson, perhaps it is *difference* itself that is being relinquished with language and exchange in general, for a hypothetical undifferentiatedness in which there can be no History because there is no difference, only "elemental" *being*; Robinson's island as a smooth, unmarked, eternally present and unchanging utopia where, as Barthes describes it, "the world is immobilized once and for all [in 'universals' and 'essences']" (1957, 243). Perhaps in giving us a happy Robinson, Tournier has also given us a new myth: the possibility of happiness.

I leave one possible conclusion to the editor of a text aptly entitled *Inside/Outside*:

> It would be difficult, not to say delusionary, to forget the words "inside" and "outside," "heterosexual" and "homosexual," without also losing in this act of willed amnesia the crucial sense of alterity necessary for constituting any sexed subject, any subject as sexed. The dream of a common language or no language at all is just that—a dream, a fantasy that ultimately can do little to acknowledge and to legitimate the hitherto repressed differences between and within sexual identities. But one can, by using these contested words, use them up, exhaust them, transform them into the historical concepts they are and have always been." (Fuss 1991, 7)

NOTES

1. In his study of Michel Tournier and his work, D. G. Bevan mentions "a certain Humphrey Richardson's Secret Life of Robinson Crusoe published in 1963 in the disreputable Traveller's Companion Series" and which catalogs "5,200 sexual extravagances" between Robinson and the fauna and flora of the island (1986).

2. "Michel Tournier et le monde sans autrui." ("Michel Tournier and the World Without Another") in *Logique du sens* (1969) or as addendum to the novel in the Folio collection. Page references are to the Folio addendum.

3. See Deleuze's *Mille Plateaux* (1980, 468f.) for his opposition between *espace lisse* and *espace strié*.

4. As in other fiction involving an exotic territory, solitude and "darkness" are intimately related here. Robinson is neither Kurtz nor Ahab—they do not return but neither do they manage to last "out there—but the words used in this journal entry specifically evoke Conrad's title and theme: "Even by day I have nothing to connect me with life—wife, children, friends, enemies, servants, customers—those anchors that keep our feet on earth. Why is it that in the heart of darkness I let myself stray so far, so deeply into the night? It may well be that presently I shall vanish without trace, sucked into the nothingness I shall have created around me" (82). We should also add that Robinson is not Odysseus/Ulysses either, that his "adventure" is to find that median point *between* not returning home, and madness or death.

5. Nineteenth-century practices as examined in Peter Gay's *The Bourgeois Experience* corroborate this view: "Certainly both sexes were seized with fatigue, not to say lassitude, after masturbation, as though they had made an effort, paid out a quantum of energy. It seemed only reasonable to deduce that the young must stay 'pure,' which is to say celibate, that they must husband their bodily supplies [for wedlock]" (1984, I: 309).

6. Freud's view is ultimately quite simple and certainly conforms to the ruling codes of his time and place—sexuality outside of reproduction is essentially "perverse": "Nor do I complain if you find the kinship between infantile sexual activity and sexual perversions something very striking. But it is in fact self-evident: if a child has a sexual life at all it is bound to be of a perverse kind: for except for a few obscure hints children are without what makes sexuality into the reproductive function. On the other hand, the abandonment of the reproductive function is the common feature of all perversions. We actually describe a sexual activity as perverse if it has given up the aim of reproduction and pursues the attainment of pleasure as an aim independent of it. So, as you will see, the breach and turning point in the development of sexual life lies in its becoming subordinate to the purposes of reproduction" (1966, 317).

7. In "Contribution to a Discussion on Masturbation," Freud writes: "We must keep in mind the significance which masturbation acquires as a carrying into effect of phantasy—that half-way region interpolated between life in accordance with the pleasure principle and life in accordance with the reality principle; and we must remember how masturbation makes it possible to bring about sexual developments and sublimation in phantasy which are nevertheless not advances but injurious compromises" ([1912] 1958, 252).

8. Whether the harem girl of the Orientalist tradition of Flaubert, Loti, and others, or the numerous representations of the exotic as sexual figures, from Gide to Duras, to refer exclusively to the French tradition Tournier belongs to.

9. An excerpt from Colin Davis' *Michel Tournier: Philosophy and Fiction* on this particular point: "Tournier himself admitted that the final pages of [*Friday*] are not entirely in keeping with the logic of the preceding narrative: 'Let us say that according to my original plan, there was no deck-boy; I added him later on in order to add a romantic touch,

a touch of adventure. My initial idea, which was more rigorous, was to have Robinson become a kind of stylite, immobilized standing on a column in the sun.' Here Tournier acknowledges that the logical conclusion of the novel is silence which precludes further action and further narrative" (1988, 31).

REFERENCES

Barthes, Roland. 1957. *Mythologies*. Paris: Seuil.

Bevan, G. D. 1986. *Michel Tournier*. Amsterdam: Rodopi Press.

Davis, Colin. 1988. *Michel Tournier: Philosophy and Fiction*. Oxford: Clarendon Press.

Deleuze, Gilles. 1969. *Logique du sens*. Paris: Editions de Minuit.

———. 1980. *Mille Plateaux*. Paris: Editions de Minuit.

Foucault, Michel. 1980. *Histoire de la sexualité. vol.3. Le Souci de soi*. Paris: Gallimard.

Freud, Sigmund. 1966. *Introductory Lectures on Psychoanalysis*. Translated and edited by James Strachey. New York: W. W. Norton and Co.

———. 1958. "Contribution to a Discussion on Masturbation." In *Complete Works*, vol. 12. London: The Hogarth Press.

Fuss, Diana, ed. 1991. *Inside/Outside. Lesbian Theories, Gay Theories*. New York: Routledge.

Gay, Peter. 1984. *The Bourgeois Experience. Victoria to Freud. Education of the Senses*. New York: Oxford University Press.

Laqueur, Thomas W. 1989. "The Social Evil, the Solitary Vice and Pouring Tea." In *Fragments for a History of the Human Body*, vol. 3. Michel Feher, ed. New York: Zone Books.

Tournier, Michel. 1969. *Friday*. Translated by Norman Denny. New York: Pantheon Books.

Werner, Stephen. 1971. "Diderot's Supplément and Late Enlightenment Thought." In *Studies on Voltaire and the 18th Century*. 86: 229–92.

11

COMING IN HANDY:

THE J/O SPECTACLE AND THE GAY MALE

SUBJECT IN ALMODÓVAR

EARL JACKSON, JR.

The atavistic aversion therapy against masturbation that the media inflicted upon young people in their treatment of the arrest of Paul Rubens (aka Peewee Herman) for alleged "indecent behavior" in a Florida adult movie theater is a particularly deplorable reminder of the willful illiteracy of sexual diversity promulgated as the national morality, in this case tantamount to criminal neglect and reckless endangerment. Given the AIDS pandemic and the increase in teenage pregnancies and other sexually transmitted diseases, if Rubens had done what his accusers claim, instead of making "an example" of him by ruining his career, the media should have literally promoted "Peewee" as a model of responsible sexual behavior and creative fantasizing for young people to emulate.

Masturbation in porn theaters is a tradition in gay male communities that provided one model for the self-conscious eroticization of safer sex practices. The theater itself serves as an environment for sexual networks that could be mobilized in response to the current public health crisis; it also showcases sexually explicit and gay-specific visual fantasies whose image repetoire has proven

vitally important to the ways in which gay men conceive and reconceive of their sexualities.[1] As attested in the works of many gay artists, the gay pornographic apparatus, moreover, informs the representational practices of contemporary gay male insurgencies. Taking as my primary texts *Law of Desire* (1986) and *Matador* (1986, U.S. release, 1987), in this essay I examine the ways in which one such artist, Pedro Almodóvar, uses structures from gay male pornographic films—and in particular films featuring displays of masturbation—as part of a confrontational construction of a gay male spectatorial subject.

Law of Desire and *Matador* lend themselves to a joint reading, having been made the same year with essentially the same principal actors. Both films, moreover, begin with scenes of masturbation; the major plots of both films are set in motion by murder (although *Law* contains far more detours and lateral plots than the murder-centered plot of *Matador*). Although only *Law* is an overtly gay film, *Matador* can be seen as a gay-oriented parody of heteropatriarchal constructions of male sexual subjectivity; both films therefore appeal to a gay male spectator as an arbiter of their intelligibility.

The differences of the two films are emblematically encapsulated in the differences between their respective opening masturbation scenes: *Law of Desire*, the act of masturbation is initially presented as part of a gay porn film under production; in *Matador*, the corresponding figure is a man masturbating in front of his VCR, watching scenes from slasher films in which women are brutally murdered. These differences are extended through their respective texts. The pornographic film of *Law* functions as a metonym for gay male sexuality and its "specular" interruption of the Freudian Oedipal "narrative" of dominant male heterosexuality that is so irreverently depicted in *Matador*.

The ordinary classification of masturbation as "autoerotic behavior" or "self-gratification" cannot accommodate the phantasmatic and libidinal trajectories through which masturbation operates as it occurs on-screen in gay porn films and in the audience, as well as in other gay male sexual venues: buddy booths, sex clubs, phone sex-lines, etc. To develop a critical understanding of these practices and their significance in Almodóvar's films, I will first reemphasize a distinction Freud made in the *Three Essays* (1905) between "autoerotism" and "narcissism"; secondly, I intend to "deviantly reinhabit" the opposition Freud proposed in "On Narcissism: An Introduction" between "anaclitic" and "narcissistic" object-choice types. These two steps allow me to situate the psychodynamics and multiple functions of gay male masturbatory practices within an "intersubjective narcissism," the definition of which depends upon an understanding of

"narcissism" as first of all a sexual-subjective process distinct from "autoerotism," and secondly a conceptualization of gay male subjectivity distinct from the "anaclitic" subject-type of the dominant, Oedipalized, heterosexual male subject.

I will then delineate the coimplicative relations between subjectivity and representation by focusing on how these two binaries of the construction of the psychosexual subject (autoerotism/narcissism; anaclitic-narcissistic) are figured within the oppositions of the narrative and specular modes of representational practice. I have suggested elsewhere that narrative and visual (specular) modes of representation are two "technologies of subjectivity" (Jackson 1991, 114). With this in mind, I will survey gay male pornographic films for typically narcissistic transgressions of Oedipalized male identity and for characteristic aberrations of the narrative and specular representational modes. Finally, after highlighting Almodóvar's adaptations of gay pornographic traditions within his work, I will conclude by extrapolating a "gay male spectator" inscribed therein, paying particular attention to how Almodóvar advances such a spectatorial model by taking it from its "illicit" and subcultural origins to recontexualize it within mainstream cinema and for a largely heterosexual audience.

GENEALOGIES OF MALE PSYCHOSEXUAL SUBJECTS

The autoerotism of prenarcissistic infantile sexuality originally "attaches itself to one of the vital somatic functions," a tendency epitomized by the oral phase "in which sexual activity has not yet been separated from the ingestion of food" (Freud 1905, 182, 198). The oral stage represents a complete identification between a "satisfaction of the erotogenic zone" and "the satisfaction of the need for nourishment." A nursing infant does not differentiate the satisfaction of its hunger with the sensual stimulation of the breast and the flow of warm milk over the erotogenic zones of its lips and mouth. The child's autoerotism expresses itself in habits that recapture these nondistinguished satisfactions. Thumbsucking is evidence that "sexual activity attaches itself to functions serving the purpose of self-preservation and does not become independent of them until later" (Freud 1905, 181–82). This "attachment" to self-preservative instincts is what Freud calls *Anlehnung*, conventionally translated in English as "anaclisis" as a noun and "anaclitic" as an adjective (from the Greek meaning "to lean on"). In its earliest and most basic meanings in Freud's work, therefore, the "anaclitic" nature of human sexuality referred to the modes of its manifesta-

tion. A function of the peculiarities of human physiology and the long period of helplessness, the mimetic dependency of sexuality on activities and experiences of the self-preservative instincts was considered a common tendency, regardless of biological sex or later sexual orientation.

In 1914, Freud published "On Narcissism: An Introduction," in which he introduces two types of object-choice patterns, the "anaclitic," typical of heterosexual males, and the "narcissistic," typical of women and "people whose libidinal development has suffered some disturbance, such as perverts and homosexuals." As one of its distinguishing features, Freud notes that the anaclitic object-choice "displays the marked sexual over-estimation which is doubtless derived from the original narcissism of the child, and thus corresponds to a transferrence of that narcissism to a sexual object" (Freud 1914, 87–88). The paradox that the heterosexual male's "anaclitic" object-choice is based on the "overvaluation" derived from an "original narcissism" is resolved in the subterranean relations between the anaclisis of sexual drives on self-preservative instincts and the role castration anxiety plays in the dissolution of the so-called positive Oedipus.

The socialization of young boys into normative heterosexuality depends largely on a terrorized discovery of sexual difference. Freud readily admits that the young boy's first sight of female genitalia does not immediately stimulate the castration fear; this comes about subsequently, "when some threat of castration has obtained hold upon him" (Freud 1925, 252)—in other words, once he has been sufficiently indoctrinated to fear the absence of the penis, and to internalize the ideologically naturalized relation between women's anatomical difference from men and the former's social and cultural disenfranchisement. In emerging as a self-consciously gendered entity, the boy is faced with two alternatives in his attitude to women: terror of her ("horror of the mutilated creature") or terroristic impulses toward her ("triumphant contempt for her").

The successfully Oedipalized heterosexual male, therefore, reaches an impasse: in order to accede to the "proper" subject position, whose alternative is the castration the woman's body has proven a possibility, he must desire the body that represents that very threat. This is why his anaclisis requires an overvaluation of the love object he also holds in contempt. He must fetishize the female body—he must desire it as the phallus, so that his possession of it will suffice to neutralize both his knowledge of sexual difference and the possibility of his own constitutional "lack." In other words, male heterosexuality is "self-preservative" because the female body is experienced as life-threatening. This

threat is alternatively overcome by villification of the woman as castrated, or by fetishizing her as the Phallus whose irreducible absence is first incarnated in and then disavowed through her body.

For such a subject, the paradigmatic confrontation with sexual difference is mythically figured in Perseus's confrontation with the Medusa, who embodies the "terror of castration" experienced at the sight of female genitalia. Like this subject's human female love object, however, Medusa is a comforting monster: the snakes that grow from her head as hair "serve actually as a mitigation of the horror, for they replace the penis, the absence of which is the cause of the horror" (Freud 1940 [1922], 273). Even her paralyzing gaze ameliorates the castration anxiety she embodies: the stiffening of the victim's body reminds him of erection and thus the continued existence of his penis. The erection is not merely an internal consolation. Brandishing it before the woman/Medusa "has an apotropaic effect"; it is "another way of intimidating the Evil Spirit" (Freud 1940 [1922], 274). Through sexual arousal the Oedipalized male exorcises the threat of sexual difference the woman represents. The erect penis is a weapon of both defense and offense, a talisman wielded in a sexual act that functions as preemptive aggression. Tumescence is "caused" by the woman, but as a response it expresses sexual desire and murderous defensive hostility (or sexual desire *as* murderous defensive hostility).

Male heterosexual relations with women are determined to a great degree by the "successful" resolution of the Oedipus through the castration anxiety of the phallic stage at which point "maleness exists but not femaleness" (Freud 1923, 145). This means that the principal binary is not male-female but male-castrated. Therefore, a male encounter with a female is an encounter with nonexistence: both hers and the possibility of his. In the anaclitic subject, therefore, self-preservative instincts are not merely the models for sexual drives and adult (heterosexual) object-choice, but the sexual drives are thematized as self-preservative instincts within the dynamics of that object-choice and that sexuality. Male heterosexuality is anaclitic because it is "attached" to self-preservative instincts, but also because it is realized as a complex of self-preservative maneuvers against the life-threatening potential within sexual difference.

Resituating the heterosexual anaclitic object-choice in its earlier developmental history in Freud's thought brings to light the implicit associations with male heterosexuality and the self-preservative instincts. Such associations, furthermore, imply an instrumental view of the (female) object: the (female) object is chosen and used primarily for the benefit and maintenance of the (male) sub-

ject. Synthesizing the disparate meanings of "narcissism" as object-choice category, on the one hand, and as ego-forming function of identification, on the other hand, allows us to reenvision gay male desire as integral to the processes of subject-constitution and intricately related to operations of self-representation. In the intersubjective, narcissistic sexual encounter among gay men, the erotic and scopic vectors of sexual subject formation that had begun with the caregiver and the child at the mirror are consciously experienced and manipulated, without the enforced exclusivity of desire and identification.

ANACLITIC AND NARCISSISTIC SUBJECTS OF REPRESENTATION

THE SPECULAR

Dominant cinema replays the circular contradictions of Oedipal male identity politics. The Oedipal male spectator's castration anxiety is assuaged by the spectacle of the female body on-screen, as the site of the "real" castration. This display, however, is ambivalent because her very "lack of a penis implies a threat of castration.... Thus the woman as sign, displayed for the gaze and enjoyment of men, the active controllers of the look, always threatens to evoke the anxiety it originally signified." One of the means by which the male subject can "escape this castration anxiety" is through "turning the represented figure itself into a fetish so that it becomes reassuring rather than dangerous," which is accomplished through the fetishistic scopophilia the film facilitates, which transforms the woman's body into the phallus (Mulvey 1975, 21).

Complementarily, the psychical operations of the male spectator also reenact the injunctions of the so-called "positive" Oedipus, the mutual exclusivity of desire and identification. The on-screen figures of desire and identification never coincide since the pleasure in looking provided by mainstream cinema is predicated upon the "sexual imbalance" organizing socially defined subjects, manifest as a tension between an active male viewer (the "bearer of the look") and a passive female object of that male gaze, and overdetermined by an "active/passive heterosexual division of labor" that makes it impossible for "the male figure...to bear the burden of sexual objectification" (Mulvey 1975, 17–18). Indeed, Jacques Lacan often described the experience (for male subjects) of being the object of another's gaze as a castration or an "annihilation" (Lacan 1978, 82–85). The gay male is at once the bearer of the desiring gaze and a subject who rapturously bears "the bur-

den of objectification," the desiring gaze of the other. In the body of the other, the narcissistic subject recognizes his (somatic) like and object of desire; in the look of the other, he sees himself as object of desire. The other's desire is the means by which he can reconstitute himself as a transitory ideal ego, confirmed in the "annihilation" of the other's desiring look. The differences between the anaclitic and narcissistic subjects are dramatically illuminated in the contrast between their respective traditions of masturbatory voyeurism. Although both gay and heterosexual men masturbate, in the latter case it is typically considered a shameful act, partially because of its impracticality (it does not issue in offspring, nor is it part of the reassertion of sexual dominance over the castratred other).

The necessity of concealment in the heterosexual case also stems from the aversion of the heterosexual male to becoming a sexual display for another's gaze. In the traditional porn movie theaters, heterosexual men might masturbate secretly beneath heavy coats, but any evidence of their activity would usually be mortifying. In the peep shows, live women pose in the middle of an arena ringed by windowed booths. As the men pay money into the slot, the window screens rise, affording them a complete view of the woman posing, but concealing the men's lower extremities from view. This scopic arrangement is alluded to in Madonna's "Open Your Heart" video (1987), and more graphically indicted in Ken Russell's *Crimes of Passion* (1986). The latter film captures the suppressed violence and pent-up despair in oblique shots of the clients' furtive ejaculations into floor buckets, a violence it exposes when, during an orgasm in the booth, a psychopathic priest (Anthony Perkins) rams a rapier-tipped dildo into an inflated rubber doll, filled with stage blood.

In gay male specular venues, the masturbation is usually visible—a lure for the spectator as well as a means of self-gratification for the masturbator; whose arousal it indicates is not always easy to determine. For example, in one of the major J/O clubs in San Francisco, customers must check all clothing except shoes. The interconnected rooms feature mirrored tables and walls, and video monitors that alternate between pornographic films and live action from other rooms in the complex. The participants also include paid and unpaid bodybuilders and models. The club forms an environmental theatre in which the ordinary divisions between spectatorship and performance and among autoerotism, narcissism, and exhibitionism no longer apply. Instead, these intrapsychic processes and intersubjective modes of self-representation describe transgressive trajectories of nomadic and multidirectional desire.

Such specular geometries complicate the cinematic representation of gay

male desire. For example, in *Head of the Class 2* (Scott Masters, 1989), Adam Grant is a student who, while waiting for his tutor in a fraternity house, wanders into a video control room from which he can monitor any room in the house. In one bedroom he selects, two students are studying. Student A (Keith Panther), a communications major, asks student B (Brian Hart) to turn on the video in his recorder, thinking it is his lesson. It turns out to be a video of student A masturbating, which arouses Grant into masturbating while watching. Student B wants to compare the actual penis size of student A to the video—Student A complies, and the two students then have sex while watching that video. The film itself regularly cuts to the two students, the video of Student A masturbating, and Grant, watching and masturbating.

THE NARRATIVE

The representational planes of a Hollywood film are asymmetrically engendered: the woman as passive exhibitionist display represents the non-diegetic spectacle, and the male protagonist personifies the motivation of narrative progression. These oppositions also structure the heterosexual male spectator's relation to the screen, in that he finds erotic pleasure in looking at the female figure as specularized object, and identifies with the male protagonist as the person whose actions control and shape the events of the filmic world (Mulvey 1975, 18–19). In other words, the heterosexual constraints on the male gaze are supported by the construction of the "hero" as the embodiment of the narrative drive. The on-screen hero's narrativity, functioning to support the antinomy of identification and desire in the scopophilic economy of the male viewer the film addresses, furthermore, reveals the structural relations among the Oedipal complex, the cinematic apparatus, and narrative hegemonically deployed as a specifically gendering technology of the subject.

The Oedipal narrative that seems to collapse homosexuality and phallocentrism, also invalidates "real" homosexuality as an anti-narrative anomaly. The male heterosexual (anaclitic) subject is imagined as both the result of and the protagonist in a series of linear, goal-directed, pleasure-sublimated narratives. Passing through the oral, anal, and phallic stages of sexual development in the correct order without lingering or diversion, he confronts the Medusa of sexual difference and submits to paternal Law. This male then becomes the hero in the battle narratives of heterosexual phallic masquerade courtship, apotropaic

conquest, and patrilineal destiny.

The adult male homosexual, in contrast, is a pastiche of interrupted narratives: a maturation "arrested" at the narcissistic stage; a "disturbance" in his libidinal development, suspending him within the sway of the pleasure principle; a failure to understand the riddle of the castration complex, thus sabotaging Oedipal resolution and fomenting a capacity for transgressive identifications. Even the polycentric erotic body of the male homosexual figures a coexistence of the oral, anal, and phallic phases of libidinal organization that should be discrete and unrecoverable moments in the subject's preoedipal history. Of course, to suggest that the erotic choices of the "homosexual male" evolve from an identifiable preservation of these phases is to conflate the somatic and specific practices of adult individuals with the metaphoric and emblematic uses of body parts to designate an abstract outline of psychosexual development. It may be just such a series of conflations, however—between the metaphoric and the referential, between the figurative and the experiential—operative within the political imaginary of the dominant culture, which makes the male homosexual an embodied crime against "nature" and his sexuality an aberration within the narrative logic of phallic truth. Gay male sexuality therefore lends itself to representation as a picture (perhaps a cubist picture)—with a simultaneity of erogenous zones—rather than as a history (a narrative).[2] In discussing gay male representational practices, therefore, I use "narrative" and "specular" in two distinct but often interrelated senses: as broad categories of representational genres, and as metaphors for specific conceptualizations of sexual identities, such as the specularity of homosexuality and the narrativity of male heterosexuality. Accordingly, the gay *Law of Desire* is marked by the specular saturation of the pornographic film, and the heterosexual *Matador* by the ineluctable teleology of the detective narrative. Almodóvar also foregrounds the contrast in the narcissistic and anaclitic J/O spectacles I delineated above: the masturbation scene in *Law of Desire* suggests multiple visibilities and the consolidation of a fantasy ideal ego; the corresponding scene in *Matador* constitutes a furtive and homicidal defense against castration anxiety.

THE STAKES OF REPRESENTATION: THE NARRATIVE AND THE SPECULAR
THE GAY PORN FILM

The specular and the narrative often seem diametrically opposed in a porn

film: the plot of the film stops at the spectacle of the sex acts whose unmotivated visual excess overpowers the linearity of meaningful acts the narrative is meant to organize. The specular undermining of the narrative is abetted by the film's construction: the blocking, lighting, camera angles, editing, and choreography of bodies accentuate the visibility of each act, at the expense of any naturalistic illusion characterizing a more holistically contextualized reality. The sex scenes also transgress the boundaries of genre (fiction, documentary); semiotic categories (symbolic [narrative], iconic [visual record]); and ontologies (real, false). Real sex within the porn film constitutes a semiological trauma the narrative sustains and the film memorializes.

In many gay porn films, however, more intricate relations obtain between the narrative and specular modes, particularly in the genre known as "erotic confession." In these films, the would-be subject addresses the other through both linguistic and visual appeal, displaying his body to the viewer and his secrets to a listener, the "other" represented by the camera or an off-screen interlocutor, respectively. The "erotic confessions" genre often represents the other-dependence of the subject in both the specular and narrative registers: the visual exhibitionism of the subject is integrated with the diegetic self-exposure of telling his life. Jean-Daniel Cadinot's *All of Me* is an excellent example of these double exposures.

All of Me is a portrait of the porn actor/model Pierre Buisson. The soundtrack consists of actual taped phone conversations between Cadinot and Buisson prior to and (at least one) shortly after their first photo session. In these conversations Buisson recounts three key sexual experiences that essentially led him to consider working in porn. The visual track features Buisson posing on an overstuffed leather sofa; Cadinot is represented by a man whose face is obscured by a still camera, incessantly taking snapshots (the clicks of the shutter punctuate the interview). This scene is interwoven with reenactments of the three stories Buisson tells on the soundtrack. At the conclusion of the third story's depiction, the scene returns to the couch and Cadinot asks Buisson to masturbate to orgasm. Buisson complies, after which Cadinot asks Buisson if he would like to make a film of his experiences, to which Buisson enthusiastically agrees. The narrative concludes with the narrator's detumescence, and the film concludes with the moment of its own inception.

The site of Buisson's self-articulation as star is a leather couch, reminiscent of the psychoanalyst's, on which he "reveals himself" (his sexual secrets) and "exposes himself" (fondling and manipulating his genitals and buttocks for maximal

visibility to the camera). The couch's numerous deep upholstery holes look like anuses themselves, and their repetition suggests the film's repetition of sex scenes, as well as the actor's repeated exposures for the camera and disclosures for the microphone. Furthermore, the buttons within these holes are literally the *point de capiton*, Lacan's domestic metaphor for that which stops the sliding of the signifier (Lacan 1977, 154). The restaged interview between Cadinot and Buisson (like a "construction in analysis") mimics an analytic session, and the film fixes the images to the stories recounted (the specular to the narrative), just as the upholstery buttons hold the couch's shape in patterns that visually echo the erotogenic zone most intensively under spectral contemplation.[3]

In the confluence of oral autobiography and nude posing, *All of Me* initially articulates a sexually differentiated subject as an intentional spectacle, and exposes itself as a deviant representational practice in showcasing a spectacle that does not *impede* the narrative, but—quite the contrary—*generates* it.[4] Cadinot's film is a fictionalized reconstruction of Buisson's screen test. Real screen tests of aspiring and/or successful porn stars have been commercially distributed since the release of William Higgins' *Screen Test* (1986) and *Screen Test # 2* (1987). In these tests an off-screen voice instructs a young man to sit down on the bed, stand up, slowly undress, and eventually masturbate to orgasm. The act of masturbation solicited by the voice is a more direct elicitation of the "truth" of sex, because it is a sexual act produced by the institution that reproduces it: a truth irreducibly an effect of that elicitation (and therefore not "truth" in the strictest sense of the term, as a preexistent reality, subject to discovery).[5] The scenarios of the screen tests are not only similar to what happens in *All of Me*, but they are precisely what happens in the first scene of *Law of Desire*. Such comparisons, however, must be qualified by the differences between Almodóvar's film and the pornographic traditions to which he is indebted.

SPECULAR TRICKS: *LAW OF DESIRE*

Although *Law of Desire* features gay characters, it is not a film exclusively (or even primarily) for gay men; although the film evokes gay pornographic film and quotes its conventions, *Law* itself is not gay porn. This internal dissonance and the larger audience the film addresses institute two important suprastructural differences between *Law of Desire* and gay male pornography:

1. The relations between the narrative and the specular are played out as tensions between the first scene and the rest of the film, and as specular-

ized modes of resistance to the master-narrative of the Oedipal development of compulsory heterosexuality.

2. The gay male spectator the film posits will be ineluctably politicized, and will emerge as a contestatory subject position vis-à-vis the "general" audience.

The film opens with a young man walking into a sparsely furnished bedroom. Taking directions from an offscreen male voice, he strips to his underwear and kisses his image in a full-length mirror. He is then told to rub his genitals against his reflection until he becomes excited, after which, still following directions, he lies on the bed and continues to stimulate himself, removes his underwear, and eventually masturbates on his knees until orgasm. After the young man climaxes, a man puts money on the stand next to him. The boy counts it and lays it down again. The director's voiceover says, "Freeze it and 'The End,'" while the scene changes to a hand marking a film reel, then to a close-up of the money on the nightstand and the large red letters "*Fin.*" This, then, was the final scene of a film-within-a-film.[6] Suddenly, a red-haired woman appears walking away from the "*Fin*" image (leaving the theater where that film had just been screened), and seeing a man in the lobby, she embraces him, as a young man walks past them. This scene is also frozen, and the words "*Law of Desire*, a Film by Pedro Almodóvar" write themselves across the scene (in spite of the fact that the "official" credits were already shown before the first scene). The frozen scene outside (and within) the theater (the lobby with the doors open, still exposing the false movie on the inner screen) is also a complex of both neutralized and inverted syntagms of "appearance" and "reality" that can be understood only retrospectively: the pair embracing are not lovers, but brother and sister; the brother is not heterosexual (as it appears in his embrace of the woman) but homosexual; the man walking by (Antonio Banderas) is not an incidental figure (Barthes's "effect of the real"), but a key figure in the love triangle and murder intrigue that will ensue.

These inversions contain further inversions: the man (Eusebio Poncelas) embracing the woman (Carmen Maura) is the "real" (intradiegetic) director of the film whose final scene opened the main film; the woman is "actually" a transsexual (the siblings are brothers). The "sister's" story is a travesty of the Oedipus: as a young boy she had an affair with her father; when the mother discovered this, the father and child fled to Algeria, where the boy had a sex-change operation, only to be abandoned by the father subsequently. In other words, the boy child's desire for the *father* is punished by the *mother* by exile

and real castration. The inversion of the Oedipus obviates phallic narrative closure just as the alterity of sexual orientations and the reversals of gender codes disestablishes the mutually exclusive divisions of artifice and reality. Within the context of the discovery of the film's inaugurating tricks, it is important to reread the economy of desire in the first scene, and the traversal of the representations of that desire across disjunctive planes of reality.

At the beginning of the opening scene, the director's voice tells the young man, "Don't look at me. Remember you are alone." When the man kisses his reflection, the voice instructs him, "Do it again. Pretend you are kissing me and you like it." The "director" is first shown when the actor hesitates to say the line "Fuck me." Eventually his repeated "fuck me's" are taken up by a man standing next to the director, with his own microphone. The sexually aroused responses now come from both the actor and the man next to the director, although it is difficult to tell whether the second man is actually aroused or merely adding sound effects. When the actor says, "I'm coming," the director responds, "I am too." Although both the director and the second man then make sounds of sexual satisfaction into the mikes, accompanying the "actual" orgasm of the actor, the director remains cool and businesslike, foregrounding the "false" nature of the entire enterprise. The interpermeating boundaries of the real and the false are thematized throughout the scene (typical of actual gay porn), here spanning intra- and metadiegetic levels.

The fact that it is a movie set makes the scene directed "really" false. The actor is not alone, but is told to pretend that he is. The pressure toward reality is based on the specificities of the male body. He must become "really" aroused in order to complete the scene, a scene which is "false" but will contain a core of sexual reality for the fantasies of subsequent viewers. In order to facilitate the real of sexual arousal, the director suggests fantasies to the actor: "Pretend you are kissing me and you like it"; "Imagine that I'm fucking you"; "Can you feel me inside you?" These fantasies have "real" effects, and indeed suggest a real outside of the film situation: the actor must have an "offscreen" sexual attraction to the director in order for the fantasies to work—but in this case such a relationship would occur within the narrative of the film that comprehends this scene (and thus doubly fictive).

Within the triply embedded masturbation sequence (a film in production within a film within a film), a psychic drama is enacted. The man at the mirror joins his introceptively experienced anatomical "self" with the externality of his image, and invests this image with a significant libidinal charge, at the urging of

the voice. When he masturbates, he gives way to the raptures of the primary processes, allowing fantasies to stimulate him sexually and to lead him to full satisfaction in the absence of any "real" object. Yet even here, psychic functions of different levels are operative simultaneously. Although the actor is using fantasy—thing presentation—to drive him to satisfaction (the pleasure principle), his fantasy is prompted and guided by the voice—that is, word presentation—from the realm of the secondary processes and the reality principle. The distinctions between pleasure and reality principles are blurred: the ultimate aim of the actor's performance is money—certainly the reality principle at work, but here it does not entail deferred satisfaction; in fact, the autoerotic satisfaction within the pleasure principle coincides perfectly with the financial satisfaction of the reality principle: libidinal and literal economies intersect (as they do in *All of Me*).[7]

When the intradiegetic actor faces his image in the mirror, the visual doubling resonates with the narrative embedding, producing a metacinematic commentary on the artifice of the film's production. Both images of the young man are just that: two-dimensional specular configurations of a "real" body that is nowhere present. The fictional actor's embrace of his ego-imago in the mirror becomes the split emblem of the film embracing itself as film: the reduplicated, fascinated-fascinating image of the body confirms the resistance of the autotelic spectacle to narrativization. The autoerotic body produces nothing, nor does it reveal any secrets. Lacan (1953) describes the "inertia" in the ego "as the resistance to the dialectic process of analysis. The patient is held spellbound by his ego, to the exact degree that it causes his distress, and reveals its nonsensical function" (12). The "conception of the mirror stage" advanced an understanding of "the formation of the *I*" that completely discredits "any philosophy directly issuing from the Cogito" (Lacan 1977, 1). The image-ego, the self-pleasuring image (the actor watching his own arousal in the mirror as a metonym for the film's superstructural specular transgression), in its "nonsensical function" resists analysis—it refuses to tell its story (it doesn't have one; the spectator is seduced into supplying it). The thematic presumption of the narcissistic constitution of the I (and the film) forecloses Cartesian self-certainty, the position necessary for the phallic coherence of narrative. The metadiegetic reflection of the film upon itself, parallel to the vision of the actor in the mirror, inhibits the generation of a master narrator (a privileged viewing subject or omniscient incorporeal storyteller) as it deconstructs the contingencies and ambivalences within the narrative compulsion toward a truth outside of subjective and intersubjective compromises.

The first scene is a specular event that does not resolve itself in a naturalizing narrative, and does not contribute to the narrative of the film as a whole. The resistance of the first scene to incorporation into the narrative whole of the film is parallel to a kind of resistance the gay male sexual subject offers the teleology of the master plot of the male child's journey into patriarchally defined heterosexuality. Gay sexuality, like the first scene, is a specular subversion of the Oedipal narrative. Besides the narrative arrest at the mirror stage that serves as a subliminal structuring fantasy within one tradition of homosexual pathologization, the polycentrality of the gay male erotic body maps simultaneous erotogenic possibilities that seem to correspond to the oral, anal, and phallic stages through which the anaclitic subject passes (See Freud 1905, 197–99, and note added in 1924, 199–200; and Freud 1923, 141–45).

HETEROSEXUALITY CAN BE MURDER: *MATADOR*

Matador begins with a shot of a woman being simultaneously strangled and drowned in a bathroom sink, filmed upward from the bottom of the sink as her head is plunged into the water. This shot is followed by a close-up of a man's face, heavily perspiring and showing signs of physical exertion. The next shot is of a man opening a straight razor, placing the drowned woman's corpse in a bathtub, and slashing her wrist. The subsequent scenes are of increasingly gory murders of women and discoveries of mutilated female corpses, alternating with various shots of the same male spectator, who is masturbating facing a television. One shot is filmed from behind the man's chair, his feet framing the television screen where the butchering continues, his panting mixing with the screams from the video and the music of the soundtrack.

In the gay *Law of Desire*, the masturbation occurs on the site of cinematic production, for the pleasure both of the figure being filmed and of the specular network comprising the director, technical assistant, and spectator. The corresponding scene in the (heterosexual) *Matador* is in a private home in front of a television (site of passive visual consumption) where a solitary man masturbates while watching video excerpts of slasher movies. In *Law*, the masturbating actor is the bodily center of a nexus of intermeshing and mutually disseminating desires (voyeurism and exhibitionism, fantasy narratives, memory play) and indeterminately recursive avenues of pleasure, emanating from the production of a film. It is creative, and intersubjectively narcissistic. In *Matador*, the masturbating man is simply viewing excerpts of already made films, lacerated segments

of films metaphorizing the dismemberments depicted therein. The relationship of (profilmic) viewer to scene in *Matador* is necrophilic, parasitic, autistic, and fundamentally homicidal to women—in other words, the paradigm of certain types of hegemonically valorized male heterosexuality.[8]

The masturbator is Diego Montes (Nacho Martinez), a celebrated toreador until a bull-inflicted leg injury prematurely ended his career, relegating him to running a school for would-be bullfighters. The next scene is actually two interlocking sequences: the matador lecturing his students on the "art of killing" the bull in the ring, and a beautiful woman (Assumpta Serna) picking up a man on the street, taking him to a hotel room, and killing him by plunging a hairpin through the back of his neck during sex. Her actions are described metaphorically by the phases of the kill the matador elaborates in the lecture, and her deadly sex act is intercut with the students' practice sessions using bulls' horns and horned carts. After the lesson, the matador speaks with Angel (Antonio Banderas), one of the students who seemed upset by the descriptions of killing. During their conversation, the matador discovers with surprise that Angel has never had sex with a woman (an assertion in symmetrical opposition to Banderas's character in *Law*, where he tells the director that he doesn't sleep with men). To encourage him, the matador tells him, "Chicks are just like bulls, you've got to hem them in first and just take them." The gender confusion within this simile parodies the phallic stage of sexual development, at which point "there is only one sexual organ." In other words, women are a negative form of men, and both are defined in relation to the deadly penetrative power of the phallus. Sex amounts to closing in for the kill. Both of these statements had been realized in the murder scene previous to the conversation.

The relationship between the heterosexuality parodied in *Matador* and the narrativity it eventuates is sexually thematized early in the plot. Leaving school, Angel feels both his heterosexuality challenged and his unresolved homoerotic attraction to Diego only ambivalently acknowledged; he responds by trying (unsuccessfully) to rape Diego's fiancée (Eva Cobo). Unable to win the affection of his maestro, Angel attempted a metonymic compensation, by sexually assaulting the woman his teacher desired. This is the logic of a narrative chain; Angel's crime illustrates the violence committed upon women within the sequences such narrative logic legislates.[9] Overcome with guilt, Angel confesses to several murders that he did not commit: two male victims of the hairpin killer, and two missing women.

The lawyer who agrees to defend the boy is the murderer herself, and therefore knows him to be innocent. The other person who is convinced of the boy's

innocence is a police detective played by Eusebio Poncelas, who played the gay director in *Law*. Here Poncelas's character's sexual orientation is not made explicit, but in his surveillance of the bullfighting school, as he watches the would-be matadors in training, the camera moves in for obsessive closeups of the students' crotches in their tight toreador pants.[10] The detective's desire to know the truth, to see "it," is here imbricated with the desire to see It—the phallus, the pillar of the masculinist order. In changing roles from the overtly gay director in *Law* to a detective in *Matador*, the actor enfigures the sublimation of erotic desire into epistemophilia, as advanced by Freud in his account of da Vinci's "homosexual nature" transforming itself into his "love of knowledge" (Freud 1911, 79–80).

During the course of the investigation, the murderous lawyer, Maria, meets the matador, and the two of them prove to be suicidal-homicidal soulmates, devoted to a vehemently phallic and death-oriented sexuality. Maria is profoundly male-identified in all aspects of her persona: in her profession, she represents the *Law* (the monolithic and repressive Law of the Father, not the polyvalent and subversive "law of desire"); in her cultural identity, she idolizes the matador to the point of enshrining his accouterments—his cloak and dagger, etc.; in her sexuality, she adheres to a conception of sex based on penetration and mastery, expressing it in a transitive negativity whereby the satiation of desire is externalized as the literal destruction of the object of desire, by murdering the partner through impalement. In their first encounter, when Maria notices Diego following her, she takes refuge in a movie theater, and when he finds her, she chooses the men's lavatory in which to hide. More than betraying her ambivalence regarding her wish to elude her pursuer, the choice of lavatory affirms her male identification through her willful "failure" of what, in Lacan's scheme, is one of the most fundamental, sexually determined means by which the signifier is fixed: the choice of one of two doors, marked "ladies" and "gentlemen," respectively (Lacan 1977, 150–51).

Near the end of the film it is revealed that Diego is also a serial killer, having murdered several young women and buried them on the grounds of the school. Both the lawyer and the matador engage in sexualized killing to compensate for perceived deficiencies in their psychosexual integrity: the lawyer's "real lack" of a penis, and the matador's symbolic castration by the bull that curtailed his career. Paradoxically, it is the Oedipal hegemony of compulsory heterosexuality that induces this sense of phallic loss and predicates the lethal narrative project of its impossible restoration.

Law of Desire and Matador can be distinguished in their divergent emblems of specific orientation toward the "real," both represented and thematized within each film: in Law of Desire, the pornographic film, in Matador, the murder mystery. In the murder mystery, all actions remain on the level of fiction, in the realm of the Symbolic. The narrative is set in motion by an act whose perpetrator is unknown. The sequence of events and interpretations which are instigated by that act are structured teleologically as the discovery of the identity of the perpetrator. This is the exact reverse of the pornographic film: in visual pornography, the act is real, and is far more important than the identity of its agents; the coincidence of act and image that pornography requires ruptures the isomorphism of any naturalistic fictional film in which it occurs. In the murder mystery, the central act is not real, the identity of the agent is primary, and the occurrence of the act founds the narrative and determines its signifying processes. The murder mystery dramatizes the progress from signifier to signified (deduction of clues), as it dramatizes the eschatology of the phallogocentric sign toward a univocal Truth through the detective's ordeal of discovery. (Is it merely coincidental that English slang for "detective" is "dick"?) The detective seeks a determinate "truth" to enact Justice (the Law of the Father) as an imperfect restitution of the lost object (the murder victim); but the solution—the fulfillment of the detective's duty—closes a narrative that cannot restore the loss that had occasioned it. The intradiegetic tragedy of the plot is reinforced metadiegetically by the "tragic" paradox that the discovery of the truth will end the narrative drive and its pleasures (just as sexual satisfaction will obliterate desire and its forepleasures). The archetypical subject of such a tragically structured murder mystery narrative is Oedipus, a detective whose catastrophic discoveries install the Law of the Father as absolute. The act of deduction in the murder mystery, moreover, rehearses the intellectual activity necessary to determine the father of a child, a necessity Freud uses to assert the primacy of the concept of fatherhood and the establishment of a nonrepresentable, unitary Father-God as a watershed in the evolution of civilization (Freud 1939 [1934–1938], 112–14).

The murderer is the obverse of the same authoritarian identity, whose act of destruction assumes such a godlike privilege over life that the act of begetting a child is conceived to be within the patriarchal logic that inaugurates the metaphysics of fatherhood. The ironic distance at which the gay male spectator views the heterosexual liaisons in Matador finds a corresponding ironic distanciation internal to the film itself, in the broad parodies of heterosexual behavior and in metadiegetic intrusions into the otherwise linear progression of the narrative. It

turns out that Angel is plagued with psychic visions of murders, and that two of the murders he had "confessed" to (two women whose bodies had not been recovered) had actually been committed by Diego. We see them through Angel's mind's eye: the first woman Diego strangles and then rapes, and the second woman he drowns in the bathtub and then rapes. The second woman is virtually identical to the drowned woman in the slasher video in the opening sequence. This reverses the ontological violations in the opening scene of *Law*. (The seemingly "real" event in *Law* turns out to be an embedded film scene; the apparent embedded film scene in *Matador* turns out to be a "real" murder.)

An even more remarkable metadiegetic—even metacritical—disruption of the narrative occurs when Maria flees into the movie theater. The film playing is *Duel in the Sun* (King Vidor, 1946), and Diego enters the theater and stands next to Maria just in time to view the last scene, in which Pearl (Jennifer Jones) and Lewt (Gregory Peck) have shot each other, and die happily in each other's arms. This not only foreshadows the murder-suicide pact that Maria and Diego will soon enter into, but this is the very film which prompted Laura Mulvey to reconsider the possibilities for the female spectator she had formulated in "Visual Pleasure and Narrative Cinema." In Pearl, Mulvey sees the figure of the oscillation between "masculine" and "feminine" phases of the libido, here split between the two brothers, Lewt and Jesse, who "represent different sides of her desire and aspiration" (Mulvey 1981, 35). Although this split allows an innovative illumination in mainstream cinema of the "female spectator as she temporarily accepts 'masculinisation' in memory of her 'active' phase," the radical potential here is not realized, and Pearl's "'tomboy' pleasures, her sexuality, are not fully accepted by Lewt, except in death" (Mulvey 1981, 37).[11]

The vacillations between passive and active in the female spectator of *Duel* are frustrated by the necessary sacrifice of the female figure who embodies them, just as female sexual autonomy in *Matador* is contained within a phallocentric economy that exhausts it in Maria's homicidal and suicidal compulsions. The critical difference between the two films, however, is that *Duel* was produced, distributed, and traditionally received within the discursive parameters of an uncontested ideology of sexual difference and an absolutely unquestioned heterosexual presumption. In *Matador* all heterosexual liaisons are always already bracketed as contingent concatenations of power differentials, and the heterosexual appeals to universality are exposed as internally contradicted hoaxes that victimize both those outside of this ideology and those who perpetrate and perpetuate it. This irreverent presumption frames *Matador*'s address to the

gay male spectator's situated knowledge of the hoax of normative heterosexuality and his countervailing erotic capacities that inform his disenchantment.

COMING TOGETHER IN YOUR FACE:
THE CONTESTATORY CONSTRUCTION OF THE GAY MALE SPECTATOR

Theorizing a "gay male spectator" must account for the dialectical relations among the contradictory identifications elicited: identifications with the desiring (and organizing) gaze of the camera and its male surrogate within the film; and with the male object of desire—in other words, the dialectic between the culturally enjoined privilege of the male spectator as subject of the gaze (the involuntary patrimony imposed upon the gay male by the very order that repudiates him), and the culturally proscribed identification with an objectified male body (the incommensurability of the gay spectator's socially mandated gender role and his "anti-social" sexual orientation).

Internally contradicted, the gay spectator is also irreducibly oppositional, which leads me to reconsider my anaclitic/narcissistic binary in terms of the divergent patterns in the pleasure in looking—anaclitic and narcissistic scopophilia. Anaclitic scopophilia serves the hegemonically constructed heterosexual male film spectator in at least two ways: (1) the unidirectional specularity of gazing on the body of a woman who cannot return the gaze naturalizes a male-gendered master-subject position; (2) the focus upon the female figure as the embodiment of "lack" protects the male from his own castration anxieties (Silverman 1983, 223). The perceived need for "self-preservation" in the face of sexual difference and the deployment of scopophilia as a defense against such a threat are both predicated upon the kind of male subjectivity produced within heteropatriarchy. The efficacy of scopophilic defenses requires the mutual exclusivity of the scopophilic and identificatory drives, and presumes an antagonism between the self-preservative (or ego-) instincts and sexual drives (see Jackson 1994b 25–27 and 186–90). "Anaclitic" scopophilia constitutes an objectification of a sexually desired image that by definition proscribes identification.

The gay male spectator as the "narcissistic" subject, on the other hand, regularly identifies with the figure he objectifies. In other words, he experiences a coalescence of drives that are radically dichotomized in his heterosexual male counterpart. For the gay male spectator, the pleasure of looking at the male object of desire potentially merges with an erotic identification with that object; scopophilia and identification become interanimating components of a specifi-

cally ego-erotic subjectivity. Even when the drives are distributed among two or more on-screen figures (in a voyeur scene, for example), the spectator's identification with the voyeuristic surrogate is qualified by that surrogate's auxillary function as a sexual spectacle himself, as he masturbates for the camera while looking at the sexual object of desire (Grant in *Head of the Class II* discussed above, for example).

Furthermore, one other function of gay male porn must be considered: seeing the sexual validates the gay spectator's self-conception by acknowledging the forms his desire takes. Scopophilic pleasure in this case does not facilitate the spectator's sense of mastery over the film image, but a political as well as erotic identification with his like on the screen. Hence, narcissistic scopophilia underwrites an act of spectatorship that parallels the process by which narcissicism—even according to Freud (at times)—establishes and conditions the ego itself (Freud 1914; Freud 1917 [1915], 243–58).

The sexual politics of identification specific to the gay male spectator become a confrontational dissonance in a mainstream spectatorial situation such as the one Almodóvar concocts in *Law of Desire*. This "in-your-face" construction of the gay male spectator derives in part from the discrepancies between the act of self-identification as gay and demonized "homosexual" constituted as an object for negative identification in the society at large. Simon Watney (1988) reminds us that there are two modes of "identification" described in the psychoanalytic literature, "the transitive one of identifying the self in relation to the *difference* of the other, and the reflexive one of identifying the self in a relation of *resemblance* to the other" (78). Therefore, when the male body as a male-desired object and the incarnation of a male-desiring subject appears on the screen in the *Law of Desire*, the processes of identification triggered in the viewers divide the audience radically, in a mutually reinforcing yet antagonistic manner. The first scene of *Law* divides the hegemonic male heterosexual and gay viewers along the lines of transitive and reflexive identifications, respectively. Averse to gazing "on his exhibitionist like" (Mulvey 1975, 20), the hegemonic heterosexual male would be further traumatized by the deliberate display of the male body as an object of pleasure that violates both the epistemological exclusionism grounding masculine subjectivity and the "active/passive heterosexual division of labor" keeping his constitutional castration anxiety in check.

Almodóvar's choice of a masturbation scene for the porno movie at the beginning of *Law of Desire* supports a higher probability of erotic identification among the gay male spectators with the on-screen figure than would a sex scene

involving two or more men. Since the AIDS crisis, in particular, there has been a marked increase in both solo male masturbation films and videos, and in the focus on masturbation as preferred sexual practice within their audiences. Considering the J/O spectacles this scene cites, masturbation is represented as a microsocial act and one whose aim is both self-gratification and the sexual stimulation of others, making apparently "autoerotic" self-indulgence an intersubjective opportunity, and transfiguring the masturbating man in the opening scene of *Law* into an embodiment of being-for-itself-for-others: a combination unforeseen in Sartre's phenomenology, and certainly one disallowed in Sartre's conception of "love" as Lacan distilled it (Lacan 1975, 240–42).[12]

If the anaclitic visual pleasures of the Oedipalized heterosexual male spectator are based upon the mutual exclusivity of the ego-instincts and sexual drives, the potential identifications for the gay male viewer inscribed within the passion play of the opening scene of *Law* reconfigure the ego-instincts and sexual drives as mutually reinforcing constituents of narcissistic spectatorial subjectivity. This is because the gay male spectator is not only a psychosexual subject, but also a political agency. The dual identification with the camera and the young man in the first scene concretizes both sexual satisfaction and the means through which it is attained as a vital part of gay male subjectivity. In other words, sexual drives are at least ego-syntonic (if not constitutive of the ego) in the political imaginary of the gay male spectator. Through Almodóvar's insinuation of gay sexuality and the epistemological positions it informs into the usually anodyne social practice of commercial cinema spectatorship, the articulation of gay male psychosexual subjectivity takes on the legitimizing ethos of an identity politics that does not abandon the anarchic and excessive energies of its transgressive pleasures.

NOTES

For comments and criticisms of earlier versions of this essay, I am indebted to William Burgwinkle, Trinidad Castro, Teresa de Lauretis, Carla Freccero, David M. Halperin, Steven Johnstone, Gilberto Martínez, Lourdes Martínez Echazábal, Richard Murphy, Stephen Orgel, and Jim Swan. I would also like to thank Judith Butler for inviting me to present this work at the "Perversions/Inversions" conference at the University of California, Berkeley, Dave Kirk for his invaluable assistance in securing copies of the necessary video materials, and as always, David Jansen-Mendoza for his unfailing inspiration, intellectual and otherwise.

1. See: Cooper 1992; Glück 1985; Jackson 1994a; Preston 1993; Wojnarowicz 1991, 138–43; and Yingling 1989, 6.

2. The narrative can be disturbed either through fixation on a stage, or a regression to a previous stage; both "fixation" and "regression" have been cited as possible "causes" for "homosexuality" (Lewes 1988, 95–98).

3. I am not arguing that this is completely intentional; however, it cannot be dismissed as merely accidental. Cadinot displays a sophisticated awareness of contemporary French intellectual life in his films. In *Under the Sign of the Stallion* (1986), a gay porn novelist is beset by his next-door neighbor, a graduate student in comparative literature, who eagerly attempts to apply poststructural methods to the novelist's fiction.

4. In contrast to the female figure's song or dance that literally "stops the show"—suspends narrative progression with a moment of fetishistic contemplation of her body as total spectacle (Mulvey 1975, 16).

5. Linda Williams (1981) characterizes psychoanalysis as "a major force in the deployment of a sexuality that has intensified the body as a site of knowledge and power, making this body the major arena for the discovery of the nonexistent 'truth' of sex," but then points out that it is "the visible intensification of the body" in cinema that makes this "deployment of sexuality, and its attendant implantation of perversions" most apparent (20).

6. There is internal evidence suggesting that the embedded film is entitled *Paradigm of the Clam*. I am grateful to Ellis Hanson for pointing this out to me.

7. The actor's fantasy, furthermore, may not correspond to what the director tells him to imagine. The actor tells us nothing. This is the reverse of a psychoanalytic session. The voice of authority provides the fantasy, the auditor responds sexually but discloses nothing discursively.

8. In bed, Diego instructs his fiancé to "play dead."

9. See, for example: de Lauretis 1984, 103–157; Rubin, 1975; and Sprengnether 1990.

10. Compare this with the opening scene of Almodóvar's *Labyrinth of Passion* (1982), in which the gay male and heterosexual female protagonists are each cruising a crowded avenue in Madrid, staring with delight at the crotches of the young male passersby. Here, the gaze and the concealed bodies are both playful, and have none of the ominous valence of the phallic weaponry parodied in the surveillance scene in *Matador*.

11. My only reservations about Mulvey's thesis here concern her decision not to address the racial dynamics in the film. Pearl's "choices" between a "ladylike" and a "sexual" identity stem from her marginalization as a "half-breed" (her mother was Native American). It is unclear to what degree the former path would have actually been open to her, but it is definitely the case that her ability to acknowledge and act on the "masculine-active" components of her psyche is conflated with the "savage" half of her heritage both intradiegetically and metadiegetically.

12. Ironically, Lacan prefaces his remarks on Sartre with a rather morbid anecdote con-

cerning a joke traditionally played on amateur matadors by the spectators at certain bullfighting ceremonies.

REFERENCES

Cooper, Dennis. 1992. "Square One." In *Wrong*, by Dennis Cooper. 81–86. New York: Grove Weidenfeld.

de Lauretis, Teresa. 1984. *Alice Doesn't*. Bloomington: Indiana University Press.

Freud, Sigmund. 1953–1974. *The Standard Edition of the Complete Psychological Works of Sigmund Freud*, translated and edited by James Strachey, in collaboration with Anna Freud. London: Hogarth. 24 vols. 1953–74.

———. 1905. *Three Essays on the Theory of Sexuality. SE* 7: 123–243.

———. 1911. *Leonardo da Vinci and A Memory of His Childhood. SE* 11: 59–137.

———. 1912. "On the Universal Tendency to Debasement in the Sphere of Love." *SE* 11. 179–190.

———. 1914. "On Narcissism: An Introduction." *SE* 14: 67–107.

———. [1915] 1917 . "Mourning and Melancholia." *SE* 14: 239–58.

———. 1923. "Infantile Genital Organization of the Libido." *SE* 19: 141–45.

———. 1924. "The Dissolution of the Oedipus Complex." *SE* 19: 172–79.

———. 1925. "Some Psychical Consequences of the Anatomical Distinction Between the Sexes." *SE* 19: 241–58.

———. 1927. "Fetishism." *SE* 21: 147–57.

———. 1939 [1934–38]. *Moses and Monotheism: Three Essays. SE* 23: 7–137.

———. 1940 [1922]. "Medusa's Head." *SE* 18: 273–74.

Glück, Robert. 1985. "Caricature." *Soup: New Critical Perspectives*. 3: 18–28.

Grosz, Elizabeth. 1990. *Jacques Lacan : A Feminist Introduction*. London: Routledge.

Jackson, Earl, Jr. 1991. "Scandalous Subjects: Robert Glück's Embodied Narratives." *Queer Theory: Lesbian and Gay Sexualities*, ed. Teresa de Lauretis. *differences* 3.2: 112–34.

———. 1994a. "Explicit Instruction: Teaching Gay Male Sexuality in Literature Classes." In *Professions of Desire: Lesbian and Gay Literary Studies*, ed. Bonnie Zimmerman and George Haggerty, 136–55. New York: MLA.

———. 1994b. *Strategies of Deviance: Studies in Gay Male Representation*. Bloomington and Indianapolis: Indiana University Press.

Lacan, Jacques. 1953. "Some Reflections on the Ego," *International Journal of Psychoanalysis*. 34: 11–17.

———. 1975. *Le Séminaire. Livre I: Les Ecrits techniques de Freud*, ed. Jacques Alain–Miller. Paris: Seuil.

———. 1977. *Écrits*. Translated by Alan Sheridan. New York: Norton.

—————. 1978. *The Four Fundamental Concepts of Psychoanalysis*. Translated by Alan Sheridan. New York: Norton.

Laplanche, Jean and Jean-Bertrand Pontalis. 1973. *The Language of Psychoanalysis*. Translated by Donald Nicholson-Smith. New York: Norton.

—————. 1986. "Fantasy and the Origins of Sexuality." *Formations of Fantasy*, ed. Victor Burgin, James Donald and Cora Kaplan, 5–34. London and New York: Methuen.

Lewes, Kenneth. 1988. *The Psychoanalytic Theory of Male Homosexuality*. New York: New American Library.

Merleau-Ponty, Maurice. 1962. *Phenomenology of Perception*. Translated by Colin Smith. London and Henley: Routledge and Kegan Paul.

Mulvey, Laura. [1975]. "Visual Pleasure and Narrative Cinema." In *Visual and Other Pleasures*, by Laura Mulvey. 1989. 14–26. Bloomington and Indianapolis: Indiana University Press.

—————. [1981]. "Afterthoughts on 'Visual Pleasure and Narrative Cinema' inspired by King Vidor's *Duel in the Sun* (1946)." In *Visual and Other Pleasures*, by Laura Mulvey. 1989. 29–38. Bloomington and Indianapolis: Indiana University Press.

Preston, John. 1993. *My Life as a Pornographer and Other Indecent Acts*. New York: Richard Kasak.

Rubin, Gayle. 1975. "The Traffic in Women: Notes on the 'Political Economy' of Sex." *Toward an Anthropology of Women*, ed. Reyna R. Reiter, 157–210. New York: Monthly Review Press.

Silverman, Kaja. 1983. *The Subject of Semiotics*. London and New York: Oxford University Press.

Sprengnether, Madelon. 1990. "Enforcing Oedipus: Freud and Dora." *In Dora's Case*, ed. Charles Bernheimer, and Claire Kahane, 254–75. Second Edition. New York: Columbia University Press.

Watney, Simon. 1988. "The Spectacle of Aids." *AIDS: Cultural Analysis/Cultural Activism*, ed. Douglas Crimp, 71–86. Cambridge, Massachusetts: MIT Press.

Williams, Linda. 1981. "Film Body: An Implantation of Perversions." *Ciné-Tracts*. (Winter): 19–35.

Wojnarowicz, David. 1991. *Close to the Knives*. New York: Vintage.

Yingling, Thomas. 1989. "How the Eye is Caste: Robert Mapplethorpe and the Limits of Controversy." *Discourse* 12.2: 3–28.

C O N T R I B U T O R S

NOTES ON CONTRIBUTORS

PAULA BENNETT is Associate Professor of English Literature at Southern Illinois University, Carbondale. She is the author of *My Life A Loaded Gun: Female Creativity and Feminist Poetics* and *Emily Dickinson: Woman Poet*. She is currently at work on *Dissenting Angels: The Emergence of Modern Subjectivity in American Women's Poetry 1850–1900* and *The Selected Poetry of Sarah Morgan Bryan Piatt*.

ROGER CELESTIN is Assistant Professor of French and Comparative Literature at the University of Connecticut at Storrs. He has published on Montaigne, Flaubert, and travel literature. His book *From Cannibals to Radicals: Figures and Limits of Exoticism* is forthcoming from the University of Minnesota Press.

KELLY DENNIS is Visiting Lecturer in Modern and Postmodern Art History and Visual Culture at the University of California, Santa Cruz. Her work on pornography and art history has appeared in *Strategies* and the *History of Photography*, and she is currently editing an anthology, *The Sex*, on representation and feminine sexuality.

EARL JACKSON, JR. is Associate Professor of Japanese Literature and Lesbian and Gay Studies at the University of California, Santa Cruz, and the author of *Strategies of Deviance: Studies in Gay Male Representation* and *Fantastic Living: The Speculative Autobiographies of Samuel R. Delany*. He is currently completing a critical memoir of his sex life entitled, *Breathless Cadenzas: Sex/Love/Theory/Steve*.

THOMAS W. LAQUEUR is Professor of the History of Medicine at the University of California, Berkeley. He is the author of *Making Sex: Body and Gender from the Greeks to Freud*, and editor with Catherine Gallagher of *The Making of the Modern Body: Sexuality and Society in the Nineteenth Century*.

CHRISTOPHER LOOBY is Associate Professor of English at the University of Chicago, where he teaches courses in eighteenth- and nineteenth-century American culture. He is the author of the forthcoming *Voicing America: A Study of Language and Nationality in the Early National Period*. He is presently working on *The Sentiment of Sex: Studies of American Literary Masculinity and Dissident Sexuality in the Nineteenth Century*.

ROY PORTER is director of the Wellcome Institute for the History of Medicine. He is the author and editor of numerous books on eighteenth-century British social history and the history of medicine and psychiatry, most recently *A Social History of Madness: Stories of the Insane*, *Mind-Forg'd Manacles: A History of Madness in England from the Restoration to the Regency*, and *Patient's Progress* (with Dorothy Porter).

VERNON A. ROSARIO II, M.D. is Visiting Assistant Professor in the History Department, University of California, Los Angeles. He received his Ph.D. in the History of Science from Harvard University and his M.D. from Harvard Medical School and M.I.T. Currently, he is working on *Science and Homosexuality*, an anthology examining nineteenth- and twentieth-century biomedical research on sexual orientation.

LAWRENCE SCHEHR is Professor of French at the University of South Alabama. He has published *Flaubert and Sons: Readings in Flaubert, Proust, and Zola* and the forthcoming *The Shock of Men—A Study of Gay Hermeneutics*. He has published numerous articles on 19th- and 20th-century French literature, including studies of Stendhal, Balzac, Nerval, Flaubert, Proust, and others. He is currently working on two books, one dealing with the representation of homosexuality in twentieth-century French literature and the other dealing with the excesses of the sign in French Realism.

EVE KOSOFSKY SEDGWICK is Professor of English at Duke University at Durham, North Carolina. She is the author of *Between Men: English Literature*

and *Male Homosocial Desire,* *The Epistemology of the Closet,* *Tendencies,* and a book of poetry, *Fat Art/Thin Art.* She is one of four co-editors of the Duke University Press "Q" series.

LAURA WEIGERT is a doctoral candidate at Northwestern University, completing a dissertation on pictorial narrative in fifteenth-century choir tapestries.

INDEX

INDEX

(Baldung Grien), 23f

Tissot, Samuel-Auguste, 6, 82, 86-87, 103-107, 108-109, 113-114, 142, 169, 203-204, 217

Titian, 49, 61

Tournier, Michel, 222, 234-246

Tristram Shandy, 88

Twain, Mark, 49, 54

Van Neck, Ann, 5

Venette, Nicholas, 77, 80-81, 84-87

Venus and Adonis (Titian), 61

Venus of Urbino (Titian), 49, 50f, 54, 58-59, 62, 63, 66

venus pudica pose, 49, 51, 58

in sculpture *vs.* painting, 59, 61

Virey, Julien Joseph, 121

virginity, 156

Voice of Evil, The (Feure), 189, 190f, 191-192

Voltaire, 119

von Haller, Albrecht, 105

von Kaysersberg, Johann Geiler, 22

Wagner, Peter, 90

Watney, Simon, 271

Whitman, Walt, 170-172

Wilde, Oscar, 164

William of Conches, 158

witches

in 16th century art, 19-41

trials of, 40

Witches Sabbath, The (Grien), 36, 37f, 38

women

19th century writers and sexual power, 192-208

and autoeroticism, 10-11

imagination in, 113

and masturbation, 108-109

men's attitude toward (Freudian), 254-255

See also Austen, Jane

Women's Bath, The (Durer), 24f, 25f, 26

Women's Bath, The (Grien), 26, 27f

Woodward, Samuel, 9

writing

as masturbation-like act, 216-217

and solitude, 238

and women, 189-208

Yeager, Patricia, 194

Zambaco, Demetrius Alexandre, 204

Zola, Emile, 218, 220